St Ives 1939-64

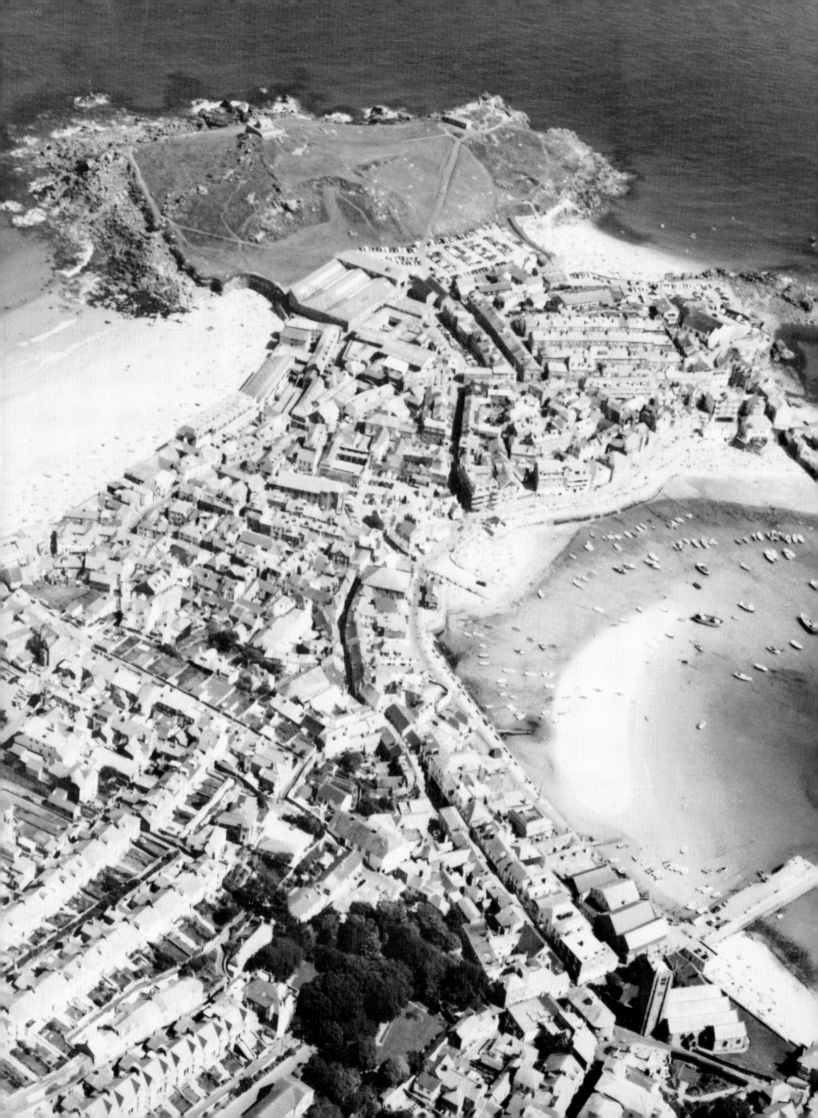

St Ives 1939-64

TWENTY FIVE YEARS OF PAINTING, SCULPTURE AND POTTERY

The Tate Gallery

front cover
ALFRED WALLIS
This is Sain Fishery That use to be
(cat.no.26)

frontispiece
Aerial view of St Ives

Unless otherwise credited, many of the photographs in this
catalogue have been taken by John Webb, Michael Duffett,
David Lambert, David Clarke and Michael England

ISBN 0 946590 20 6
Published by order of the Trustees 1985
for the exhibition of 13 February–14 April 1985
Copyright © 1985 The Tate Gallery All rights reserved
Published by Tate Gallery Publications,
Millbank, London SW1P 4RG Designed by Caroline Johnston
Printed in Great Britain by Balding + Mansell Limited, Wisbech, Cambs

CONTENTS

7 Foreword

9 Acknowledgments

11 Maps of Penwith and St Ives

13 St Ives: A personal memoir 1947–55 *David Lewis*

42 Poems by W.S. Graham

49 Colour plates

97 Chronology *David Brown*

115 Biographical Notes

148 Catalogue

 I Before 1939 [149]

 II 1939–45 The War Years [161]

 III 1946–54 The Older Generation [171]

 IV 1946–54 The Younger Generation [179]

 V Nicholson and Hepworth [190]

 VI Lanyon [196]

 VII 1954–64 Frost, Wynter and their contemporaries [199]

 VIII Heron [208]

 IX Hilton [212]

 X Post 1964 [215]

220 The St Ives Pottery *Oliver Watson*

228 Ceramics

242 General Bibliography

243 List of Lenders

244 Index

FOREWORD

A hundred years ago, Whistler and the young Sickert spent part of the winter of 1884 in St Ives. From that time onwards St Ives has been a place for painters, sharing with Newlyn across the narrow Penwith peninsular a rivalry to be the art capital of West Cornwall. In the late nineteenth and early twentieth centuries Newlyn had the priority, though St Ives could always claim to be more cosmopolitan in outlook. After 1939 however it was St Ives that achieved a sudden international notoriety.

The reason for this was the same accident of war that drove the avant-garde painters across the Atlantic to New York with momentous consequences for the history of art. As far as the exodus to America was concerned, it was mainly the surrealists who emigrated; of the smaller abstract avant-garde of the 1930s, a substantial proportion ended up in St Ives.

Thus were immediately established the two central paradoxes of St Ives art: here was a regional school, one of the strongest in the history of British art, with artists more internationally minded than those in the metropolis. And secondly, here were abstract artists, compelled by the landscape they inhabited to rethink their position vis-à-vis the natural world.

This exhibition is devoted to twenty five years of art in St Ives, from that settlement in 1939 to the early death in 1964 of perhaps the most gifted of the second generation of St Ives artists, Peter Lanyon, the only major figure to be Cornish-born. We have provided a preface, which centres on the visit Christopher Wood and Ben Nicholson paid to St Ives in 1928 when they discovered the paintings of an elderly untutored fisherman, Alfred Wallis. There is also a postlude which briefly takes the story on to 1975, the year which saw the deaths of Barbara Hepworth, Bryan Wynter and Roger Hilton. The main body of the exhibition tells the story in chronological sequence, from the arrival of Nicholson, Hepworth and Gabo in 1939 and their linking up with the potter, Bernard Leach, through the difficult war years to post-war reconstruction. In the late 1940s and 1950s a new generation slowly gathered together in St Ives – Lanyon, Wells, Frost, Wynter, Heron, Hilton – particularly around the Penwith Society, the artists' exhibiting society which provided a focus for the often quarrelling competitive artists of St Ives. By the late 1950s St Ives art was attracting international attention, and for a few years could claim to be a world centre. Deaths and departures changed all that, as did the general shifts of emphasis in the contemporary art scene (notably the collapse of Paris and rise of New York; and the advent of Pop Art) but this does not detract from what had been achieved.

There has never been a survey of St Ives art, and so far little serious preparatory research has been done. Recent publications have shown that this situation is changing, and the distance of time now makes a major exhibition appropriate.

The exhibition was first proposed to the museum at Pittsburgh by the

architect David Lewis. The Director of the Carnegie Institute, Jack Lane, approached the Tate Gallery, and we had planned to do the exhibition together. Gene Baro, well remembered from the period when he was at the American Embassy in London, was going to work on the selection. Unfortunately Mr Baro's untimely death, and difficulties of scheduling and of funding have made this impossible, though I would like to take this opportunity of thanking Mr Lane and his colleagues in the United States for their initial enthusiastic support. An American showing of a St Ives exhibition would clearly have been desirable.

The exhibition has been selected by Dr David Brown, Assistant Keeper in the Modern Collection of the Tate Gallery, in consultation with me. Dr Brown has taken enormous trouble to provide a first chronology of art in St Ives, and biographical notes, which embody much new research. He has been assisted by Ann Jones who has compiled the catalogue entries and has also done a great deal of research for the catalogue. The planning of the exhibition and catalogue have been patiently supervised by Caroline Odgers of the Gallery's Department of Exhibitions.

We have not provided a conventional introduction, but are most grateful to David Lewis for his introductory essay. Mr Lewis lived in St Ives from 1947 until 1956 and was deeply involved with the artistic community there. His account will help others sense the excitement and ambition that was generated by a small group of artists and writers in a little Cornish town, as remote as anywhere in the British Isles.

The acceptance of ceramics as one of the fine arts was very much a part of the St Ives aesthetic, and it would have been quite wrong to exclude Bernard Leach and the Leach pottery from this exhibition. In one way this is a landmark for the Tate Gallery, because never before have so many ceramics been included in an exhibition at Millbank. We have been greatly assisted by Dr Oliver Watson, Assistant Keeper in the Department of Ceramics at the Victoria & Albert Museum. He has selected and catalogued the ceramics, and has contributed an essay on the history of pottery in St Ives.

David Lewis's essay draws on recorded conversations he and Sarah Fox-Pitt made for the Tate Gallery Archive. Some of the material that we have been actively collecting is to be seen in the Archive Display adjacent to the exhibition. May I particularly thank those who are helping with gifts of material to the Tate Archive; their generosity is greatly appreciated, and it will notably assist us in our ambition to provide the definitive archive of twentieth-century British art here at the Tate Gallery.

Many others have helped us in the work of collecting information for the catalogue: we are especially grateful to the artists themselves and their families who have been consulted constantly about their representation in the exhibition. Dr Brown and I wish that more work could have been shown, and that more artists could have been included. The only consolation we can offer is that other exhibitions are likely to follow this one.

Finally I should like to thank the many private owners and directors of public collections who have gone out of their way to lend generously to this exhibition: without them nothing would be possible.

Alan Bowness *Director*

ACKNOWLEDGMENTS

It is a pleasure to thank the many people who have responded enthusiastically to requests for information and other help in the preparation of this exhibition. Nearly all the living artists in the show have given advice and information on their works as well as biographical details. Most of Barbara Hepworth's assistants have given biographical details. Private owners and curators of public collections have been helpful and welcoming. Others who have aided in various ways include Maureen Attrill, Kit and Ilse Barker, Griselda Bear, Peter Bird, Arthur Caddick, Anna Clarke-Potworowski, J.M. Cock, Ann Compton, Alan Davie, Peter Davies, Kate Dinn, Cordelia Dobson, Nessie Dunsmuir, Ann Forsdyke, Jean English, Elena Gaputyte, William Gear, H.C. Gilbert, W.S. Graham, Hilary Gresty and the staff of Kettle's Yard, Cambridge, John Halkes, B.S. Hall, Patrick Hayman, Patrick Heron, John Hubbard, John Hulton, Rowan James, Michael Kidner, Terry Knight, Trevor Laity, Valerie Lowndes, Irene Morris, Patrick T. Murphy, Susan Murray, Leonard Nott, Marjorie Parr, Wendy Parr, Roy Ray, Sonia Robinson, Brian Smith, Hassall Smith, Marion Thomas, William and Ruth Tudor, Polly Walker, John Williams and Nancy Wynne-Jones. Kathleen Watkins made the Minute Books of the Penwith Society available for consultation with the permission of the Trustees of the Society and the Chairman Roy Walker. I have learnt much about pots on safaris with Oliver Watson. Stanley Cock and Les Douch led me to H.H. Robinson's 1896 account of 'St. Ives as an Art Centre'.

Sarah Fox-Pitt, Tamsyn Woolcombe, Beth Houghton, Wendy Ciriello, Iain Bain, Caroline Johnston, Caroline Odgers, Catherine Clement, Caroline Da Costa and other Tate Gallery staff have contributed much.

I owe particular debts to Wilhelmina Barns-Graham, Miriam Gabo, Rose Hilton, Sheila Lanyon, Christina Lodder, Margaret Mellis and Monica Wynter. Toni Carver has always responded cheerfully and rapidly to many urgent and unreasonable requests for details and photocopies of items in *The St. Ives Times and Echo* and its predecessors. Denis Mitchell, denizen of St Ives and Newlyn for the past fifty-five years has withstood, over many months, a sustained barrage of questions about events in St Ives thirty or forty years ago and answered a surprisingly high proportion of these questions. I owe much to Ann Jones who has helped greatly with research, in particular scanning many issues of the *St. Ives Times* and other St Ives newspapers. My thanks and apologies to those whose names are missing from the above list through faults of my memory but who have contributed to the making of the exhibition. I thank my Director, Alan Bowness, for setting me off on a fascinating voyage, which led me to the sight of artworks unknown to me and to meeting so many nice people, and a lot of pleasure and satisfaction. My gratitude to the artists who made the exhibits and the rest of you, named and unnamed. Thank you.

David Brown

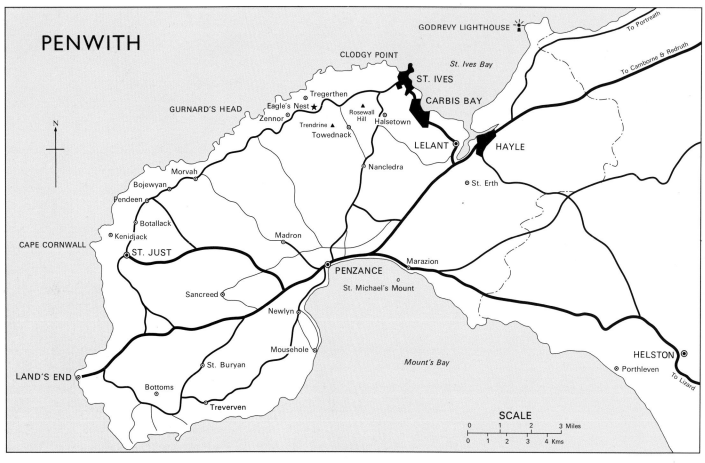

PENWITH

GODREVY LIGHTHOUSE

CLODGY POINT

St. Ives Bay

ST. IVES

CARBIS BAY

To Portreath

To Camborne & Redruth

GURNARD'S HEAD

Tregerthen

Eagle's Nest ★

Rosewall Hill ▲

Halsetown

LELANT

HAYLE

Zennor

Trendrine ▲

Towednack

N

Nancledra

St. Erth

Morvah

Bojewyan

Pendeen

Botallack

Madron

Kenidjack

CAPE CORNWALL

ST. JUST

Marazion

PENZANCE

St. Michael's Mount

Sancreed

Newlyn

HELSTON

Mousehole

Mount's Bay

Porthleven

LAND'S END

St. Buryan

To Lizard

Bottoms

Treverven

SCALE

```
0        1        2      3 Miles
0   1    2    3   4 Kms
```

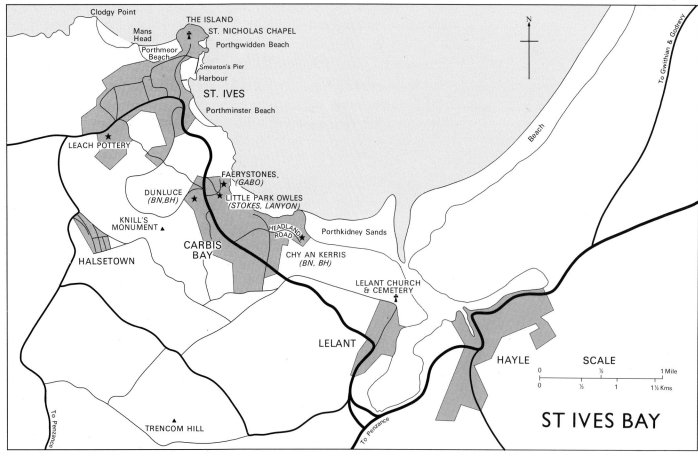

Clodgy Point

THE ISLAND

ST. NICHOLAS CHAPEL

Porthgwidden Beach

Mans Head

Porthmeor Beach

Smeaton's Pier

Harbour

ST. IVES

Porthminster Beach

N

To Gwithian & Godrevy

Beach

LEACH POTTERY ★

FAERYSTONES, (GABO) ★

DUNLUCE (BN, BH) ★

LITTLE PARK OWLES (STOKES, LANYON) ★

KNILL'S MONUMENT ▲

HEADLAND ROAD ★

Porthkidney Sands

HALSETOWN

CARBIS BAY

CHY AN KERRIS (BN, BH)

LELANT CHURCH & CEMETERY ✝

To Penzance

LELANT

HAYLE

SCALE

```
0            ½           1 Mile
0    ½       1      1½ Kms
```

ST IVES BAY

To Penzance

TRENCOM HILL ▲

ST IVES TOWN CENTRE

THE ISLAND

PORTHGWIDDEN BEACH

THE TOWER *(BERLIN)* ★

CARNCROWS ★ *(MORRIS)*

No 4 ★ *(BARNS GRAHAM, LEWIS)*

TEETOTAL ST.

PENWITH GALLERY ★

ISLAND SQ. BACK RD. EAST

BARNALOFT *(LEACH)*

12 QUAY STREET ★ *(FROST)*

PORTHMEOR STUDIOS ★

BACK ROAD WEST

QUAY ST.

PORTHMEOR BEACH

ALFRED WALLIS HOUSE ★

NORWAY SQ.

MARINERS CHURCH

FISH ST.

PORTHMEOR SQ.

THE WHARF

PORTHMEOR ROAD

THE DIGEY

Slip

HARBOUR

OLD CEMETERY

Smeaton's Pier

TREZION, SALUBRIOUS PLACE ★ *(NICHOLSON)*

LIGHTHOUSE

No 36 ★ *(PENWITH GALLERY)*

CLODGY VIEW

FORE STREET

WHARF ROAD

No 28 ★ PALAIS de DANSE

No 18 *(PENWITH GALLERY)* ★

West Pier

TREWYN ★ ★ TREWYN STUDIO *(MILNE)* *(HEPWORTH)*

✝ ST. IVES PARISH CHURCH

HIGH ST.

★ 3 ST. ANDREW'S STREET *(HERON)*

BEACH

★ ARTS CLUB

THE STENNACK

TREGENNA HILL

★ ATTIC STUDIO *(LANYON, GABO)*

RAILWAY STATION

PORTHMINSTER BEACH

SCALE

¼ Mile

0 100 200 300 400 Metres

N

ST IVES
A personal memoir, 1947-55

DAVID LEWIS

Cornish Coastline, photograph: Studio St Ives, *Tate Gallery Archive*

West Penwith Landscape, photograph: Sarah Fox-Pitt, *Tate Gallery Archive*

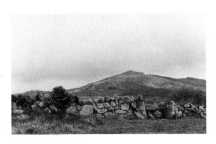

West Penwith Carn, photograph: Eric Wynter, *Tate Gallery Archive*

The landscape is permanent, the rhythm of the sea's pounding is infinite. Yet no moment is the same: one minute's windgust, cloudshape, coldness of rain is changed by the next. Art makes us pause to contemplate: even violent art contains the stillness of the infinite. To understand one must engage, then turn away. One must go beyond passion, and re-engage, bringing the distance of stillness.

Half a lifetime lies between then and now. Looking back, none of us was aware that those years were historic or unique. None of us realised that on this small land's end peninsula called Penwith, jutting out into the Atlantic, with its ever-changing moods of earth and sea and sky, an evolution in the modern movement of art was taking place the importance of which is only beginning to be realised forty years later. The hard edge language of the international style of the thirties, so full of the optimism of new aesthetic and social orders opposing the rising tides of fascism and transcending national boundaries, was being re-cast to reflect a deep sense of man's relation to the land, to the infinite rhythms of nature, affirming age-old cultural values in a contemporary world that was falling apart.

How do I set out to write about those far-off years? Some memories are sharply etched, others are muffled like murmurs. In the mirrors of the mind there is real history and that of perceptions.

It began for me in a London pub in the late autumn of 1947 when Dolf Reiser gave me the keys to his cottage at Bosporthennis, near Gurnard's Head. I could stay there the winter, he said. I got off the green double-decker from Penzance and trudged up a muddy road between granite hedges towards the November moors. Grey boulders stuck out of the fields like knobs of the land's skeleton breaking the skin. Dolf's cottage was granite too, with small square windows edged with white, and a slate roof.

I did not know anyone. So soon after the war, there were still shortages of food and fuel. The farmer and his wife whose land the cottage was on were young earthy people. Their soil was a dark sticky loam. In wellington boots I worked in the fields with them, sacking and loading potatoes. My hands graduated from blisters to callouses.

But morning or evening, whenever I could, I would clamber through the wet grey gales to the granite outcroppings at the crest of the moors, and I would find a niche in the lea of the rocks so that I could gaze out to sea. I loved the drama of winter days. Gusts of brine soaked wind would seize the tumbling clouds overhead and shred them. Occasionally a fishing boat with a rust brown mizzen would ride the crests and troughs of the sea's swells with the grace of a nautical

cowboy. And thin moor grasses would shimmer and undulate as the gale raged at them. Symphonies of grey and sage green, and the dark brown of winter bracken and seagreen of gorse.

Or I would walk to Gurnard's Head where narrow ridges of rock jut and sheer cliffs plunge to the sea far below as it surges into the land with rhythmic thrusts and sighs, and above the sea's surges gulls white as wave spume wheel tirelessly on air currents. High up there in the hollows of the rocks, little colonies of pinks flourish and ripple in the wind, protecting scowling spiders shortlegged as beetles in their roots. Far away in the recesses of windgusts a metallic church bell tolls for evensong. Zennor. Time within time.

Headland and Sea, photograph: David Lewis, *Tate Gallery Archive*

II

Alone, I read and wrote a lot that winter. I had already published some juvenilia now mercifully forgotten, and was still trying my wings. With me in Dolf's cottage I had some favourite books. They were mostly poetry – Yeats, Eliot, Pound's earlier cantos, Auden, Eluard and Lawrence. I also had Joyce's *Ulysses*, a few books from Gollancz's Left Book Club, two or three things by Herbert Read including *Poetry and Anarchism*[1] and a pamphlet entitled *The Education of Free Men*[2], and several issues of *Horizon* and *Transition*. They were all lined up on the window sill of the upstairs bedroom.

The war had ended with hope tempered by despair and melancholy. Shattered houses and churches were in every town and city. Whole areas of London were reduced to rubble. It was hard to grasp that the great British Empire which had for several generations before the war covered a third of the world, splattering its jigsaw of pink (why pink?) across every school atlas including my own, would shrink like a receding tide to Shakespeare's emeralds set in a silver sea. In poetry and art there was a rebirth of romanticism and Englishness, introverted presages of political reality. Tambimuttu's *Poetry (London)* and John Lehmann's *New Writing* published poems of intense insularity, corollaries of Sutherland and Piper. But these were not for me. I was drawn to languages more firmly constructed, more classical.

Looking back, 1947 had been an important year for me. Douglas Cooper was a friend of my mother. He would come to dinner and devour rather than eat. In the spring before I left London for Cornwall he permitted me to punctuate his book on Juan Gris. Through Cooper and Gris I learned at a deeper and more essential level how Picasso and Braque fragmented the world of euclidean geometry and renaissance perspective, and assembled a new art based directly on elements of painting perceived as components of visual language, colour, texture, plane, mass, space, light, and multiple viewpoints. No cubist did this with greater calm that Gris.

Through Gris I crossed into the territory of the great non-figurative artists, Mondrian, Brancusi and Arp; and through them in turn I was drawn to the English avant-garde of the thirties, Unit One, *Abstraction-Création*, Ben Nicholson, Henry Moore, Barbara Hepworth and Paul Nash. After visiting

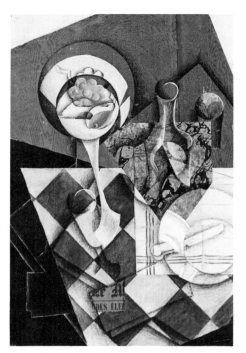

Juan Gris, 'Still life with fruit dish and water bowl', 1914, *Rijksmuseum Kröller-Müller, Otterlo*

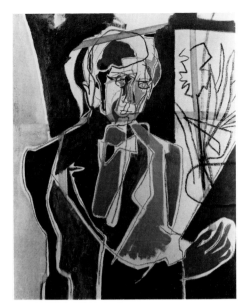

Patrick Heron, 'Portrait of Herbert Read', 1950, *National Portrait Gallery*

Cooper's incredible private collection of cubist paintings I saw, or thought I saw, cubist elements in Pound and Eliot; Arp in Eluard's poetry; and Brancusi in Moore and Hepworth; and I was fascinated by Joyce's slapstick of allusion, sound and multiple time in *Work in Progress.*

Cooper was critical of these departures from his focus. I drifted even further that summer when I met William Turnbull and Eduardo Paolozzi, and with Wolf Mankowitz arranged two small exhibitions of their work at the Apollinaire in London. An odd preparation for a winter alone in Cornwall? At Bosporthennis I spent countless hours watching the rhythms of nature; the land's macro-form responding to its shaping by the wind and lashing rain, the erosion of rock and the turning over and over of seastones; and the micro-forms of birds riding the shrieking gales, and insects capturing the sheltered warmth of the sun in nests and webs. In these I perceived Blake's eternity: but I also saw the dynamics of cubist asymmetry translated to the rolling moors and the sea; rock against wind, water against land.

That winter Herbert Read's anarchism appealed to me precisely because of its emphasis on the growth of self, on becoming. Vaguely I could see a parallel here with the idea of building, of allowing the inherent forms and colours of a painting to assert themselves in space and light that I had found in Gris. In my Left Book Club stuff I discovered that Marx's idea of oppression had its roots in poverty and deprivation. Was it possible that freedom from want might therefore mean freedom from externally imposed order in a post-revolutionary world? 'Freedom', Read wrote in 1946, 'is a positive condition – specifically freedom to create, freedom to become what one *is*. The word implies an obligation. Freedom is not a state of rest, of least resistance. It is a state of action, of projection, of self-realisation.'[3]

'The discipline of art', he wrote in *Poetry and Anarchism*, 'directs our sensibility, our creative energy, our intuitions, into formal patterns . . . into works (literally constructions) of art. But discipline, and the order it gives, does not exist for itself: it is not an end, but a means . . . It is only by variation that the artist achieves beauty. The discipline of art, therefore, is not static: it is continually changing, essentially revolutionary.'[4]

III

In the spring of 1948 – two events of personal importance: I moved from Bosporthennis to Higher Tregerthen; and I met John Wells and Peter Lanyon in the pub at Gurnard's Head.

Johnny had bicycled over from Newlyn to meet Peter. Characteristically – as I was quickly to learn – Peter, seeing someone he didn't know, came over and asked who I was, just like that. His spontaneity contrasted with Johnny's reticence. Somehow it came out that Johnny lived, as he still does, in Stanhope Forbes' old studio overlooking Newlyn harbour. And as soon as he and Peter heard that my father, Neville Lewis, had studied painting there in 1914, I was legitimate. It also came out that Peter, Johnny and a young painter called Bryan Wynter who lived near Zennor, had exhibited as part of a small group in St Ives,

Zennor, photograph: David Lewis, *Tate Gallery Archive*

in the crypt of a chapel and in the back room of a bookshop, and for the first time I heard about the excitement of a new aesthetics of landscape. Were these the first voices of a new art? I did not realise it then, but that evening I crossed the threshold of a new world of incredible richness that would change my life.

Together the three of us drove in Peter's car to Zennor. Wearing a commando beret Peter liked to drive as though he were under fire from snipers. I had never before heard Cornish anthems, a tradition involving religious choirs in pubs parallel to the great colliery choirs of Wales but originating here I believe among the tin miners. That night we heard them, in full and majestic throat, under the night sky in the courtyard of the Tinners' Arms.

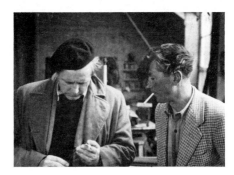

Peter Lanyon and John Wells, in Anchor Studio Newlyn, c.1950, *Tate Gallery Archive*

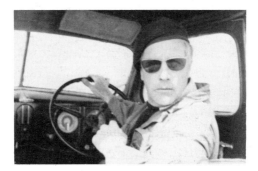

Peter Lanyon at the wheel, c.1950, *Tate Gallery Archive*

IV

Higher Tregerthen is a group of four granite cottages a mile from Zennor and situated below Eagles Nest, where the painter Patrick Heron lives now. Deaf old Mrs Painter, the mother of George Painter, Proust's biographer, lived next door, in the cottage which D.H. Lawrence and Frieda had lived in during the First World War, and in which Lawrence wrote *The Rainbow*. I had the Tower, which Katherine Mansfield and Middleton Murry had occupied briefly at the same time as the Lawrences.

I shared the Tower with the poet, David Wright. For a while we were part of a group of Zennor romantics, including the poets George Barker and John Fairfax; and John Heath-Stubbs stayed with us. Bryan Wynter lived in the Carn, a cottage high above us on Lawrence's 'shaggy moorhill' where even on the calmest days the wind was impatient; and beyond, in a remote cottage above the village of Nancledra lived another painter, David Haughton.

The walk to St Ives was on a footpath along the cliff's edge. Like Murry and Lawrence thirty years before, I would plunge along that footpath over granite stiles and heather on Friday afternoons to visit Peter, to whom I was drawn far more strongly than to the Zennor poets. Sometimes the wild wind from the sea would slap my face with rain gusts; sometimes the sun would illumine the fields with saturated green or the bright yellow of mustard. For hours Peter and I would talk in the studio, struggling to articulate not what the landscape looked like, but how to explore it inside and out, its rocks and fields and sea, its textures and saturations, its opacities and transparencies of colour, and how to *experience*

Higher Tregerthen below Eagles Nest, photograph: David Lewis, *Tate Gallery Archive*

Penwith Milestone, photograph: David Lewis, *Tate Gallery Archive*

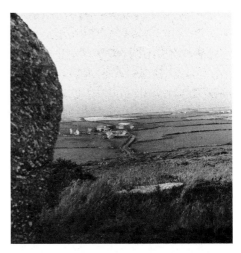

Landscape between Zennor and St Ives, photograph: David Lewis, *Tate Gallery Archive*

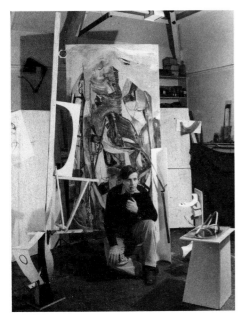

Peter Lanyon in the Attic Studio 1951, photograph: Studio St Ives, *Tate Gallery Archive*

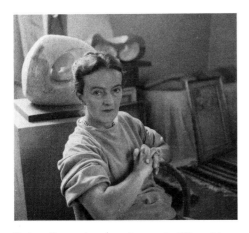

Barbara Hepworth *c.*1952, photograph: Gilbert Adams

it through art, not through representation but through the *action* of painting and making constructions.

He spoke a lot about his debts to Naum Gabo, Adrian Stokes, Ben Nicholson and Barbara Hepworth, and about his own Cornishness. We talked about the land and the sea, how wind and water scraped and scoured rock, hill and dune; we talked about particular places; about the tactility of colour, a dry powdery yellow, a slimy green lapping against a succulent red you could run your tongue over. We talked about harbours and houses that took their forms from nestling into hill-forms; we talked about Cornish people, so-called primitive fisherfolk, boatbuilders, masons and farmers, and how intuitively and with extraordinary sophistication they derived their form-languages of harbours and cottages from the rhythms of nature. And we talked about Alfred Wallis.

I was very poor that year. I think Peter's wife Sheila knew; I owe more to her than she knows. She always had a hot meal and a bath ready for me. But it wasn't enough. By midsummer I was quite ill. Peter asked Dr Roger Slack, the medicineman of the artists, to come out to Tregerthen and take a look at me; and next thing, I was in the Edward Hain hospital.

V

As soon as I was well enough to be discharged Peter said, let's go and see Ben and Barbara. It was a hot Saturday morning. The Nicholsons lived in a house called Chy-an-Kerris. On one side the house faced Headland Road, on the other it had a sloping garden and looked across the railway line along which would fuss a little train with a black steam engine puffing white smoke followed by two red carriages, and across the grasstipped dunes to the wide sweep of Carbis Bay. From Headland Road you walked down some steps into a small courtyard which Barbara used for carving stone out-of-doors and she had a downstairs studio for wood carving facing on to it. Everything was painted white, courtyard and room.

A pale grey stone sculpture, probably *Eos*, was on a carving table. It was lunchtime when we got there. Barbara sat at the table with a plate of chops, peas,

boiled potatoes and salad, which she consumed without offering us any. She clearly knew Peter well, and began talking about his painting and her sculpture as though I wasn't even present. But as soon as she heard that I lived near Zennor I was included in an intense conversation about inhabiting the landscape, and how in non-figurative painting and carving the artist is no longer in a subject-object relationship with nature but can *be* the object, and assume *directly* the natural agencies of wind and surface.

The sculpture on the table had a concave painted surface of skyblue, and we talked about the insideness of landscape, the thrusts of sea into land, the endless rubbing of wind on rock, sea on rock, rock against rock in the surf creating concave and convex surfaces; and we talked about reflections of sky in seapools, and how sea and sky and land become interchangeable, a symphony in which visual elements, mass, penetration, linear rhythm and colour become free, waiting for the artist-composer to set them in new configurations.

In 1951 Barbara Hepworth recalled these thoughts with great elegance. 'From the sculptor's point of view one can either be the spectator or the object itself. For a few years I became the object. I was the figure in the landscape and every sculpture contained to a greater or lesser degree the ever-changing forms and contours embodying my own response to a given position in that landscape. What a different shape and 'being' one becomes lying on the sand with the sea almost above from when standing against the wind on a high sheer cliff with seabirds circling patterns below one; and again what a contrast between the form one feels within oneself sheltering near some great rocks or reclining in the sun on the grass-covered rocky shapes which make the double spiral of Pendour or Zennor Cove; this transmutation of essential unity with land and seascape, which derives from all the sensibilities, was for me a voyage of exploration. There is no landscape without the human figure: it is impossible for me to contemplate pre-history in the abstract. Without the relationship of man and his land the mental image becomes a nightmare. A sculpture might, and sculptures do, reside in emptiness; but nothing happens until the living human encounters the image. Then the magic occurs – the magic of scale and weight, form and texture, colour and movement, the encircling interplay and dance occurs between the object and the human sensibilities.'[5]

I remember how feminine I thought she was that day, in spite of her white ducks and working shirt and her chestnut hair in a coarse brown net, and how her small and alive eyes contrasted with her strong hands. I remember watching how she felt every surface, not with her fingers but with her palms, and thinking how caressive her images of the landscape were too. Ben emerged and sat on the wall listening to us with his head on one side like a cocky sparrow. Barbara finished eating and went indoors with her plate.

Peter had warned me that they wouldn't want us to stay, and said goodbye. But Ben insisted on my staying. 'Lunch?' he enquired, his head on one side again. He brought out two hardboiled eggs, some Ryvita, a couple of triangles of Swiss cheese, and a silver pot of the palest tea. 'Ping-pong?'

Granite hedge, Penwith, photograph: David Lewis, *Tate Gallery Archive*

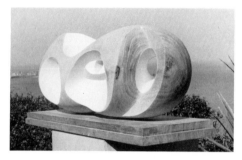

Barbara Hepworth, 'Pendour', 1947/48, *Hirshhorn Museum, Smithsonian Institution, Washington*

Sea rock, Isles of Scilly, photograph: David Lewis, *Tate Gallery Archive*

VI

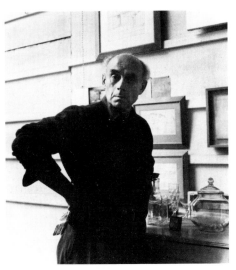

Ben Nicholson in No. 5 Porthmeor Studios, 1953,
photograph: Roger Mayne

I had played a lot of ping-pong at school and thought I was quite good, but I'd never played like that. Instead of a net, Ben had an eight inch plank laid flat on a pile of books at the same height as the net would be. This simple substitution completely changed the game. 'Reinvented' was the way Ben put it. You could hit the ball over the plank in the usual way, or you could hit the ball onto the plank and off, or you could hit the ball onto the plank and onto the table and off, and the width of the plank meant that you could angle your shots so widely as to be almost lateral, with exponential increases in energy and hilarity.

It was not because I had just emerged from the Edward Hain that I was thrashed by Ben within an inch of my life. In all the subsequent years I won only a handful of games against him. He was expert as a juggler and fast as a cat, darting here and there in his sea-blue trousers and white undershirt, his bald head bobbing about so much like a ping-pong ball that he would even leap in the air and play with his head. We laughed until our sides ached; and we had to sit side by side on the floor to get our breath.

The ping-pong table was the only furniture in what must have once been a living room, overlooking the walled garden and the sea. Between games we went upstairs to Ben's whitewashed studio which must have been once a bedroom, also overlooking the majestic sweep of Carbis Bay, to see what he referred to as 'some work'.

Most of the paintings were small, taking their cue perhaps from the size of the room. They were on paper or hardboard, a composition of compressed wood fibres used by carpenters, and were based on textured surfaces which were layers of thin pigment applied with broad brushes, or wiped on with rags soaked in turpentine, and scraped with razor blades to form what Ben referred to as 'a ground'. On to the ground he drew in pencil, and painted interstitial shapes with sharp flat colours. Some of the paintings were 'pure abstracts', circles and rectangles; others were 'still lifes', which reminded me at first of transparent cubist tables with bottles and goblets made linear, and some included elements of landscape, a glimpse of a hill and a farmhouse or of a harbour. The most astonishing thing was a playfulness that seemed to come from what he said was 'free colour' but which struck me as being anything but free, sharp assonances of green or red or orange, so firmly held in the geometry of the work and so precisely 'right' that although they each might have been exactly the colour of orange lichen or mauve foxglove or green seaweed, they were in that particular painting the most electric and radiant accents of orange or mauve or green or pink I had ever come across. And as if to increase the options in the way that he had increased the options in the game of ping pong when he incorporated that devilish plank, some of the hardboards were incised, or carved into relief, so that colour and texture were set to work not simply on one plane but on several.

In many later conversations Ben and I returned repeatedly to the 'free' elements of painting and reliefs. If a line or a space could be exact, so too could a colour – in its purity, its dimension, and its 'quality', that is to say its density and its texture, and then of course in its precise relationship to everything else that was going on in that particular painting. Someone once asked him how he got a certain colour, and he said 'if I knew I'd never be able to get it again'.

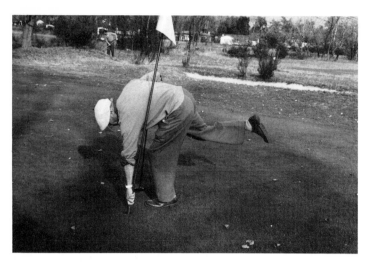

Ben Nicholson playing golf, photograph: Charles Gimpel,
Tate Gallery Archive

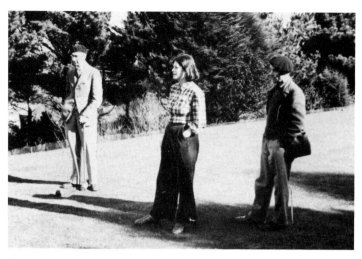

Herbert Read, Margaret Gardiner and Ben Nicholson playing croquet
at Little Park Owles, Carbis Bay, 1942, photograph: Barbara Hepworth
Trustees of Ben Nicholson Estate

The analogy between these paintings of Ben's and the social aspects of Herbert Read's philosophy of anarchism seemed obvious to me, and Ben would listen patiently while I ran out my skein of conjecture. Or Ben would let me talk about Gris, and about the precision of 'constructed' colour. Then Ben would steer our focus to shift from painting to sports, and would talk about his paintings as physical analogues. He would talk about perfectly placed shots in football, about the sturdy and unhurried play of Hapgood for Arsenal whom Ben particularly admired because he dominated the centre like a compositional pivot and passed the ball with authority and precision, or the fluidity of Lacoste in tennis. It was 'all a question of rhythm', he would say, the natural authority of 'unselfconscious precision'. He would talk in the same way about billiards, about snooker, and multi-coloured balls on a field of green, or about golf and the beautiful course along the dunes and estuary at Lelant on which he used to play; and I remember vividly his description of the flight of his white ball arcing as though it were a pencil line against the blue summer sky, and how it crossed the green-crested ivory of the dunes to the undulating green of the course with its chalk white bunker, only to bounce into a line of 'the opaquest black', which turned out to be the funeral procession for the just-deceased golfing pro! 'There are days', he used to say, 'when you can't put a foot right and you might as well give up. Then there are other days when you can't put a foot wrong.'

About the room itself. Ben worked on a small ordinary kitchen table, and on it were tubes of oil paint and rags and glass jars stuffed with brushes and pencils, either flat brown carpenters' pencils which produced a juicy black line or pencils striped like barbers' poles, and he had a way of laying a sharpened pencil on the table as though it were the instrument of a surgeon. The only other furniture, if you could call it that, was a small black radio for listening to jazz, and the mantel over the fireplace on which he had bottles and glass goblets, a striped tankard, some gaily coloured fishing floats, and two or three paintings by Alfred Wallis. I had of course seen a few of Wallis's paintings at Peter's. But this was the first time I had seen so many, for Ben brought out one after another, and we had that first afternoon the first of our several conversations about Wallis.

Ben talked about Wallis in a different way to Peter. To Peter, Wallis was a

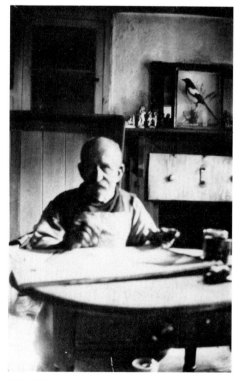

Alfred Wallis, 1928, *Trustees of Ben Nicholson Estate*

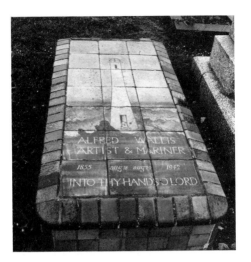

Grave cover of painted stoneware tiles for Alfred Wallis, in St Ives old cemetery. Made by Bernard Leach, 1942

Cornishman and his paintings were the language of an emotional and mystical oneness with the sea and ships, with lighthouses and cliffs, with harbours and boats riding the storms, and with nestling granite houses holding firm under threatening skies. To Ben, Wallis was a painter. He spoke about him with the same reverence that he reserved for Mondrian and Miró. He described how Wallis would begin with a piece of cardboard, sometimes torn or cut in an odd shape so that its edge had a compelling rhythm to start with and a surface with a particular colour and texture, and how he would make a painting of ships and storms using only the simplest at-hand colours – household enamels obtained from the hardware store down the street or from fishermen painting their boats at low tide in the harbour – and how he would incorporate the incidental shape of the cardboard and its colour, and make them precise elements in his painting. For Ben, the excitement of Wallis was in how alive and direct they were, and from them he learned the most difficult lesson of all, how to be unselfconscious and innocent while being true to the intensity and precision of experience.

VII

A few doors up from Chy-an-Kerris was Faerystones, where Naum and Miriam Gabo had lived, and further up again was Little Park Owles, which had been the house of Adrian Stokes and his wife Margaret Mellis, and was later bought by Peter and Sheila. I was too late to know the Gabos, who had emigrated to the U.S. a few months before, and too late to know the Stokes too. Without being an art historian it is not too hard to piece together how the Penwith peninsula drew to its picturesque working harbours perhaps the most astonishing dramatis personae of any concentration of artists in the history of English painting and sculpture, from Turner onwards.

What in particular attracted young Ben Nicholson to Cornwall in the late twenties I don't exactly know, but lyrical paintings of Porthmeor Beach and Feock estuary date from 1928. In an evocative little introduction to a Nicholson exhibition at Kalman's in 1968 John Wells recalls meeting Ben and Winifred Nicholson at J.R.M. Brumwell's, and swimming and going out in boats with Christopher Wood.[6] And that was the year when Nicholson and Wood walked by chance down Back Road West in St Ives and 'discovered' Wallis.

'In August 1928', wrote Nicholson in 1943 in his famous essay on Wallis in *Horizon*,[7] 'I went over to St Ives with Kit Wood: this was an exciting day, for not only was it the first time I saw St Ives, but on the way back from Porthmeor Beach we passed an open door in Back Road West and through it saw some paintings of ships and houses on odd pieces of paper and cardboard nailed up all over the wall, with particularly large nails through the smallest ones. We knocked on the door and inside found Wallis, and the paintings we got from him then were the first he made . . . He used very few colours, and one associates with him some lovely dark browns, shiny blacks, fierce greys, strange whites, and a particularly pungent Cornish green.

'Since his approach was so childlike one might have supposed that his severe selection of a few colours was purely unconscious, but I remember one day he

was complaining that he was short of some colours, and when I asked him which, he said he needed rock-colour and sand-colour, and I got these for him in the yacht-paint he was using. Kit Wood remarked that it might easily spoil his work to give him new colours when so much of its point depended on the use of a few, but it seemed to me that since he had asked for them he must be ready to deal with them. Next day he made a new painting, using, of course, rock-colour for anything but rock and sand-colour for anything but sand, and keeping to his usual small number of colours: and as I went out, having admired the colour of the painting (we had, of course, not spoken to him about the number of colours he used), he said: "You don't want to use too many colours"'.

It was therefore not surprising that persistent invitations from Adrian Stokes to Nicholson and Hepworth to come to St Ives as war clouds gathered in 1939 and to bring their triplet children with them out of the danger of London should have been so appealing. Stokes and the Nicholsons were good friends. Adrian's book *Colour and Form* had recently appeared and was perhaps the first serious attempt by a painter to identify the abstract, non-descriptive interrelationship between the two elements that is such an important key, not only to the non-figurative art of the 1930s but also to the early Sienese and Florentine painters.

Ben Nicholson and Naum Gabo, Carbis Bay 1940s, *Nina and Graham Williams*

Margaret Mellis recounts[8] that she and Adrian went to St Ives in May 1938 after their honeymoon in Italy. 'Cornwall had particularly good light and we could get materials and Adrian liked the landscape very much and we both wanted to paint.' After moving into Little Park Owles and following Munich, 'Adrian was quite sure that war would break out and London would be blown up . . .

'There was this week and we didn't know whether there was going to be a war or not and if there wasn't going to be war Eddie Sackville-West was coming to stay, and if there was war Ben and Barbara were going to come and so there was a war and Ben and Barbara arrived in a thunderstorm along with the triplets and a cook,' and they stayed through the winter.

While they were at Little Park Owles, Ben and Barbara kept writing to Miriam and Naum Gabo, encouraging them to come, and Barbara found Faerystones, a small house a few doors down from Adrian's, for them to move into. Miriam Gabo recalls[9] how 'we were all very much together . . . going to Adrian's almost every evening, and he coming down to talk with Gabo and borrowing books from one another . . . I found Adrian very difficult to get along with, he kind of patronized the ladies. But he talked to Gabo a lot. They had a certain amount of quarrelsomeness over art ideas. Adrian used to talk a lot about psychology.'

For Ben and Barbara having the Gabos in Cornwall continued an important association that was to span a decade. With the architect J.L. Martin, Ben and Naum had edited CIRCLE,[10] an important collection of writings and illustrations bringing together for the first time under one cover the most influential painters, sculptors, architects and essayists of the international movement. Ben and Barbara had a studio on the Mall in Hampstead. Henry Moore was a neighbour; Piet Mondrian 'lived in a house back to back to the Mall, it even has a plaque on it now';[11] the Gabos lived on Ormonde Terrace, off Primrose Hill; and Herbert and Ludo Read were frequent visitors.

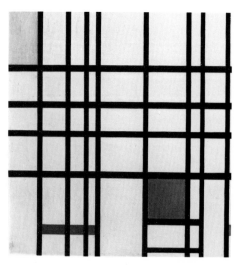

Piet Mondrian, 'Composition in Red Yellow and Blue', *c.1936, Tate Gallery (T 00648)*

Ben talked a lot to me later about his white reliefs and Barbara's purity of sculptural form in their white studio on the Mall. He treasured Mondrian's

enthusiasm for the studio's 'radiance' and peacefulness; although he did say that when Mondrian noticed through the skylight the topmost leaves of a tall chestnut tree he admonished Ben; 'too much nature!' For Mondrian perhaps the movement of leaves in a summer breeze was a distraction. When Jean Hélion, a painter both of them liked, got married, Mondrian spoke about the distractions of marriage and children to a painter's concentration. Ben reminded Mondrian of the triplets he and Barbara had. Mondrian waved that on one side. 'C'était par hazard.'

More implicitly than explicitly I began to see how Ben's white reliefs and Gabo's constructions related to the continuous space of Le Corbusier's Villa Savoie and Maxwell Fry's Sun House in Hampstead. Ben did not enjoy intellectual discussions about art, but he always listened attentively and silently: he and Barbara were clearly affected deeply by the intellectuality of Mondrian, Gabo and particularly Read, for whom they had a deep and lifelong respect. Gabo and his brother Antoine, who I got to know well in Paris in the early fifties, were constructivists: they perceived space and time in the world of actual (as opposed to theoretic or mathematic) experience as continuous depth and movement, and the essence of sculpture was to cause us to focus on the physical poetry of movement. I personally will never forget standing one day in Antoine Pevsner's studio looking at a sculpture composed of a particularly beautiful metal spiral, which one might have been forgiven for considering in mathematical terms, when suddenly the sculptor charged at the piece with a broom handle and clanged it inside like a bell, exclaiming: 'Voilà, monsieur! L'éspace est dedans!' – and so it was. Pevsner's sculptures were metal planes formed from rods that were fused radially to form spirals, while Gabo adopted curvilinear plastics because of their transparency and the linearity of edge, and he used strings to accentuate or modify movement. For both Gabo and Pevsner 'the new space' – which is the hallmark of our century as we probe its infinities with shuttles and satellites – represents a visual poetry; as Herbert Read wrote 'a kinetic image of continuous extension'.

'Gabo has said that the Constructive idea sees and values art only as a creative act. "By creative act, it means every material or spiritual work which is destined to stimulate or perfect the substance of material or spiritual life." This is essentially Plato's conception of the function of art: the work of art is an embodiment of the physical laws of the universe, which are harmonic in their nature, and in virtue of this representative function, the work of art is capable of modifying man's environment and of transmitting this harmony to his soul . . . "Works that express harmony with beautiful reason" is as near as we can get to a definition of Gabo's constructions.'[12] It is not surprising to hear Miriam say that 'Gabo was the same kind of anarchist that Herbert was.'[13] The congruence of these thoughts with the concept of 'dynamic equilibrium' (in contrast with static balance) expressed in Mondrian's paintings and with the radiance of Nicholson's reliefs is obvious, even if 'Gabo gave (Mondrian) arguments because Gabo's idea was that (art) should have depth and space in it.'[14]

Ben and Barbara tried to get Mondrian to join them in 1940 in Cornwall too, but Mondrian was too urban. In spite of the war he preferred to stay in London – until in 1940 he was bombed from his studio and left for New York.

Meanwhile Peter let Gabo have his studio while he went into the Air Force,

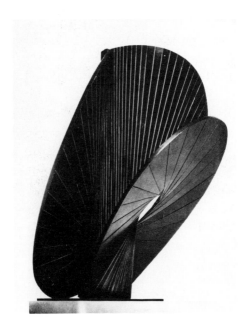

Antoine Pevsner, 'Surface développable', 1938, *O. Müller, Basle*

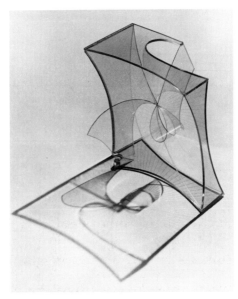

Naum Gabo, 'Construction in Space – Crystal', 1937, *Vassar College Museum, Poughkeepsie, N.Y.*

and there Gabo began the paintings of the 1940–43 period. Miriam recalls that the first of these paintings was red, the next green (now in the Guggenheim in New York), not curiously enough because of the resonant greens of Cornwall but because of Ireland where they had gone for a brief holiday, followed by a yellow painting. The paintings meant a lot to him. 'He used to talk sometimes about wanting to have colour in sculpture. The Greeks used to have it, so maybe it was a good idea. He concocted a synthetic red, covering the whole studio with red powder.' But he made the sculptures of that period at home, not at Peter's studio which he used only for painting. 'Gabo had a friend quite early on in the ICI laboratories, John Sisson, and he gave Gabo samples and advice and was generally a help to him.' Later Kenneth Clark during the war wrote to the Ministry of Supply and asked for offcuts of plastic for Gabo. Gabo would heat the plastic to bend it, using the kitchen stove, or 'he sat over the fireplace in Cornwall for days bending it bit by bit, he didn't use a mould.'[15]

That first winter at Little Park Owles, Adrian gave Ben a small room to work in and he began making white reliefs right away, continuing without interruption the focus that he had in London. But Barbara had nowhere to carve. She began drawing from the figure, and also non-figurative 'ideas' for sculpture using radial lines which in her future sculptures became strings. Whether she 'got very influenced by Gabo at that time'[16] or whether strings generally were 'in the air' since Henry Moore, her neighbour on the Mall, was also using them is perhaps beside the point since the three artists used them so differently. For Moore, a much more organic sculptor than Hepworth, strings related to tendons and fibres, for Gabo they were line and movement in space, for Hepworth, somewhere between the two, they were lines of tension within mass and were colour elements as well.[17]

Like Barbara, Ben also began drawing, but in landscape, making trips alone or with Adrian. Margaret Mellis recalls his fascination with Halsetown and Pendeen.[18] Halsetown was a village that had been built a century ago for tin miners; its grey granite cottages with small square windows were arranged in a precise geometry in rolling moorland almost like prehistoric stones, Avebury or Carnac. At Pendeen and also at Lelant abandoned engine houses, each with a tall

Naum Gabo in his studio, *c.*1944, photograph: Studio St Ives, *Nina and Graham Williams*

Abandoned tin mines at Pendeen, *David Lewis*

Ben Nicholson, 'Cornish Landscape, Pendeen', 1940–41

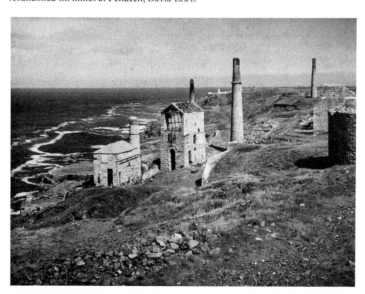

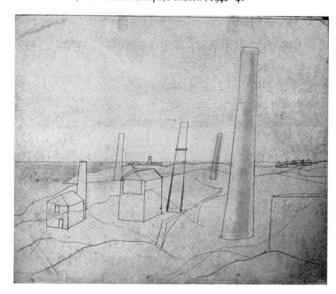

chimney, stood on windswept cliffs above the sea. In these remote places man's geometry contrasts with the organic rhythms of nature. As soon as he and Barbara moved into Chy-an-Kerris Ben began incorporating figurative landscape elements into small paintings, 'pot boilers' he called them because he thought they would sell,[19] but he immediately discovered that they set up formal interrelationships of colour, mass, texture and linear rhythm that added layers of allusion: 'poetic' was the word he liked to use.

Sven Berlin, the sculptor and author who was later to be Wallis's biographer,[20] was a pacifist ordered by the courts to work on the land. Together he and Adrian dug up the lawns at Little Park Owles and grew vegetables to supplement wartime shortages. Every afternoon in the summer of 1940 and '41 there was tea on the terrace with a view to the sea through the pines 'like Cézanne' and long talks with Adrian, Margaret, Barbara and Gabo. Visitors came and went, among them Stephen Spender and Natasha, who 'played the piano beautifully'. When Ben and Barbara moved into Chy-an-Kerris and painted everything white, visiting them was 'a bit like going to the dentist'.[21]

Another frequent visitor was Peter. Before Peter went into the Air Force Ben began giving him lessons. 'Ben used to be very helpful and would come around and see what you were doing all the time. But once Peter got going I don't think he wanted to be helped quite so much . . . there was too much attention, you couldn't do what you wanted'. Gabo was quieter, 'he was just there'.[22] Gabo and Peter formed a deep friendship; 'Gabo kept Peter's photograph on his desk till the day he died'.[23] Yet another frequent visitor was Patrick Heron, also a conscientious objector. For fifteen months he worked in the Leach pottery, but spent countless hours with Stokes and Gabo.[24]

W. Barns-Graham and David Lewis on Porthmeor Beach, St Ives, c.1954, photograph: Roger Mayne

W. Barns-Graham in No. 1 Porthmeor Studios, 1954, photograph: Roger Mayne

VIII

In the late summer of 1948, a month or two after I began visiting Chy-an-Kerris to see Ben and play ping-pong I met Willie Barns-Graham. At the time she was painting a series of street scenes of houses with steps and balustrades, and she was known as W. Balustrade Graham. I was surprised to find that 'Balustrade' was not a man but a woman, and a beautiful woman at that, with blue eyes that flashed like knives. She would sometimes come to see me at Higher Tregerthen or I would visit her on my now more frequent walks along the cliffs to St Ives. I loved the huge windows of her studio overlooking Porthmeor Beach. On the hot calm days, even though it was the end of the season, the sands were covered with holiday-makers, and the studio was filled with the shrieks of children and seagulls. Then came the majestic storms of autumn and winter when the wind moaned across the roofs and waves pounded up the beach to the granite base of the building, encrusting the studio windows with crystalline spray. It has always seemed to me that Willie's Swiss glacier series of paintings that followed the balustrades, majestic and sensuous experiences of whites, blues and greys, transparencies and opacities, were more paintings of that window than they were of ice and snow at Grindelwald.

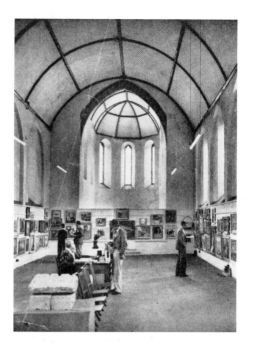

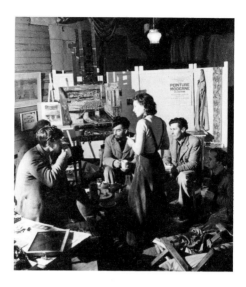

St Ives Society of Artists exhibition in the New Gallery, Norway Square, St Ives c.1950, *Tate Gallery Archive*

left
The Crypt Group 1947, from left to right:
Peter Lanyon, Bryan Wynter (hidden), Sven Berlin,
W. Barns-Graham, John Wells and Guido Morris in the
studio of W. Barns-Graham, photograph: the Central
Office of Information 1946/7, *Tate Gallery Archive*

Porthmeor Studios were entered from Back Road West. Two doors from Willie's studio was Wallis's cottage, and all around were the streets and fishermen's cottages that figure in his paintings. Down a narrow alley from Willie's towards the harbour was an old granite chapel that had been converted into an art gallery, the St Ives Society of Artists. Its walls were lined with academic landscapes, seascapes and flower-pieces.

The Society was dominated by a feisty old painter of storms at sea, Commander Bradshaw. He was as violently opposed to modern art, particularly art of the non-figurative variety, as his seas were to the puny ships they tossed about. Because no one had the courage to stand up to the redoubtable old seadog with the walking stick, modern works were relegated to a small area by the big doors. I wasn't sure whether they were being permitted charitably to come a little way in, or were made, like naughty children, to stand in the corner: but there you would find a group of small things by Ben and Barbara, and also one or two paintings by Lanyon, Wells, Wynter and Barns-Graham.

It was not much, but something. There was a feeling of revolt in the air, a quiet sense of advances being made. Below the chapel was the crypt, which one entered through a side door. Annual exhibitions by Peter, Willie, Bryan Wynter, Sven Berlin, David Haughton and George Barker's brother Kit were held there in the late summer. I remember thinking how Guido Morris's posters and catalogues, so exquisitely printed on handmade paper, would have been more appropriate to a pre-Raphaelite exhibition; yet in a way they were less incongruous in the crypt of that gaunt chapel than the paintings and sculptures of the young artists. At the same time one could also see that in the precise composition of his printed sheets lay a fascination with the spacial quality of his letters, with thick stems trailing away to delicate serifs, akin to abstract painting.

Another place where you could find exhibitions of the new art was in the small back room of George Downing's bookshop on Fore Street. George was a huge genial man, who made this little gallery available for one-person shows, with no more expectation than the delight, interest and inevitable controversy they

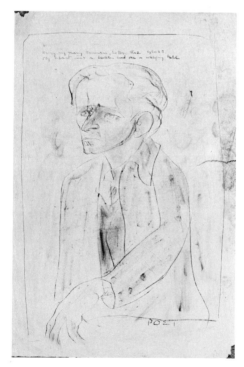

Sven Berlin, 'Portrait of Guido Morris', 1945, offset monotype with colour ground, *Tate Gallery Archive*
8135.40

would generate. And they did. Nicholson, Hepworth, Leach, Lanyon, Barns-Graham, Wynter and many others had small potent exhibitions there, several with catalogues by Guido.

And then there was the Castle Inn. Endell, the sculptor Denis Mitchell's elder brother, was its kindly and forbearing publican. On the dark panelled walls of his bar the work of the younger artists was welcome and always to be found. The Castle was our club, particularly on Saturdays. There you would find Bryan Wynter, who like me had trekked in from his lonely cottage on the moors, David Haughton, George Barker, the poet W.S. (Sydney) Graham, Sven Berlin, Denis Mitchell, Guido Morris, Susan Wynter the magical toymaker, Willie, Terry Frost, Johnny Wells, Peter and many others. Often a couple of mild and bitters would be enough to loosen tongues and tempers: and then the big generous frame of Sven would glide gently through the crowd to restore order. On the walls around that smoke-filled room, which was crowded with artists, and with fishermen in dark jerseys and caps playing skittles, and Arthur Caddick oblivious of the hubbub reciting poetry in a booming voice, you could discover on a Saturday evening works that are now in museums and well-known private collections around the world, but which were not much thought of in those days, except by the smallest group.

IX

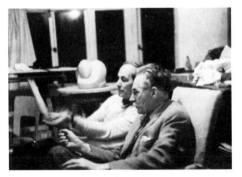

Naum Gabo and Bernard Leach at Faerystones, Carbis Bay 1940s, *Nina and Graham Williams*

Also through Peter I got to know Bernard Leach in early 1949, and began to visit his pottery regularly on my walks into St Ives from Tregerthen. Like Guido – whose Latin Press was in an old sail loft perched on rocks above the sea, in a part of St Ives beyond the harbour called The Wastrel – Bernard was outside the mainstream and something of an English mediaevalist too, in spite of his fascination with the great ceramic traditions of Japan and Korea. His pottery was on the other side of town, high up on a hill overlooking the majestic sweep of the bay, and he was always ready to wipe his hands on his canvas apron, swing round on his stool and talk.

Talking was important to him. It clarified his enthusiasms, and carried him to the threshold of his writings. He was a pioneer, trying to make relevant to the contemporary world ancient traditions threatened with extinction. Full of pride and fight, he felt it was his mission to restore the dignity of pottery and handcrafts as art forms in an increasingly technological world, and that meant re-establishing the language in the contemporary world through example, and substantiating that language philosophically and with scholarship.

Part of his greatness was that his life was a complex interweaving of two strands, east and west. Born in Hong Kong, and schooled at the Slade in London under 'the gritty eye and tomahawk nose' of Henry Tonks, he was inspired by the writings of Lafcadio Hearn to return to the Far East, this time to Japan. By training as a draftsman and an etcher, he lived first in Tokyo, paid a lengthy visit to Peking, and then returned to Japan in 1916 to begin potting. Through his work he met Soetsu Yanagi and Shoji Hamada. Yanagi became the intellect of the

modern revival of handcrafts in Japan, and Hamada flowered to become the master potter of this century. In 1920 Leach returned to England bringing Hamada with him, and together they set up the pottery at St Ives, building an oriental climbing stoneware kiln, the first of its kind in the west.

'When he started in Cornwall,' Bernard wrote, 'neither Hamada nor I had any experience of crafts in England. Our ideas were more or less bounded by conditions of craftsmanship in Japan. The conclusion we came to was that making and planning around the individuality of the artist was a necessary step in the evolution of crafts.'[25]

The pottery was divided into two functions, 'production' wares and unique or 'studio' pieces. Bernard believed deeply that pots are meant for use, and that the relation of kitchenware to food establishes a vital physical link with the soil, the senses and art. He wanted to see the widest possible distribution of handmade pottery. Production pots – mugs, plates, porringers, mixing bowls, milk jugs, egg cups, teapots – were thrown by the hundreds by Bernard, his son David, various assistants including Bill Marshall and Kenneth Quick, and by two newly arrived young Americans, Warren and Alix Mackenzie. Production sales kept the pottery going: they supported the making of 'studio' pieces, painted and incised by Bernard,[26] 'decorated' as he called it, with leaping fish, birds, trees or stylised landscapes, or with curvilinear abstract forms which seemed to have evolved from the limpid trails of his potter's brush.

One entered the pottery through a sort of farm gate. On the right was Bernard's house. Straight ahead was a shed that served as a shop. On the left downhill was the pottery and the kilns. Behind the shop was a little tinkling stream, called the Stennack, with tall grasses concealing a bed of rocks. Sometimes we would play cricket. The bowler had to stand on the far side of the road and watch for cars in both directions before hurling the ball through the open gate at the batsman who cowered in front of the shop door. Bernard as a bowler was like a daddylonglegs. He had a deadly spin, knowing exactly how to bounce the ball off a particular tilted rock embedded in the surface of the driveway. I remember especially the occasion when George Wingfield Digby, on one of his periodic visits from the Victoria and Albert Museum, was at bat and readied himself to address the ball with impeccable correctness, only to be bowled out first by Bernard's careening trajectory off that complicitous rock.

After a firing and the kilns had cooled, the stream came into play. Bernard would inspect every pot as it came out, paying particularly critical attention to the studio pieces. If any pot didn't pass muster he would address stern words to it as though it were guilty, and lob it with a parting epithet on to the rocks in the stream. 'When we heard the crash of the pot in the river below, a sense of inner cleanliness returned.'[27] Little did he know that after he was safely in his cottage and in bed, we would return at the dead of night to scramble among the shards, in the hope of rescuing any pot that may have escaped the rocks by landing on the grassy bank beyond. I still have such a plate, with me here in Pittsburgh, in which one can detect, among its rich overfired bubblings beautiful as a weatherbeaten face, the vague outlines of a motherbird feeding her young in the nest! Bernard would not have been pleased.

He was perfect for the part he played, midway between East and West. Gaunt and stooping, with hair and moustache like dried grass and small laughing eyes, I

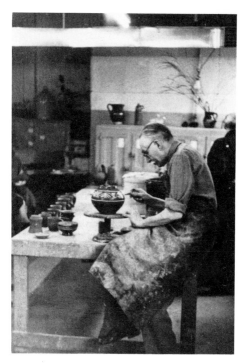

Bernard Leach, 1950s?, photograph: Warren Mackenzie, *Tate Gallery Archive*

suspect he was always paternal, even as a young man. He loved to talk about pots. Many were the evenings when we would sit in his kitchen sharing food, and he would bring out one by one, as the conversation ebbed and flowed, his special pots, things by Hamada, Cardew, Pleydell-Bouverie and Lucie Rie, side by side with ancient pieces from Korea or the Sung dynasty of China. And he would hold them with both hands cupped, his long fingers sensing their surfaces, and his palms savouring their form, weight, and asymmetry.

But it was always the anonymous pots for which he reserved his greatest praise. He liked most of all the ancient teabowls made by unknown craftsmen and used and treasured by anonymous generations – for these combined the spirit of aesthetics, culture, tradition and selflessness that were the ideal described with classic eloquence by Yanagi.[28] And as if to bridge the gap for us between those traditions and ours, we would talk about common clays, mediaeval English pottery, slipware and saltglaze, and we would talk about the moors of Penwith, the grasses and ferns and trees bent in the wind, and we would talk about the sea and the flight of birds, about the wateriness of Bernard's pen and ink drawings which were everywhere – and gradually I became aware of a common earthiness shared by us all.

X

In the drawer of an upstairs studio in the pottery was a painting of St Ives by Alfred Wallis on a piece of old cardboard. Wallis had painted it in the round, a visual journey, as it were, around the edges, so it didn't matter where you started. But probably you would start at the harbour, seen in plan with its granite quays like protective arms around boats moored to long ropes, and cottages along the waterfront. St Ives Bay was squashed down a bit to fit it in between the harbour and Hayle sands and estuary (cardboard colour) on the far side, but under the surface of the sea were seining nets heavy with pilchards. Then you would turn the painting at right angles and walk up the Stennack, with houses on each side and the stream at the top. Then you would turn the painting at right angles again, and now you have deep green moors with a small pencil moon in the cardboard sky. And finally you turn the painting for a fourth time and you get the coastline with its black rocks and grey-blue sea, ending at Godrevy Light. A journey in time and space: how often I experienced that painting as I walked and ran down the steps and ramps and terraces from the hilltop to Porthmeor, the wind, the rain and the sun in my face.

In the summer of 1949 Willie and I were married. We had a grand wedding in her native Scotland and Peter was our best man. First we lived on Bethesda Hill, and then at 4 Teetotal Street. But in spite of the grandness of our wedding and the kindness of one of Willie's aunts, life was difficult for us. Jobs were difficult to find. I tried for a post as a breakfast waiter at the swanky Tregenna Castle Hotel, and carried letters of reference from Ben and from Herbert Read. The people at Tregenna Castle had never heard of either of them. I didn't get the job. So I worked as a waiter and short order cook at Rose's cafe on the waterfront with another young painter, Robert Brennan, and a sunbronzed goddess of a waitress

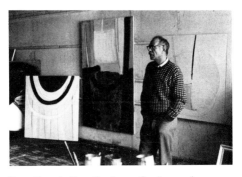

Terry Frost in No. 4 Porthmeor Studios c.1961, photograph: Roger Mayne

called Mary. Terry Frost, who lived just down the street, was also a waiter at a remarkable place called St Christopher's run by Philip and Sally Keeley. The Keeleys kept several artists going by showing their paintings and sculptures wherever they had wall space, and by swapping art for meals; and in the early mornings before work Terry and I sometimes would walk along the quay together and across the sands of the harbour at low tide, talking about painting.

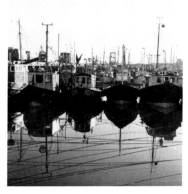

Boats in Cornish Harbour, photograph: Sarah Fox-Pitt, *Tate Gallery Archive*

The sky, reflected in the water, became grey clouds disturbed by ripples when the wind blew, and the boats seemed then to rock back and forth suspended between sky and reflected sky, moored to ropes that became looping black lines in space. Suddenly the natural world appeared to be made up of interchangeable pieces, linked only by rippling rocking motions caused by the wind. Terry made a series of paintings based on these experiences, called 'Walk along the Quay'. Willie and I bought one of the first of them, small, in blacks and greys, and the painter Adrian Heath got another one, rather larger and with more colours.

One day Terry brought along his little son Adrian, who was then three and a half or four. A black cat was sitting on the harbour wall, preening itself in the morning sun. It had a small tuft of white on its left front paw, a medallion of white on its chest, and a small tuft of white on the right side of its nose. 'O look at that white cat,' cried Adrian in delight, 'covered all over in black'. 'My God', said Terry, 'the little bugger's going to be a bleedin' painter!' And off we were, on a discussion about layering one colour over another, until all that's left is a linear edge like an eclipse of the sun: and years later Terry did a series of eclipse paintings called black suns, one of which I have in my room as I write, with a rim of acid yellow emerging from a green-black circle flat as a pan, reminding me always of this incident thirty-five years ago.

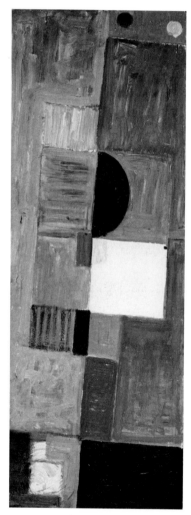

Terry Frost, 'Walk along the Quay', 1948, first version, *W. Barns-Graham and David Lewis*

The 'Walk along the Quay' paintings were definitely beginnings for Frost. Boat shapes, masts, riggings, water, sky, ripples, all became free compositional elements of mass, line, colour, texture and movement rocking to and fro 'because the boats are never still, never static, and so you've got this terrific sort of up and down motion, this leaning over that . . .'[29] Indeed, when Ben first saw them he told Terry: 'you've got on to something that can last you for the rest of your life', and he was right. From that point on Frost has never deviated from the shapes, rhythms and freedom of that experience.

And talking of freedom, it was a period in which there was an extraordinary spirit of interpersonal comradeship and responsibility. Artists respected each other and helped each other along. Everyone was scraping a living. Patrick Heron recalls Ben selling 'one of his best hard edge abstractions to my friend Fello Atkinson in 1948 I think – a beauty, framed by himself, for £15 and (Ben) wrote: if you would like to pay me in monthly installments of £1, it will be OK by me.'[30] If an artist sold something, he would buy something from someone else to encourage and help out. Patrons were shared. The aftermath of the war had a lot to do with it. For a while there was a sense of a new beginning. Terry recalls that 'all that energy for goodness was released, energy to try to do something, and so the whole system that had been a closed shop before the war was opened up to people for writing, painting and acting who never thought they could take part in it . . . There was no materialistic greed at that time, people just wanted to do things for real reasons.'[31]

For Terry, this freedom became every day a renewed discovery of colour.

Rapidly his palette became brighter, his paint thicker and more sensuous, and his forms became endless variants on the vocabularies of abstracted boat and harbour shapes. He discovered that simple colours mixed could give you almost anything: red, yellow and blue could make black, but not just any black, a cold black, a warm black, a green black, an opaque black; and that the infinity of yellows was not simply a question of the yellow itself, but also of the intensity of the colours around it. And Terry quickly found that as far as colour was concerned: 'I liked to get my nose into it like a pig rutting in the ground.'[32]

Although Terry's paintings gained not only in brightness but also in impasto, it seemed to me that John Wells and Willie were also working in parallel discoveries of personal freedom, though in different manners. Johnny had been a medical doctor in the Scilly Isles in the thirties. He had built a small hospital on St Mary's. But his patients lived on many different islands, and his house calls were paid from island to island by motor boat. He began painting in his spare time, and was deeply affected by his early friendship with Ben, Barbara, Winifred Nicholson and Gabo. From Gabo in particular he learned the poetry of interior spaces. When Willie and I went drawing with Ben on the Scillies, on St Martin's and Bryher, we experienced at first hand Johnny's islands mysteriously suspended between sky and sea, with shafts of silver light tinged with pink and lavender as the sun set beyond blue veils of sea mist.

And similarly Willie's paintings grew in simultaneous delicacy and robustness as she freed herself from literal figuration, and began a series of abstract compositions in which the forms were rhythmically hollowed out like sculptures. These paintings began, as I have mentioned earlier, as studies of glaciers in the Swiss Alps, and quickly evolved into compositions of great originality. 'The massive strength and size of the glaciers, the fantastic shapes, the contrast of solidity and transparency, the many reflected colours in strong light,' she wrote in February 1965 '... this likeness to glass and transparency, combined with solid rough edges made me wish to combine in a work all angles at once, through, and all round, as a bird flies, a total experience.'[33] From the glaciers back to Porthmeor, the interplay of opacity and transparency, of intersecting lines, some drawn, some etched, and of colour free from description but evocative of nature, her paintings became at once stone, sea and cloud in perpetual movement.

Wilhelmina Barns-Graham, 'Composition February', 1954, *Private Collection*

XI

In 1949 a number of artists rebelled against the autocracy of the academics and resigned from the St Ives Society. The rebels were not only the younger non-figurative artists. Several of the figurative artists resigned as well. A new group was formed, which took the name Penwith, so that artists from Newlyn, Penzance and other parts of south-west Cornwall could join. Hodder's potato loft on Fore Street was acquired, painted white, and converted into a gallery, and Herbert Read became the Penwith's president. Because it was felt that figurative and non-figurative artists had different backgrounds and goals, it was decided to divide the exhibitions into three sections, each with its own jury, A for figurative,

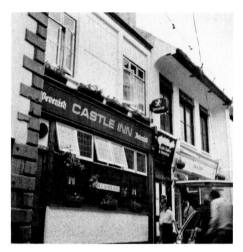

The Castle Inn, and next door upstairs, The Penwith Gallery, St Ives, photograph: David Lewis, *Tate Gallery Archive*

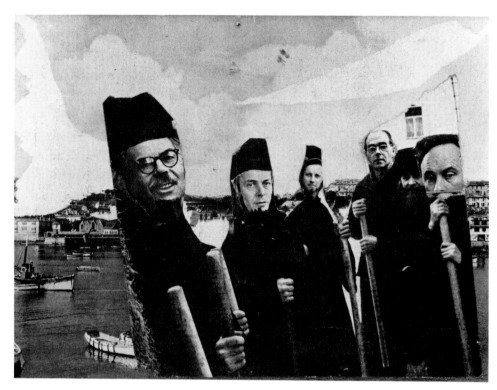

Christmas card by Peter Lanyon for Terry Frost, left to right: Terry Frost, Bryan Wynter, Peter Lanyon, Roger Hilton and Patrick Heron, St Ives Harbour in background, *Tate Gallery Archive 7919*

left
Sven Berlin 1952/3, photograph: Gilbert Adams

B for non-figurative and C for crafts. Each section would have its own jury, and the idea was that artists were free to label each work they submitted according to the jury they wanted to judge it.

At first things went along smoothly. But jealousies began to erupt. Peter felt strongly that the B section was not only dominant, but that Ben and Barbara were manipulating the Penwith to promote their own direction. Sven felt that romantic work of his kind in sculpture and painting could never get a proper evaluation from either an A jury that had a figurative bias and a B jury that had a hard edge bias: and Peter was upset at Sven for writing a book about Alfred Wallis, when Wallis was a Cornishman and Sven wasn't. Meetings became stormy and humour became cutting. Arthur Caddick demanded to know, at the top of his voice, what Nicholson and Hepworth intended to do, 'now that you have separated the sheep from the goats.' Ben was hurt and spoke of little else for days. There were several resignations, including Peter's. As Penwith's curator, I found myself unhappily caught in the middle.

1950 and 1951 were topsyturvy years. Others joined the Penwith, including Heron, Frost and Wynter, about the time that Peter left – and they were Peter's friends. To increase the range of the exhibitions and also to obscure the divisions, a certain number of guest artists and lenders were invited to exhibit. It was not unusual to walk into a Penwith show and see Pasmores, Picassos, Arps, Michael Cardews and Dod Proctors. And besides exhibiting paintings, sculptures and crafts, the Penwith published a series of illustrated Broadsheets, 'PS', edited by

Terry Frost, Denis Mitchell and me, for which Herbert Read and others wrote.

Certainly the B section was growing stronger and stronger. London art galleries had begun showing several of the younger artists in addition to Nicholson and Hepworth. The Redfern showed Wynter; Roland Browse and Delbanco showed Willie; Leicester Galleries showed Frost; and Gimpels took Lanyon. St Ives was becoming an increasing focus of avant-garde attention. And as this happened it seemed that the town became three quite distinct worlds: the world of the townspeople, of the artists, and of the visitors.

The world of the townspeople was strangely untouched by the artists. That was its appeal. It wasn't that the Cornish rejected the artists: not at all. The artists were an important and permanent part of their everyday lives and their economy. But their subculture of fishing boats, primitive methodist chapel Sundays, and the cemetery half way up the hill to which trailed ant-like blackcap funeral processions, was a world that turned on a different axis.

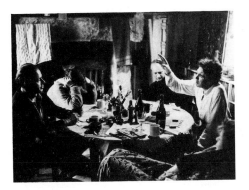

W.S. Graham (right) with Karl Weschke and Bryan Wynter (left) at the Carn, Zennor c.1956, photograph: Roger Mayne

The artists similarly had their own world. In those years it was a mutual support system. Or, should I say, it was two mutual support systems: the figurative or 'old' artists and the non-figurative or 'new' artists, without much contact between them. And when the B section of the Penwith split up, this second system broke into three subsidiary pieces that overlapped, the Ben-Barbara-Bernard group that had in a sense 'arrived', the younger group of struggling artists that included Frost, Berlin, Wells, Guido Morris, Wynter and Barns-Graham, and writers like Robin Skelton and W.S. Graham, who could be found on Saturday evenings in the Castle and on sunny Sunday noons at the Sloop on the harbourfront, and thirdly dissident Peter.

The visitors formed quite another world. From Easter to the end of August, St Ives would fill up with holiday makers. They jammed the cafes and the bric-a-brac shops which would suddenly open behind demountable shutters along the waterfront like glittering Aladdin caves, and on every street of granite cottages bed-and-breakfast signs would hang out like metal flags. Among these crowds surging down Fore Street and jamming the beaches were welcome faces. Artists of emerging national and international reputation visited, including Victor Pasmore, William Scott, Mark Rothko, Robert Adams, Patrick Heron, Roger Hilton, Trevor Bell, Priaulx Rainier and Michael Tippett, and several stayed to work. Others included writers and historians such as Elias Canetti, J.P. Hodin and John Summerson, dealers and curators such as George Dix from New York and Willi Sandberg from Holland, scientists such as J.D. Bernal and Solly Zuckerman, and collectors such as E.C. 'Peter' Gregory, J.R.M. Brumwell and Margaret Gardiner.

Many artists came to see what was going on, left, and came back for longer periods. Some were friends of artists who were already in St Ives. Adrian Heath, who had been coming down for years, stayed with the Frosts. The constructionist Anthony Hill, the Dutch painter from the Cobra Group Constant Nieuwenhuys, and the typographer-printer Anthony Froshaug stayed with Willie and me. Patrick Heron helped Alan Davie find a cottage at Treen.[34] Brian Wall, John Forrester, Peter Potworowski, Sandra Blow, Paul Feiler and Patrick Hayman came and stayed on.

Critics, dealers and curators, who primarily came to see Ben and Barbara, were encouraged to see other studios. Frequent visitors included Philip James of

the Arts Council, Lilian Somerville of the British Council, David Baxandall of the Scottish National Gallery, and Norman Reid from the Tate. Gradually paintings by Lanyon, Frost, Wynter, Wells, Barns-Graham and Heron were acquired by national collections. And George Dix took a group of paintings by John Wells to New York, one of which I came across just the other day in a collection in Atlanta, Georgia.

But when sales were disappointing for months on end, artists would exchange works as a show of respect and appreciation. Ben took a gouache of Willie's that was particularly meaningful to him, and gave us a white relief in exchange.[35] Terry tells how Ben deeply admired an early 'rocking boat' painting in black, white and green, and swapped an early Nicholson canvas for it, a diamond divided into quadrants that I remember had been hung in Chy-an-Kerris to conceal a damp patch in the wall. The next day Terry got a letter from Ernest Brown at the Leicester Galleries in London, prompted by Philip James of the Arts Council, asking for three paintings including the black, white and green one. 'I had to go round and see Ben. "It'll do you more good to show in London", he said. So we reshook hands, and Leicester sold all three'. But Frost had lost his Nicholson.[36]

Ben Nicholson, 'White Relief', 1936, *Florsheim Collection, U.S.A.*

XII

The most important to me personally of all the artists who came and went were Victor Pasmore, Priaulx Rainier and Patrick Heron. Pasmore had already moved from his earlier figurative paintings of the reaches of the Thames at Hammersmith through a brief pointillist phase to the edge of abstract art. At St Ives he made pen and ink drawings of the spiral movements of waves as they curled and crashed on the rocks at Porthmeor and Porthgwidden. The spiral paintings, and his constructions which followed, led me one step further towards my decision to become an architect.

Equally persuasive was Priaulx Rainier's music. When I first heard it, I was at home with its abstract constructions of sound. But within those constructions I heard the haunting sounds of Priaulx's native South African high veld, the sough and sigh of winds in tall grasses suddenly punctuated by the shrill cry of a bird or the nervous trajectory of an insect. And when she began new compositions reflecting her acutely aural experiences of Cornwall, I perceived within her constructions for wood-winds, strings and percussion, the movements of wind against rock, sea on sand, and the alert notes of sandpipers, and I found for the first time direct parallels between contemporary music, the art that was being made around me, and the landscape.

Patrick Heron is perhaps the most literate painter I have ever met. Yet that in itself is misleading. When I met him in London in 1950 he was better known as a critic than as an artist. Yet there was nothing literary about his painting. Quite the reverse. His art explored a progression of visual experiences which informed and sharpened his literary sensibilities, to a point that his capacity to enter into the work of the painters and sculptors he wrote about was, in my view, unmatched in English criticism since Ruskin.

Priaulx Rainier, 1953

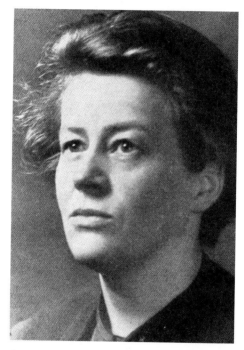

Patrick Heron rocking his loganstone at Eagles Nest, photograph: David Lewis, *Tate Gallery Archive*

He had lived in St Ives as a boy, and had returned for extended periods ever since. His father was the founder of *Cresta*, and was a deeply cultured man. His shops designed by Wells Coates in the early 1930s were among the first essays in modern architecture and product design in this country. At the time I first knew Heron and his wife Delia they spent their summer months in a house with a balcony overlooking St Ives harbour. Patrick's deepest interests were Matisse and Braque, but his own paintings were increasingly linear. He had a way of drawing on canvas directly from the tube, introducing colour into line, so that space in his paintings was not merely a function of drawing but was syncopated by colour, moving it back and forth, bringing a new freedom.

The fact that he was not part of the permanent scene at St Ives was important for us. He was a link with the international world but a generation younger than Read. His art however was in many respects, in spite of his affinities with Braque and Matisse, closer to the romanticism of Lanyon and Wynter. His linear paintings seemed in tune with the jaunty faceted cubism of Wynter's still lifes with skulls and seabirds, and with the underwater drawings and paintings that Wynter had begun as a result of paddling around perilously in a glass-bottomed canoe at the base of the great cliffs where the sea surged. On his extended visits to St Ives he would join Peter and Johnny on their adventures at Geevor Mine, where they made strange constructions out of abandoned mine machinery.

Through Patrick I became friends with Roger Hilton in London, and encouraged him to visit us in St Ives. Patrick said at that time that Roger was the most painterly of the younger British artists, a painter's painter. I still agree with this view. He was thin, acerbic, intellectual, impoverished. Mrs Stevens, who did for us once a week and resembled a hippo, took one look at him sitting in our kitchen when he came to us for breakfast, and said 'Oo's 'ee? Boil'n up for soup'. His oils were simple bold statements, with incredible subtlety of colour and texture. I wrote a catalogue for him for an exhibition at the Simon Quinn Gallery

Bryan Wynter, *Tate Gallery Archive*

Peter Lanyon at Geevor Mine, 1950s, photograph: Gilbert Adams

David Lewis and Roger Hilton on the Newhaven Dieppe ferry 1954, photograph: W. Barns-Graham

[35]

in Huddersfield where, as usual, he sold nothing. Willie and I went to Paris with him, and then to Holland, where our meetings with Corneille, Bram van Velde and Aldo van Eyck cemented my growing enthusiasm for the Dutch movement, for de Stijl and Mondrian, leading me one step further to my decision in 1956 to begin a new career in architecture.

XIII

Ben Nicholson and Barbara Hepworth separated in 1950. Barbara found a wonderful walled studio, Trewyn, on Ayr Lane in the heart of St Ives. Ben took a large studio at Porthmeor, a few doors down from Willie's studio and next door to a studio occupied by Terry. For a while he commuted back and forth from Chy-an-Kerris. But after about a year he moved into St Ives, to Trezion, up a long flight of granite steps.

These events had a deep impact on their work. First came the unhappy task of closing down Chy-an-Kerris. Denis Mitchell had begun working for Barbara as an assistant before she left Chy-an-Kerris, and when she moved to Trewyn she built her working life in large measure around his working day. Ben had no one like Denis, so he called on me. Together we dismantled the house, and alternated moving paintings, materials and pieces of furniture with, of course, games of ping-pong.

Ben was particularly sensitive about leaving the garden rank and unkempt. One hot afternoon I went at the docks and nettles with a billhook. Deep in the weeds under a granite wall I found a wood carving of Barbara's. One can only assume that Barbara had thrown it out four years earlier, but who knows for sure. Anyhow, there it was, sodden from rain, cracked and worm-eaten, with moss in its inner cavities where paint colour had flaked. Ben said: 'David, you found it, you should keep it.' I said: 'Ben, that's very generous, but surely it's Barbara's. She should decide what's to be done with it.' But Ben and Barbara were not on speaking terms, so the sculpture was put in a box where, I suppose, it remained until Ben gave it to the Tate after Barbara's death.

Trezion overlooked St Ives harbour, across the roof of the Primitive Methodist Church on Salubrious Place. This roof looked like an upturned boat, and Ben made several drawings of it. He had a Calder mobile suspended from his ceiling, so that as its balls turned in the seabreeze they cast an intricate kaleidoscope of shadow and line. He also had a painting by Mondrian, and several Wallis's which seemed to relate directly to the sea and sky, and to the tumble of buildings and planes of the roofs down to the harbour below.

Ben's big new studio at Porthmeor enabled him to begin large paintings for the first time since the outbreak of war. But his new paintings were deeply affected by his experience of the Penwith landscape. He had a small open MG. He painted it himself, a careful shade of dove grey to go with its crimson seats and his blue cap. The car was too small for three people. So either Willie or I would go drawing with him, at Zennor, Portreath and other places along the coast. 'He drove his car in the countryside rather like his drawings; people used to shake their fists.'[37] He enjoyed drawing with Willie because her drawings were, like his, directly

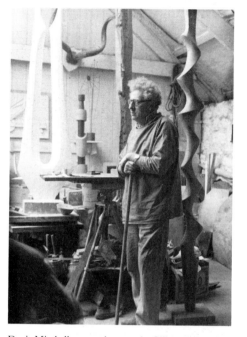

Denis Mitchell, 1952, photograph: Gilbert Adams

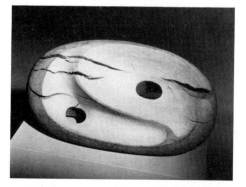

Barbara Hepworth, 'Tides I', 1946, *Tate Gallery* (*T 02008*)

St Ives, View of rooftops and harbour from Trezion, 1953, photograph: Roger Mayne

Trendrine Farm, Near Zennor, photograph David Lewis, *Tate Gallery Archive*

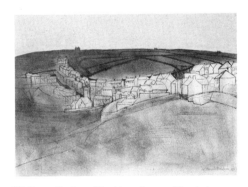

W. Barns-Graham, 'Porthleven', 1951, *The Artist*

Ben Nicholson's No.5 Porthmeor Studios, October 1949, photograph: Studio St Ives, *Trustees of Ben Nicholson Estate*

representational: farms, villages, fields like patchwork with enclosing walls like seams, harbours and sea. Her's were oil offsets on textured paper; his were pencil explorations of mass and linear movement in space. He particularly loved to draw a farm called Trendrine. Its buildings formed an enclosed court and nestled into the hillside above the fields, the cliffs and the sea.

But his paintings were never directly landscape. A goblet or a bottle provided linear profiles of semicircle and rectangle: circle and square, point counterpoint. In his canvases he conveyed, not figuration, but the actual quality of place: the visual and tactile texture of sand dunes, and their curvilinear rhythms against the wateriness of sky; the particular qualities of soft sage or hard orange of lichen; the shell delicacy of pinks; the grain of rock; the ivory smoothness of rubbed seastone; the dense rust brown of sails. And it was the metaphorical quality of these elements that led us, in evening sessions before exhibitions, to arrive at appropriate titles for his abstract and linear cubist paintings.

Terry's studio and Ben's were next door to each other. Through the wall Terry and I could hear Ben's radio playing jazz, and we could hear him moving about and scraping away at canvas surfaces with razor blades, or at the hardboards from which he cut his reliefs. Then suddenly the radio would be switched off, and there would be a concentrated silence. A few hours later he would pop his head in at the door of Terry's studio, or round me up at Teetotal Street, and cock his head on one side: 'Want to see something new, old chap!' Sometimes if we were critical, he would scratch out the new painting and start again. One day he said to Terry: 'I'll give you a lesson on cubism.' He just drew on his table round a tumbler, and up a jug, and round, and round, and of course (the line of) the tumbler cut through the handle of the jug so that you got the two objects intersecting: it was all done so beautifully. 'That's cubism', Ben said.[38]

Trewyn's impact on Barbara was even deeper than Trezion's on Ben. Trewyn was surrounded by a high granite wall which continued round the corner like a bastion, broken only by a firmly shut door painted deep blue. From the street you could not tell that what lay beyond the wall, and the door seemed to be part of the hillside. Through the blue door you found yourself in a cellar, with open wooden stairs like a ladder at the far end, and you would then climb up the ladder like a miner and emerge into the white sunfilled studio above, a distillation of light and calm.[39]

The entire experience was like a Hepworth sculpture: like entering a carving with a dark exterior, and encountering captured whiteness, space and reflected concavities of light inside. The garden was at the same level as the upstairs studio, and on one side of the garden as it terraced uphill were two greenhouses. Apart from some mature trees and hedges the garden was relatively a wilderness when Barbara bought Trewyn; but over the following summer months Priaulx Rainier rebuilt it, creating an astonishing oasis of flowers, shrubs, and terraced walkways which in subsequent years became filled with sculptures. And Denis refurbished the greenhouses, which became Barbara's studios for rough carving, wood and stone.

1950 was fortunately an important work-year for Barbara. Commissions for a large two-part sculpture in blue limestone from the Arts Council and the Festival of Britain filled the greenhouses with activity. Denis was joined by Terry Frost and John Wells as assistants to Barbara on these major works. Lund Humphries commissioned the first big monograph on Hepworth, and I joined the crew for several months to track down, catalogue and photograph her sculptures and drawings from the beginning, the first time this had been attempted.

Barbara had in the past two years done a series of studies of operating theatres in hospitals, drawings of surgeons and nurses at work in their masks and gowns. Once she was in Trewyn, she established a routine of drawing from models every evening after her day of carving. She made a series of studies of male and female nudes together, standing, seated or lying; and portrait heads of a young woman called Lisa who had a mane of dark brown hair. It is not difficult to see the direct influence of these drawings, with their emphasis on surface and volume, on the large sculptures that were being made in the courtyard.

At Barbara's studio we formed a community within a community. We came at eight and worked until five with exactly an hour off for lunch. In 1950 Barbara was asked to be the British sculptor at the Venice Biennale, and she in turn asked me to write the catalogue. Barbara would draw chalk lines across her stones for Denis, Terry or Johnny to rough out; but line in three dimensions was a plane or a convex or concave surface, and she knew within a hair's breadth what she wanted in volume and texture. Work was at once intense and consistent. Denis recalls that 'she had an extraordinary eye . . . we carved side by side . . . I was her hands.' She had a theory that 'you carved to the beat of your heart. What used to happen was that you would be outside carving and she'd be in the studio drawing, and you'd stop to breathe a second and have a rest and she'd come out and say, "are you stuck?"'[40]

After five o'clock people would come and sit in the garden or the studio to talk or listen to music. Frequent visitors included Priaulx, the Shakespearian scholar Frank Halliday and his wife Nancie, and Bernard Leach. Conversation would

Barbara Hepworth at work in Trewyn Studio 1953, photograph: Roger Mayne

Barbara Hepworth, 'Two Figures with folded Arms', 1947, *Tate Gallery* (T 00269)

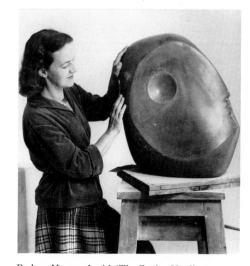

Barbara Hepworth with 'The Cosdon Head', 1949, *Birmingham Museum and Art Gallery*

almost always revolve around sculpture, music and world events. Barbara had an intense interest in the philosophic aspects of politics, particularly socialism, and how they related to art. Sculptural analogies of landscape were always of great interest to her also, although unlike Ben she seldom ventured into the landscape herself and never drew it.

Although she wrote so poetically about the inspiration of landscape in her work, she drew her sense of it vicariously rather than directly: from her childhood memories of the Yorkshire moors, from her association in the thirties with Henry Moore, from sea pebbles and the magnificent sweep of Carbis Bay seen from the windows of Chy-an-Kerris, and from our conversations. In Denis Mitchell's words, 'I always said that Trewyn wasn't walled in to keep people out, it was to keep her in. She loved being in there, locked in.'[41]

XIV

Those years, 1950 and 1951, were important years for Peter too; for in his isolation he began a journey into a landscape-seascape experience that became utterly his own and consuming.

'The sea then became something which was down towards my feet, less towards the side of my feet, less perhaps in front of me as it was as I looked out from the beach. I then walked over the Western Hill, and the gale struck me straight on. It was very cold too, though it was June. I lay down and looked over the edge and watched the sea coming in, striking on the shore and on to the rocks there, and breaking off and going away out to sea again, and I came back over the Western Hill, inwards, southerly, and down under the lea and the shelter, and there I sat down in the grass – long grass with a lot of remains of sea pinks, and the grass browning slightly due to a certain amount of sunshine. The sun began to come out at that time and the grass blew and the sea and the sky became bluer.'[42]

'I merely state my preference for painting as being a recreation of experience in immediacy, a process of being, made now. The mark of the hand and arm can be either frozen gesture or revelation. There is a huge difference between the two: the gesture made in desperation or joy is not enough, it is scything the air. In painting, gesture must attach itself and become its opposite, and be cut and thrashed and extracted from a wealth of soil-based and rooted knowledge . . . Man knows a mine in him and acknowledges the aspiration of the stars. In the very small and the very big there is a common image. Both germ and star affirming their gender can see the surface whereon man is made more naked.'[43]

Cornish Landscape – Peter Lanyon and two of his children, photograph: Sheila Lanyon, *Tate Gallery Archive*

XV

So the landscape was the common factor for all of us, a presence of perpetual power which in its transitoriness reminds us of our own, yet simultaneously contains infinity. Everyone used it differently for their voyages of self discovery. In a way we were all refugees, blown by the winds across its face, its gaunt cliffs, its windscoured uplands, its seething sea, searching for somewhere to take root. Yet any pathway we followed, over moorlands, or down the shafts of mines, or along the corridors of gales, led only to oneself.

> 'So I would have it, waved from home out
> After that, the continual other offer,
> Intellect sung in a garment of innocence.
> Here, formal and struck into a dead stillness,
> The voyage sails you no more than your own.
> And on its wrought epitaph fathers itself
> The sea as metaphor of the sea. The boat
> Rides in its fires.'

W.S. Graham
from *The Nightfishing*,
Faber and Faber, 1955

NOTES

1 Herbert Read, *Poetry and Anarchism*, Faber & Faber, London 1938.

2 Herbert Read, *The Education of Free Men*, Freedom Press, London, December 1944.

3 Herbert Read, *Chains of Freedom*, reprinted in *Anarchy & Order*, Faber & Faber, London, 1954, pp.161, 162.

4 Herbert Read, *Poetry and Anarchism*, reprinted in *Anarchy & Order*, p.76.

5 *Barbara Hepworth, Carvings and Drawings*, Introduction by Herbert Read, Percy Lund Humphries & Co., Ltd, London 1952.

6 John Wells, Introduction to the catalogue, *Ben Nicholson Early Works*, Exhibition, at the Crane Kalman Gallery, London, 27 June–31 July 1968.

7 Ben Nicholson, *Alfred Wallis*, Horizon, Vol.VII, No.37, 1943, reprinted in Edwin Mullins, *Alfred Wallis, Cornish Primitive Painter*, Macdonald, London, 1967.

8 Margaret Mellis, Taped interview with David Lewis and Sarah Fox-Pitt, 31 May 1981, Tate Gallery Archive TAV 272AB, p.1.

9 Miriam Gabo, Taped interview with David Lewis and Sarah Fox-Pitt, 28 May 1981, Tate Gallery Archive TAV 270AB, pp.23, 24.

10 CIRCLE: International Survey of Constructive Art, Edited by J.L. Martin, Ben Nicholson and Naum Gabo, Faber & Faber, London, 1937, reissued in 1971 by Faber & Faber, London and Praeger Publishers, Inc., New York.

11 Miriam Gabo, op. cit., p.26.

12 Herbert Read, Introduction to the catalogue, *Naum Gabo: Constructions, Paintings, Drawings*, Exhibition at the Tate Gallery, London, 15 March to 15 April 1966.

13 Miriam Gabo, op. cit., p.18.

14 Miriam Gabo, op. cit., p.55.

15 Miriam Gabo, op. cit., p.12.

16 Miriam Gabo, op. cit. p.43.

17 Drawings by Barbara Hepworth from this period were reproduced in Kathleen Raine, *Stone and Flower, Poems 1935–43*, Poetry London, Nicholson & Watson, London, 1943.

18 Margaret Mellis, op. cit., pp.50, 51.

19 Margaret Mellis, op. cit., p.24.

20 Sven Berlin, *Alfred Wallis, Primitive*, Poetry London, Nicholson & Watson, London, 1949.

21 Sven Berlin, in conversation with David Lewis and Sarah Fox-Pitt, June 1981.

22 Margaret Mellis, op. cit., pp.33–35.

23 Miriam Gabo, op. cit., p.46.

24 Patrick Heron, Taped interview with David Lewis and Sarah Fox-Pitt, 11 April 1981, Tate Gallery Archive, TAV 247AB.

25 Bernard Leach, *Beyond East & West*, Faber & Faber, London 1978. p.139.

26 David Leach, Taped interview with David Lewis and Sarah Fox-Pitt, 3 June, 1981, Tate Gallery Archive, TAV 268AB.

27 Bernard Leach, op. cit., p.143.

28 Soetsu Yanagi, *The Unknown Craftsman*, Kodansha International Ltd, Tokyo, Japan, 1972.

29 Terry Frost, Sound track for the film *Colour Positive*, B.B.C., November 1977.

30 Patrick Heron, op. cit., p.34.

31 Terry Frost, Taped interview with David Lewis and Sarah Fox-Pitt, 10 April 1981, Tate Gallery Archive, TAV 246AB. p.40.

32 Terry Frost, op. cit., p.60.

33 W. Barns-Graham, Letter, 1 February 1965, quoted in the Annual Report, Tate Gallery, London, 1964–65, Appendix 3, p.30.

34 Patrick Heron, op. cit., p.30.

35 This white relief *Square and Circle, 1937* is now in the Florsheim Collection, USA.

36 Terry Frost, op. cit., pp.25, 26.

37 W. Barns-Graham, Taped interview with David Lewis and Sarah Fox-Pitt, 14 April 1981, Tate Gallery Archive, TAV 250AB, p.22.

38 Terry Frost, op. cit., p.22.

39 David Lewis, *Barbara Hepworth: 1903–75*, Carnegie Magazine, Pittsburgh, USA, Vol.XLIX, No.9, November 1975, pp.398–406.

40 Denis Mitchell, Taped interview with David Lewis and Sarah Fox-Pitt, 13 April 1981, Tate Gallery Archive, TAV 249AB, p.25.

41 Denis Mitchell, op. cit., p.51.

42 Peter Lanyon, '*Offshore*, A Description of a Painting in Progress', June 1959, Tate Gallery Archive, TAV 210AB, p.2.

43 Peter Lanyon, 'Landscape – Coast Journey and Painting', Tate Gallery Archive, TAV 368, p.40.

POEMS BY W.S.GRAHAM

W.S. Graham, a member of the St Ives group, has kindly allowed us to reprint the following poems which seemed particularly appropriate to the exhibition. They have been taken from *Collected Poems 1942–77*, published by Faber & Faber.

LINES ON ROGER HILTON'S WATCH

Which I was given because
I loved him and we had
Terrible times together.

O tarnished ticking time
Piece with your bent hand,
You must be used to being
Looked at suddenly
In the middle of the night
When he switched the light on

Beside his bed. I hope
You told him the best time
When he lifted you up
To meet the Hilton gaze.

I lift you up from the mantel
Piece here in my house
Wearing your verdigris.
At least I keep you wound
And put my ear to you
To hear Botallack tick.

You realise your master
Has relinquished you
And gone to lie under
The ground at St Just.

Tell me the time. The time
Is Botallack o'clock.
This is the dead of night.

He switches the light on
To find a cigarette
And pours himself a Teachers.
He picks me up and holds me
Near his lonely face
To see my hands. He thinks
He is not being watched.

The images of his dream
Are still about his face
As he spits and tries not
To remember where he was.

I am only a watch
And pray time hastes away.
I think I am running down.

Watch, it is time I wound
You up again. I am
Very much not your dear
Last master but we had
Terrible times together.

THE THERMAL STAIR

For the painter Peter Lanyon killed in a gliding accident 1964

I called today, Peter, and you were away.
I look out over Botallack and over Ding
Dong and Levant and over the jasper sea.

Find me a thermal to speak and soar to you from
Over Lanyon Quoit and the circling stones standing
High on the moor over Gurnard's Head where some

Time three foxglove summers ago, you came.
The days are shortening over Little Parc Owles.
The poet or painter steers his life to maim

Himself somehow for the job. His job is Love
Imagined into words or paint to make
An object that will stand and will not move.

Peter, I called and you were away, speaking
Only through what you made and at your best.
Look, there above Botallack, the buzzard riding

The salt updraught slides off the broken air
And out of sight to quarter a new place.
The Celtic sea, the Methodist sea is there.

> You said once in the Engine
> House below Morvah
> That words make their world
> In the same way as the painter's
> Mark surprises him
> Into seeing new.
> Sit here on the sparstone
> In this ruin where
> Once the early beam
> Engine pounded and broke
> The air with industry.
>
> Now the chuck of daws
> And the listening sea.
>
> "Shall we go down" you said
> "Before the light goes
> And stand under the old
> Tinworkings around
> Morvah and St Just?"
> You said "Here is the sea

Made by alfred wallis
Or any poet or painter's
Eye it encountered.
Or is it better made
By all those vesselled men
Sometime it maintained?
We all make it again."

Give me your hand, Peter,
To steady me on the word.

Seventy-two by sixty,
Italy hangs on the wall.
A woman stands with a drink
In some polite place
And looks at SARACINESCO
And turns to mention space.
That one if she could
Would ride Artistically
The thermals you once rode.

Peter, the phallic boys
Begin to wink their lights.
Godrevy and the Wolf
Are calling Opening Time.
We'll take the quickest way
The tin singers made.
Climb here where the hand
Will not grasp on air.
And that dark-suited man
Has set the dominoes out
On the Queen's table.
Peter, we'll sit and drink
And go in the sea's roar
To Labrador with wallis
Or rise on Lanyon's stair.

Uneasy, lovable man, give me your painting
Hand to steady me taking the word-road home.
Lanyon, why is it you're earlier away?
Remember me wherever you listen from.
Lanyon, dingdong dingdong from carn to carn.
It seems tonight all Closing bells are tolling
Across the Duchy shire wherever I turn.

DEAR BRYAN WYNTER

1

This is only a note
To say how sorry I am
You died. You will realise
What a position it puts
Me in. I couldn't really
Have died for you if so
I were inclined. The carn
Foxglove here on the wall
Outside your first house
Leans with me standing
In the Zennor wind.

Anyhow how are things?
Are you still somewhere
With your long legs
And twitching smile under
Your blue hat walking
Across a place? Or am
I greedy to make you up
Again out of memory?
Are you there at all?
I would like to think
You were all right
And not worried about
Monica and the children
And not unhappy or bored.

2

Speaking to you and not
Knowing if you are there
Is not too difficult.
My words are used to that.
Do you want anything?
Where shall I send something?
Rice-wine, meanders, paintings
By your contemporaries?
Or shall I send a kind
Of news of no time
Leaning against the wall
Outside your old house.

The house and the whole moor
Is flying in the mist.

3

I am up. I've washed
The front of my face
And here I stand looking
Out over the top
Half of my bedroom window.
There almost as far
As I can see I see
St Buryan's church tower.
An inch to the left, behind
That dark rise of woods,
Is where you used to lurk.

4

This is only a note
To say I am aware
You are not here. I find
It difficult to go
Beside Housman's star
Lit fences without you.
And nobody will laugh
At my jokes like you.

5

Bryan, I would be obliged
If you would scout things out
For me. Although I am not
Just ready to start out.
I am trying to be better,
Which will make you smile
Under your blue hat.

I know I make a symbol
Of the foxglove on the wall.
It is because it knows you.

THE VOYAGES OF ALFRED WALLIS

Worldhauled, he's grounded on God's great bank,
Keelheaved to Heaven, waved into boatfilled arms,
Falls his homecoming leaving that old sea testament,
Watching the restless land sail rigged alongside
Townful of shallows, gulls on the sailing roofs.
And he's heaved once and for all a high dry packet
Pecked wide by curious years of a ferreting sea,
His poor house blessed by very poverty's religious
Breakwater, his past house hung in foreign galleries.
He's that stone sailor towering out of the cupboarding sea
To watch the black boats rigged by a question quietly
Ghost home and ask right out the jackets of oil
And standing white of the crew "what hellward harbour
Bows down her seawalls to arriving home at last?"

Falls into home his prayerspray. He's there to lie
Seagreat and small, contrary and rare as sand.

Oils overcome and keep his inward voyage.
An Ararat shore, loud limpet stuck to its terror,
Drags home the bible keel from a returning sea
And four black shouting steerers stationed on movement
Call out arrival over the landgreat houseboat.
The ship of land with birds on seven trees
Calls out farewell like Melville talking down on
Nightfall's devoted barque and the parable whale.
What shipcry falls? The holy families of foam
Fall into wilderness and "over the jasper sea".
The gulls wade into silence. What deep seasaint
Whispered this keel out of its element?

ALFRED WALLIS, **Houses and Trees**
(cat.no.21)

ALFRED WALLIS, **This is Sain Fishery That use to be**
(cat.no.26)

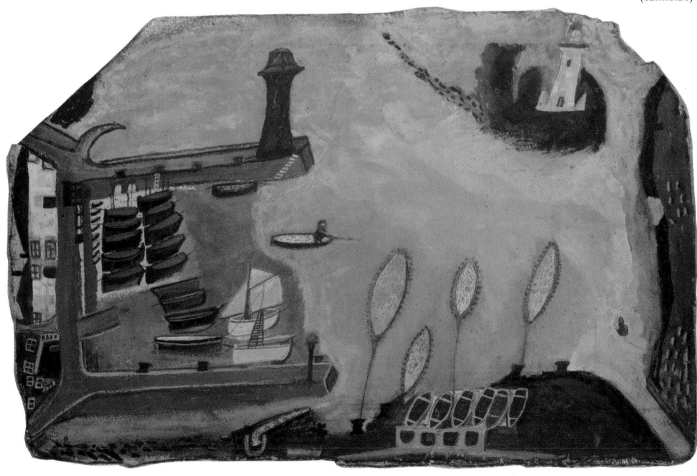

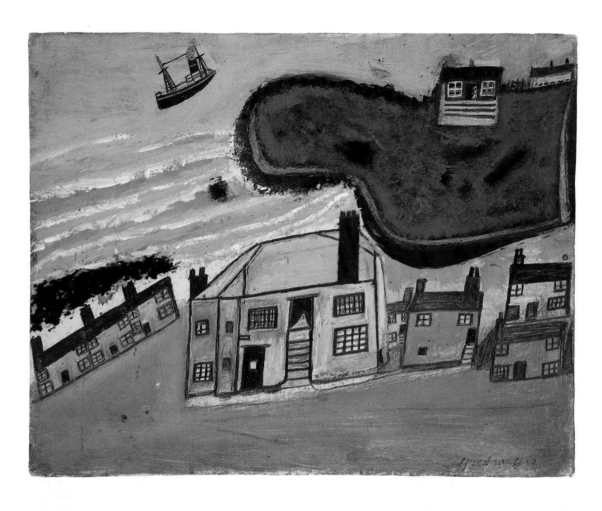

ALFRED WALLIS
**The Hold House Port Mear
Square Island Port Mear
Beach** (cat.no.22)

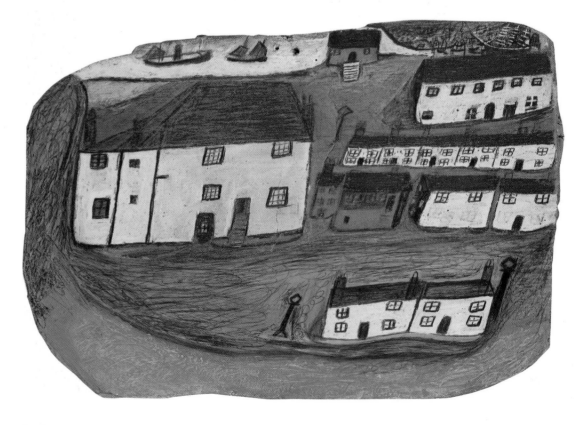

ALFRED WALLIS, **St Ives**
c.1928 (cat.no.12)

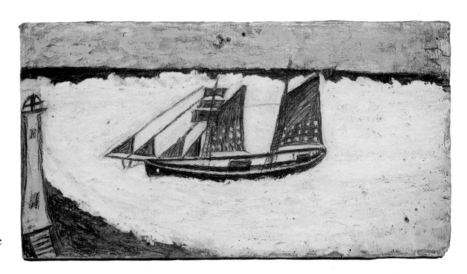

ALFRED WALLIS
Schooner and Lighthouse
c.1925–8 (cat.no.11)

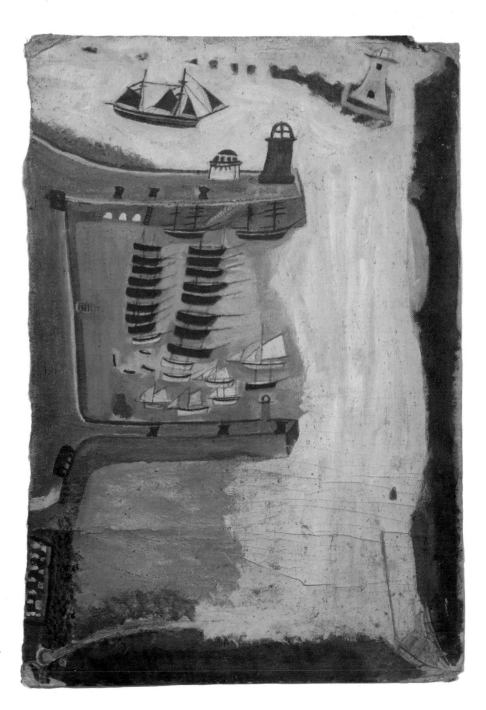

ALFRED WALLIS
**St Ives Harbour, Hayle Bay
and Godrevy and the
Fishing Boats** (cat.no.15)

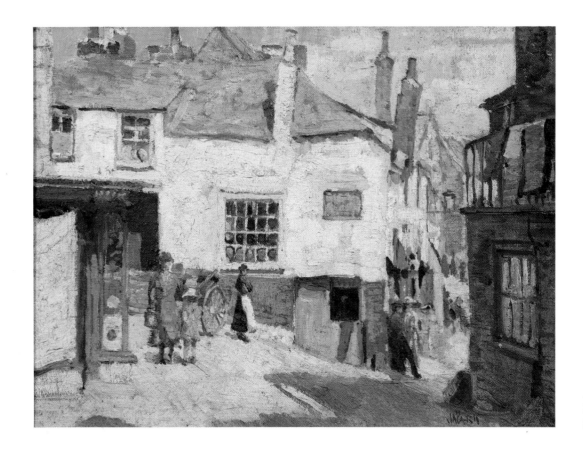

JOHN PARK
**Slipway House, St Ives
(Chy-an-Chy)** *c.*1930 (cat.no.8)

MARY JEWELS
Cornish Landscape
*c.*1940–50 (cat.no.2)

CHRISTOPHER WOOD
Porthmeor Beach 1928 (cat.no.32)

CHRISTOPHER WOOD
The Harbour, Mousehole
1930 (cat.no.37)

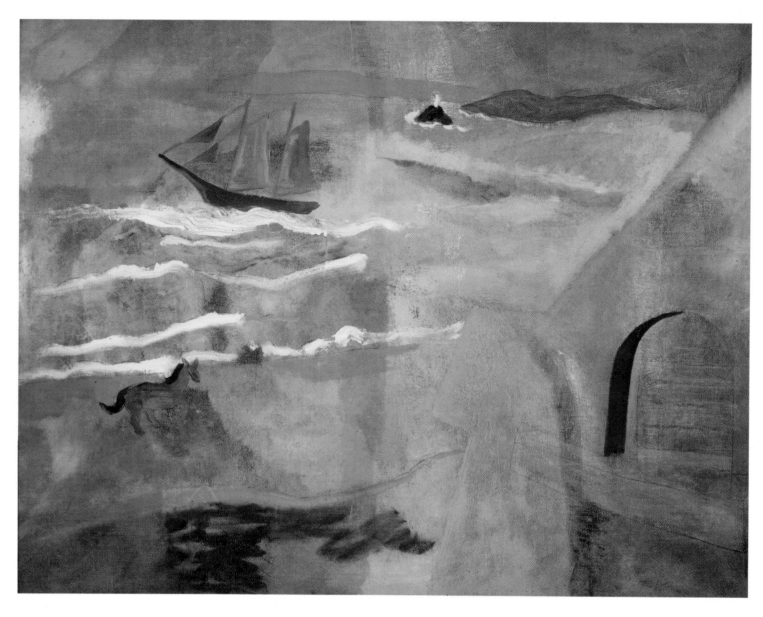

BEN NICHOLSON, **Porthmeor Beach** 1928 (cat.no.4)

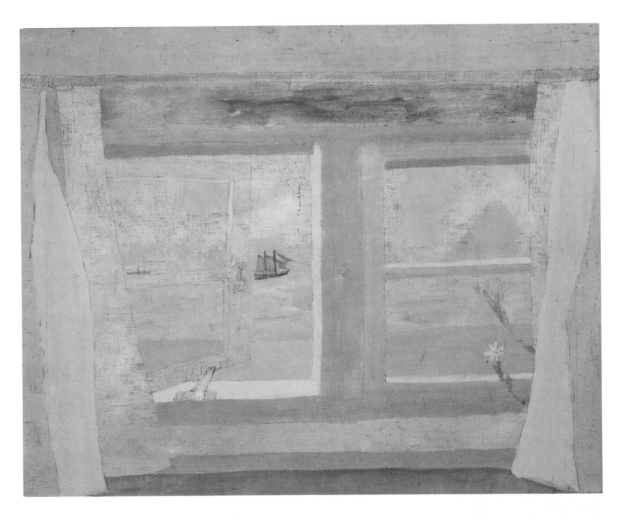

BEN NICHOLSON, **Porthmeor,**
Window looking out to Sea 1930 (cat.no.6)

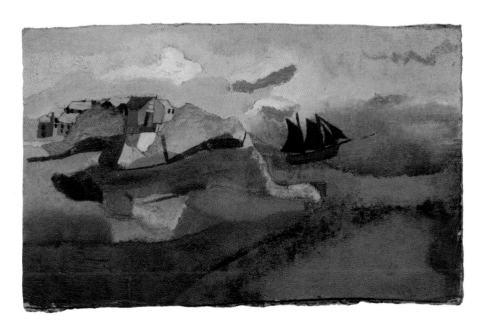

BEN NICHOLSON, **Cornish Port**
*c.*1930 (cat.no.7)

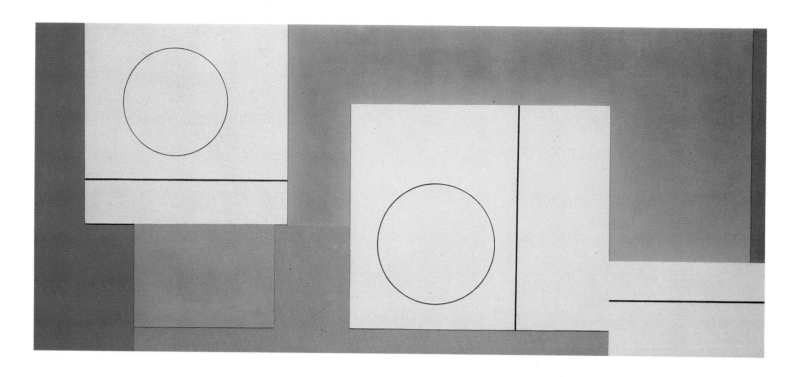

BEN NICHOLSON
1941 (Painted Relief Version 1)
(cat.no.64)

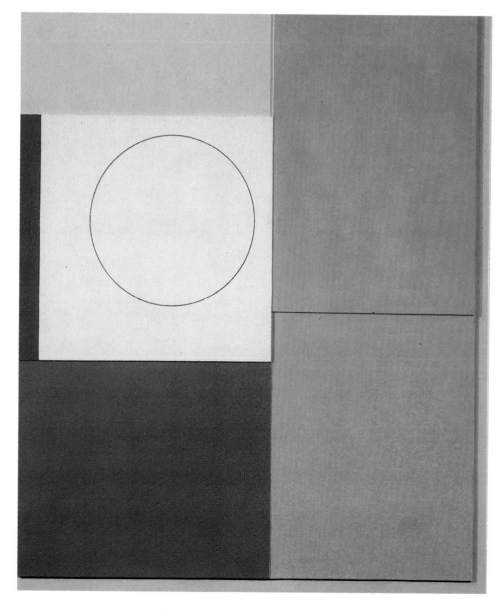

BEN NICHOLSON
**1940 (Painted Relief,
Version 1)** (cat.no.63)

BEN NICHOLSON, **Still Life
and Cornish Landscape**
1944 (cat.no.69)

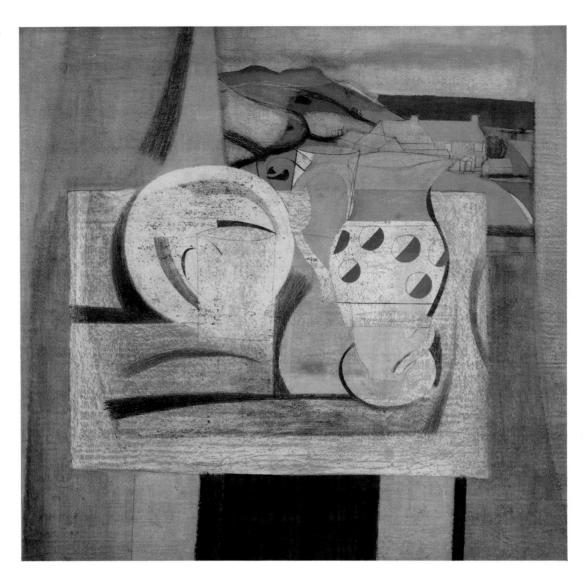

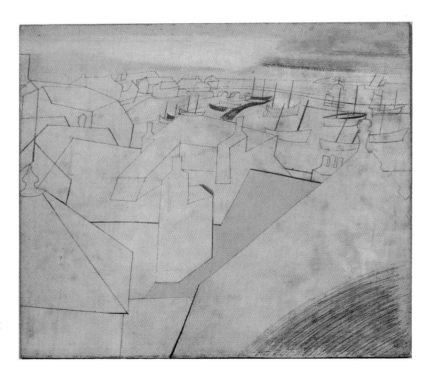

BEN NICHOLSON, **October 20 1951
(St Ives Harbour from Trezion)**
December 1951 (cat.no.92)

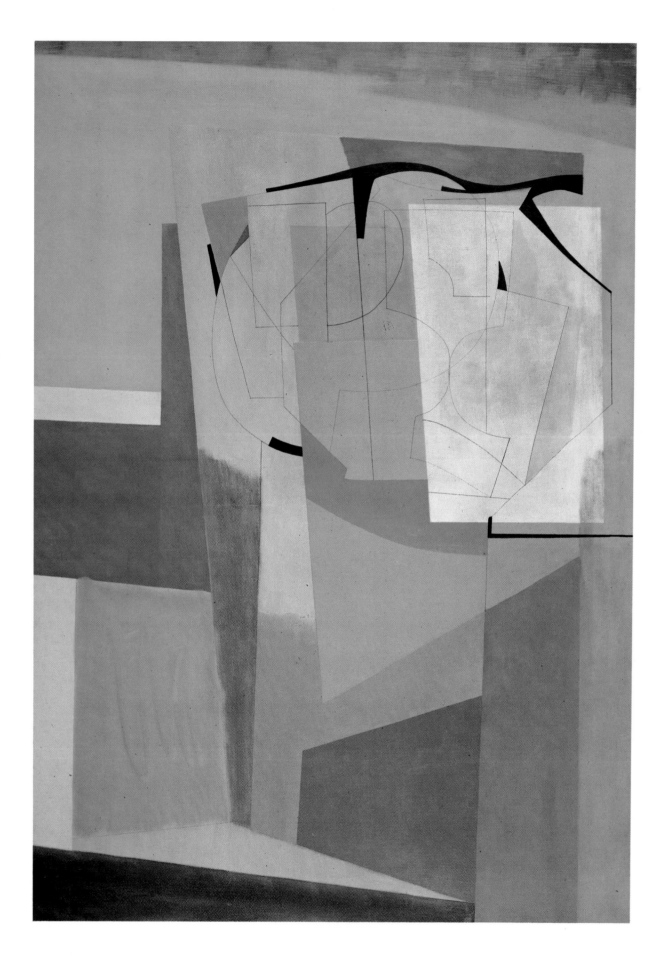

BEN NICHOLSON, **June 4–52** (Tableform)
June 1952 (cat.no.95)

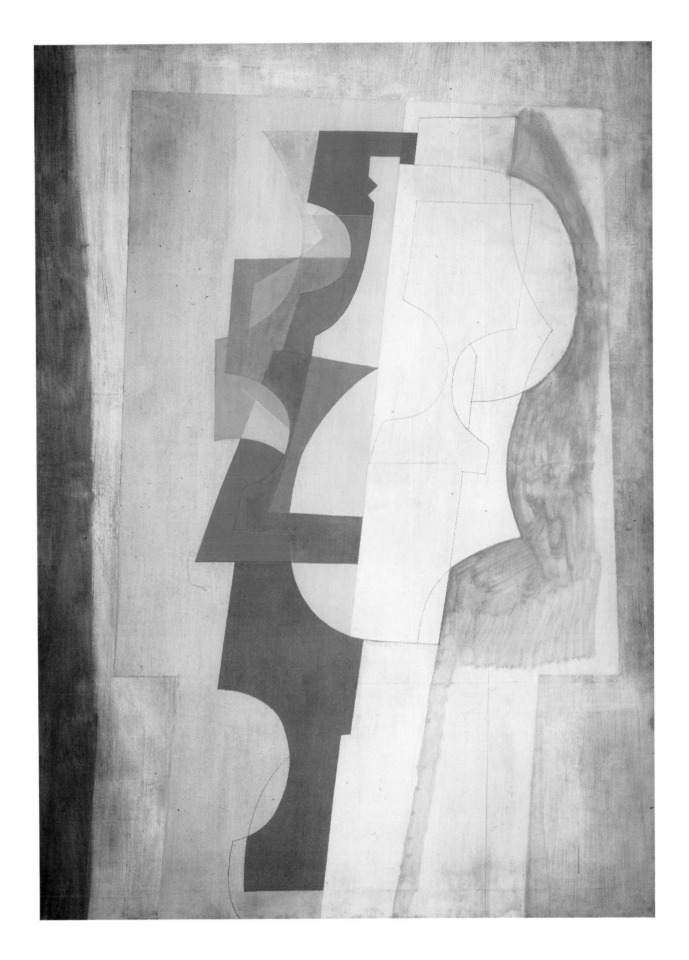

BEN NICHOLSON, **February 1953 (Contrapuntal)**
(cat.no.96)

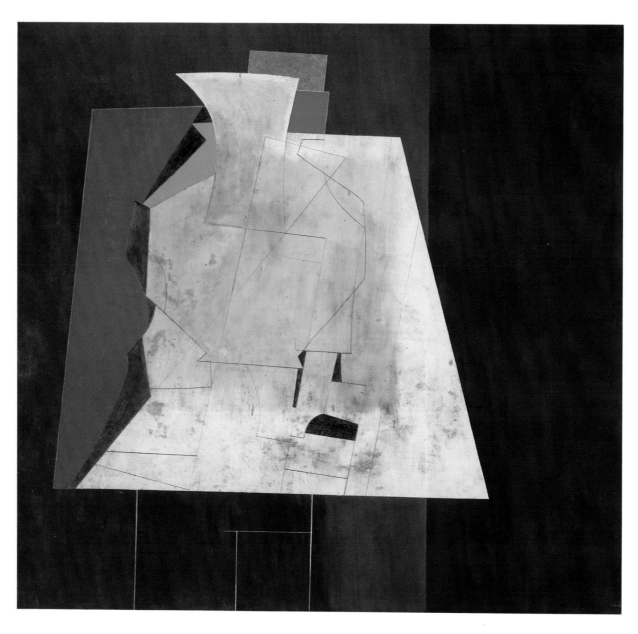

BEN NICHOLSON, **December 1955 (Night Facade)**
December 1955 (cat.no.143)

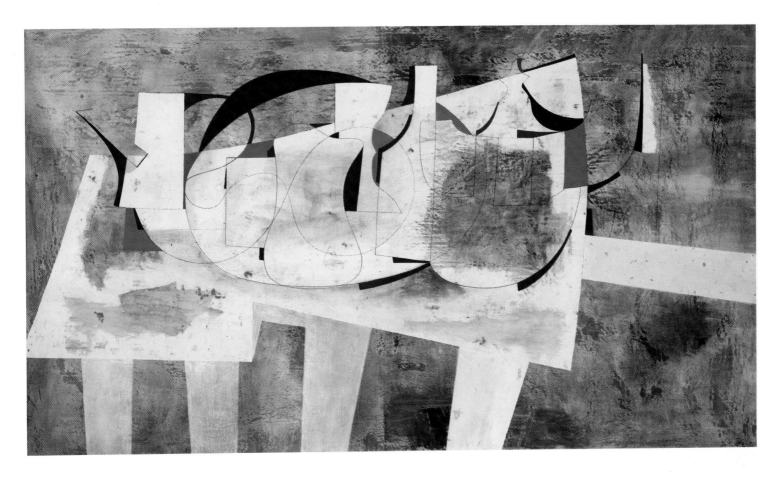

BEN NICHOLSON, **August 56 (Val d'Orcia)**
August 1956 (cat.no.145)

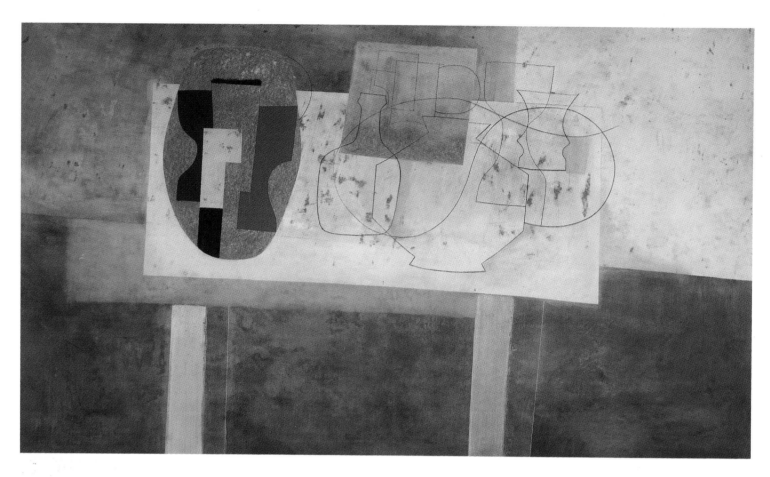

BEN NICHOLSON, **Boutique Fantasque** 1956
(cat.no.144)

NAUM GABO, **Linear Construction in Space No.1**
1944–5 (cat.no.47)

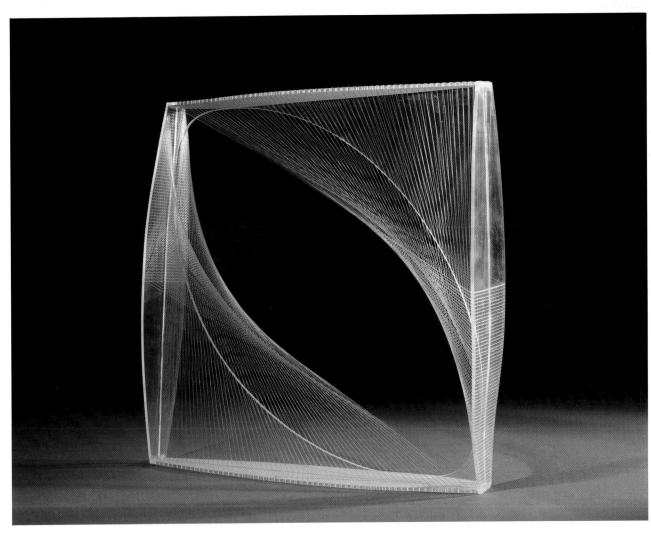

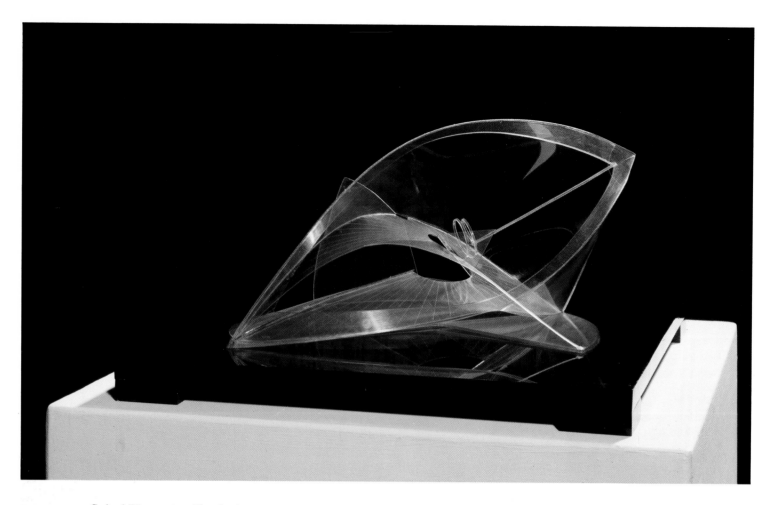

NAUM GABO, **Spiral Theme (1st Version)**
(cat.no.43)

NAUM GABO
Kinetic Oil Painting in Four Movements
1943 (cat.no.45)

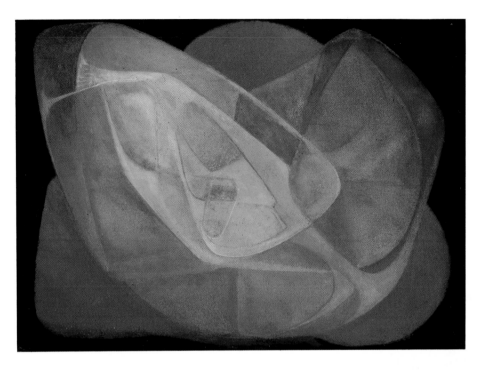

NAUM GABO
Painting: Construction in depths 1944 (cat.no.46)

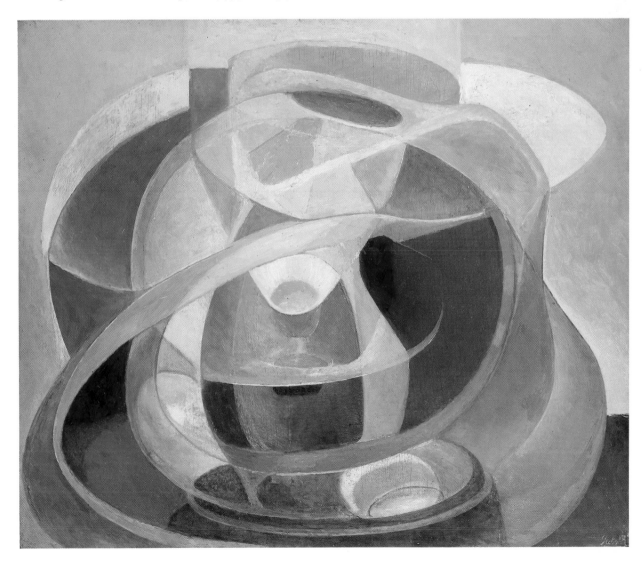

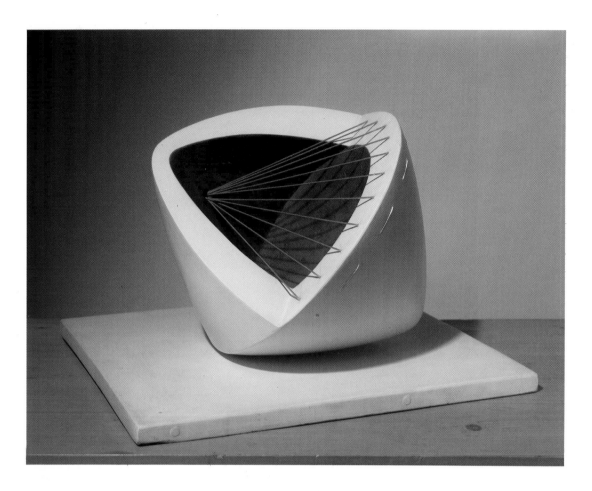

BARBARA HEPWORTH
**Sculpture with Colour,
Deep Blue and Red**
1940–3 (cat.no.50)

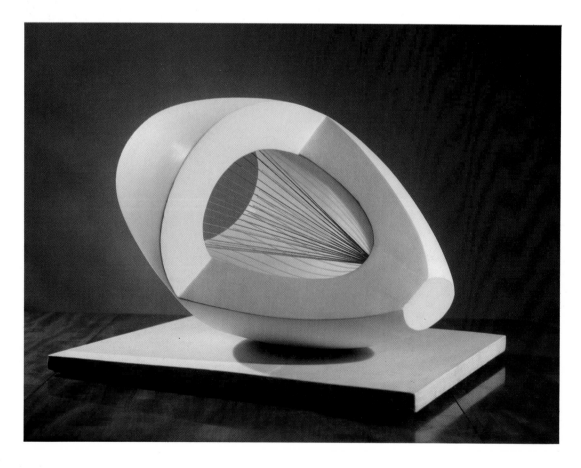

BARBARA HEPWORTH
**Sculpture with Colour (Oval
form), Pale Blue and Red**
1943 (cat.no.54)

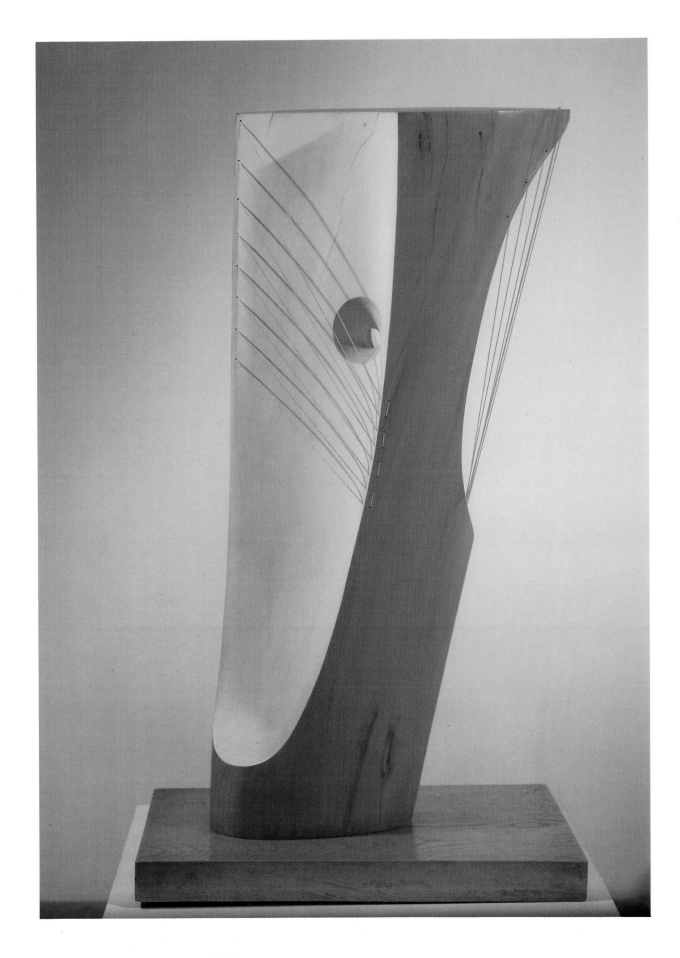

BARBARA HEPWORTH, **Wood and Strings** 1944
(cat.no.56)

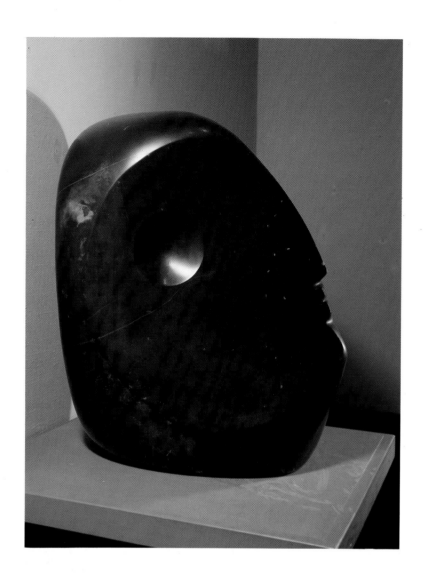

BARBARA HEPWORTH
The Cosdon Head 1949
(cat.no.77)

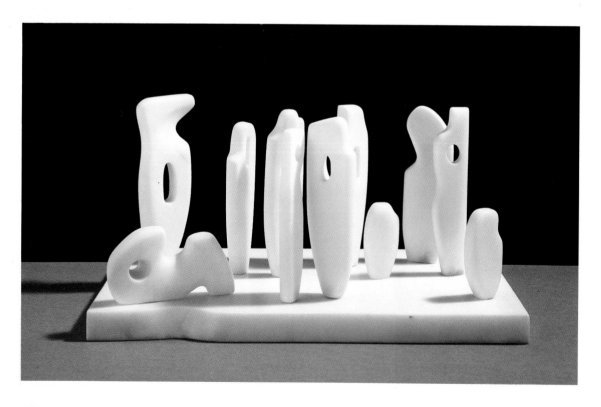

BARBARA HEPWORTH
Group 1 (Concourse)
4 February 1951 (cat.no.79)

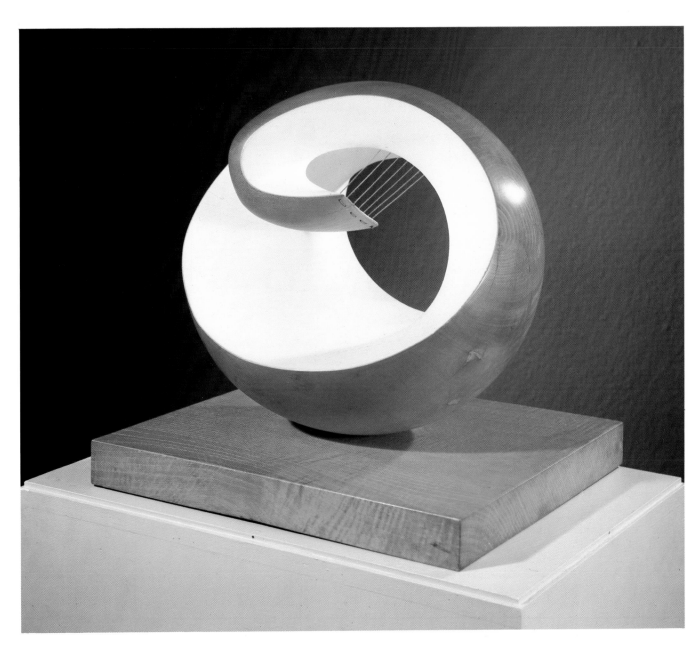

BARBARA HEPWORTH, **Pelagos** 1946
(cat.no.73)

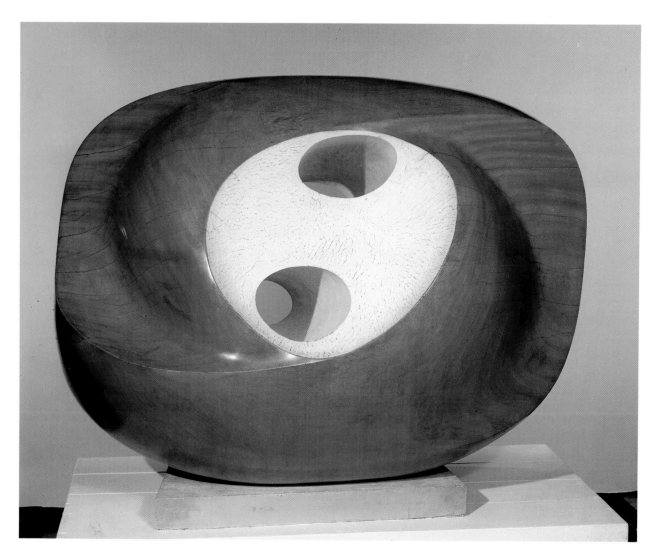

BARBARA HEPWORTH, **Oval Sculpture (Delos)** 1955
(cat.no.133)

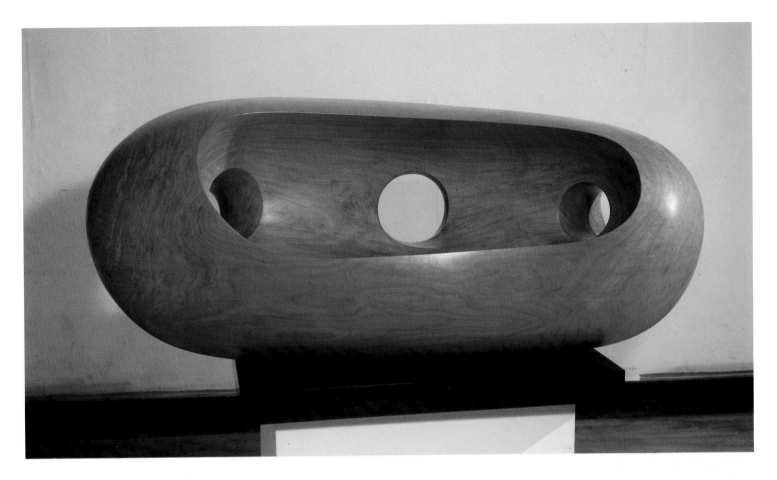

BARBARA HEPWORTH, **River Form** 1965
(cat.no.138)

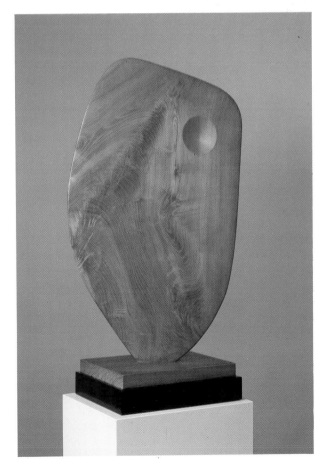

BARBARA HEPWORTH
Single Form (September) 1961
(cat.no.136)

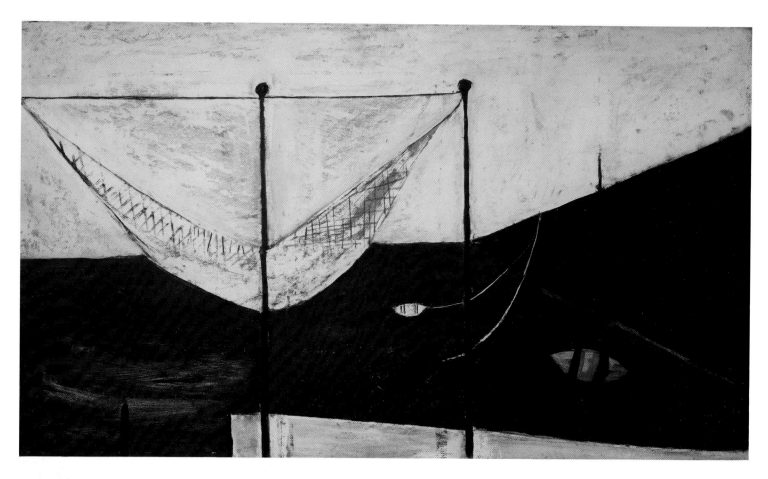

WILLIAM SCOTT, **The Harbour** 1950–1
(cat.no.122)

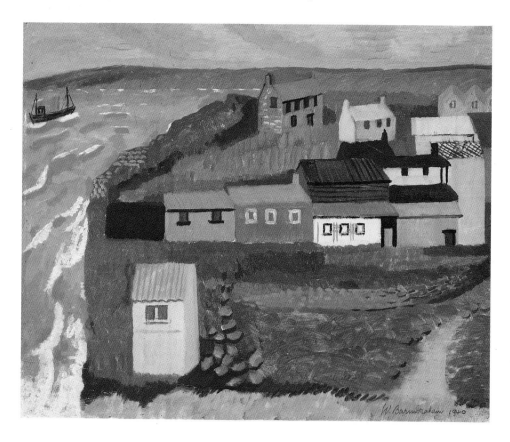

W. BARNS-GRAHAM
Island Sheds, St Ives no.1
(cat.no.39)

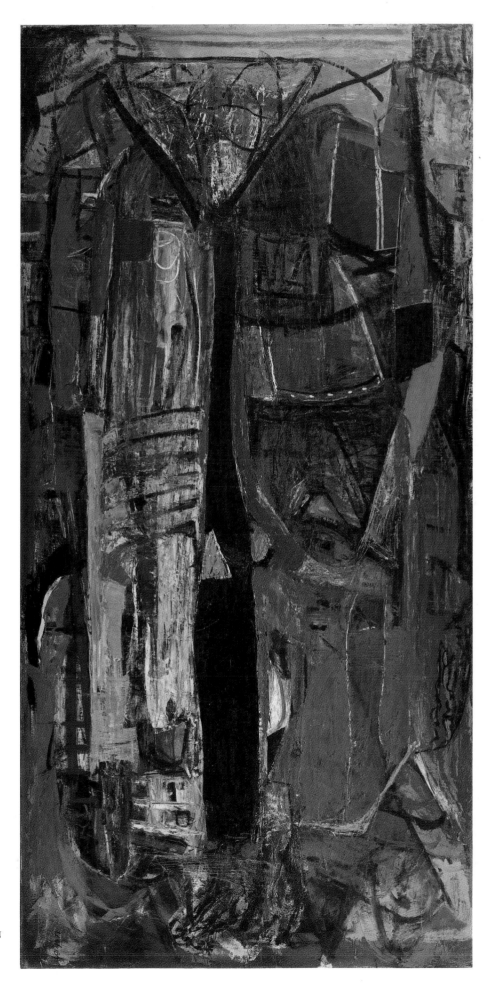

PETER LANYON
St Just 1951
(cat.no.114)

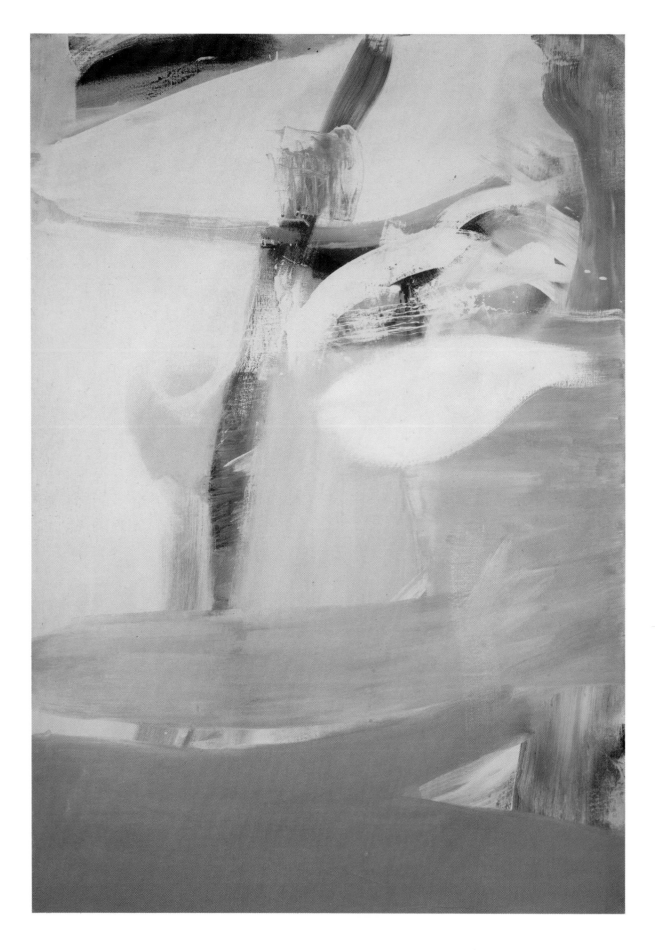

PETER LANYON, **Drift** 1961
(cat.no.155)

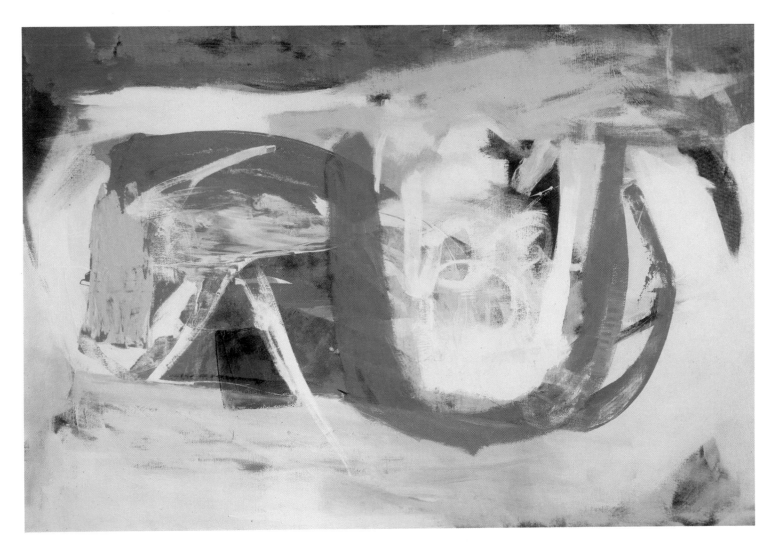

PETER LANYON, **Loe Bar** 1962
(cat.no.156)

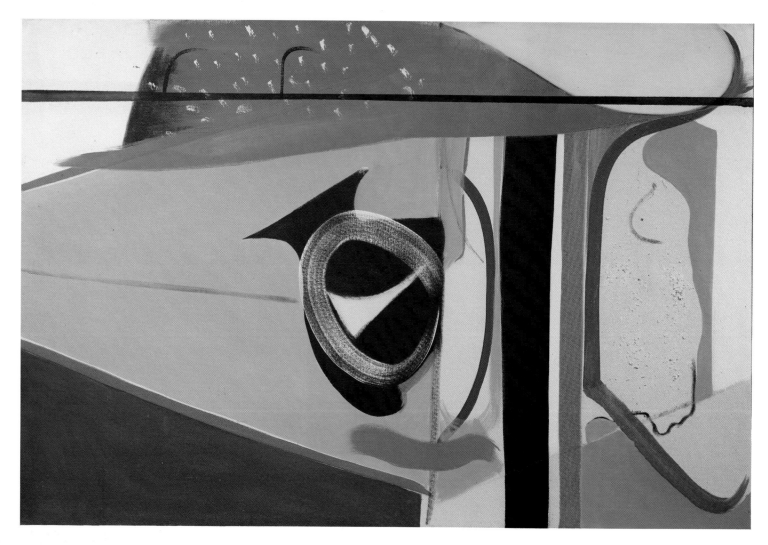

PETER LANYON, **Clevedon Bandstand**
(cat.no.157)

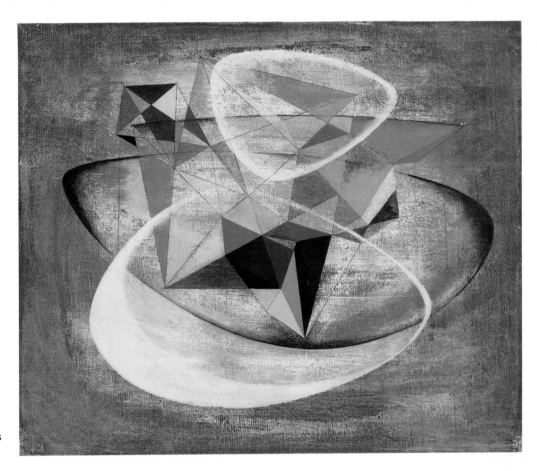

JOHN WELLS, **Crystals and Shells**
1946 (cat.no.124)

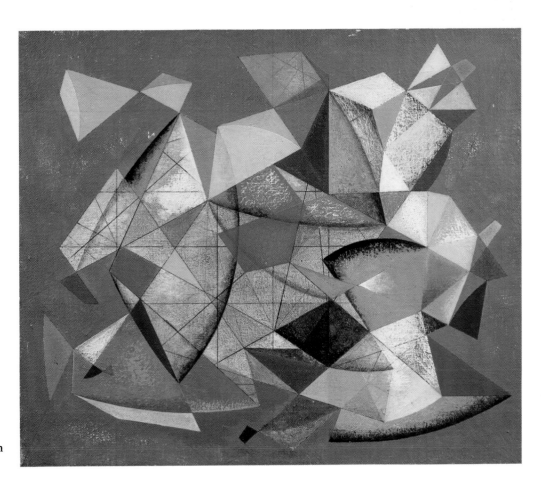

JOHN WELLS, **Music in A Garden**
1947 (cat.no.125)

BRYAN WYNTER, **The Indias** 1956
(cat.no.188)

BRYAN WYNTER, **Firestreak II** 1960
(cat.no.190)

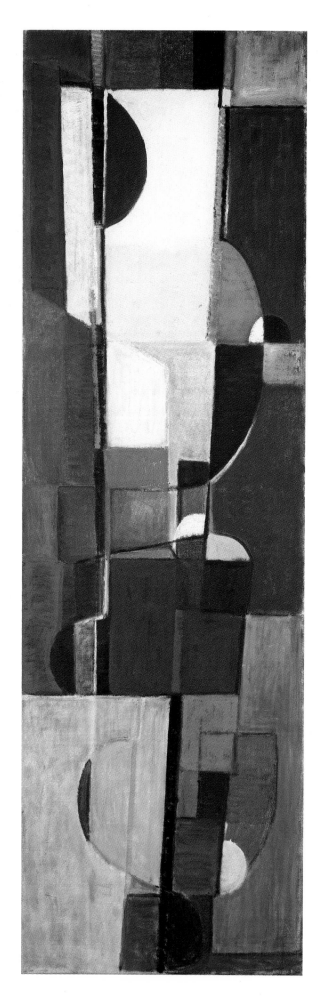

TERRY FROST, **Walk Along the Quay** 1950
(cat.no.99)

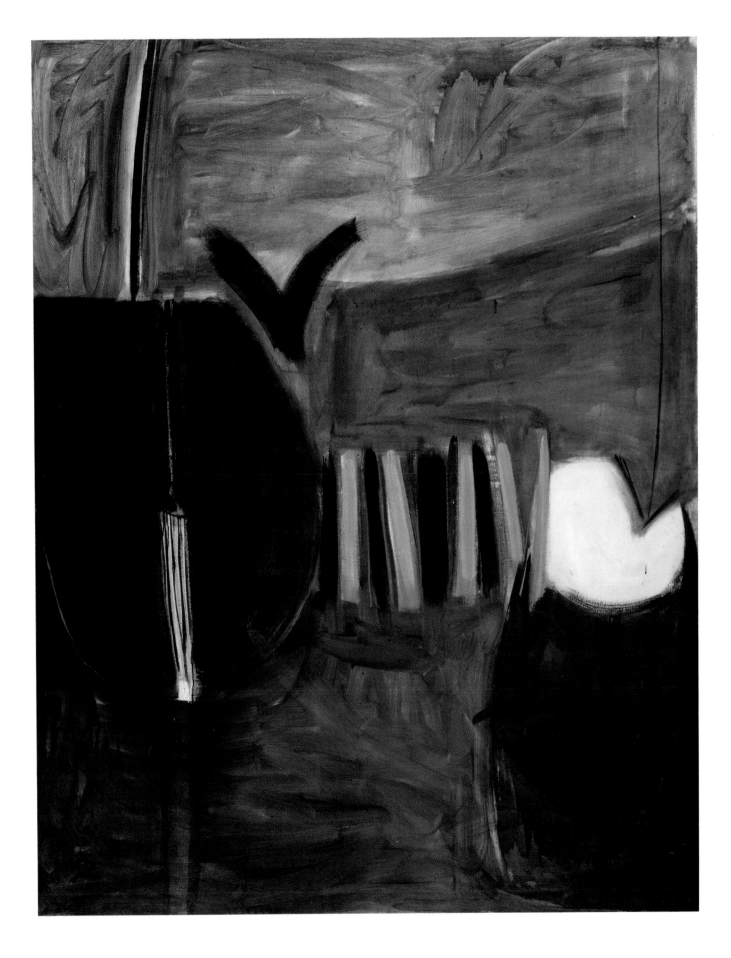

TERRY FROST, **Force 8** October 1960
(cat.no.168)

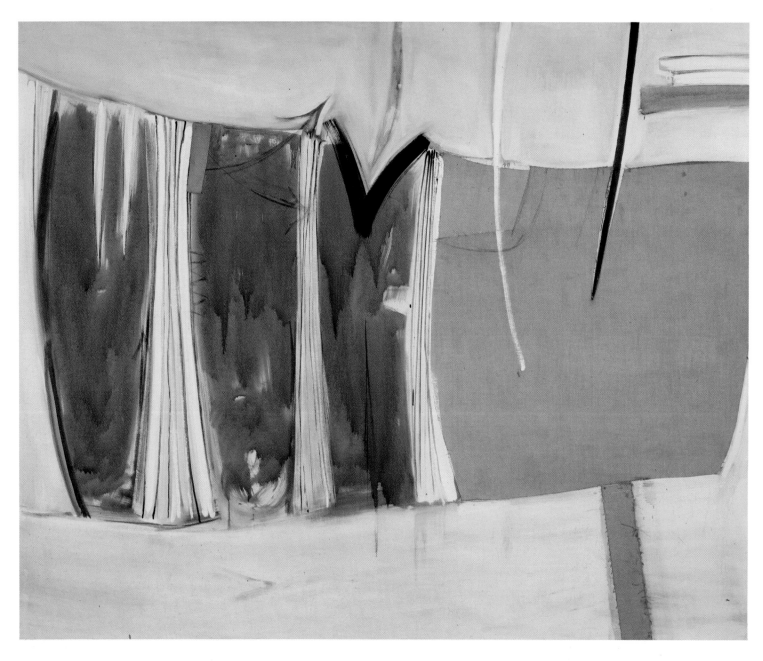

TERRY FROST, **Three Graces** June 1960
(cat.no.167)

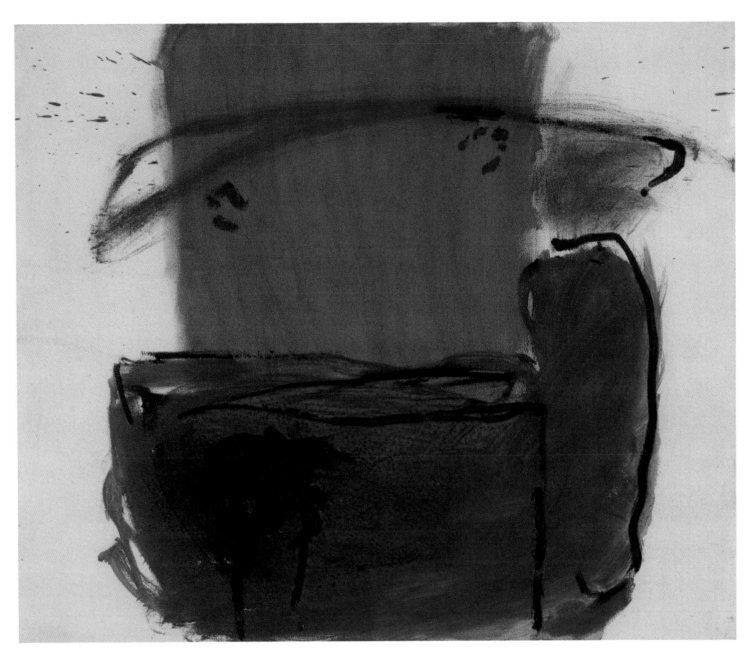

ROGER HILTON, **Blue Newlyn** 1958
(cat.no.202)

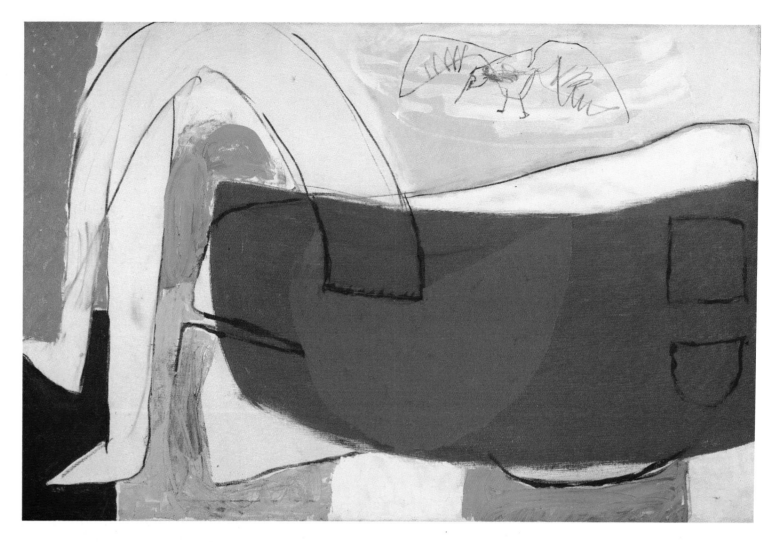

ROGER HILTON, **Figure and Bird** September 1963
(cat.no.212)

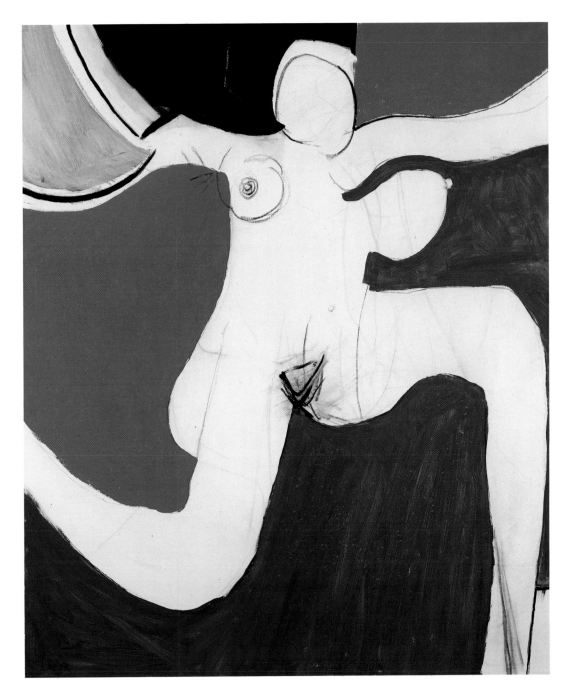

ROGER HILTON, **Oi Yoi Yoi** December 1963
(cat.no.213)

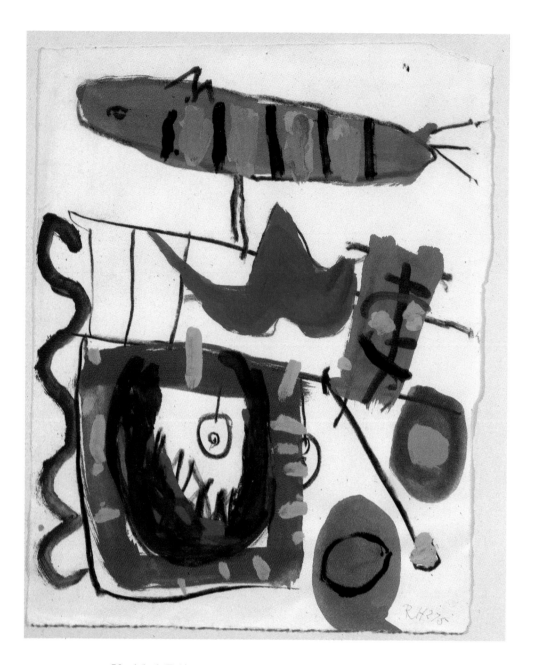

ROGER HILTON, **Untitled** February 1975
(cat.no.224)

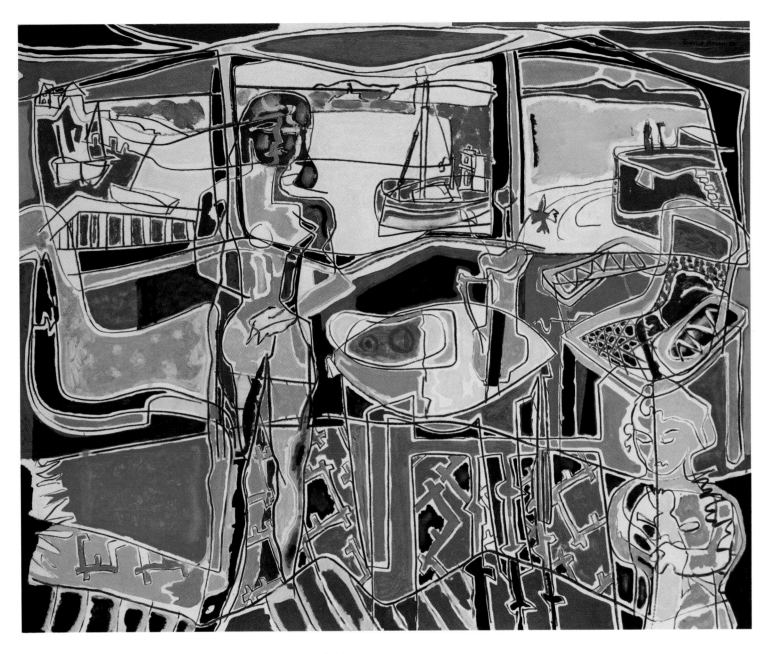

PATRICK HERON, **Harbour Window with Two Figures, St Ives**
July 1950 (cat.no.109)

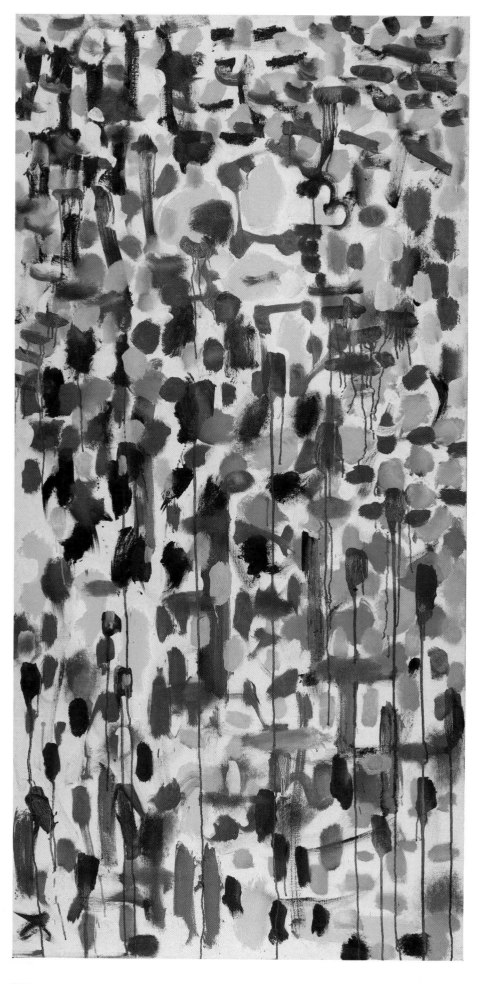

PATRICK HERON
Autumn Garden 1956
(cat.no.192)

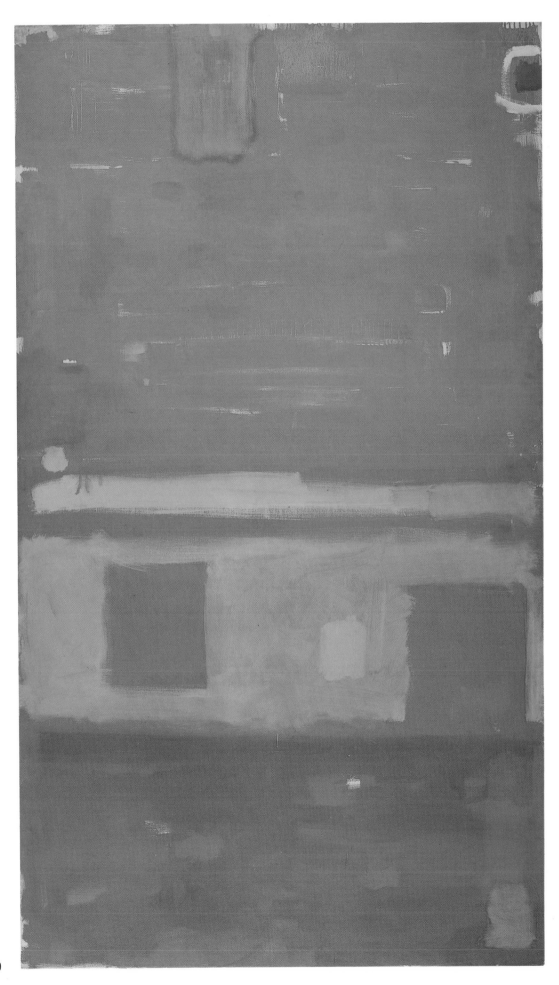

PATRICK HERON
Cadmium Scarlet
January 1958 (cat.no.196)

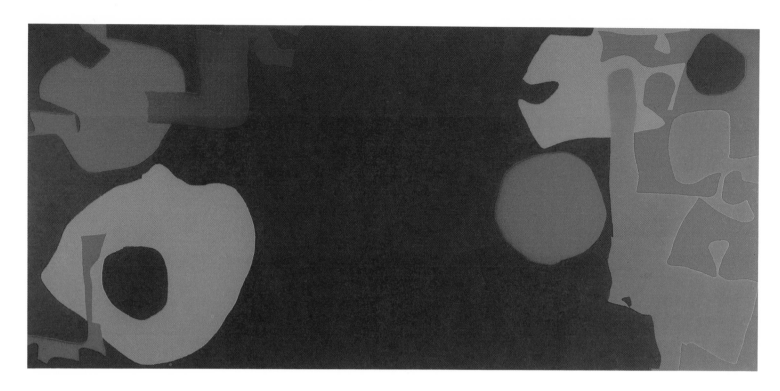

PATRICK HERON, **Big Cobalt Violet** May 1972
(cat.no.217)

KARL WESCHKE, **View of Kenydjack** 1962
(cat.no.185)

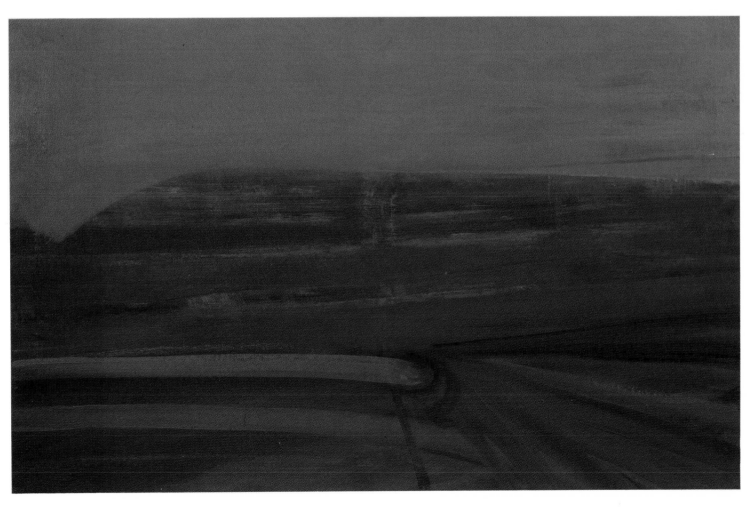

BRYAN PEARCE, **St Ia Church, St Ives** 1971
(cat.no.227)

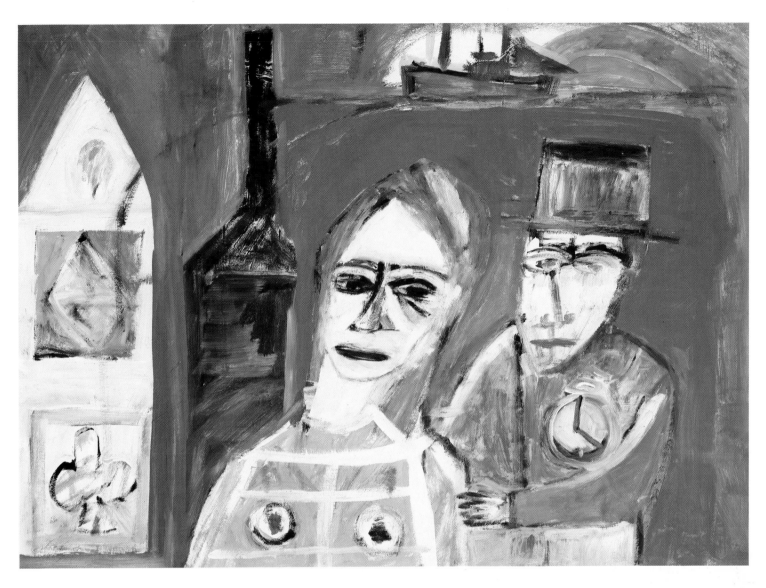

PATRICK HAYMAN, **Tristan and Isolde in Cornwall** 1965
(cat.no.169)

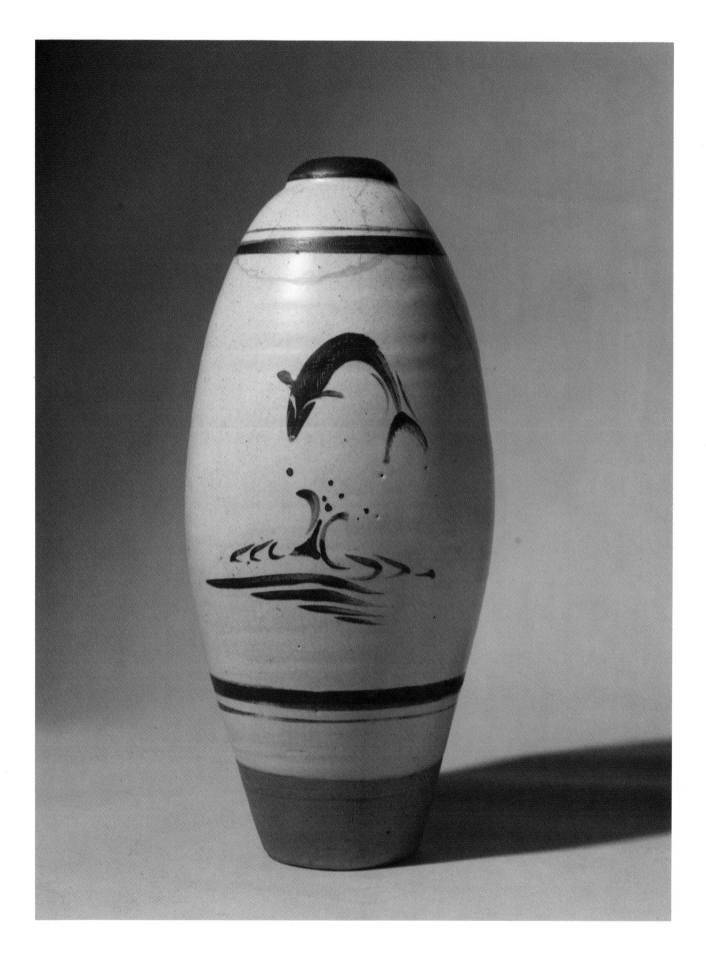

BERNARD LEACH, **Vase**
(cat.no.c3)

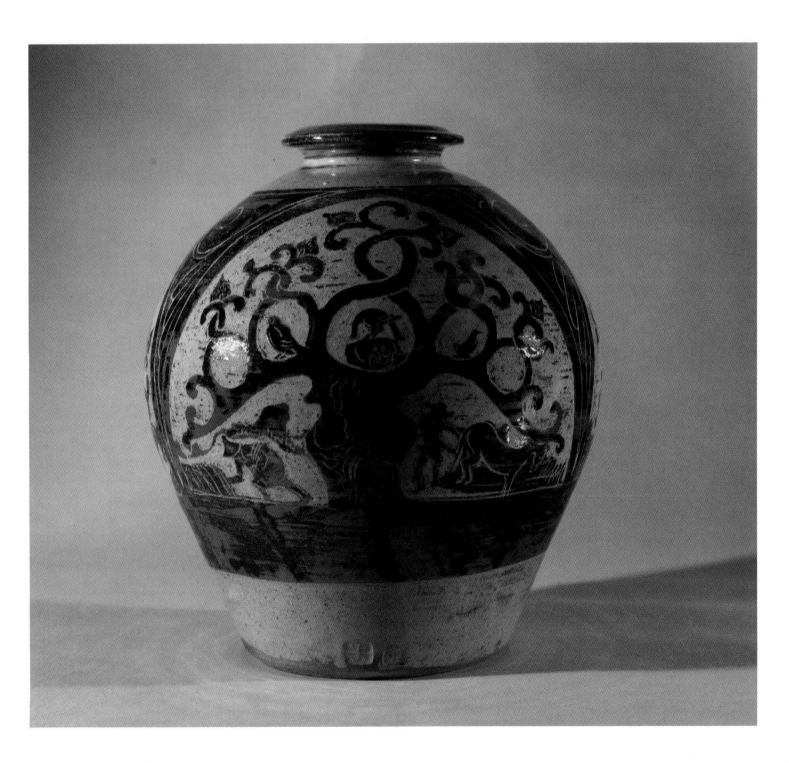

BERNARD LEACH, **Vase with 'Tree of Life' designs**
(cat.no.C5)

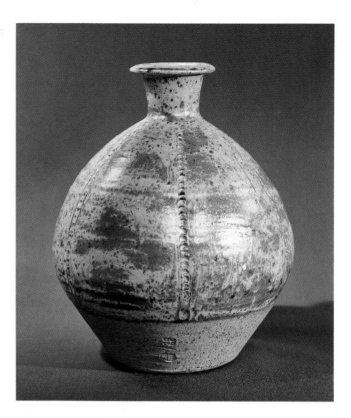

BERNARD LEACH, **Vase**
(cat.no.c6)

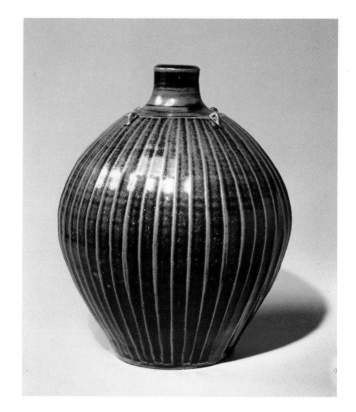

BERNARD LEACH, **Vase**
(cat.no.c7)

JANET LEACH, **Jar**
(cat.no.c35)

JANET LEACH, **Vase**
(cat.no.c36)

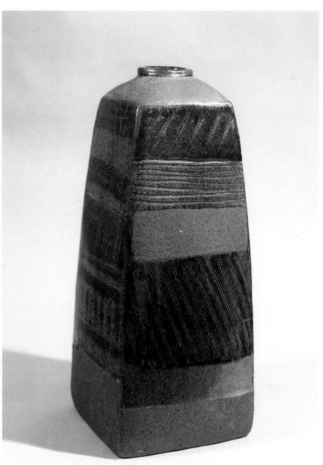

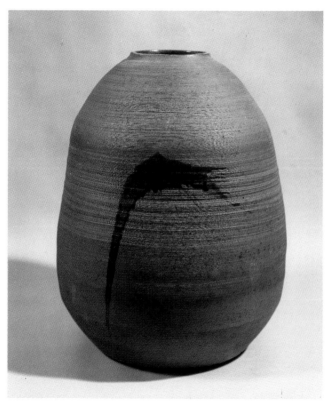

CHRONOLOGY

Throughout this catalogue exhibitions referred to were held in London unless otherwise stated.

1811

J.M.W. Turner visits St Ives during his tour of Devon and Cornwall. Turner makes four drawings of St Ives in sketch book in British Museum ref. TB CXXVA 47, 48, 49, 50 (identified as being of St Ives by Roy Ray, St Ives School of Painting).

1853

Penzance School of Art established. New building erected 1880 (the School was closed in 1984 and the building used for adult education classes).

1860

James Clarke Hook, R.A. (1819–1907) sketches in St Ives.

1876

Railway system extended to Penzance and to St Ives 1877.

1878

Great Western Railway hotel, the Tregenna Castle opens in St Ives.

1882

Walter Langley the first artist to settle in Newlyn (Newlyn to St Ives is about 10 miles). [Langley had visited Newlyn before, as had some of the other artists who later settled. Many artists visited the place for a few weeks or months each year. Stanhope Forbes settled in 1884 and T.C. Gotch in 1886. *See* Caroline Fox and Francis Greenacre, catalogue of exhibition *Artists of the Newlyn School*, Newlyn Art Gallery and tour 1979.]

1883–4

Whistler, Sickert and Mortimer Mempes spend part of the winter in St Ives painting in oil and watercolour.

1885

First artists settle in St Ives and in the next ten years the town is visited by many artists who come to stay for varying periods or to settle. Many studios built by converting sail lofts and cottages, others built for the purpose. [H.H. Robinson 'St Ives as an Art Centre' in *Historical Sketch of St Ives and District* compiled and published by W. Badcock, St Ives 1896. Attention was drawn to this little known and rare publication by an article 'The Art Colony at St Ives' by a St Ives local historian, the late Cyril Noall (1919–1984) (SIT 15.3.57). Robinson's article is reprinted below (almost certainly by the Harewood Robinson mentioned in the text) from the copy of the publication in the Courtney Library, Cyril Noall Bequest, Royal Institution of Cornwall, Truro.]

St Ives as an Art Centre:

> When St. Ives first became a resort for Artists is not known. Probably the Phœnicians, who seem to have been at the bottom of everything in Cornwall, founded an art colony here, and took back with them, with the tin and copper, impressionist sketches of St. Ives Bay and the surrounding country. Suffice it to say, in the way of ancient history, that so long has St. Ives been visited by painters in pursuit of their art, that, to use the old law phrase, "the mind of man runneth not to the contrary. It is of St. Ives as the abode of a continuously residential colony of artists that we would speak, and for that we must go back rather more than ten years.
>
> St. Ives had before then been visited summer after summer by painters of greater or less note, who hailed from London and elsewhere, and who used St. Ives as a temporary sketching ground. The fishermen "down along" have still stories to tell of "Squire" Hook (the Royal Academician, whose seascapes still delight us), of the late Mr. Henry Moore, R.A. (who, alas! painted the last of his blue rolling seas last year), of Mr. Whistler, and many others. Amongst those whose names are well remembered as old frequenters are Mr. R. W. Allan, A.R.W.S.; Mr. W. H. Bartlett, the late Mr. Vernier, a well-known French artist of great talent; Mr. and Mrs. Chadwick (the latter afterwards prominent members of our settled colony, and respectively forerunners of many American and Scandinavian artists, who have chosen St. Ives for a lengthy sojourn). It is to the year 1885 that must be perhaps ascribed the first settlement of St. Ives as an *all the year round* place of abode and work for artists. Newlyn, on the south coast of Cornwall, had for some years been so settled; but, as we have said, St. Ives had theretofore been only a place of sojourn to nomadic painters. The year before a small studio (which has long since gone back to its original state of ruin) had been constructed by the Hon. Duff Tollemach out of a disused and ruinous building at Carn Crowse, and in 1885 Mr and

Mrs. Harewood Robinson and Mr. William Eadie had studios made (in the one case out of an old wooden carpenter's shop, in the other out of an out-house), and settled in St. Ives as winter residents. The following summer a number of painters swooped down on St. Ives with the intention of making it their abode and field of labour. Mr. and Mrs. E. E. Simmons, Mr. Louis Grier (followed by his brother, Mr. E. Wyly Grier), Mr. Howard Russell Butler, Mr. and Mrs. Chadwick, and afterwards, in quick succession, Mr. and Mrs. Adrian Stokes, Mr. and Mrs. Grönvold, Mr. Julius Olsson, Mr. Lowell Dyer, Mr. Zorn (whose picture of St. Ives in the Luxembourg Gallery has contributed no little to the popularity of St. Ives), Miss Scherfbeck, Mr. Blomefield, and Mr. W. H. Y. Titcomb.

Old sail lofts and cottages were sought out, and turned into studios, and large skylights appeared everywhere among the grey roofs of the old town; by the enterprise of the townspeople new studios were built, some of imposing size, and St. Ives took its place as a world-known centre of art work.

For these ten years St. Ives has had and kept a truly cosmopolitan character—painters have resorted to it from all countries, from the United States, Canada, Australia, France, Germany, Austria, Holland, Danemark [sic], Norway, Sweden, and farthest Finland; and pictures painted have carried something of St. Ives into all countries. In all the chief exhibitions of Europe, in our Royal Academy, and Municipal Exhibitions; in the salons of Paris, Berlin, and Munich; in the galleries of America; in Canada, Australia, and New Zealand; in short, everywhere where pictures are to be seen some work is to be found which owes its inspiration to our little Cornish fishing town. Pictures painted in St. Ives have been acquired by the Chantry [sic] Fund for the Nation, by the French Government for the Luxembourg, by the chief English Corporations for Municipal Collections, and by Art Societies for the public galleries of America.

In the year 1887 a small gallery for the exhibition of works by members of the community was, at the instance of the artists, opened by Mr. Lanham. It has since been enlarged and improved. Pictures are selected and hung by a Committee of Artists chosen by the Exhibitors from amongst themselves.

In the year 1888 an Artists Club was formed by Mr. Louis Grier, and met for a year in his studio. In 1890 a permanent club was established, and has a yearly membership list of from seventy to eighty.

It is manifestly impossible to give a list of the artists who have made St. Ives their home. Amongst the many past and present members of the community, or periodically visiting St. Ives, may be mentioned, in addition to those already spoken of, Messrs. Ernest Waterlow, A.R.A., Herbert Marshall, Alfred East, Barlow, Folliot Stokes, Millie Dow, Jameson, Laurence Eastlake, Arnesby Brown, Morris, Talmage, Fuller, Bosch Reitz, Jevons, and Ludby.

1887

Lanham's Galleries open. Extended by 1896. [James Lanham founded a general merchant's business in the High Street, St Ives in 1869, later selling artists' materials. Lanham sold the business 1911 to Benjamin Bramham who in turn sold it 1919 to Martin Cock whose descendants still run a business of selling artist's materials, stationery as well as being wine merchants and estate agents. In 1910 Martin Cock founded the *St Ives Times*. The *St Ives Weekly Summary and Visitors' List* was founded in 1889 by James Uren White and continued publication until 1918. In 1957 the *St Ives Times* took over another St Ives newspaper the *Western Echo*, founded 1899 by W.J. Jacobs, editor 1899–1954, to form the *St Ives Times and Echo*. All these papers form a rich source of information on art and the art community in St Ives and district over the past ninety-six years. *The West Cornwall Arts Review* was also published in St Ives. No copies of this magazine have been traced. It was advertised in W. Badcock's *Historical Sketch of St Ives and District* 1896 where it is stated that: 'This magazine appears on the 1st of every alternate month, and deals chiefly with matters connected with painting, music and literature and contains articles by well known artists and can be had of Mr J.U.White, bookseller, printer, stationer etc, Fore Street, price threepence'. According to Robinson the pictures shown at Lanham's were 'selected and hung by a committee chosen by the exhibitors from among themselves'. This system continued until at least as late as 1927 when the St Ives Society of Artists was formed. Lanham's galleries, two large and one small, were available for hire for exhibitions, mainly of art, both one-man and group shows, until 1970 when they were let off on a long term basis to three artists. The galleries were curated from 1943 for about twenty years by a St Ives painter, Marcella Smith (oral information on James Lanham Ltd by J.M. Cock 26.9.84 and B.S. Hall, 24.10.84).]

1888

St Ives Art Club starts by informal meetings of artists, at first only men, but later including women, at the 'Foc'sle', the studio of Louis Grier. Permanent premises obtained in 1890.
Art Gallery opens in Penzance, next to the Art School; converted into a library after Newlyn Gallery opened.

1890

The *St Ives Weekly Summary and Visitors List* (22.3.90) gives details of paintings by Louis and Wyly Grier to be sent to various exhibitions. The following year (WS 4.4.91 & 11.4.91) the list is extended discussing works by sixteen artists including the Griers, Millie Dow (1848–1919, one of the 'Glasgow Boys'), Julius Olsson, W.H.Y. Titcomb, H.H. Robinson, Adrian and Marianne Stokes. By 1898 artists' studios are open to the public on a Monday in March (WS 26.3.98) and in 1899 that Monday is referred to as 'Show Day' though in later years the day is changed to Thursday, a custom which lasts until after the Second World War, fading out in the 1950s.

1895

22 October: Passmore Edwards Gallery, Newlyn, opens.

1902

22 March – 7 May: Exhibition at Whitechapel Art Gallery (opened 1901) of art produced in West Cornwall including work by the following St Ives artists: Arnesby Brown, Millie Dow, Louis Grier, Moffat Lindner, Fred Milner, Julius Olsson, H. Harewood Robinson, Adrian Stokes, Marianne Stokes, Algernon Talmage and W.H.Y. Titcomb along with paintings from Falmouth, Newlyn and Penzance. Catalogue introduction by Norman Garstin.

1914

November 1914–*c*.November 1920: Frances Hodgkins living in St Ives and occupying No.7 Porthmeor Studios teaching in order to live, paints a conversation piece 'Mr and Mrs Moffat Lindner and Hope' 1916 (Hope was their daughter) (Dunedin Public Art Gallery).

1917

Cedric Morris spends a year in Zennor painting in watercolour, including a portrait of Frances Hodgkins. Early 1919 Cedric Morris and Lett Haines move to Newlyn and stay at first in Newlyn in house of Mrs Tregurtha, Vine Cottage, mother of Mary Jewels (widowed 1918) and her sister Cordelia, wife of Frank Dobson. Morris encourages Mary Jewels to paint. Morris and Haines stay in Newlyn nearly two years until late 1920 and see much of Frances Hodgkins. They make frequent visits to

Cornwall in the twenties. [According to Richard Morphet, catalogue of *Cedric Morris* exhibition Tate Gallery 1984 p.95 note 13 'Cedric and Lett both insisted that Cedric knew Alfred Wallis and his work before his discovery by Nicholson and Wood in 1928'.]

1919

Borlase Smart settles in St Ives.
*c.*1919–26: Marlow Moss living in Cornwall.
*c.*1919 Allan Gwynne-Jones painting at Zennor.

1920

June–December: Matthew Smith living and painting at St Columb Major.
1920–3: Bernard Leach and Shoji Hamada build first Japanese climbing kiln in Europe (see separate chronology on pottery).

*c.*1922

Charles Ginner painting at Porthleven.

*c.*1923–1925

Alfred Wallis starts to paint 'for company' at the age of 68–70.

1925

Cryséde hand printed silk business moves from Newlyn to the Island, St Ives. [Founded by Alec Walker at St Peter's Hill, Newlyn, in the early 1920s Cryséde produced hand printed silk and linen using Walker's designs in brilliant colours. Tom Heron ran the firm from 1925 and moved it to St Ives; Walker continued to create the designs but concentrated more and more on his painting, having an exhibition at the Wertheim Gallery in 1932. Heron left Cryséde in 1929 and went to Welwyn Garden City where he founded a new firm, Cresta, that year.]
*c.*1925–8: Borlase Smart living in Salcombe, Devon. [Smart's obituary (SIT 7.11.47) states that he lived for three years at Salcombe. His exhibit at the RA in 1926 was submitted from Porthmeor, Salcombe and his work shown in 1929 from Ocean Wave Studio, St Ives. The report of Show Day at St Ives 1929 (SIT 22.3.29) mentions Smart '. . . who has recently returned to St Ives'. Residence in Salcombe in 1927 would explain his absence from among the founder members of the St Ives Society of Artists.]

1926

Christopher Wood visits St Ives.

1927

A notice calling a meeting at Lanham's Galleries on 19 January to discuss the possibility of forming a society to advance art in St Ives by mutual co-operation, signed by George Bradshaw, secretary of Lanham's Hanging Committee, published in SIT of 14 January. An article by W.H. Truman on the same page discusses the need to raise the quality of art in St Ives and the status of artists. At the meeting on 19 January it is decided to form such a society.
26 January: Inaugural meeting of the St Ives Society of Artists held at Lanham's Galleries. Founder members include Moffat Lindner, G.F. Bradshaw, Bernard Leach, John Park, Mrs Shearer Armstrong, W.H. Truman, F. Spenlove, and Martin Cock. Society includes artists and lay members who are not practising artists. Moffat Lindner becomes President (until 1946) (SIT 28.1.27).
20 May: Opening at Lanham's Gallery, of St Ives Society of Artists exhibition of forty-one works by artists who have lived or stayed in St Ives. This included Millie Dow, Adrian Stokes R.A., Louis Grier, W.H. Titcomb, Francis Hodgkins (portrait group of Mr & Mrs Moffat Lindner and their daughter), Borlase Smart, Marianne Stokes, Julius Olsson and John Park (SIT 20.5.27).

1928

Spring: The St Ives Society of Artists acquires one of the Porthmeor Studios (?No.5) as a gallery and as headquarters.
16 June: Porthmeor Gallery, St Ives Society of Artists, opened by Julius Olsson R.A. Works included in exhibition by Moffat Lindner, Olsson, Adrian Stokes, Stanhope Forbes, Lamorna Birch, Park, G.F. Bradshaw, Borlase Smart, Ernest and Dod Procter, Alethea Garstin, Shearer Armstrong, Terence Cuneo and W. Arnold Foster (SIT 22.6.28).
August: Ben and Winifred Nicholson stay with Marcus and Irene Brumwell who rent a cottage at Pill Creek, Feock, near Truro. Christopher Wood and John Wells also among the guests. Nicholson and Wood visit St Ives and 'discover' Alfred Wallis for themselves in Back Road West. Nicholson spends three weeks and Wood three months in St Ives.

1930

Denis Mitchell moves from Swansea to Barnoon, St Ives and soon starts painting.

1932

Extended St Ives Society of Artists gallery (nos. 4 and 5 Porthmeor Studios) opens (SIT 27.1.33).

1933

John Tunnard leaves London to live at Cadgwith, near the Lizard.

1936

Dr John Wells takes up medical practice in the Scillies with the intention of saving money for five years so that he can paint full time; he stays until 1945. He had met Nicholson and Wood in 1928 and that summer studied for one month at Stanhope Forbes School in Newlyn.
William Scott visits Cornwall and stays six months at Mousehole.
1936–7: Peter Lanyon studies at Penzance School of Art.

1937

Lanyon meets Adrian Stokes (1902–72, not Adrian Stokes, R.A. (1854–1935) who, with his wife, Marianne, was painting in St Ives in the 1890s and later.) and makes his first abstract work.
After their wedding Stanley Spencer and Patricia Preece together with Preece's companion Dorothy Hepworth spend six weeks in St Ives. He paints six views including one of the harbour.

1938

Leonard Fuller and his wife Marjorie Mostyn settle in St Ives and he opens the St Ives School of Painting on 4 April SITE 3.4.59.
Lanyon spends four months at the Euston Road School.
Paul Nash paints 'Nocturnal Landscape' (Manchester City Art Gallery) in which Men-an-Tol prehistoric remains near Morvah are depicted, although Nash never visited them.

1939

January–July: Adrian Heath attends the Stanhope Forbes painting School at Newlyn.
Lanyon studies at the St Ives School of painting.
3 April: Adrian Stokes and Margaret Mellis move into Little Park Owles, Carbis Bay. Visitors in June include Victor Pasmore and Thelma Hulbert and in August William and Nancy Coldstream.
25 August: Ben Nicholson and Barbara

Hepworth arrive with their triplets, together with a nursemaid and a cook. The Coldstreams return for a few days at the beginning of the war (3 September). Naum and Mirian Gabo arrive by 15 September and within twenty-four hours find and move into a bungalow 'Faerystones', (four rooms plus kitchen with earth floor) near Little Park Owles. [They intended leaving for America, but decided to remain in Britain so Miriam Gabo could be near to her children by her first marriage; the children spent the war years first in Ireland, and later in Canada returning in 1944.] Hepworth has idea of camouflaging the four chimney stacks of a power station at Hayle. Designs made by Coldstream, Mellis, Nicholson and Stokes but all executed by Mellis.

Nicholson and Hepworth, triplets and nurse remain at Little Park Owles until 27 December. [An account of some aspects of life at Little Park Owles at the time and of some of Nicholson's activities, was written by Margaret Mellis in 1977, based on her diaries. An extract is as follows:

'Things settled down to a routine in the crowded house. Ben worked in Adrian's studio, Adrian kept his big room at the sea end of the house where he had his desk and books. Barbara worked in their bedroom where she did drawings because there was not enough room to make sculpture. The triplets and the nurse lived in my studio and I worked in our bedroom. This went on for four months which meant a lot of hard work and organisation. But for me there was the great compensation that Ben took an interest in my paintings and seemed to approve of what I was trying to do. He was very helpful and exhilarating and I began to get on quite well.

'Ben never stopped working and if he wasn't actually painting or making reliefs he was writing letters to people who were interested in the movement. They might show works, buy them or write about them. When he wasn't doing that he was looking round St. Ives for new people who might be interested. He had already begun to work towards what eventually became the Penwith Society in 1949. His aim was always to help people to do good work and get it shown and to stimulate a wider interest in modern art. He enjoyed manoeuvering people and arranging events. For instance at this time Peter Lanyon was finding it hard to know what to do next with his painting. Adrian had persuaded him to go to the Euston Road School in 1938 but this had not suited him. He now suggested that Ben should give him lessons. It was a brilliant idea and gave Peter a great stimulus and he never looked back after that. It suited Ben because he was very hard up. The dual influence of Ben and Gabo who were quite different and yet part of the same movement was very fruitful. After Peter had been working with Ben for some months we all went to his studio to see what he had been doing and were very impressed by the liveliness and variety of his work. I remember particularly his Box Construction made of layers of coloured gelatine sandwiched between glass in front of a painted background. ('Box Construction', 1940 coll. Pier Art Centre, Stromness, Orkney).

'After Christmas, 27 December, Ben and Barbara moved to a small house called Dunluce and this relieved some of the congestion and the tension that seemed to have built up between us by then. Adrian paid the rent and we lent them various household things.']

15th September 1939

. . . I am living in a distant part of England [Cornwall]. This is far away from any of the places threatened by air attack – although I don't perceive any conviction anywhere that the plunderers of the air will not fly in over these fishing villages. But I am not intending to write about what is happening in the field. I shall write and indeed can only write about what I myself see, feel and think. I am one of the millions living in this terrible time. I am only a silhouette against the background of the volcanic conflagrations of history . . .

[Naum Gabo, diary entry for 15 September 1939, ms., Family collection, translated by Dr Christina Lodder who is preparing an English translation of Naum Gabo's diaries for publication and has kindly supplied translations for this catalogue. They are reprinted with the permission of the Gabo family. © Dr Christina Lodder. Dr Lodder's work was made possible by a grant from the Julia A. Whitney Foundation.]

1939–40

Kokoschka spends nine months painting at Polperro.

1940

March: Lanyon joins the Air Force as a flight mechanic; he returns to St Ives on leave on several occasions during the war. While away he lets Gabo use his St Ives studio behind the Lanyon's family residence 'The Red House' Belyars, St Ives. 10 March: Wilhelmina Barns-Graham comes to stay with Margaret Méllis; they had studied together at the Edinburgh College of Art. Barns-Graham decides to stay in St Ives and within a week or two meets Borlase Smart who finds her a studio, No. 3 Porthmeor Studios, normally occupied by George Bradshaw away on war service in the Navy.

April: Alastair Morton comes to stay with Nicholson and Hepworth and they discuss the idea of a war chronicle; later Nicholson and Hepworth find that Gabo is thinking along the same lines and there is some discussion about a war chronicle being published as an issue of *Circle* but the idea is not realised. Morton gets Nicholson and Hepworth each to compile albums of photographs of selected works by them for him. Morton tries to get Nicholson a camouflage job at an I.C.I. factory at Hayle. Nicholson thinks about getting a job in an aircraft factory. Morton later offers to send Hepworth a block of beechwood for carving as she can obtain neither wood nor stone; however because of lack of facilities apart from making a few small plaster maquettes she is restricted to drawing and painting in gouache until 1943 when she begins to carve in wood again.

(Much of the information in the above paragraph is based on letters from Ben Nicholson and Barbara Hepworth. See Scottish National Gallery of Modern Art, Edinburgh, 1978. *Alastair Morton and Edinburgh Weavers.* Exhib. cat. introd. Richard Calvocoressi.)

Hepworth spends most of her time during the war bringing up her children and growing vegetables in her garden. In 1940 Mellis starts to make collages and on 3 October gives birth to a son.

Barns-Graham works in a factory making camouflage for a year during the war but has to give up the work after developing dermatitis.

Stokes starts a market garden and is helped by Sven Berlin, a conscientious objector, who later renounces his pacifist stance after seeing a convoy bombed by German aircraft and joins the army in 1942. Stokes and Leach join the Home Guard as privates, Mitchell is a corporal, Leonard Fuller is captain in charge, and Borlase Smart intelligence officer. Nicholson and Gabo become air raid wardens in Carbis Bay, with Shearer Armstrong in charge. Nicholson begins to paint pictures with landscape motifs, as well as abstracts. Wells meets Gabo through Nicholson.

Visitors during the war years include Margaret Gardiner and Desmond Bernal, Solly Zuckerman, Arthur Duckworth (in the Army), Joan Robinson (Cambridge economist, friend of Margaret Gardiner), Hepworth's sister Elizabeth and her husband John Summerson, Anne Mellis, Ashley Havinden, E.H. Ramsden and Margot Eates, Herbert Read, Stephen and Natasha Spender and Michael Ventris

(Gabo's godson), Jim Ede, John Skeaping, Cyril Connolly, Rayner Heppenstall, Helen Sutherland and Peter Gregory. (Information Miriam Gabo 12.3.84, W. Barns-Graham 1.11.84 and Margaret Mellis 1.11.84).

From Naum Gabo's diaries:

> 7th February 1940
> . . . Something is happening to me which I do not understand. This is the third month now that I have not been able to work. There are lots of works in my head. It isn't apathy, or laziness, or any lack of interest. It is something different which I am unable, as yet, to define. It is like a sack pressing against me which does not allow me to move. I sit for whole days and evenings and I sleep while still awake. I do not dream but in my head there is a continual flow of images from the past, of past events, sights, and thoughts which have at some time been in my mind, and all this is carried past, very quickly, like telegraph poles from the window of a train.

> 15th June 1940
> . . . We go to bed early while it is still light so that we do not have to black out the windows, before switching out the light and making our mood even blacker. Meanwhile one looks at the sea (for the past few days it has been especially calm, especially blue and especially endearing). It lies stark naked between my window and the horizon and captivates one by its simplicity. The heart suffers looking at it and the contrast with what is happening in the world. One looks and thinks how many more days or weeks will this peace last on this little plot of land?

> 6th July 1940
> . . . Our life on this island, in this last fortress of the old Europe, gradually enters into the framework of a state of siege. The daily raids and the sound of the siren have become commonplace . . . We are waiting for the invasion; bombings, parachutists, and very probably fighting . . .
>
> . . . My position is not one of the happiest. As a foreigner I am registered and do not have the right to go anywhere without permission. I do not even have the right to defend this island together with my comrades.
>
> . . . It would be better to leave here if we could get a visa for America. We are waiting for a reply; and although crossing the ocean is dangerous, here there is no less danger.

> 28th July 1940
> . . . When I informed my friends a few days ago about my intention [to move to America] they made a fuss: I should acknowledge myself to be conquered if I left Europe and then the whole constructive idea would come to naught . . . I must remain at my post and move into an area of activity, appropriate to the moment, etc . . .
>
> 'All this is because they are still not strong in themselves and still need a leader, but mainly it is because they have not had the same

experiences as I have had during the last quarter of a century. They stand on the threshold and see the future in the bright light of constructive ideas – but I know how slow and how painful the processes of history can be. I do not foresee the triumph of the constructive idea in the near future. Perhaps it will not be our lot to see this triumph in our lifetime . . .

> 8th September 1940
> . . . We spent an uneasy night. Last night's radio broadcast informed us that a large number of German planes had broken through to London and had successfully bombed the city and the docks . . .
>
> . . . During the night Adrian [Stokes] (who is in the home guard) was called to his post. Everything is ready for an attack, apparently a German landing is expected . . .

> 9th September 1940
> A nightmarish rumour has reached me. The local home guard has been on the alert for two days. My friends Ben [Nicholson] and Adrian [Stokes] are not sleeping at night and today they told me that in military circles there are rumours that the Germans have landed a force, that they have dropped parachutists somewhere on the South East Coast, and what is worst of all that they are using poisonous gases against which the government is not ready to equip the population with special masks . . .

> 10 September 1940
> . . . I realise, that in my heart I am definitely against the idea of America.

> 15th October 1940
> . . . And so we have stayed to pass the winter here. I am pleased that I have finally made this decision. I shall work this winter. I must prepare an exhibition. I hope that fate will give me the necessary spiritual calm . . .

1941

From Naum Gabo's diaries

> 22nd April 1941
> . . . Yesterday taking down the shutters before going to bed I saw the sky glowing. Plymouth was burning. It is about 100–120 kilometres from us yet the glow was enormous and explosions of the bombs and the red rockets of the defending guns were all visible.
>
> The Night attack made itself felt through these strange lights . . .
>
> I observed these hellish fireworks for a long time but I didn't wait for the end. I went to sleep trying to forget what I had seen, trying not to think or imagine what was happening to the people under those lights in that blazing and bombarded city . . .

> 10th May 1941
> . . . There was a full moon and it was very light. At eleven o'clock a mobile detachment of Huns arrived and buzzed overhead like wasps. Then came the explosions. Our house shook, the windows rang . . .

1941: Leach Pottery hit by a German land mine.

1942

12 March: On Show Day paintings by Barns-Graham on view in her studio (SIT 20.3.42)

18 March–9 May: *New Movements in Art: Contemporary Work in England* exhibition, London Museum, Lancaster House, organised by E.H. Ramsden. Includes two reliefs by Wells, two collages by Mellis and other works by Gabo, Hepworth, Lanyon, Mondrian and Nicholson. Nicholson plays some part in their selection.

Barns-Graham shows in St Ives Society of Artists Summer exhibition.

From Naum Gabo's diaries:

> 23rd May 1942
> . . . The first thing to which I can draw attention with some justification as being of relative importance is the fact that . . .
>
> I have made one new construction, ['Spiral Theme' 1941–2, Coll. Tate Gallery;] and have shown it, together with some other earlier constructions to the London public at the London Museum. To my complete surprise this object has produced, what I would describe as, a tremendous effect on the mass of visitors (there were about 10,000), as well as on the small number of critics from magazines and newspapers who have been impervious to my ideas until now. It is still a mystery and puzzle to me what precisely it is in this, my latest work, that has moved their hearts. As the creator of this work, I personally don't consider that its content is substantially richer or more forceful than that of the other two constructions which I made three years ago and exhibited with this piece. Truthfully speaking the theme of this piece was worked out by me at the same time, if not earlier, than these two other constructions (of 1937 and 1939). ['Construction on a Line in Space' and 'Construction in Space' respectively]. Using the psychological calm which has resulted from an encouraging turning point in the course of the war I have devoted myself to the execution of this piece and have created it in every detail within these last three months. Why is it that it is precisely this spiral construction that has hit the nail on the head and not the other two which I still consider no less successful? Probably I'll never be able to explain this.

June: Graham Sutherland goes to West Penwith to make sketches of miners and the underground workings of Geevor tin mine, Pendeen, near St Just, for the War Artists Advisory Committee. Between June and December Sutherland divides his time between Cornwall, making sketches, and his home in Trottiscliffe, Kent, making finished drawings. While in Cornwall stayed with friends, E.B. Hoyton and his wife, Enid, and through them met Nicholson, Hepworth, Gabo, Stokes and Mellis.

29 August: Death of Alfred Wallis in Madron workhouse. He is buried in St Ives cemetery and Bernard Leach makes a ceramic plaque for his grave.
September: Nicholson and Hepworth move from 'Dunluce' to 'Chy-an-Kerris' at the far end of Carbis Bay away from St Ives.

1943

January: Articles on Alfred Wallis by Sven Berlin and Ben Nicholson published in *Horizon* (respectively pp.41–50 and 50–54). Work by Nicholson, Hepworth, Lanyon and Wells reproduced in 'English Abstract Painting' in *Partisan Review* May/June issue.
March: Gabo accepts proposal from Herbert Read to design a car exterior. Design accepted in May. Gabo visits Jowitt car factory in Bradford in September (letters in Gabo Archive, Beinecke Library, Yale University Library.) In later years Gabo designs doorknobs, bathroom fittings and coat hangers for the SS. Queen Elizabeth.
Smart asks Barns-Graham to introduce him to Nicholson and Hepworth as he is keen for them to exhibit with the St Ives Society of Artists. Barns-Graham telephones Nicholson to introduce him.
[In a letter (8.10.84) Barns-Graham recalled the event:

'Borlase Smart was an academic painter and it is to his credit in these last years of his life he had an ever increasing open mind, tremendously energetic and busy devoting himself to widen the society with "new blood" and arranging travelling exhibitions at home and abroad.

'After many talks together, [with Barns-Graham] Borlase thought it deplorable having artists living in the area of the calibre of Ben Nicholson and Barbara Hepworth not exhibiting in the St. Ives Society of Artists, and knowing I knew them, and he had got hold of a catalogue about them, asked for help. He was primarily an *enthusiast* and this is the word I used when preparing the way for Borlase with my telephone call to Ben Nicholson, himself an enthusiast and a feeling for people he'd call "very alive".

'Borlase immediately followed up this introduction and returned to my studio with his success. B.N. and B.H. had agreed to exhibit in the gallery! He later came in for some harsh criticism from his colleagues for "bringing in the moderns with their rubbish"! He was quite undaunted, passionate for knowledge – eager to learn, for sharing and understanding of art, however much in contrast to his own work.

'Only a matter of weeks and days before his last illness 1947, with me sitting at his feet at

St. Christophers guest house, where he was a frequent visitor and I was a resident, he excitedly announced to me, hissing his S's as was his manner of speech, he said "I have just done my *firsst besst* painting"! He was 65!']

1944

January 1944–April 1945: Patrick Heron working in the Leach pottery. He meets and makes friends with Nicholson, Hepworth, Gabo, Stokes, Mellis, Wells and Berlin.
15 February: Borlase Smart invites Gabo to join the St Ives Society of Artists. Also invites Gabo and Miriam Gabo to show work in Smart's studio on Show Day, 2 March, Gabo replies, 5 March, declining invitation as he has always refrained from joining groups of artists. However, Miriam Gabo joins the Society. (Letters in Gabo Archive, Beinecke Library, Yale University Library).
2 March: On Show Day paintings by Ben Nicholson shown along with those by Borlase Smart in Smart's studio, No.1 Porthmeor Studios (SIT 10.3.44 The writer of the article was moved to remark: 'In the same studio, in astounding contrast, Ben Nicholson exhibits a group of geometrical designs for which he is famous. This innovation of modern art was a surprise to many visitors'.)
Spring: St Ives Society of Artists Exhibition includes work by new members, Ben Nicholson and Miss Miriam Israels (Mrs Miriam Gabo) (SIT 7.4.44).
Summer: St Ives Society of Artists exhibition includes 'Painting (oil) 1939' (24, £45) and 'Painting (gouache) 1943' (25, £27) by Ben Nicholson and 'Landscape, Donegal' (122, Not for sale) and 'Flowerpiece' (125, Not for sale) by Miriam Israels, as well as works by Barns-Graham and Lanyon. (According to Miriam Gabo, 26.11.84, her two paintings were in oil).
Gabo joins the Design Research Unit set up in 1943 with Herbert Read in charge.
Scottish poet W.S. (Sydney) Graham and his wife Nessie Dunsmuir go to live in two caravans and a shed at Germoe, near Praa Sands, S.E. of Marazion. Visited by Nicholson who takes Graham to St Ives to meet Hepworth. In 1944 or 1945 Graham visited by Robert Colquhoun and Robert McBryde and on another occasion by John Minton and in late 1945 by Bryan Wynter. Grahams move to Mevagissey 1946. Graham goes to teach in New York for a year 1947–8. Grahams finally leave

Mevagissey 1949. They return to Cornwall December 1955, living at Old Coastguard Cottages, Gurnard's Head from March 1956. Later living at Gulval and then Madron. (Information Nessie Dunsmuir, October 1984)
Graham's poem 'The Night Fishing' is based on his fishing experiences in Scotland and Mevagissey. He has written poems about Hilton, Lanyon, Wynter, Wallis, and Lowndes. See *W.S. Graham: Collected Poems 1942–77*, London 1979 and pages 42–48 of this catalogue.
November: The Mayor of St Ives in a speech stresses the need for a museum and art gallery in post-war days. In a letter to the *Western Morning News* (published 25.11.44, reprinted SIT 1.12.44) Borlase Smart urges, for this purpose, the purchase by public subscription of Treloyhan Manor and its wooded estate overlooking St Ives Bay, at the market price £23,000. The art gallery, writes Smart, could exhibit work produced in St Ives over sixty years from the 1880s and the 'extensive grounds would provide the long-felt want of a public park.' The suggestion comes to nothing. [St Ives Museum has oil paintings by Park, Smart, Fuller, Olsson, Louis Grier and Adrian Stokes R.A. and there is also the Barbara Hepworth Museum in St Ives. There is relatively little in Cornwall in the way of publicly owned Cornish art of the past 100 years. Up to a few years ago a collection of paintings, on long loan, by some members of the Penwith Society and others was on view in the Society's gallery, but was returned to the various lenders.

Newlyn Art Gallery owns paintings by Elizabeth Armstrong, Stanhope Forbes, Norman Garstin, Dod Procter, Charles Simpson and other Newlyn painters. Penzance Town Council owns a small collection, notably Norman Garstin's 'The Rain it Raineth Every Day' and Elizabeth Armstrong's 'School is Out', which is shown in Penlee House, Penzance. Falmouth Polytechnic has a collection of paintings by H.S. Tuke and Falmouth Art Gallery owns work by Arnesby Brown, Laura Knight, Alfred Munnings as well as three by Tuke.

The County Museum in Truro owns works by Borlase Smart, Stanhope Forbes, Elizabeth Armstrong, Norman Garstin, Frank Bramley, H.S. Tuke and a few others.

The Cornwall Education Committee owns a collection, for loan to schools, mainly of 'St Ives' art either given by artists

or bought at nominal prices.

A substantial collection of Cornish Art, both Newlyn and St Ives is in Plymouth Art Gallery which has oil paintings by Lamorna Birch, Forbes, Langley, Olsson, Tuke, Fuller, Norman Garstin, Alethea Garstin, Smart, Frost, Heron, Lanyon, Mackenzie, Pearce, Pender, Wallis, Wells, Weschke and Wynter.

The largest collection of St Ives art since c.1925 is in the Tate Gallery. Part of that collection is the bequest by Miss Ethel M. Hodgkins, a Carbis Bay resident, received in 1977 consisting of twenty-one works, by Barns-Graham, Frost, Hayman, Hepworth (3), Mackenzie, Mitchell, Nicholson (6) and Wells (6).

The collection made by Margaret Gardiner, which in 1978 she presented to the Pier Gallery, Stromness, Orkney, has works by Michael Broido, Frost, Gabo, Hepworth (13), Hilton, Heron, Lanyon, Mellis, Nicholson (11), Simon Nicholson, Wallis (7) and Wells.

Kettle's Yard, Cambridge, has a collection presented to the University by Jim Ede in 1966, including about 100 paintings by Alfred Wallis, a few post-1939 works by Ben Nicholson, one Hepworth slate carving of 1965, a Gabo sculpture, works by Bryan Illsley, Kate and Simon Nicholson, Bryan Pearce and a drawing of St Ives by Christopher Wood (and several non-Cornish works by Wood).

The Arts Council Collection includes works by Barns-Graham, Bob Bourne, Bell, Frost, Haughton, Hayman, Hepworth, Heron, Hilton, Brian Ingham, Andrew Lanyon, Peter Lanyon, Lowndes, Mackenzie, Mellis, Milne, Mitchell, Ben, Kate and Simon Nicholson, Pasmore (drawing made on Cornish beach and a related painting), Scott ('Sennen' 1950), Wallis, Wells, Weschke, Wynter and Nancy Wynne Jones.

The British Council collection includes work by Barns-Graham, Bell, Frost, Hepworth, Heron, Hilton, Andrew and Peter Lanyon, Nicholson, Scott (harbour painting), Tunnard, Wells and Wynter and a John Minton gouache 'Stormy Day, Cornwall' 1946.]

c.1944

Gabo introduced to Dr John Ince, a Redruth physician, by mutual friends, Edgar and Jane Lowenstein. Ince commissions Gabo to design a fireplace and the two of them search for suitable stone.

They find serpentine at Tintagel and this is used for the purpose.

1945

John Wells gives up medical practice in the Scillies, moves to Newlyn and takes up art full-time.

Show Day changed from Thursday to Saturday at Borlase Smart's suggestion 'so that the man-in-the-street could see for himself the works by these "foreigners" who have come to reside in their midst.' 'A young RAF corporal, G. Peter Lanyon, who is now in Italy, showed a well executed painting of Ypres.' (WE 10.3.45) (Lanyon painted this when on holiday in Holland and Belgium before the war).

St Ives Society of Artists moves from 4 and 5 Porthmeor Studios to the deconsecrated Mariners' Church (built 1902) near the harbour. First exhibition there opens 26 July and includes paintings by Nicholson and sculpture by Hepworth (WE 4.8.45). From 1945 'advanced' artists such as Nicholson, Hepworth, Wells and others exhibit with the St Ives Society of Artists and their work grouped in a corner near the font. For a number of years the Mariners' Church is frequently referred to as the 'New' Gallery. From 1945 Endell Mitchell, landlord of the Castle Inn, Fore Street, puts on exhibitions in the saloon bar, one-man and mixed, of local 'advanced' artists including Barns-Graham, Wells, Frost, Lanyon, Nicholson (linocuts), Berlin, Wynter, Tom Early, David Haughton, Agnes Drey and Denis Mitchell. [Endell Mitchell, (1906–1968) moved from Swansea to St Ives 1932 and ran a market garden with his brother Denis Mitchell until 1938 when he became landlord of the Castle Inn; he showed a few paintings from 1938–45 including exhibitions of children's art. Gave up the Castle Inn 1951 when he became landlord of an inn in Weymouth.] Sven Berlin invalided out of the Army and returns to St Ives.

Patrick Heron leaves the Leach Pottery and moves to London.

Adrian Ryan goes to stay in Mousehole and lives there until 1951.

Bryan Wynter moves to St Ives, later camps in the vicarage garden at Zennor.

c.October: Wynter settles at the Carn, Zennor.

November: Guido Morris arrives from London and sets up Latin Press for seventh time. Begins printing in April 1946.

December: Peter Lanyon demobilised from

Air Force and returns to St Ives.

Early in 1945 Philip Hendy, director of Leeds Art Gallery, (shortly to become director of the National Gallery in London) was making arrangements with Gabo for an exhibition of his work that summer at Temple Newsam, Leeds, but for reasons unknown the plan does not come to fruition. Also in 1945 Gabo writes to Oliver Brown of the Leicester Galleries, London, asking about the possibility of an exhibition in 1946 but after exchanging correspondence Brown says that there is no space in the exhibition schedule for that year. Gabo keen to have an exhibition in 1946, the twenty-fifth anniversary of the publication of the 'Realist Manifesto' and in July writes to Alex Reid and Lefevre Gallery asking about having an exhibition there between January and April 1946. Later Duncan McDonald of that gallery says he will come and see Gabo when he is in St Ives at Christmas; later suggests November 1946 for Gabo exhibition. In the event Gabo does not show there. [These disappointments may have contributed to Gabo's decision to leave England for good in November 1946 and settle in the U.S.A.]. (Letters in the Gabo Archive, Beinecke Library, Yale University. The Gabo Archive gives some indication of the range of his correspondence. In 1945–6 Charles Biederman writing about a publication planned on Constructivism, and wants to include some of Gabo's writings. In April 1946 Marlow Moss writes to Gabo from Lamorna on behalf of Max Bill 'a young and very talented artist' who wants photographs for a new publication he is organising; also in 1946 Gabo corresponding with Kurt Schwitters, in Ambleside, whom he knew in Berlin in the 1920s.)

1946

16 March: On Show Day Nicholson ('Painting 1946'), Hepworth ('Wood Sculpture with Strings' and 'Drawing for Sculpture') and Lanyon and a few others exhibit with Smart in his Porthmeor studio. (SIT 22.3.46; WE 23.3.46)

St Ives Society of Artists annual general meeting, Moffat Lindner resigns as president. Mrs Dod Procter, R.A. elected president.

Robin Nance re-establishes his workshop in collaboration with his brother Dicon.

May: Terry Frost moves to Cornwall, first to Carbis Bay, then to 12 Quay Street, St Ives. Attends the St Ives School of Painting.

July: Heron spends four weeks in Mousehole.

From c.1946: William Scott spends summer in Cornwall, usually near Mousehole, meeting Wynter, Lanyon and Frost who introduce him to Nicholson.

Peter Potworowski spends summer near Sancreed, where he rents a cottage from a local farmer and in later years makes visits often in winter and spring (summer being spent abroad) during vacations from Bath Academy of Art until c.1957.

Berlin, Lanyon, Morris, Wells and Wynter found the Crypt Group (so named as they exhibit in the Crypt of the Mariners' Church).

First exhibition opened by Borlase Smart, September, catalogue printed by Guido Morris.

September: Letter published in *The Western Echo* (21.9.46) by Harry Rountree 'Dear Sir, Surely those who are encouraging our young modern artists are doing a great dis-service both to the artists and art. What a pitiful racket this alleged art is . . . Fifty years I have been a professional artist and I see nothing original in these alleged modern ideas . . . This modern racket started in France; it rotted French art – in France it is now dead . . . Young men, drop it. – get back to work and sweet sanity'. Following week (28.9.46) letters by Borlase Smart, Guido Morris and Bryan Wynter and next week (5.10.46) reply by Rountree who writes of Smart 'I would remind him that some people are so tolerant that they hunt with the hounds and run with the hare. Surely this brand of tolerance commands no respect' and of Morris 'Since when has a jobbing printer been classed as an artist'. Following week (12.10.46) 10 letters including those from Wynter, Bernard Leach, Berlin, Morris, Lanyon and 'The Toymakers' at the Toy Trumpet Workshop, all critical of Rountree. Wynter: 'I understand that your correspondent Mr Rountree had not at the time of his first letter, visited the exhibition which he so strenuously attacks . . . his recent letter provokes the uneasy suspicion that he has not yet remedied this initial error. I sincerely hope that he will be able to correct me'. [Rountree does not deny Wynters' assertion.] Morris '. . . In fact I have not claimed to be an artist; I prefer to call myself "craftsman"'. Correspondence closes following week (19.10.46) with letters including those from Rountree and Smart. Smart states that attendance at exhibition increased after correspondence in the

newspaper and that it was framed and displayed in the Crypt. 'I have been accused of running with the hares and hunting with the hounds. That is precisely my outlook, as I definitely intend to like the best in both traditional and advanced art'.

[Harry Rountree (1878–1950). Painter, illustrator, poster designer and caricaturist. Born in New Zealand, came to England, 1901. Contributor to *Punch*. Celebrated series of advertisements for 'Cardinal' polish and 'Cherry Blossom' boot polish. Series of caricatures of St Ives worthies hung in bar of Sloop Inn, St Ives until early 1970s (Obituary SIT 29.9.50).]

Summer: St Ives Society of Artists exhibition includes two works each by Stokes, Mellis, Berlin and Nicholson, Hepworth, Lanyon and Wells: works by latter four form group in catalogue, suggesting shown together by the font.

September: Stokes leaves Cornwall. Mellis leaves in December.

November: Gabo leaves for America.

1947

Winter: St Ives Society of Artists exhibition includes works by Hepworth, Lanyon, Nicholson and Wells (SIT 3.1.47).

2 March: Death of Stanhope Forbes.

13 and 15 March: Show Day increased to two days for first time to include Saturday as well as Thursday. Seventeen artists show in the Crypt of the New Gallery ('Special show of those painters residing outside St Ives district, and those in St Ives who have no studios' WE 22.3.47), including Hepworth, Lanyon, Mitchell, Alice Moore, Nicholson, Misomé Peile, Wells and Wynter. A portrait by Frost on view at the St Ives School of Painting and a self-portrait by Frost at No.4 Piazza, a studio he shares with Wing Commander C.A.C. 'Bunny' Stone who shows paintings of aeroplanes. Barns-Graham's No.1 Porthmeor Studios open, Berlin's sculpture on view at the Tower on the Island and printing by Morris at the Latin Press (SIT 21.3.47).

April: G.R. Downing starts to have art exhibitions at the back of his bookshop, 28 Fore Street. Exhibitions include April, mixed exhibition of Lanyon, Mitchell and Wells; May, Morris followed by Berlin; June, Barns-Graham; CAC Stone; July, Bryan Wynter; 15–26 July, mixed exhibition works by Hepworth, Lanyon, Nicholson and Wells including Hepworth's 'Sculpture with Colour, Blue and Red',

1943 and Nicholson's 'White Relief' 1936; 29 July–9 August, 'Paintings with Knife and Brush' by Terry Frost; 2–13 September, Peter Lanyon, followed by Garlick Barnes. All the catalogues printed by Morris. In later years he does an occasional poster for Downing's Bookshop exhibitions but rarely catalogues. [George Downing, a Cornishman, opened his bookshop after the war, c.1946. He ran it until 1957 when he went to Nigeria to manage the bookshop of University College, Ibadan. He was killed in a traffic accident in Ibadan on 5 January 1962. He was chairman of the executive council of the St Ives Festival of Music and the Arts in 1953 and borough councillor 1949–53. (Obituary SIT 12.1.62).]

31 May: Annual meeting of St Ives Society of Artists Borlase Smart elected president in succession to Dod Procter, R.A. Reported that in 1946 sales of work had been £2172 in St Ives, £500 at St Austell and £164 in Newquay. 150 works by members to be shown in October in the National Museum of Wales, Cardiff. Smart refers to the lack of studio accommodation in St Ives, 'out of 100 premises built as studios in the district only 38 were in use by professional artists' (SIT 6.6.47). [There are probably fewer studios occupied by artists in St Ives in 1985. Apart from the thirteen Porthmeor Studios (two of which are used for the St Ives School of Painting) and six or seven attached to the Penwith Gallery there is little more than half a dozen others. Six Piazza studios in Back Road West, demolished in the mid 1960s, were replaced by studio flats, few of which, if any, are used for making art.]

Summer: St Ives Society of Artists exhibition includes one work each by Wells and Wynter and two each by Berlin (drawing and a sculpture) Frost, Hepworth (1 drawing 1 sculpture) Lanyon and Nicholson.

Summer: David Bomberg painting in Zennor area.

August: Second exhibition of Crypt Group: Berlin, Lanyon, Morris and Wells and Barns-Graham.

September: Exhibitions at Castle Inn. Hilda Jillard, followed by Mitchell and Early together.

David Haughton moves to Cornwall from London renting cottage at Nancledra.

Terry Frost studies at Camberwell School of Art 1947–9 (and unofficially 1949–50).

3 November: Death of Borlase Smart (obituary SIT 7.11.47)

November: David Lewis moves from London to West Penwith. [Lewis lived at Bosporthennis 1947–8 and then shared a cottage at Higher Tregerthen with poet David Wright 1948–9 and met poets George Barker who lived for some months in West Penwith, and John Heath Stubbs who made visits. Lewis married W. Barns-Graham 1949 (marriage dissolved 1963) and they were to live in St Ives. He wrote art criticism for several periodicals 1949–55, including *Listener* and *Time and Tide* and catalogue introductions for exhibitions of Hepworth (Venice Biennale), Robert Adams, Hilton and Forrester and the first Hepworth catalogue of sculptures. Curator of Penwith Gallery 1951–4. Left St Ives 1956 to study architecture at Leeds. (see introduction) p.13.]

1948

January: Borlase Smart Memorial Fund inaugurated with the aim of buying the Porthmeor Studios, a block of thirteen studios offered for sale for £6,000 by the painter Moffat Lindner, aged 96. £2,036 raised for the Memorial Fund and the studios bought with the aid of an interest-free loan of £4,500 from the Arts Council, to be paid back out of rents. [Ownership of the studios was to be vested in three managing trustees of the Borlase Smart memorial Trust, *ex officio* the Director of Art of the Arts Council, the Director of the Tate Gallery and a representative of the St Ives Society of Artists. After the breakaway of a number of members of the latter Society resulting in the formation of the Penwith Society in 1949, the third trustee, who would ordinarily be a local (i.e. West Penwith) resident, to be appointed by the other two trustees.]

Show Day in New Gallery includes work by Hepworth and Nicholson, as well as Lamorna Birch, Dod Procter, Lindner and Norman Wilkinson; elsewhere in studios work by Wells, Lanyon, Berlin and Morris (WE 13.3.48).

Spring: St Ives Society of Artists exhibition includes paintings by Barns-Graham and Nicholson, a construction by Lanyon and sculpture by Berlin and Hepworth (SIT 23.4.48). Spring exhibition Newlyn Society of Artists includes work by Berlin and Fuller, pots by Bernard Leach, typography by Morris and wooden objects by Robin and Dicon Nance (SIT 16.4.48)

Summer: St Ives Society of Artists exhibition: one work each by Frost and Barns-Graham, one drawing and one oil by Lanyon, one drawing, one oil and one sculpture by Berlin and one sculpture by Hepworth 'Wood and Strings' £200, one painting by Wells and two by Nicholson. ('Levant, Cornwall' 1946–8, £100 and 'Painting (yellow on grey)' 1946 £40 (catalogue).

John Armstrong moves to Mousehole, living there until 1955.

Alfred Wallis, Primitive by Sven Berlin published. *Ben Nicholson* with introduction by Herbert Read published by Lund Humphries.

John Tunnard teaching design at Penzance School of Art 1948–65.

June: William Gear spends about ten days in St. Ives painting about ten watercolours and six small oils.

Sir Alfred Munnings elected President of the St Ives Society of Artists after death of Borlase Smart, unveils a plaque and opens memorial exhibition of paintings by Stanhope Forbes at Newlyn Art Gallery and makes a verbal attack on work of Matisse at Tate Gallery.

Peter Lanyon elected to Committee of St Ives Society of Artists.

Downing's Bookshop exhibitions June, Marjorie Mostyn (wife of Leonard Fuller); August, embroidery by Alice Moore (reviewed SIT 20.8.48); September, paintings by Patrick Heron (reviewed SIT 10.9.48), October, paintings by Kit Barker and Bryan Wynter (reviewed SIT 8.10.48). [Kit Barker (b.1916), painter who knew David Haughton in London, went to live in Newlyn 1947, stayed six months until the end of year and then he and his wife moved to a cottage near Zennor. Returned to London end of 1948 and then to USA 1949–53. Has lived and worked near Petworth, Sussex since 1953.]

3 August: Last Crypt Group exhibition – work by Kit Barker, Barns-Graham, Berlin, Haughton, Heron, Lanyon, Ryan, Wells and Wynter. Exhibition opened by Francis Watson (not Francis Watson who became Director of the Wallace Collection) Director of British Council Visual Arts Department (author of *Art Lies Bleeding*, London 1939) (SIT 6.8.48).

1949

15 January: Last exhibition of St Ives Society of Artists which includes works by 'advanced' artists, Hepworth (two oil and pencil 'Theatre Group 4' and 'Conclusion'), Lanyon ('Construction in Space, Sphere'), Haughton, Berlin and others (SIT 21.1.49).

5 February: Extraordinary general meeting of St Ives Society of Artists. Secretary David Cox resigns, as do the chairman, Leonard Fuller, and committee members Shearer Armstrong, Hyman Segal and Lanyon 'and the entire section of modern artists' subsequent to the meeting (SIT 18.2.49).

The meeting was called by ten members, Fred Bottomley, George Bradshaw, Kathleen Bradshaw, H.T. Brown, Frances Ewan, Bernard Ninnes, H.T. Robinson, Harry Rountree, Dorothea Sharp and Marcella Smith. They accused the chairman and secretary of acting too much on their own initiative and complained that as a result of a rule passed at the 1948 annual general meeting members might not necessarily have at least one work hung in an exhibition.

8 February: The Penwith Society of Arts in Cornwall founded at a meeting at the Castle Inn, St Ives at 2.45 p.m. arranged by people who resigned from the St Ives Society of Artists and by other artists and craftsmen sympathisers and supporters in the district. Founder members nineteen in number: Shearer Armstrong, Wilhelmina Barns-Graham, Sven Berlin, David Cox, Agnes Drey, Leonard Fuller, Isobel Heath, Barbara Hepworth, Marion Grace Hocken, Peter Lanyon, Bernard Leach, Denis Mitchell, Guido Morris, Marjorie Mostyn, Dicon Nance, Robin Nance, Ben Nicholson, Hyman Segal and John Wells. The meeting decides to invite Herbert Read to be President (which he accepts), and Leonard Fuller elected Chairman, David Cox Honorary Secretary (the same positions these two held in the St Ives Society of Artists). It is agreed that the Society be founded as a tribute to the late Borlase Smart. Unlike the St Ives Society of Artists the Penwith Society includes both artists and craftsmen among its members who will all be subject to re-election every two years. The Society will also include lay members.

21 February: At a general meeting artists agree to invite the following to become members: Dorothy Bayley, Bryan Wynter, David Haughton, Tom Early, Garlick Barnes, Misomé Peile, Dod Procter R.A., John Tunnard, W. Arnold Foster and craftsmen David Leach, Alec Carne and Alice Moore. George Downing elected Honorary Treasurer. All become members with the exception of John Tunnard.

14 March: At a general meeting decide to invite Mary Jewels, R.G. Perry, Miss A.K. Jillard and Miss Jeanne du Maurier to be

members. All accept. Endell Mitchell elected an honorary lay member. Agreed that the Public Hall at 18 Fore Street be rented at 35 shillings a week as premises for the Society.

24 May: General meeting: Mrs Sefton ('Fish') and Barbara Tribe elected members.

26 May: Committee meeting – Barbara Hepworth suggests that future hanging committees should have two sculptors, two craftsmen, two traditional and two modern artists plus the officers and that 'Members should choose to which group they should belong and mark their works accordingly when sending in and would vote [jury members] according to their group'. Consideration of the matter deferred until another meeting.

18 June: First exhibition opened by Miss Phyllis Bottome, a novelist (Augustus John had been invited to do so but could not). 2755 pay to see the exhibition and sales (27 items) amount to £222.

7 September: Herbert Read gives the presidential address.

September–October: Borlase Smart Memorial exhibition (afterwards shown at Plymouth Art Gallery).

15 November: General meeting agrees to have groups A and B in place of 'Representational' and 'Abstract' respectively and group C for 'Craftsmen'. Sven Berlin, Isobel Heath and Hyman Segal decline to be placed in a group. Segal's view is that 'the new society had been formed to get away from such an artificial state of affairs and the two groups had seeds of dissention'.

April: At annual general meeting of St Ives Society of Artists Bernard Ninnes pays tribute to what Borlase Smart did for the Society. 'Another Society had been formed which claimed to be carrying out his ideals, and had he known of the crisis which had occurred during the last year or so he would have approved of what they had done in trying to pull the Society out of the mire and put it once more, on a sound foundation.' (WE 16.4.49).

Letter from Smart's widow Irene, in the same issue of the newspaper opposes Ninnes' contention. '. . . Borlase Smart stood for kindliness and tolerance, and would never have associated with a policy based on vindictiveness and intrigue as displayed at the extraordinary general meeting.'

Ben Nicholson the first artist to apply to the Borlase Smart Memorial Trustees for a

Porthmeor studio, No. 5, which Borlase Smart had occupied, followed briefly by David Cox who was leaving the district. Nicholson given tenancy of the studio which he occupies until June 1958. [In a letter of 24 May to Philip James, then Director of Art of the Arts Council, Nicholson wrote that he was working in a small converted bedroom and that 'this imposes a very definite limit on the size of paintings I can make and also I find it increasingly difficult during the "holidays" *to work at all* with a houseful of children.' In a letter of 4 June Nicholson pointed out that he had a commission to paint two large panels for a New Zealand ship. 'On my last attempt to secure a big studio in St Ives when Borlase Smart was helping me to try and secure one I nearly succeeded in renting one when the block of which it was a part was purchased by a local 'reactionary' artist and the studio I'd applied for was let instead I was told, to some woman who paints very very small watercolours'. Nicholson objected to a clause in the lease prohibiting radios, gramophones or musical instruments in the studio '. . . I frequently work to a radio – I find it extremely helpful in removing my thoughts from surrounding noises and in enabling me to become 'subconscious'.' The clause was deleted. The studio is now occupied by Patrick Heron. (Letters in Arts Council files).]

Spring: First number of quarterly *The Cornish Review* published. Founder and editor Denys Val Baker. First series ran to ten issues 1949–52. Second series twenty-seven issues 1966–74. First series particularly had many articles on painters, sculptors and craftsmen working in Cornwall and illustrations of their work. [Denys Val Baker (1917–84), a Welshman, settled in Cornwall after the 1939–45 War, living first in St Ives and later in a cottage overlooking the Fowey estuary. He wrote much about Cornwall, both in his short stories, novels and autobiography (see obituary *Times* 10.7.84).]

Canadian writer Norman Levine in St Ives for the summer and spends much of next thirty years there. Long short story 'The Playground' based on his experiences during his first year there and colourful characters he meets. Novel *From a Seaside Town* set in place very much like St Ives.

August: Hepworth buys Trewyn Studio, with, a rarity for central St Ives, a garden.

Exhibitions: Robin Nance's shop, March, Lanyon, Wells and Bernard Leach. Downing's Bookshop, February, Art by

Cornish Children; June, Berlin, Wells and Haughton; July, Barns-Graham; August, Early and Mitchell, David Leach (review by Hepworth SIT 19.8.49); 23–30 April, exhibition of work by Celtic Craftsmen at Catholic Hall, part of an Inter-Celtic Festival including pottery by Bernard Leach and from other potteries, work by Sven Berlin and Lanyon, (a slatecut), [Lanyon made three copies (information Mrs Shelia Lanyon 24.10.84) of this slatecut ($17\frac{3}{4} \times 27\frac{3}{4}$ inches), in different colours. A red version with the title 'Red House, Red Boat' was shown in the exhibition *Peter Lanyon: Drawings and Graphic Work*, City Museum and Art Gallery, Stoke-on-Trent (and tour) 1981 (51). In the catalogue it was incorrectly described as a lino-cut and wrongly dated 1951; the date is *c*.1949.] Guido Morris, Alice Moore (embroidery) and Dicon Nance (woodwork and ship modelling) as well as twelfth century Chinese pottery (SIT 6.5.49).

1950

7 February: Penwith Society: Segal resigns, followed two weeks later by Cox (secretary of the Penwith Society) and Berlin. Later Isobel Heath and then in May Lanyon and Morris resign, all as a result of the Society instituting the A B and C group system. This results in considerable correspondence in the press; the *St Ives Times* publishes (3.5.50) letters from Segal (the first to resign) and F. Fardoe, Guido Morris and Denys Val Baker, on the division of members into A and B groups which they see as disturbing the harmony, unity and tolerance of the Society. Isobel Heath following her resignation writes (10.3.50) 'It was very unfortunate that so much pressure was necessary to have the letters of resigning members read at the meeting of February 21st for all the letters were tolerant and moderate although firm . . . (and) I notice that the minutes of the previous meeting were not read showing as they did that no fewer than eight of the members (seven of which were foundation members) objected to this rule, and some very strongly'.

Arthur Caddick, a lay-member of the Penwith Society, writes a letter dated 20 March to the *Western Morning News*, which it publishes, maintaining that most of the constitutional rules of the Society have not effectively come into force. A similar letter also published in the *West Briton* and the *Cornishman*. [Caddick, Yorkshire-born

poet, lived near St Ives 1945–81. He has written much about St Ives e.g. 'Laughter at Lands End', *Cornish Review* (Second Series) No.1, Spring 1966, pp.65–79, and 'Renaissance at St. Ives' in *Both Sides of the Tamar*, ed. Michael Williams, Bossiney Books, St Teath, Bodmin, 1975, pp.80–92. Caddick's *Quiet Lutes and Laughter* (published London, Fortune Press, 1955) contains a number of satirical poems about artists in St Ives. 'Cuckoo Song' is remembered by many there.

Extracts from Forewords to 'Paintings from Penwith' by Mr Peter Lanyon

I. 'To see Cornwall as a Cornishman sees it, it is necessary not merely to have been born and brought up in the county, but to come from Cornish stock.'
 Mr Ronald Bottrall,
 Director of Education, British Council

II. '—the work of a true Cornishman, born and bred in West Penwith, not one of the cuckoo orphans come down to claim the home where the rightful heirs belong to be Peter Lanyon's work has a backbone of granite underneath its charm; when this trips up the foreigner there is a chuckle of laughter on the Downs, from knockers deep beneath the soil and ghosts, never laid, that haunt the Lanyon Quoit. You take risks here, Stranger.'
 Miss R. Glynn Grylls

CUCKOO-SONG

O Auntie! Fetch the family tree!
Have I Cornish blood in me?
Did my forebears ever rove
Somewhere round by Lanyon Cove?
Did they chase the fairies in
The mystic darkness of the glynn?
Did they live on Bodmin's hills
Roasting goats for Celtic grylls?
O Auntie! Fetch our pedigree!
Have I Cornish blood in me?
If I'm not a proper Celt,
Do I hit below the belt
If I say that, now and then,
I've seen the little whimsy men,
Leaping on the Bottrall Downs,
Laughing like demented clowns?
The cuckoo calls! I must, I must
Become a Cornishman or bust.
Buy up scores of family trees,
Bottrallize me, Auntie please!
And then—O then!—no cuckoo, I
Shall sing canary-like on high,
Fed on proper Celtic groundsel
From the Ancient British Council.
 Polarthur Trebruce Pencaddick

Arthur Caddick © 1955

May: Dennis Allen B.A. appointed curator of the Penwith Society at a salary of £3/10s per week and commission of 5 per cent on sales.

June: Arts Council gives annual grant of £150 towards employing curator. 'Hotel Evenings' instituted when on Wednesday evenings two or more artist members would be present in the gallery to answer questions and to try and 'explain' some of the more modern works in an attempt to make more sales. (It was a great success according to Denis Mitchell, October 1984).

July: Committee meeting reported that the ABC voting system has been used by the jury for the Spring exhibition that it 'went well with fair voting'.

First Penwith *Broadsheet* published (three more follow in 1951–3). Others edited by Denis Mitchell, David Lewis and Terry Frost.

7 and 14 July: (SIT) Review in two parts of Penwith Society's third exhibition by Patrick Heron at the invitation of the Penwith Society committee. Letter (SIT 14.7.50) from Denys Val Baker criticising what seems to him to be Heron's extravagant praise both of the Penwith Society and of some of the artists, Val Baker continues 'His words, like those of certain other people who have recently written about the Penwith Society, appear carefully calculated to sustain a myth about the Society's national, and even international importance. This sort of thing, however well meant, will eventually do untold damage, unless checked now'. Heron's articles draw acid comments (letter SIT 21.7.50) from Guido Morris to whom some of Heron's remarks on the work of Leonard Fuller and Marjorie Mostyn seem to be patronising. He concludes '. . . it seems a pity that the junior school of "critics" should be left unhampered to indulge in flights of phantasy (sic), at the expense of an assumedly gullible public, and to the mockery of the striving artists themselves'.

June: Hepworth's work shown in the British Pavilion at the Venice Biennale (with that of John Constable).

20 October: Letter from Peter Lanyon published in *St Ives Times* in which he states that he had been unable to work since he left the Penwith and that he was thinking of leaving St Ives. [Lanyon did not leave St Ives and did not return to the Penwith Society after the A and B group rule was abolished in 1957 but exhibited with the Newlyn Society of Artists, becoming chairman in 1961. He continued to write letters to the local press and on one occasion

(SITE 22.11.57) wrote accusing the paper of bias 'towards the group centred around Mr. Nicholson or Miss Hepworth . . . [and] that you as the only newspaper in St. Ives should not appear to be biased in favour of those with the biggest names or who can bask in the reflected glory of other's achievements'. This evoked tart comments from the editor: 'Mr Lanyon, a particularly obtrusive "Isolationist", who has been given more space in this newspaper than any other artist in St. Ives, has such a weight on his shoulders that it is remarkable that he should accuse us of bias . . . the isolationist, with his cry of stinking fish, is something of an institution in St. Ives, an institution which has its value . . . But it is fortunate that the future of St. Ives is not in his hands.']

[Among the subjects on which Lanyon wrote to the press was his hostility to the division of the artist members of the Penwith Society into A and B groups (not defined but roughly Traditional/Figurative and Modern/Abstract artists respectively).]

Following a report (SIT 31.7.53) on a talk Leonard Fuller gave to St Ives Rotary Club in which he made a plea for a more tolerant approach to modern art Lanyon wrote (7.8.53) '. . . There will be no art in St Ives soon if this idiotic division continues . . . Modern art, traditional art, primitive art, big and little art, may one day be able to bump around in a jolly manner again and bless St Ives for its ignorance about the fine points of art politics . . .'

Sir Herbert Read, President of the Penwith Society, wrote (SIT 21.8.53) in reply from his home in Yorkshire:

'. . . Mr. Peter Lanyon accuses the Penwith Society of Arts of perpetuating a division between "modern" and "traditional" art which makes nonsense of art. He further insinuates that this "forced" division is to the benefit of "a favoured few".

'. . . it has always seemed to me that the Penwith Society has set an admirable example in developing a regionalism in art which is, in my view, the only art politics that matter in the long run. Such a sense of "region" or locality implies, not a merging of outlines or a compromise of principles as between one school and another; but rather a parliament of art in which all points of view are represented, each under its appropriate (and self-chosen) label. I do not know whether a two-party system of "modern" and "traditional" is fair enough to minorities; and if there are forms of art which the division excludes, let us hear about them and make place for them.

'. . . My desire is to see the society as an art

centre for the Penwith region, not narrowly dogmatic, but promoting an activity (the art of painting) and at the same time a sense of community. A sense of community does not mean an obliteration of differences – indeed, it thrives on rivalries.

This produced a reply from Lanyon (SIT 24.8.53)

'. . . At last tolerance has appeared, though it has done so from a distance.

'I do not propose to argue about regionalism or locality because I am on the receiving end of this "ism" being a native of St. Ives and I am bound to see it a bit differently.

'But I must express dismay, horror and a little anger at the idea of a two-party system or a multi-party one for the arts, because I am persuaded that there is only one partisan of art, and that is the artist, and there are as many sorts of art as there are artists, but there still remains Art.

'For the convenience of criticism or philosophy, it may be useful to categorise the arts, but it is impertinent and even arrogant for artists to attempt to control other artists by making party loyalty a condition of sale and amenities. This is what the Penwith Society does.'

Lanyon felt that the Penwith Society was becoming predominately a society of abstract artists. An Arts Council exhibition 'Six Young Painters' with works all figurative, by Michael Andrews, John Bratby, Harold Cohen, Martin Froy, Derrick Greaves and Philip Sutton, at Falmouth led Lanyon to write (SIT 6.7.56).

'. . . The spirit of this Falmouth exhibition is close to that of Newlyn some seventy or eighty years ago – a concern for the environment and life of people.

'The St. Ives school, younger than Newlyn, developed as a landscape school culminating in the sea paintings of Borlase Smart. It is, to say the least, a pity that this school has become the tool of an essentially abstract rather than realist movement, and that, temporarily, this aspect of painting is the most vital in St. Ives.

'. . . The school that has developed is due to the influence upon this society of Ben Nicholson and Barbara Hepworth, and their work in achieving this has led to the present position of painting in St. Ives.

'While this society [the Penwith] by constitution, aims to maintain the older and more realist tradition, it is clear to anyone visiting the gallery, that this painting is being strangled, and that a largely abstract society of painters is emerging.

'Having supported this society, through the Arts Council, the public may now consider it appropriate to question the administration of public funds and to inquire whether the Arts Council should continue to support a society so one-sided and clearly determined to uphold abstract as opposed to realist painting, and whether an additional grant to this society for educational purposes would not be better used by other societies.

'The Newlyn Society of Artists has not been able to obtain a grant from the Arts Council, when with its assistance these younger realist painters could develop in Cornwall and have a gallery.

'Either the Newlyn or the St. Ives Society of Artists should now receive the support of public funds and those artists who paint outside the abstract style the younger realists included should be welcomed into these societies.

'It is regrettable that the current Falmouth exhibition cannot visit St. Ives and be exhibited in the Penwith Gallery, thus giving St. Ives an opportunity of seeing the direction of younger painting in England rather than the older and now academic abstraction of the older generations.'

A fortnight later (SIT 20.7.56) Lanyon wrote:

'I for one, together with many young artists in St. Ives and elsewhere, have benefitted from the untiring devotion of Mr Nicholson and Miss Hepworth to the development of a contemporary movement in British art, but this does not persuade me to keep quiet when I consider that their influence should be modified to permit the development of a broader based society. I believe there is no other society in Britain so vital and energetic as the Penwith Society of Arts and although I have criticised and warned and have not been able to accept their terms of membership my objections are made with a sincere desire to assist in a better approach to the new problems of artists today.'

Finally SIT 3.8.56:

'. . . My interest is in the future of St. Ives as a colony of painters and through this I am also concerned for the unique character of St. Ives and what the painters contribute to it.

'I support and admire the new realist painters because they try to face problems outside the purely aesthetic ones which have concerned my own generation. We stand to gain immeasurably from that approach just as they may also gain from ours.

'The tendency, before the war, to categorise and label styles of art has led I believe to a narrowing of experience and it has encouraged many young artists to adopt a style which may not adequately express the problems of their time.'

Lanyon was also concerned with Cornish people living in Cornwall (he was to be elected a Cornish Bard in 1961 for services to Cornish art). He wrote (SIT 19.6.53) on the 1953 St Ives Festival:

'. . . I could not object, if the festival were encouraging native talent not only in St. Ives but throughout Cornwall.

'Many laugh at Cornish nationalism, but when a lavish festival comes to St Ives and does not come out of St. Ives many are persuaded that here is another case of the "foreigner" rejecting the contribution of the "local".

'The Arts Council . . . does little to supply the essentials of a really high standard of "local" achievement'.

[Ben Nicholson wrote (uncommon for him) a letter (SIT 3.7.53) complaining that in a BBC broadcast a critic gave a 'particular negative viewpoint on a group of artists . . . the St. Ives Society of Artists'. Nicholson also protested that 'Priaulx Rainier's part in the recording made by the three founders of the festival was deleted. Without . . . her creative contribution, there would have been no festival at all'. Priaulx Rainier, born Natal 1903, composer, lives in St. Ives and London.]

1950 (continued)

Publication of Denys Val Baker, *Paintings from Cornwall*, Penzance, with illustrations of paintings in both 'traditional' and 'modern' idioms.

J.P. Hodin 'The Cornish Renaissance' published in Penguin *New Writing* No.39, discusses art in St Ives.

Scott paints pictures relating to harbours (and in 1951 and 1952).

First work by Hepworth 'Bicentric Form' 1949 bought by Tate Gallery.

Frost takes No.4 Porthmeor Studios and studies for intermediate NDD at Penzance School of Art so as to obtain maintenance grant.

Victor Pasmore visits St Ives to meet Ben Nicholson and makes a number of drawings of Porthmeor Beach from which motifs are later used in abstract compositions.

Paul and June Feiler rent cottage in West Cornwall and make frequent visits.

1951

January: Penwith Society: George Downing succeeds Leonard Fuller as Chairman, who becomes Honorary Secretary (until February 1954).

June: David Lewis becomes Curator (until 1954).

January/February: Exhibition of *Works by fifteen artists and craftsmen around St Ives*, Heal's Mansard Gallery, organised by Denis Mitchell and Tom Early. Work by Barns-Graham, Berlin, Tom Early, Frost, Hepworth, Heron, Lanyon, Leach, Mitchell, Morris, Nicholson, Misomé Peile, Wallis, Wells and Wynter (catalogue by Morris).

St Ives Festival of Britain art competitions:
Penwith Society winners: Barns-Graham,
painting prize of £75 for 'Porthleven',
Hepworth, prize for sculpture £75, and
Bernard Leach, prize for crafts £40.
Winning works presented to the town.
St Ives Society of Artists only one prize,
for painting, won by Bernard Ninnes for
'Cornish Village' (Ninnes and Barns-
Graham's paintings are reproduced in
Cornish Review No.8 summer 1951).
Wynter teaching at Bath Academy of Art,
Corsham until 1956 (and Lanyon 1950–7
and Frost 1952–4).
Arts Council exhibition *60 Paintings for '51*
includes works by Armstrong, Heron,
Lanyon, Nicholson, Pasmore, Scott,
Tunnard and Wynter.
Nicholson and Tunnard design murals for
Festival of Britain restaurants on South
Bank.
Frost and Wells working as assistants to
Hepworth from 1950, carving Festival of
Britain figures 'Contrapuntal Forms'.
Nicholson and Hepworth divorced.
Hepworth goes to live in Trewyn Studio
and Nicholson to Trezion on Salubrious
Place, St Ives.
From March: Patrick Hayman living in
Carbis Bay and later in St Ives returning to
London late summer 1953.
Adrian Heath visits St Ives in summer,
makes diagrammatic drawings of
movements of sea from which he executes
paintings in London 1951–2.
St Ives exhibitions include: Robin Nance's
shop, September, Patrick Hayman;
December, 'Prints under £1' by Hayman,
Lanyon, Alix and Warren Mackenzie and
Wells. The latter reviewed by Bernard
Leach (SIT 30.11.51).
1951 (or 1952): Alan Lowndes goes to live
in St Ives (until 1970).

1952

Death of W. Arnold Foster.
May: Penwith Society: Jewels resigns as
member. Pasmore joins.
Nicholson awarded first prize for painting
at 39th Carnegie International Exhibition.
John Milne becomes assistant to Hepworth
and settles in St Ives.
December: John Park leaves St Ives 'after
50 years' (SIT 12.12.52). Exhibitions: Robin
Nance's Shop; September, Patrick Hayman.

1953

February: Penwith Society: Misomé Peile
becomes Chairman.

October: Associate membership
introduced, not more than ten candidates to
be recommended by two successive hanging
committees, to be voted upon at next
general meeting.
Roger Leigh goes to St Ives and becomes
Hepworth's assistant.
Bryan Pearce starts to draw and paint.
June: St Ives Festival to celebrate Queen's
Coronation includes art exhibition and
musical performances.
Latin Press goes into liquidation and Guido
Morris leaves St Ives as does Sven Berlin.
John Forrester goes to live in St Ives.
[Forrester, b.21 June 1922, New Zealand,
had a one man exhibition in New Zealand
1952. In St Ives first painted abstracts but
then started to make constructions, some
suggesting architecture to hang on the wall
and some brightly coloured. Had one man
exhibition at Downing's Bookshop and
showed with the Penwith Society.
Represented in *British Painters and
Sculptors* exhibition at Whitechapel Art
Gallery 1955 and one-man exhibition at
Gimpels 1955. Exhibited in *Statements*
(review of British Abstract Art), ICA 1957.
Official advisor and design consultant on
Parkhill redevelopment project, Sheffield
1954–8. Left St Ives 1958 and stayed for
some months in Siena and later lived in
Paris and in Italy.]

1954

Victor Pasmore resigns as member of
Penwith Society.
Nine Abstract Artists edited by Lawrence
Alloway, Tiranti, published with statements
and reproductions of works by Frost,
Heath, Hilton, Pasmore, Scott and others.
Works by Nicholson shown at Venice
Biennale and later in Paris; he receives
Ulissi Award.
Brian Wall goes to live in St Ives.

1955

Penwith Society: Denis Mitchell becomes
Chairman (until February 1957). Miss
Bateman appointed Curator (until April
1956).
March: Exhibition at Heals Mansard
Gallery of abstract designs, organised by
Denis Mitchell and Stanley Dorfman
including work by Robert Adams, Barns-
Graham, Dorfman, Forrester, Frost,
William Gear, Hepworth, Heron, Hilton,
Lanyon, Mitchell, Michael Snow and
Wells. Also shown place setting mats with
designs screen-printed on to linen by
Mitchell and Dorfman from designs by

Adams, Barns-Graham, Dorfman,
Forrester, Frost, Gear, Heron, Hepworth,
Hilton, Lanyon, Mitchell, Snow and Wells.
Later designs by Trevor Bell, Agnes Drey,
Roger Leigh and Alexander Mackenzie
screenprinted on to mats. Marketed under
the name of Porthia Prints, founded by
Mitchell & Dorfman.
Patrick and Delia Heron buy Eagles Nest.
Karl Weschke goes to live at Tregerthen,
Zennor, as does Trevor Bell.
Late 1955: Anthony Benjamin goes to live
in Cornwall.
Nicholson retrospective exhibition at Tate
Gallery. Patrick Heron *The Changing Forms
of Art* (London) published with references
to Hepworth, Hilton, Lanyon, Nicholson,
Scott, Wallis, Wells and Wynter and to
West Penwith.
Lanyon, William Redgrave and Frost found
the St Peter's Loft school of painting, a
summer school which runs until 1960. (see
letter from Peter Lanyon *Art News and
Review* 29.10.55).

1956

January/February: Arts Council Exhibition
Modern Art in the United States. Tate
Gallery – a selection from the collections of
the Museum of Modern Art New York
including paintings by Baziotes, Gorky,
Kline, de Kooning, Motherwell, Pollock,
Rothko, Still, Tobey, Tomlin.
Penwith Society: Deidre Bell appointed
Curator. George Downing made honorary
lay member. Bryan Wynter rejoins the
Society.
Early 1956: Patrick and Delia Heron move
into Eagles Nest, Zennor. One of their
first guests is Roger Hilton who meets
W.S. Graham at Gurnards Head.
Kate Nicholson moves to St Ives.
Michael Kidner spends few weeks in
Zennor, and in 1957 five months in St Ives
with a few short visits and again in 1958.
Painting made during first visit 'Abstracted
from Nature' about 4 feet high, shown at
Penwith Gallery 1957 (letter from Michael
Kidner 20.6.84).

1957

February: Penwith Society: Ben Nicholson
resigns membership. Bruce Taylor made
Chairman. A and B group rule dropped at
general meeting of Society (24.10.57).
Hepworth proposes that Society should
move from 18 Fore Street, where premises
on first floor, to 36 Fore Street, premises on
the ground floor, with a shop front. [The
premises were owned by the Chairman of

the Penwith Society, Bruce Taylor, and were only half the area of 18 Fore Street, the rent was higher at No.36. When discussed at the committee meeting of 17.12.57 Hepworth and Wall's proposal that the move be made was defeated 4–3. One argument for moving was the fear that the lease of 18 Fore Street would not be renewed. In the end the move was made but resentment and adverse criticism resulted when Hepworth took over 18 Fore Street herself. At a committee meeting of 6 June 1958 the minutes read 'Barbara Hepworth said she was prepared to do anything the Penwith wanted but she was not prepared to get out for a rival group. If the Penwith wanted the old gallery, whether it was half or the whole of it she was completely willing to accede with our wishes'. Some aspects of the affair are unclear as the minutes of the meetings of the Society at about this time are incomplete.]

June: Death of Agnes Drey – later Memorial Exhibition held.

Hilton rents space in Newlyn overlooking the harbour which he retains until 1959 or 1960, painting there each summer. Later he also rents one of the Piazza studios in St Ives, though does not use it much.

Sandra Blow stays with Herons at Eagles Nest, and liking the area rents a cottage at Tregerthen, Zennor for a year. She exhibits with the Penwith Society becoming an Associate Member.

Bob Law moves to St Ives living there, later moving to Nancledra until 1960.

Joe and Jos Tilson buy cottage in Nancledra and stay there each summer 1958–62, with visits from Peter Blake. They leave for good after Joe Tilson catches poliomyelitis.

c.1957: Alan Davie goes to stay for holiday with Herons at Eagles Nest. Davie later rents cottage in West Penwith for a couple of years when buys a disused cottage near Land's End which he has converted into a studio and living quarters.

1958

February: Penwith Society: Denis Mitchell made acting chairman after Barbara Hepworth proposed as Chairman, but declined, in December the previous year.
March: Miss Joanna Reiseger appointed Curator.
July: Janet Leach made Acting Chairman.
June: Nicholson gives up his studio and goes to live in Ticino, Switzerland, with his wife Felicitas Vogler (they married in 1957).
Summer: Mark Rothko visits St Ives with his wife and child and they stay with Peter

Lanyon and his family at Little Park Owles for about a week. Rothko meets many artists including Davie, Heron, Feiler and Wynter. Arriving in Plymouth by boat from the U.S.A. John Hubbard is advised by a travel representative that as he is an artist he should go to St Ives. This he does and stays two months. He returns annually for week or two until c.1966.

1959

Penwith Society: February, Roger Leigh elected Chairman. March: Vivian Nankervis appointed Curator (until 23.9.63). 15 June: exhibition of work by eight local sculptors in Trewyn Gardens, the small public garden in the centre of St Ives. Opened by Ronald Pickvance of the Arts Council. An Alfred Wallis exhibition is held in the Penwith Gallery. Both exhibitions take place at time of St Ives Carnival. Travelling exhibition of work by members to celebrate ten years of the Society's existence to be shown in Middlesbrough, Nottingham, Cirencester, Eastbourne, Norwich, Cardiff and Liverpool Galleries. Lanyon invited to be included but declines. [The Penwith Society, like the St Ives Society of Artists, regularly circulated travelling exhibitions showing a range of members work to galleries in the South West and elsewhere in Britain.]

Arts Council Exhibition *The New American Painting*, Tate Gallery, February–March 1959, work by Baziotes, Brooks, Francis, Gorky, Gottlieb, Guston, Grace Hartigan, Kline, de Kooning, Motherwell, Newman, Pollock, Rothko, Stamos, Still, Tomlin and Tworkov.

Alan Wood, painter, first visits St Ives. Lives and works in Zennor 1961–3 and in Yorkshire 1963–5 returning to Cornwall 1965–6 to teach in Falmouth School of Art. Lived in Canada since 1974.

Denis Val Baker *Britain's Art Colony by the Sea* (London) published. This book discusses St Ives and West Penwith art, both 'traditional' and 'modern' and illustrates a wide range of painting including some by Park, Fuller, Wells and sculpture by Berlin, Hepworth, Mitchell and Wall.

July: Clement Greenberg, American art critic, visits St Ives (on his first visit to England since 1954) and stays for six days with Patrick Heron. [Greenberg and Heron first met in London in August 1954, when Greenberg also met many other artists. On his return to the U.S.A. he suggested to

Hilton Kramer that Heron should write for *Arts New York* which he did from 1954–9.] Amongst artists Greenberg meets in 1958 are Sandra Blow, Hilton, Wells and Wynter. (Oral information from Patrick Heron 26.10.84).

Peter Lanyon takes up gliding.
September 1959–January 1960.
Francis Bacon stays in St Ives painting at No.3 Porthmeor Studios.

1960

21 May: Penwith Society: Chairman Roger Leigh sends a letter to all professional members. Points out that new premises are needed as present lease runs out in April 1961 and discusses 'apathetic decay' of Society and hopes that members will come to a meeting 26 May to discuss the matter.

'I feel that the apathetic decay of the Penwith Society due to the disinterest of many members began to set in over two years ago. This has many causes:- inadequate gallery premises, unwillingness of some members to continue exhibiting with others; lack of support from some for serving on committees and running the show: the feeling that the same old names crop up on the committees you elect and form a "clique"; perhaps that the constitution should be radically revised, maybe the lectures and film shows are unnecessary, and that more of you now have commitments for exhibiting your work elsewhere in this country and abroad and cannot keep back additional work for showing in St. Ives. There may be other grievances and suggestions connected with Penwith's rather gloomy present existence and I hope you will discuss these on Thursday.

'The impossibility of some of you to be able to find work for this gallery as well as your London shows is, of course, a measure of success of the society and its exhibitions, and it would be a shame if we could not continue this propagation of work of serious artists. On the other hand, maybe 12 years is the limit of development of a group such as ours and perhaps one door should be closed to enable another to open.

'At committee meetings since the last general meeting some 3 new full members have been elected and 7 associate members and if we are to continue, then you must be prepared to spend 2 hours every month on committee running the works. Nearly all the present committee members have done more than their share of work, as indeed have the various older members of the society, and one suggestion has been made that a small group of some of the older and founder members should be formed as an advisory body of "Trustees"; that is to say, they should be ineligible for any committees, hold no vote, but could still exhibit if their work were accepted.'

26 May: Professional assembly: Resignations received from Bell, Frost, Heron, Hilton, Wynter. Brian Wall resigns at meeting. In a discussion five other members are against the Society continuing its existence.

16 June: General meeting to discuss possibilities of new premises, either Palais de Danse at £9,000 which is too expensive or the premises opposite the Guildhall, £3,000 which are soon sold. Society finally buys St Peter's Loft premises, an old pilchard-packing factory, for £4,300 in January 1961 with aid of Gulbenkian grant of £4,500 and a loan of £1,500 from St Ives Borough Council for refurbishment. Tony O'Malley settles in St Ives.

18 April: Elena Gaputyte opens the Sail Loft Gallery in Back Road West and runs it until 1963. Has one man exhibitions by Lanyon, Pearce, Hayman, Lowndes, Jeremy and Mary Le Grice, William Featherstone (a Canadian Sculptor who lives in West Penwith 1960–71); and Elena Gaputyte herself. Group exhibitions include work by William Redgrave, Jack Pender, Kate Nicholson, Barns-Graham, Derek Guthrie and Margo Maeckelberghe. September: *Situation: An Exhibition of British Abstract Painting* at R.B.A. Galleries. Roger Coleman writes in introduction 'The present exhibition was therefore organised by a committee, largely consisting of artists, to provide an opportunity for themselves and others who habitually work on a large scale to show their paintings comfortably. The conditions set by this committee were that the works should be abstract, that is, without explicit reference to events outside the painting – landscape, boats, figures – hence the absence of St Ives painters, for instance, and not less than 30 square feet.' Executive committee: Lawrence Alloway, Bernard Cohen, Roger Coleman, Gordon House, Henry Mundy, Hugh Shaw, William Turnbull, Robyn Denny (secretary). Work by twenty painters. (A second *Situation* exhibition held in 1961 at the New London Gallery with work by the same twenty painters, with, additionally, sculpture by Anthony Caro).

1961

February: Penwith Society: John Crouch (a councillor) elected chairman.

15 March: committee decides to send copies of a letter to the chairman from Mackenzie, Mitchell and Snow to all the professional members and former members, Bell, Broido, Frost, Heron, Hilton, Lanyon, Wall, Weschke and Wynter, together with copies of a letter from Hepworth in which she resigns from the Committee and the Society.

Extracts of the letter from Mackenzie, Mitchell and Snow:

'Criticism of the Society in the past has usually centred round allegations that its affairs were too much dominated by a small group of influential members, always on the Committee, and that these members, whilst publicly proclaiming the necessity of strengthening the Society by welcoming new blood have at the same time seemed quite unwilling to relinquish power and let young people share control.

'It has been partly criticism of this sort which has kept Peter Lanyon from showing with us in the past, and, more seriously, contributed towards bringing about the resignations of Terry Frost, Brian Wall, Trevor Bell, Patrick Heron and Bryan Wynter. Older members of the Committee may recall that it was also this sort of criticism which resulted in Penwith being formed as a breakaway from the old St. Ives Society where a similar set of circumstances did in fact prevail.

'. . . we are questioning the wisdom and diplomacy of some of the members of the Committee in standing yet again for election when the nomination list was not lacking in the names of young untried and willing members.

'. . . The present Committee is rich in "elder statesmen" to an altogether unreasonable degree. Added to this it would surely have been more sensible for not more than one member of a family to seek office at the same time.

'. . . We ourselves feel affronted by the Committee's apparent lack of sensitivity to the sick state of the Society, and the way in which they are ignoring its declared aim. It makes it very difficult for us to remain associated with it. Whilst earlier resignations may seem to have been premature, the criticisms expressed by those who resigned seem to have been justified yet again.

'. . . We feel that the Society stands or falls by the quality of the shows that it can put on. For many reasons these have latterly been deplorable. . . . many artists are wondering how much longer they can afford to associate themselves with a group of such diminished importance, whose executive, by virtue of its self-perpetuating composition, is so very open to the suspicion of partiality and bias.

'To a great degree the remedy lies in your hands. Imaginative steps are needed to make freshly apparent the liberal and progressive nature of the Penwith Society. Without being in any way ungrateful for their services we would respectfully suggest that some of the more long-serving and long-suffering members of the Committee should retire in favour of fresh young members who could be co-opted. Their works would obviously be wanted for the shows, but it would show some greater awareness of the climate of public opinion if they would consent to act as advisers when called upon instead of sitting on the Committee every time. Family duplication of Committee membership might also well be avoided – this would open at least two places for new members and be of the very greatest assistance in combating criticism from both inside and outside the Society. . .

'Any possible means of associating young artists in the area more closely with the Society should be explored, with special attention to those discouraged in the recent elections. There is no need to keep empty places for full membership available when the machinery for making Associates exists.

'In face of what we know to be the greatest challenge to its very existence we appeal to the Committee to act now upon these ideas, and to act before it is too late . . .'

Extracts from Hepworth's letter:

. . .'I allowed my name to be nominated this time only on this account – that I felt that not to do so would be unwise in view of the £4,500 involved. [The purchase of new premises with the aid of the Gulbenkian Grant]. The rest was up to the Annual General Meeting.

'When the letter signed by Denis Mitchell, Alexander Mackenzie and Michael Snow was read last night I realised that I must leave the Society. I consider that it was an attack on not only my motives but also on ideals which I hold and which I have tried to serve diligently in Penwith for twelve years i.e. the free continuity of the structure and standards of the Society for young artists of *the future*. This attack on me is not new. There have been many in the past and all made very difficult to bear through my friends, my relations and my employees. This last one I will not tolerate as even a founder member has the right to enjoy freedom of action in their life and in their work.

'Throughout the twelve years the Society has gone through many vicissitudes – the worst being brought about by minority groups from outside . . . I have complete faith in young people. I challenge the middle-age group to take up its responsibilities in the matter and to come forward and accept the yoke that time puts upon the shoulders of each successive generation.

'I shall miss working with so admirable a group as your committee Mr. Chairman. I have the highest opinion of all. I shall also miss, very much indeed, being your representative on the St. Ives Trust whose work is so important; it will be necessary to elect somebody in my place.

'Please understand that only my complete resignation from the Society will give the peace of mind and freedom of thought which I now desire for myself. There is nothing in this letter which I would desire hidden and I

send you my most sincere good wishes for a good year's work for the cause of Penwith Society.

20 June: Committee asks chairman to write to Barbara Hepworth asking her to remain a member of the Society and the representative on the Civic Trust.

27 June: Hepworth replies agreeing to both requests.

29 August: Mackenzie proposes (passed unanimously) that Hepworth be invited (which she accepts) to introduce Sir Herbert Read when he opens the new gallery officially on 23 September (the gallery opens to the public on 30 August).

19 October: General meeting of Society. Hepworth elected to the hanging committee (Hepworth is re-elected to the general committee 10 February 1964).

9 May: Major W.P. Wylde opens the Fore Street Gallery, in premises previously occupied by the Penwith Society, with Mrs M.V. Lister-Kaye as Curator. Gallery later taken over by Elizabeth Rainsford. Peter Lanyon gives advice and encouragement. The gallery continues for about four years and has mainly mixed shows including work by Snow, Broido, Breon O'Casey, Guthrie, Giles Auty, Redgrave, Hayman, Lowndes, O'Malley, Benjamin, Heron, Frost, Pender, Symonds, Maeckelberghe, Brennan and Conn, as well as sculpture and pottery and a one-man exhibition of work by Lanyon. Steps Gallery, near the Fore Street Gallery, opened by Tony Shiels, but it only runs for about six months. Exhibitions in May include 'Bob Law's "Ten Wheeler," a larger version of a "Nine Wheeler," which baffled and infuriated visitors a year or two ago'. (*Cornishman* 10.5.61).

Simon Nicholson living in St Ives until 1964.

1962

Charles Gimpel advises American painter Hassall Smith, who wants to spend a year in England, to stay in St Ives area; he advertises and, receiving a reply offering to let a house in Mousehole, and liking the name of the port, takes it and stays there 1962–3, rents a studio on the slipway in Newlyn. Later, having got to know many artists in West Penwith and elsewhere, Hassall Smith comes from California to teach at Bristol 1966, retiring in 1984.

1963

Summer: Penwith Society exhibition includes three works by Peter Lanyon

'Boulder Coast' (23) 'Rosewall' (24) and 'Two Tablets, Mexico' (25), the first time Lanyon has exhibited with the Penwith for 13 years. [According to Sheila Lanyon (27.10.84) Lanyon agreed to show after being asked by the Vice Chairman of the Penwith, Breon O'Casey, with whom Lanyon got on well.]

Patrick Hayman living in St Ives 1963–4.

Frost leaves St Ives to live in Banbury.

1964

February: Penwith Society: Annual meeting. John Crowther, architect, elected chairman. Problems of the Society discussed, mainly lack of support, financial stranglehold because of shortage of money and the defects of the gallery, the rough walls being unsuitable for showing pictures.

March: Jacqueline Edmunds appointed Curator (until March 1965).

June: Merlyn Evans, resident part of the time in St Ives, invited to become a member.

Paintings by Hilton shown in British Pavilion at Venice Biennale (with Gwyther Irwin, Bernard Meadows and Joe Tilson).

31 August: Death of Peter Lanyon after a gliding accident.

1965

Barbara Hepworth appointed D.B.E.

June: Marie Yates, an artist who is elected a member of the Society in 1966, appointed Curator of the Penwith Gallery (until March 1967).

November: Roger Hilton and family leave London to live at Botallack Moor, St Just, Penwith.

1966

April: Leonard Williams elected Chairman of Penwith Society.

1967

June: Kathleen Watkins appointed Curator/secretary of Penwith Society (still holds post 1985).

1968

23 September: Leach and Hepworth given honorary Freedom of Borough of St Ives.

September: Work by more than thirty St Ives artists, almost all members of Penwith Society, shown in gallery of Austin Reed, Regent Street, London. (Previous exhibition of work by Penwith artists at Austin Reed in 1962).

1969

May: Marcus Brumwell elected Chairman of Penwith Society.

April: Marjorie Parr opens gallery in Wills Lane, St Ives, which she runs for two years and puts on exhibitions, one-man and group by many St Ives artists, including Douglas Portway. [Marjorie Parr had opened an antique shop in the King's Road, Chelsea in 1963 and a year later began to show modern art in the basement. In 1970 the whole building was used for showing art including that by St Ives artists. The gallery was sold in 1975.]

1971

August: Penwith Society purchases additional property next to the gallery.

1973

Bernard Leach appointed C.H.

1974

December: Terry Frost moves from Banbury to Newlyn.

1975

Deaths of Bryan Wynter, 11 February; Roger Hilton, 23 February and Barbara Hepworth, 20 May.

Corrigendum and Addendum

The Steps Gallery was founded by a painter, Michael Dean, in his studio at 4 Academy Place, Fore Street, St Ives and opened on 13 April 1960 with an exhibition of paintings by Barns-Graham and Benjamin, sculpture by Roger Leigh and pottery by Janet Leach and William Marshall, as well as work by other artists. (SITE 15.4.60) A second exhibition, of paintings by Dean himself and Tony Shiels and sculpture by Brian Wall, opened in August. The gallery was re-opened in 1961 by Tony Shiels who ran it for the summer of that year, (information Michael Dean 16.1.85).

Bob Law's 'Ten Wheeler' exhibited at the Steps Gallery in 1961 was a painting about 5 × 6 feet in size, almost entirely black with a narrow white band around the edges. On the white band were drawn in lines of black paint near semicircular loops, and other shapes suggesting diagrammatic trees. The painting derived from Law's 'Field Drawings'. He had exhibited a smaller, similar painting at the Newlyn Gallery a year or so before. (Information Bob Law 18.1.85)

MEMBERS OF THE PENWITH SOCIETY OF ARTS IN CORNWALL

1950 (April)

A
Shearer Armstrong
W. Arnold Foster
Garlick Barnes
Dorothy Bayley
Leonard Fuller
Marion Hocken
Jeanne du Maurier
Marjorie Mostyn
Misomé Peile
Dod Procter RA
A. H. Sefton ('Fish')
Barbara Tribe

B
W. Barns-Graham
Agnes Drey
T.E.C. Early
David Haughton
Barbara Hepworth
Mary Jewels
Hilda Jillard
Peter Lanyon
Denis Mitchell
Ben Nicholson
John Wells
Bryan Wynter

C
Alec Carne
Bernard Leach
Alice Moore
Dicon Nance
Robin Nance

1955 (Spring)

A
Shearer Armstrong
Garlick Barnes
Leonard J. Fuller ROI RCA
Alethea Garstin
Marion G. Hocken ROI
Robert Monier
F.R. Martin
Marjorie Mostyn RCA
Misomé Peile
Jack Pender
Dod Procter RA
William Redgrave
A.H. Sefton ('Fish')
Billie Waters
Guy Worsdell

B
W. Barns-Graham
Stanley Dorfman
Agnes Drey
John Forrester
Terry Frost
Patrick Heron
Barbara Hepworth
Hilda Jillard
Roger Leigh
Alexander Mackenzie
Denis Mitchell
Ben Nicholson
M.N. Seward Snow
John Wells

C
Bernard Leach
David Leach
Michael Leach
William Marshall
Alice Moore
Kenneth Quick

1965 (Autumn)

W. Barns-Graham
Bob Bourne
Robert Brennan
Michael Broido
Don Brown
Roy Conn
Patrick Dolan
Jane Furness
Elena Gaputyte
Alethea Garstin
Dick Gilbert
Derek Guthrie
Barbara Hepworth
Patrick Hayman
Elizabeth Hunter
Brian Illsley
Bernard Leach
Janet Leach
Jeremy LeGrice
Alexander Mackenzie
Scott Marshall
William Marshall
Margo Maeckelberghe
John Milne
Denis Mitchell
Alice Moore
Paul Mount
Kate Nicholson
Breon O'Casey
Tony O'Malley
Bryan Pearce
Jack Pender
Terence Pope
Tommy Rowe
Billie Waters
John Wells
Guy Worsdell

1975 (Autumn)

Robert Adams
W. Barns-Graham
John Bedding
Bob Bourne
Robert Brennan
Don Brown
Roy Conn
Trevor Corser
Bob Crossley
John Emanuel
Paul Feiler
Terry Frost
Alethea Garstin
Tony Giles
Dick Gilbert
Graham Hewitt
Bryan Illsley
Leslie Illsley
Bryan Ingham
Bernard Leach
Janet Leach
Jeremy LeGrice
Alexander Mackenzie
William Marshall
Margo Maeckelberghe
June Miles
John Milne
Denis Mitchell
Alice Moore
Paul Mount
Kate Nicholson
Breon O'Casey
Tony O'Malley
Bryan Pearce
Douglas Portway
Michale Praed
Peter Rainsford
Mary Rich
Lieke Ritman
Ken Symonds
Roy Walker
John Wells
Karl Weschke
Guy Worsdell

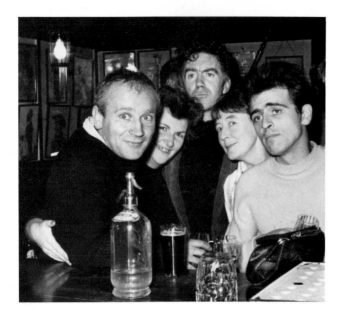

The Sloop Inn, *c.*1958
left to right: Karl Weschke, Nancy Wynne-Jones,
W.S. Graham, Nessie Graham and Brian Wall.
Photograph: P.E.O. Smith

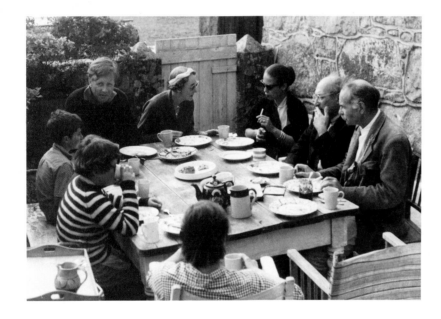

Lunch at Chapel Kerris, Paul, Penzance, Cornwall, August 1958
as seated round the table clockwise starting bottom
centre: June Feiler, Helen, Christine (hidden) and Anthony
Feiler, Peter Lanyon, Marie Miles, Mell Rothko,
Mark Rothko and Terry Frost. Photograph: Paul Feiler

Cricket team taken in field outside Gurnards Head, *c.*1960
left to right: Denis Mitchell, Anthony Benjamin, Ronnie Duncan,
Trevor Bell, Patrick Heron, Bob Crossley (?), John Hoskin (sitting),
Roger Leigh, Patrick Dolan, Terry Frost and William Redgrave

BIOGRAPHICAL NOTES

WILHELMINA BARNS-GRAHAM
b.1912

Born St Andrews, Fife 8 June 1912.
Edinburgh College of Art 1932–37, fellow
students included Denis Peploe, William
Gear, Charles Pulsford, Margaret Mellis,
Jean Bertram, (who later married Norman
Reid), Norman Reid. Studio in Edinburgh
1936–40. Andrew Carnegie post-graduate
travelling scholarship, taken up 1940, when
on advice of the Head of Edinburgh School
of Art, Hubert Wellington, who thought
Barns-Graham's work would be in
sympathy with that of Nicholson,
Hepworth and Mellis, Barns-Graham
moved to St Ives. Borlase Smart became a
supporter and friend. Joined Newlyn
Society of Artists and St Ives Society of
Artists 1942. Introduced Borlase Smart to
Nicholson and Hepworth, with intention of
persuading them to exhibit with St Ives
Society of Artists, 1943. Visited
Switzerland, made studies of glaciers
1948–52. Founder member of Penwith
Society 1949. Awarded prize for
'Porthleven' in Penwith Society Festival
exhibition 1951, picture presented to
St Ives Borough Council. Married David
Lewis 1949 (divorced 1963). Italian
Government Travelling Scholarship 1955.
Taught at Leeds School of Art 1956–7.
Studio in London 1961–3. Returned to
St Ives 1963. Began to spend more time
working in Scotland 1973. Lives and works
St Ives and St Andrews.

Selected one-person exhibitions
Downing's Bookshop, St Ives, 1947, 1949;
Redfern Gallery, 1949, 1952; Roland
Browse and Delbanco, 1954; The Scottish
Gallery, Edinburgh, 1956, 1960, 1981; City
Art Gallery, Wakefield, 1957; Richard
Demarco Gallery, Edinburgh, 1968; Bear
Lane Gallery, Oxford, 1968; Sheviock
Gallery, N.E. Cornwall, 1970; Park Square
Gallery, Leeds, 1970; Marjorie Parr
Gallery, 1971; Wills Lane Gallery, St Ives,
1976; The New Art Centre, 1978; L.Y.C.
Museum and Art Gallery, Cumbria, 1981;
Byre Theatre, St Andrews, 1981; Crawford

Centre for the Arts, St Andrews, 1982;
Henry Rothschild Exhibition, Germany,
1982; Pier Arts Centre, Stromness, Orkney,
1984.

Selected group exhibitions
Crypt Group, St Ives, 1947, 1948; *Abstract
Art*, AIA Gallery, 1951; *The Mirror and the
Square*, AIA, New Burlington Galleries,
1952; *Seven Scottish Artists*, Scottish Arts
Council tour of Scotland, 1955; *Penwith
Society of Arts, Tenth Anniversary*, Arts
Council tour, 1960; Peterloo Gallery,
Manchester (with Roger Hilton, Breon
O'Casey, Kate Nicholson, Jeffrey Harris),
1966; *British Artists of the Sixties*, Tate
Gallery, 1977; *Cornwall 1945–1955*, New
Art Centre, 1977; *Contemporary Art from
Scotland*, Scottish Gallery, Edinburgh
(tour), 1981–2.

Selected bibliography
Scottish Gallery, 1956. *W. Barns-Graham*.
Exhib. cat. introd. Alan Bowness.
Crawford Centre for the Arts, St Andrews,
1982. *W. Barns-Graham Paintings and
Drawings*. Exhib. cat. introd. William
Jackson.

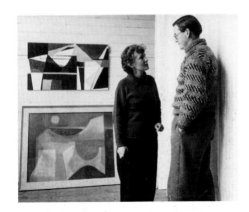

Wilhelmina Barns-Graham (with David Lewis in her
Porthmeor studio) *c*.1953, Tate Gallery Archives

TREVOR BELL
b.1930

Born Leeds 18 October 1930. Leeds Art College 1947–52. Taught part time at Harrogate Art College *c*.1953–55, painted industrial landscapes during this time. Met Terry Frost at Leeds 1955, who suggested he go to St Ives. Sold domestic possessions and went to St Ives with wife on a motorcycle 1955. Rented a cottage at Tregerthen, Zennor, next door to Karl Weschke, before moving to a cottage in Nancledra, later bought by Roger Hilton. Shared studio space with Brian Wall in a basement of Seamen's Missions (now St Ives Museum), began painting 'ropes and boats' images and landscape-based abstracts, reflecting the interaction of forces e.g. ocean breaking on the land and the structure of waves, fields and cliffs. Became member of Penwith Society Spring 1956. Spent two periods, each of 3–4 months in Anticoli Corrado, near Tivoli, Italy, on an Italian Government Scholarship 1958. Left St Ives 1960, became Gregory Fellow at Leeds University. Taught part time at Ravensbourne School of Art 1964–6, Bradford School of Art 1966–8. Head of painting Winchester School of Art 1968–72. Taught briefly at Hornsey School of Art and Florida State University 1972–3, and Leicester Art School 1974–5. Returned to Florida State University, Tallahassee, where he lives and teaches.

Selected one-man exhibitions
Waddington Galleries, 1958, 1960, 1962, 1964; Esther Robles, Los Angeles, 1961; City Art Gallery, Leeds, 1962; Bear Lane Gallery, Oxford, 1962; Greenwich Gallery, 1969; Park Square Gallery, Leeds, 1970; Richard Demarco Gallery, Edinburgh (toured to Belfast and Sheffield), 1970; Whitechapel Art Gallery, 1973; Corcoran Gallery of Art, Washington, 1973; The Four Arts Institute for Contemporary Art, Florida State University, 1980; Virginia Miller Galleries, Florida, 1981.

Selected group exhibitions
Penwith Society of Arts, Tenth Anniversary, Arts Council tour, 1960; *Six Young Painters,* Arts Council tour, 1959; Paris International Biennal, 1959; *New Paintings 1958–61,* Arts Council tour, 1961; *The Gregory Fellows, University of Leeds,* Arts Council Gallery, Cambridge (tour), 1964; *Artists at Curwen,* Tate Gallery, 1977. *Cornwall 1945–1955,* New Art Centre, 1977.

Selected bibliography
Waddington Galleries, 1958. *Trevor Bell.* Exhib. cat. introd. Patrick Heron. Norbert Lynton. London letter, *Art International.* March 1964. (vol.8). Patrick Heron. Two cultures, *Studio International.* Dec. 1970. (vol.180). John Elderfield. Trevor Bell, *Studio International.* June 1970. (vol.179). Richard Demarco Gallery, Edinburgh, 1970. *Trevor Bell.* Exhib. cat. introd. John Elderfield. The Four Arts Institute for Contemporary Art, Florida, 1980. *Trevor Bell.* Exhib. cat. introd. Roy Slade, Francois Bucher.

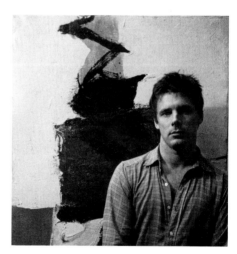

Trevor Bell 1958, photograph: Studio St Ives

ANTHONY BENJAMIN
b.1931

Born Boarhunt, Hampshire 29 March 1931. Part Time engineering course Southall Technical College 1946–9. Regent Street Polytechnic 1950–54, three months drawing in Leger's studio, Paris 1951. Moved to Cornwall December 1955 and by means of a legacy, bought Sven Berlin's cottage at Cripplesease, near St Ives. Grew flowers on '50 acres of granite', and painted landscape-based abstracts part time. Joined Newlyn Society *c*.1957. French Government Award, studied in Hayter's Atelier 17 in Paris 1958–9. Returned to Cornwall 1959–60. Italian Government Award 1960–61. Lived in London 1961–7. Taught in Canada and U.S.A. 1967–73. Returned to London end of 1973. Current work mainly drawings and prints and a commission for the P.O. company for a large mural painting, a sandblasted mural, a bronze relief together with drawings and prints. Lives and works London.

Selected one-man exhibitions
Newlyn Art Gallery, 1958; Queens University, Belfast, 1964; ICA, 1966; Museum of Modern Art, Oxford, 1967; University of Calgary, 1969; Gimpel and Weitzenhoffer, New York, 1970; Comsky Gallery, Los Angeles, 1971; The Foundation Sonja Henie Niels Onstadts, Oslo, Norway, 1972; Concourse Gallery, Polytechnic of Central London, 1974, Gimpel Fils, 1976–7; Graffiti Gallery, Hjo, 1979; Rhok Gallery, Brussels, 1980; Den Internasjonale Kunstuke, Ringerikes Kunstforening, Norway, 1981; Blackman Harvey Gallery, 1982; Jersey Arts Centre, 1984.

Selected group exhibitions
Grabowski Gallery (with Brian Wall), 1962; City Art Gallery, Manchester (with Tilson and Irwin), 1963; *64 Decade Exhibition,* (awarded Painting Prize) Ashgate Gallery, Kent, 1964; *British Contemporary Drawing,* Munich, 1965; *British Contemporary Art,* Nottingham, 1966; *New Sculpture,* The Museum of Contemporary Art, Nagoaka, 1967; *British Contemporary Painting,* Arts Council Tour, 1967; *British Sculpture,* Coventry Cathedral, 1968; *British Contemporary Prints,* British Council, Mexico City, 1968; *British Contemporary Painting,* I.C.A. (American tour) 1968; *The Graphic Biennale, Prizewinner,* Cracow, 1970; *British Sculpture,* Francis Aronsen Gallery, U.S.A. 1971; *The Third*

International Exhibition of Invited Original Drawings, Rijeka, Yugoslavia, 1972; *Cracow Prize winners Touring Exhibition*, Germany, Norway, Sweden and Finland, 1973; *Sculpture at Albright-Knox Art Gallery*, Buffalo U.S.A., 1974; *British Artists Prints 72–7*, British Council Tour, 1977.

Selected bibliography
ICA, 1966. *Anthony Benjamin*. Exhib. cat. Norbert Lynton. Anthony Benjamin's new work, *Studio International*. Sept. 1966 (vol.172).
Norbert Lynton. Anthony Benjamin, *Art International*. Oct. 1966 (vol.10).
University of Calgary, Canada, 1969. *Anthony Benjamin*. Exhib. cat. introd. Oliver Bradbury.
Kenneth Coutts-Smith. Art as a technique of knowing. The work of Anthony Benjamin, *Arts Canada*. Spring 1972.
Concourse Gallery, Polytechnic of Central London, 1974. *Anthony Benjamin Graphic Work*. Exhib. cat. introd. Sheldon Williams.

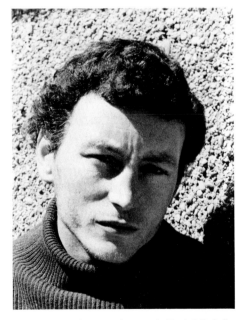

Anthony Benjamin 1957, photograph: Denis Mitchell

SVEN BERLIN
b.1911

Born London 14 September 1911 of an English mother and Swedish father. Spent two years as engineering apprentice. Student at Beckenham School of Art for one year. Trained as professional adagio dancer *c*.1929 and performed in music halls until *c*.1938. Studied at Camborne School of Art in 1934 and 1938–9. Settled in Carbis Bay and worked in Adrian Stokes' market garden. Article on Alfred Wallis published in *Horizon* 1942. Became conscientious objector, but joined army 1942 serving forward observer in the Royal Artillery until discharged 1945. Went to live in St Ives in the Tower on the Island. Co-founder of Crypt Group 1946. Founder member of Penwith Society 1949, resigned 1950. Moved to Cripplesease 1950, left there by horse and gypsy wagon 1953. Lived in New Forest, Hampshire 1953–70, near Cowes, Isle of Wight 1970–5 and since then in Wimborne Dorset.

Selected one-man exhibitions
Community Centre, Camborne, 1939; Lefevre Gallery, 1946; Mid-day Studio, Manchester, 1947; Downing's Bookshop, St Ives, 1947, 1948, 1951; St Georges Gallery, 1948; Castle Inn, St Ives, 1950; The Fox & Hounds Gallery, Lyndhurst, 1955; Bladon Gallery, Hurstbourne Tarrant, 1956, 1966; Mailman's Gallery, Lyndhurst, 1958; Maye's Gallery, Southampton, 1963; Creative Art Patrons, 1965; Emery Down Workshops & Studios; 1966; Ogilvy & Mathers, 1967; Pace Gallery, Houston, Texas, 1968; Hamwic Gallery, Southampton, 1969; Poole College Festival of Arts, Dorset, 1970; Higher Gaunts House, Wimborne; 1980; Wimborne Bookshop, 1981; Wills Lane Gallery, St Ives, 1982; New Art Centre, 1983.

Selected group exhibitions
St Ives Society of Artists, St Ives, 1942–9; Arts Council tours 1945–9; Crypt Group, St Ives 1946–8; Redfern Gallery 1945–50; Penwith Society, St Ives, 1949; *Important Contemporaries*, Tooth's, 1954–8; Southampton City Art Gallery (Wessex Group), 1958–62; *Cornwall 1945–55*, New Art Centre, 1977; *The Animal*, New Art Centre, 1983; Liverpool Garden and Sculpture Festival, 1984.

Selected bibliography
Writing by Sven Berlin:
Some aspects of creative art in Cornwall, *Facet*. Bristol, 1948.
My world as a sculptor, *Cornish Review*. Spring 1949 (no.1).
Alfred Wallis, Primitive. Poetry London, 1949.
I am Lazarus. Gallery Press, 1961, Norton Co., New York, 1961.
The Dark Monarch: A Portrait from Within, Gallery Press, 1962. (This book, about St Ives and some of its denizens, was published 7 September 1962 and withdrawn 17 September 1962 after four successful libel actions).
Jonah's Dream: A Meditation on Fishing, Phoenix House, 1964; Kaufmann, inc. California, 1976, 1981.
Dromengro: Man of the Road. Collins, 1971.
Pride of the Peacock: The Evolution of an Artist. Collins, 1972.
Amergin: An Enigma of the Forest, David and Charles, Newton Abbot, 1978.

Writing by others:
David Burnett, Peter Davies, William Hoade. *Sven Berlin: An Artist and his Work*. The Wimborne Bookshop, Wimborne, Dorset, 1981.
David Burnett. England's neglected artist, *Dorset, the County Magazine*. Nov. 1981 (issue 97).

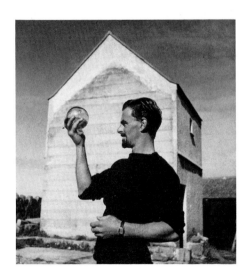

Sven Berlin (outside the Tower, his studio on the Island) 1948, photograph: Gilbert Adams

SANDRA BLOW
b.1925

Born London 14 September 1925.
St Martins School of Art 1941–6. Royal
Academy Schools 1946–7. Lived in Italy,
working occasionally at Academie della
Belle Arte, Rome 1947–8. Travelled in
Spain and France 1949–50. Settled in
London 1950. Went to Zennor 1957, to stay
with Patrick and Delia Heron, found a
vacant cottage to rent at Tregerthen nearby
and stayed about a year, returned to
London 1958, made frequent visits to West
Penwith during the next few years.
Associate member Penwith Society 1958.
Began teaching at Royal College of Art
1960. Arts Council Purchase Award 1965.
ARA 1971. RA1978. Hon FRCA 1983.
Lives and works London.

Selected one-person exhibitions
Gimpel Fils, 1951, 1952, 1953, 1960, 1962;
Saidenberg Gallery, New York, 1957;
New Art Centre, 1966, 1968, 1971, 1973;
RA, 1979.

Selected group exhibitions
Forty years of Modern Art, ICA, 1950;
British Abstract Art, Gimpel Fils, 1951;
The Mirror and the Square, AIA, New
Burlington Galleries, 1952; Galleria
Originale, Rome (with Adams, Eduardo
Paolozzi and Victor Pasmore) 1952; *Young
British Artists*, The Art Club Chicago (and
tour), 1957; *Metavisual, Tachiste, Abstract*,
Redfern Gallery, 1957; *Statements*,
ICA, 1957; *Young British Painters*,
Rotterdam (and tour), 1958; International
Guggenheim Award, 1958; British Section,
Young Artists Section, Venice Biennale,
1958; John Moores Exhibition Liverpool,
1959, 1961, 1965; *Vitalita nell' Arte*, Palazzo
Grassi, Venice, (and tour), 1959; *Pittsburgh
International*, Carnegie Institute,
Pittsburgh, 1961; *Painting in the Sixties*,
Tate Gallery, 1963; *Contemporary British
Painting and Sculpture*, Albright Knox
Gallery, Buffalo, 1964; *Recent British
Painting, Peter Stuyvesant Foundation
Modern Collection*, Tate Gallery, 1967;
Prints Exhibition, Museum of Modern Art,
Oxford, 1969; *English Landscape in the 20th
Century*, Camden Arts Centre, 1969; *British
Painting '74*, Hayward Gallery, 1974;
British Painting 1952–1977, RA, 1977; *The
Hayward Annual 1978*, Hayward Gallery,
1978.

Selected bibliography
Pierre Rouve. Sandra Blow, *Arts Review*.
Feb. 1966 (vol.18).
Edward Lucie Smith. Art as something
public, *Studio International*. Feb. 1966
(vol.171).
Hayward Annual, 1978. Exhib. Cat. introd.
Sarah Kent.
RA, 1979. *Sandra Blow*. Exhib. cat. introd.
Sandra Blow.

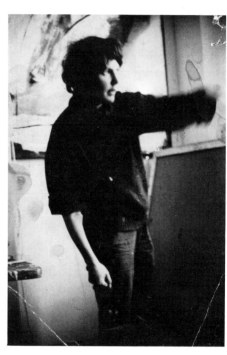

Sandra Blow *c.*1958

PAUL FEILER
b.1918

Born Frankfurt am Main 30 April 1918.
Came to England 1933. Slade School
1936–9. Interned 1939 and sent to Canada.
Returned to England 1941. Taught art in
Combined Colleges of Eastbourne and
Radley, near Oxford 1941–6, and West of
England College of Art from 1946. Head of
Painting 1963–75. First visited Cornwall
1949 with his first wife, the painter, June
Miles, visited various artists including
Bryan Wynter, who was at the Slade with
Feiler. Work became more abstract from
1950. Bought chapel at Kerris, Paul, near
Newlyn 1953, where he now lives with his
wife, the painter Catherine Armitage. His
studio at Paul was Stanhope Forbes's first
studio in Cornwall.

Selected one-man exhibitions
Redfern Gallery, 1953–7, 1959; Obelisk
Gallery, Washington D.C., 1954, 1958;
Arnolfini, Bristol, 1961; Grosvenor Gallery,
1962, 1965; Richard Demarco Gallery,
Edinburgh, 1969; Sheviock Gallery,
Plymouth, 1969; Archer Gallery, 1972;
Goodman Gallery, Johannesburg, S.A.,
1975; St Clements Hall, Mousehole, 1975;
Wills Lane Gallery, St Ives, 1977;
Meredith College, N.C., U.S.A, 1979;
Duke University, N.C., U.S.A, 1979;
Crawford Arts Centre, St Andrews 1981
(toured to Edinburgh, Warwick Arts Trust,
Southampton, Alpirsbach).

Selected group exhibitions
Bristol City Art Gallery, (with Bryan
Wynter, R.W. Treffgarne, Adrian Ryan,
Patrick Heron), 1950; Bryanston School,
Dorset (with Bryan Wynter, William Scott,
Peter Lanyon, Patrick Heron), 1952; *The
Unknown Political Prisoner*, ICA, 1953;
Figures in their Setting, Tate Gallery, 1953;
The Mirror and the Square, AIA, New
Burlington Galleries, 1952; *Nine English
Painters*, Dublin, 1954; The Octagon, Bath
(with Bryan Wynter, Peter Potworowski,
Peter Lanyon), 1955; *The Seasons*, Tate
Gallery, 1956; *Statements*, ICA, 1957;
British Abstract Painting, Paris, Milan,
Montreal, Melbourne, Sydney, 1957;
Metavisual, Tachiste, Abstract, Redfern
Gallery, 1957; *Dimensions*, O'Hana Gallery,
1957; *British Abstract Painting*, Auckland,
Liege, Johannesburg, Cape Town, 1958;
The Religious Theme, Tate Gallery, 1958; *50
Years of British Painting*, Shanghai, Peking,
1959; John Moore's, Liverpool, 1959, 1961,

1963; *Contemporary British Landscape Painting*, Arts Council, 1960–61; *British Painting in the 60's*, Tate Gallery, 1963; Arnolfini, Bristol (with Peter Lanyon, Roger Hilton, Alan Davie), 1963; *Cornwall 1945–55*, New Art Centre, 1977.

Selected bibliography
Robert Melville. *Architectural Review.* Apr. 1953.
Richard Seddon. British Landscape since World War II, *Studio.* Oct. 1954 (vol. 148).
Pierre Rouve. *Prism des Arts.* Nov. 1957.
John Steer. Paul Feiler, *Studio* Dec. 1962. (vol.164).
Evan Anthony. *Spectator.* 22 Apr. 1972.
Crawford centre for the Arts, St Andrews, 1981. *Paul Feiler.* Exhib. cat. introd. John Steer.
John Russell Taylor. *The Times.* 17 Oct. 1982.
Michael Shepherd. *Sunday Telegraph.* 11 Oct. 1982.

Paul Feiler (at his Redfern Gallery exhibition) 1959, photograph: David Farrell

TERRY FROST
b.1915

Born Leamington Spa, Warwickshire 13 October 1915. After leaving school 1930 worked in various shops and factories. Called up when Army Reserve mobilised 1939. Taken prisoner in Crete June 1941. Spent war in POW camps. Met Adrian Heath at Stalag 383 in Bavaria, who encouraged him to paint in oils. Released from POW camp 1945. Evening classes Birmingham Art College 1945. Moved to Cornwall May 1946. At suggestion of Adrian Heath studied at Leonard Fuller's St Ives School of Painting. Lived first in a caravan at Carbis Bay and later in a house in Quay Street. Camberwell School of Art 1947–9 and unofficially 1949–50. Executed first abstract paintings 1949. Returned to live in St Ives 1950. Worked as assistant to Barbara Hepworth 1950–2. Member of Penwith Society 1951. Taught life-drawing at Bath Academy of Art, Corsham 1952–4. Gregory Fellow in Painting, Leeds University 1954–6, spent summers at St Ives. Taught at Leeds School of Art 1956–7. Returned to St Ives, painted full time summer 1957. Visited U.S.A. for first time 1960, met Mark Rothko, Barnett Newman, Frans Kline, Willem de Kooning, Robert Motherwell and Clement Greenberg. Moved to Banbury, taught

part-time at Coventry Art College 1963. Taught part-time at Reading University 1964 and full time from 1965, later Reader in Department of Fine Art. Fellowship in Painting Newcastle University 1964. Taught at Voss Summer school, Norway 1967. Moved to Newlyn December 1974. Taught at Banff Summer School, Canada 1975. Lives and works Newlyn.

Selected one-man exhibitions
Leicester Galleries, 1952, 1956, 1958; Bertha Schaefer, New York, 1960, 1962; Waddington Galleries, 1961, 1963, 1966, 1969, 1971, 1974, 1978; Galerie Charles Lienhard, Zurich, 1963; Laing Gallery, Newcastle-upon-Tyne, (Retrospective) (toured to York, Kingston-upon-Hull, Bradford), 1964; San Francisco, Santa Barbara and San Jose Galleries, 1964; Arnolfini, Bristol, 1965; Queen Square Gallery, Leeds, 1967; Lincolnshire Association Arts Centre, Lincoln, 1967; Bear Lane, Oxford, 1968, 1970; Museum of Modern Art, Oxford, 1969; City Art Gallery, Plymouth, 1970; Dartington Hall, Devon (toured to Bristol), 1971–2; ICA 1971; Peterloo Gallery, Manchester, 1971; Plymouth City Museum and Art Gallery (Retrospective) (toured to Bristol,

Terry Frost (with his sons, Matthew and Stephen, on Smeaton's Pier) 1958, photograph: Brian Seed

Serpentine, Newcastle, Leeds,
Birmingham), 1976–7; Compass Gallery,
Glasgow, 1978; New Art Centre, 1980,
1983; Franz Wyans Art Core, Vancouver,
1980, 1982; London Regional Gallery,
Ontario, 1982; Rufford Craft Centre,
Nottingham, 1982; Prescote Gallery,
Banbury, 1982.

Selected group exhibitions
Abstract Art, AIA Gallery, 1951; *British
Abstract Art*, Gimpel Fils, 1951; *Mirror
and Square*, AIA, New Burlington
Galleries, 1952: *Space in Colour*, Hanover
Gallery, 1953; *9 Abstract Artists*, Redfern
Gallery, 1955; *Six Painters of Cornwall*,
Scandinavian tour, 1955–6; *Recent Abstract
Painting*, Whitworth Gallery, Manchester,
1956; *Statements*, ICA, 1957; *Metavisual,
Tachiste, Abstract*, Redfern Gallery, 1957;
Dimensions, O'Hana Gallery, 1957; *British
painting 1700–1960*, Moscow (toured to
Leningrad), 1960; *Penwith Society of Arts,
Tenth Anniversary*, Arts Council tour, 1960;
*Kompas II: Contemporary Painting in
London*, Stedelijk Van Abbe Museum,
Eindhoven, 1962; *British Painting in the
Sixties*, Tate Gallery, 1963; *54:64, Painting
and Sculpture of a Decade*, Tate Gallery,
1964; *British Art Today*, San Francisco
Museum (toured to Dallas and Santa
Barbara), 1962–3; *British Painting*,
Hayward Gallery, 1974; *British Painting
1952–77*, RA, 1977; *Cornwall 1945–1955*,
New Art Centre, 1977.

Selected bibliography
J. Darracott. Terry Frost, *Isis 30*. Jan. 1957.
J.P. Hodin. Terry Frost, *Quadrum*.
May 1956.
Laing Art Gallery, Newcastle-upon-Tyne,
1964. *Terry Frost*. Exhib. cat. introd.
Philip James.
Lincolnshire Association Arts Centre, 1967.
Terry Frost. Exhib. cat. statement Terry
Frost.
Plymouth City Museum and Art
Gallery/Arts Council, 1976. *Terry Frost,
paintings, drawings and collages*. Exhib. cat.
introd. David Brown.
Rufford Craft Centre, Nottingham, 1982.
Terry Frost. Exhib. cat. statement Terry
Frost.
London Regional Art Gallery, Ontario,
1982. *Terry Frost, Recent Paintings*. Exhib.
cat. introd. David Lewis.

LEONARD FULLER
1891–1973

Born Dulwich 11 October 1891. Clapham
School of Art 1908–12, RA Schools
1912–14. During Army Service 1914–19
met Borlase Smart. Taught at St Johns
Wood School of Art 1922–32 and Dulwich
College 1926–38. Moved to St Ives 1938
and founded the St Ives School of Painting,
4 April 1938, which he ran until his death
when it was taken over by his widow
Marjorie Mostyn. Founder-member of the
Penwith Society 1949 and first Chairman.
Died St Ives 24 July 1973.

Selected group exhibitions
RA 1919–50; St Ives Society of Artists,
St Ives, 1938–49; Penwith Society, St Ives,
1949; *Penwith Society of Arts, Tenth
Anniversary*, Arts Council tour, 1960.

Leonard Fuller (portrait of Herbert Thomas and sitter,
left) *c*.1950

NAUM GABO
1890–1977

Born Russia 5 August 1890, named Naum
Pevsner; younger brother of the sculptor
Antoine Pevsner. Entered Munich
University 1910, studying medicine, then
the natural sciences; also attended art
history lectures by Wölfflin. Transferred in
1912 to an engineering school in Munich.
Met Kandinsky, in 1913–14 joined his
brother Antoine (then a painter) in Paris.
After the outbreak of war moved first to
Copenhagen, then Oslo. Began to make
constructions 1915, under the name
Naum Gabo. 1917–22 in Moscow with
Pevsner, Tatlin, Kandinsky and Malevich.
Wrote and issued jointly with Pevsner a
Realistic Manifesto proclaiming the tenets
of pure Constructivism 1920. Lived in
Berlin in contact with the artists of the de
Stijl group and the Bauhaus 1922–32. With
Pevsner, designed the set and costumes for
Diaghilev's ballet *La Chatte* 1926. Lived in
Paris, a member of Abstraction-Création
1932–6. First visited England 1935.
Married Miriam Israels, painter, great niece
of the Hague School painter Jozef Israels,
and settled in London 1936. Edited *Circle:
International Survey of Constructivist Art*
with J.L. Martin and Ben Nicholson 1937.
Moved to Carbis Bay, Cornwall, September
1939. Joined Design Research Unit 1944.
Moved to the U.S.A. 1946 and settled at
Middlebury, Connecticut 1953. Became a
U.S. citizen 1952. Professor at the Graduate
School of Architecture, Harvard University
1953–4. From 1950 onwards carried out
several sculpture commissions, including a
sculpture for the Bijenkorf store in
Rotterdam 1955–7. Hon. K.B.E. 1971.
Died Waterbury, Connecticut, 23 August
1977.

Selected one-man exhibitions
Kestner Gesellschaft, Hanover, 1930;
London Gallery, 1938; Wadsworth
Atheneum, Hartford, 1938; Julien Levy
Gallery, New York, 1938; Vassar College,
Poughkeepsie, New York; Hayden
Memorial Library, Massachusetts Institute,
1951; Pierre Matisse Gallery, New York,
1953; Boymans Museum, Rotterdam,
(toured to Amsterdam) 1958; Stedelijk
Museum, Amsterdam, (toured to
Mannheim, Duisburg, Zurich, Stockholm
and Tate Gallery) 1965–6; Albright Knox
Art Gallery, Buffalo, 1968; Louisiana

Museum, Humblebaeck, (toured to Oslo, Berlin, Hanover, Grenoble, Paris, Lisbon) 1970–2; Tate Gallery, 1976–7.

Selected group exhibitions
Open Air exhibition, Tverskoi Boulevard, Moscow, 1920; *Erste Russische Kunstaustellung*, Galerie van Diemen, Berlin, (toured to Amsterdam) 1922–3; *Constructivistes Russes: Gabo et Pevsner*, Galerie Percier, Paris, 1924; *Gabo and Pevsner, Russian Constructionists*, Little Review Gallery, New York, 1926; *International Exhibition of Modern Art*, Société Anonyme, Brooklyn Museum of Arts and Sciences, (toured to New York, Buffalo, Toronto), 1926–7; *Abstract Art of Gabo, Pevsner, Mondrian and Domela*, Wadsworth Atheneum, Hartford, Arts Club of Chicago, 1936; *Cubism and Abstract Art*, Museum of Modern Art, New York, 1936; *Abstract and Concrete*, Reid and Lefevre, 1936; *Constructive Art*, London Gallery, 1937; *New Architecture: An Exhibition of the Elements of Modern Architecture*, Mars Group, New Burlington Galleries, 1938; *Abstract and Concrete Art*, Guggenheim Jeune, 1939; *New Movements in Art*, London Museum, 1942; Leicester Museum and Art Gallery, 1942; *Naum Gabo–Antoine Pevsner*, Museum of Modern Art, New York, 1948; *Two Exhibitions: Naum Gabo and Joseph Albers*, Arts Club of Chicago, 1952; *The Unknown Political Prisoner*, Tate Gallery, 1953; *Alexander Calder Mobiles – Naum Gabo Kinetic Construction and Constructions in Space*, Wadsworth Atheneum, Hartford, 1953; *Art in Britain Centred Around Axis, Circle, Unit One*, Marlborough Fine Art, 1965; *Pioneers of Modern Sculpture*, Hayward Gallery, 1973; *Paris-Moscou*, Musée National d'Art Moderne, Paris, 1978; *The Planar Dimension: Europe 1912–1932*, Solomon R. Guggenheim Museum, New York, 1979; *Circle: Constructive Art in Britain 1934–1940*, Kettle's Yard Gallery, Cambridge, 1982; *The First Russian Show: A Commemoration of the Van Diemen Exhibition, Berlin 1922*, Annely Juda Fine Art, 1983.

Selected bibliography
Writings by Gabo:
Naum Gabo, Noton [Antoine] Pevsner. *Realisticheskii Manifest*, [*The Realistic Manifesto*]. Moscow Second State Publishing House, 5 Aug. 1920.
Naum Gabo. Constructive art, *The Listener*. 4 Nov. 1936.
J. Leslie Martin, Ben Nicholson, N. Gabo (eds.). *Circle: International Survey of Constructive Art*. Faber and Faber 1937, 1971. (contains two essays by Gabo: 'The Constructive Idea in Art' 'Sculpture: Carving and Construction in Space'.
Eric Newton, William Coldstream, Naum Gabo. The artist in the witness box: centre party v left wing, *The Listener*. 25 Jan. 1940.
Naum Gabo, The concepts of Russian art, *World Review*. June 1942.
Naum Gabo. Prepare for design, *World Review*. April 1943.
Naum Gabo, Herbert Read. Constructive art: an exchange of letters, *Horizon*. July 1944.
Katherine S. Dreier, James J. Sweeney, Naum Gabo. *Three Lectures on Modern Art*. New York Philosophical Society, 1949.
Naum Gabo, Leslie Martin, Herbert Read. *Gabo: Constructions, Sculptures, Paintings, Drawings, Engravings*. Lund Humphries, 1957.
Naum Gabo. *Of Divers Arts*. Princeton University Press, 1962, 1971, Bollingen Series XXXV. 8.

Writings by others:
Alexei Pevsner. *A Biographical Sketch of My Brothers Naum Gabo and Antoine Pevsner*. Amsterdam, Augustin and Schoonman, 1964.
Studio International, April 1966 (vol.171), (Special issue).
Jean Clay. *Visages de l'Art Moderne*, Paris Editions Rencontre, 1969.
Albert E. Elsen. *Origins of Modern Sculpture: Pioneers and Premises*. 1974.
Tate Gallery, 1976. *Naum Gabo*. Exhib. cat. introd. Teresa Newman.
David Thompson. Naum Gabo talks to David Thompson, *Art Monthly*. Feb. 1977.
Ronald Alley. *Catalogue of the Tate Gallery's Collection of Modern Art: Other than Works by British Artists*. Tate Gallery and Sotheby Parke Bernet, 1981.
Andrei B. Nakov. *Abstrait/Concret: Art Non-objectif Russe et Polonais*. Paris Transédition, 1981.
Christina Lodder. *Russian Constructivism*. Yale University Press, 1983.

Naum Gabo (in his studio at Carbis Bay during the war), photograph: Studio St Ives

DAVID HAUGHTON
b.1924

Born London 28 August 1924. Early life spent in India. Slade School. Moved to Nancledra, near St Ives 1947. Member of St Ives Society of Artists c.1948, resigned 1949. Became a member of Penwith Society 1949 soon after its foundation; resigned from Penwith Society 1952. Left Cornwall 1951 to teach at Central School of Arts and Crafts (until 1984). Worked on St Just suite of prints for St George's Gallery 1958–60. Lives in London.

Selected one-man exhibitions
Exhibition of etchings, St Georges Gallery, (toured to Sweden, South Africa, Canada, U.S.A., Japan and Brazil) 1960–3; Hilton Gallery Cambridge 1964 (with Hughes Stanton); Newlyn Art Gallery, Newlyn (toured to Exeter, Cirencester and Sheffield) 1979; Work of Art Gallery 1983.

Selected group exhibitions
Crypt Gallery, St Ives 1948; St Ives Society of Artists, St Ives, 1948–9; Penwith Gallery, St Ives, 1949–52; *20th Century Drawing*, Roland Browse and Delbanco, 1949; *Contemporary Cornish Painting*, Arts Council tour of Britain, 1949; *Six Cornish Painters*, Montreal City Art Gallery, (toured Canada) 1955; *Contemporary English Landscape*, I.C.A. 1957; Grabowski Gallery, 1965; Piccadilly Gallery, 1965; *English Drawings*, Bradford, 1965; *Four Holistic Painters*, Commonwealth Institute, 1972; *Cornwall 1945–55*, New Art Centre 1977.

Selected bibliography
Norman Levine. David Haughton's St Just, *The Painter & Sculptor*. Summer 1961 (vol.4).
Newlyn Art Gallery, Newlyn 1979. *David Haughton*. Exhib. cat. introd. John Halkes.

David Haughton (Central School) 1957, photograph: Roger Mayne

PATRICK HAYMAN
b.1915

Born London 20 December 1915. Lived in New Zealand 1936–47. Started to paint in Dunedin 1938. Returned to London 1947. Lived in Cornwall December 1950–summer 1953, first in Mavagissey, and from March 1951 in Carbis Bay and later in St Ives. Lived in London with frequent long summer holidays in St Ives 1953–64. Founded and edited *The Painter and Sculptor*, a magazine specialising in figurative art 1958–63. Spent one year in St Ives 1964–5 and became a member of the Penwith Society. Also writes and illustrates his own poems. Lives and works Barnes, London.

Selected one-man exhibitions
Robin Nance, The Wharf, St Ives, 1951, 1952; Gallery One, 1954; Piccadilly Gallery, 1956; Portal Gallery, 1961; Sail Loft Gallery, St Ives, 1962; Beaux Arts Gallery, 1963; Grosvenor Gallery, 1965; Ashgate Gallery, Farnham, 1966; William Ware Gallery, 1968; Travers Gallery, 1969; Bear Lane Gallery, Oxford, 1970; Richard Demarco Gallery, Edinburgh, 1970; Zaydler Gallery, 1971; Wills Lane Gallery, St Ives, 1972; Whitechapel Art Gallery, 1973; University of Saskatchewan, Canada, 1974; James Art Studio, Saskatoon, 1974; Thomas Gallery, Winnipeg (toured to Saskatoon), 1977; Kesik Gallery, Regina, 1980; Salt House Gallery, St Ives, 1982; New Zealand House Gallery (with Helen Kedgley), 1984; Norman MacKenzie Art Gallery (University of Regina) and Mendel Art Gallery, Saskatoon, 1985.

Selected group exhibitions
London Gallery, 1947; *Prints under £1* (with Peter Lanyon, Alix and Warren Mackenzie and John Wells), Robin Nance shop, St Ives, 1951; AIA group exhibitions, 1953, 1954; Penwith Society, 1951–3, 1964; *Arts Council collection 1967–8, Paintings Bought by Alan Bowness and Robyn Denny*, Arts Council Tour, 1969–71; *Alive to it all*, Rochdale Art Gallery (Arts Council tour to Serpentine Gallery, Hull, Plymouth and Sheffield), 1983; *5 Newcomers to Crane Kalman*, Crane Kalman Gallery, 1983; *Another Pair of Eyes (works chosen by William Packer)*, Michael Parkin Fine Art, 1984.

Selected bibliography

Gallery One, 1954. *Patrick Hayman*. Exhib. cat. introd. Patrick Heron.

Patrick Hayman. A painter's notes, *The Painter and Sculptor*. Winter 1959–60.

Sail Loft Gallery, St Ives, 1962. *Patrick Hayman*. Exhib. cat. introd. Peter Lanyon.

Whitechapel Art Gallery, 1973. *Patrick Hayman, Recent Work*. Exhib. cat. introd. Richard Demarco.

Basil Dowling. Patrick Hayman: painter and poet, *Landfall*. Caxton Press, Christchurch, New Zealand, 1974.

Patrick Hayman. A painter's reflections, *The Jewish Quarterly*. Autumn 1974.

Peter Millard. Patrick Hayman, *Arts Manitoba*. Canada, 1977.

Duane MacMillan. Art & History, Patrick Hayman, *Arts West*. Canada, 1979.

Patrick Hayman. Lovers like mice, *Poetry London*, 1982.

Patrick Hayman (Dunvegan, Carbis Bay) *c*.1951

ADRIAN HEATH
b.1920

Born Maymyo, Burma 23 June 1920. Came to England 1925. First visit to Cornwall 1938, studied under Stanhope Forbes at Newlyn for six months. Slade School, Oxford 1939. Joined the RAF 1940, prisoner of war 1941–5 in Germany, met Terry Frost in POW camp Stalag 383, Bavaria. Spent one month painting in St Ives 1945 before returning to Slade School 1945–7. Visited Terry Frost at Quay Street, St Ives 1949, met Ben Nicholson, returned again summer 1951. Arranged exhibitions at his studio in Fitzroy Street for abstract artists 1951–3. Chairman of AIA 1955–64. Visiting lecturer at Bath Academy of Art, Corsham 1955–76. Served on Art Panel of the Arts Council 1964–7. Artist in Residence University of Sussex 1969. Senior Fellow South Glamorgan Institute of Higher Education 1977–80. Part time lecturer Reading University since 1980. Lives and works London.

Selected one-man exhibitions

Redfern Gallery, 1953, 1966, 1973, 1975, 1978, 1981, 1983; Symons Quinn Gallery, Huddersfield, 1956; Lords Gallery, 1957; Hanover Gallery, 1959, 1960, 1962; De Unga Gallery, Stockholm, 1959; Museum am Ostwall, Dortmund, 1961; Mickery Loenersloot, Amsterdam, 1967; Bear Lane Gallery, Oxford, 1969; Lancaster House, Brighton, 1959; Park Square Gallery, Leeds, 1970; Bristol City Art Gallery (Retrospective) (toured to Sheffield), 1971–2; Oxford Gallery, Oxford, 1973; Camden Arts Centre, 1975; Kettle's Yard Gallery, Cambridge, 1976; Polytechnic Gallery, Newcastle upon Tyne, 1979; Oriel, Cardiff, 1979; Compass Gallery, Glasgow 1981; Pallant House Gallery, Chichester, 1981; British Council tour of Norway, 1984.

Selected group exhibitions

Abstract Art, AIA Gallery, 1951; *British Abstract Art*, Gimpel Fils, 1951; Salon de Réalites Nouvelles, Paris, 1952; *This is Tomorrow*, Whitechapel Gallery, 1956; *Recent Abstract Art*, Whitworth Art Gallery, Manchester, 1956; *Dimensions*, O'Hana Gallery, 1957; *Statements*, ICA, 1957; *Metavisual, Tachiste, Abstract*, Redfern Gallery, 1957; *British Art Today*, San Francisco Museum (toured to Dallas and Santa Barbara), 1962–3; *British*

Painting in the Sixties, Tate Gallery, 1963; *54:64 Painting and Sculpture of a Decade*, Tate Gallery, 1964; *London Group 1914–1964*, Tate Gallery, 1964; *British Painting*, Hayward Gallery, 1974; *British Painting 1952–1977*, Royal Academy, 1977; *Cornwall 1945–1955*, New Art Centre, 1977.

Selected bibliography

Adrian Heath. *Abstract Art: its Origins and Meaning*, Alec Tiranti, 1953.

Hanover Gallery, 1959. *Adrian Heath, Recent Paintings*. Exhib. cat. introd. Andrew Forge.

City Art Gallery, Bristol, 1971. *Adrian Heath*. Exhib. cat. introd. Norbert Lynton.

Pallant House Gallery, Chichester, 1981. *Adrian Heath, Paintings 1951–59 and Recent Works*. Exhib. cat. introd. Adrian Heath.

Adrian Heath *c*.1953, photograph: Ida Kar

BARBARA HEPWORTH

1903–1975

Born Wakefield 10 January 1903. Leeds School of Art, Henry Moore fellow student, 1920. Royal College of Art 1921–4. Lived in Italy 1924–6. Married John Skeaping 1925. Lived in Hampstead 1928–39. Met Ben Nicholson 1931. Joined Seven and Five Society 1931. Frequent visits to France 1932–6, met Picasso, Braque, Mondrian, Brancusi, Gabo. Became member of Abstraction-Création, 1933 and Unit One 1934. Married Ben Nicholson. Moved to St Ives 25 August 1939 stayed with Adrian Stokes and Margaret Mellis, at Little Park Owles, in December moved to Dunluce, Carbis Bay, then to Chy-an-Kerris, Carbis Bay 1942. Ran a nursery school and market garden. Made drawings of operating theatres 1947–8. Bought Trewyn Studio, St Ives August 1949, lived there permanently after marriage dissolved 1951. Founder member of Penwith Society, 1949. Two works commissioned for the Festival of Britain 1951. Awarded second prize in *The unknown political prisoner* competition 1953. Visited Greece 1954. CBE 1958. Won major award São Paulo Bienal 1959. DBE 1965. Trustee of Tate Gallery 1965–72. Honorary freedom of the Borough of St Ives 1968. Died in fire in studio 20 May 1975. Barbara Hepworth Museum, St Ives opened 1976.

Selected one-person exhibitions

Beaux Arts Gallery, 1928; Reid and Lefevre Gallery, 1937, 1946, 1950, 1952; Temple Newsam, Leeds (Retrospective), 1943; Wakefield City Art Gallery (Retrospectives), (tours) 1944, 1951; Durlacher Bros. New York, 1949; Venice Biennale, 1950; Whitechapel Art Gallery (Retrospectives), 1954, 1962; Walker Art Center, Minneapolis (Retrospective) (toured United States), 1955–6; Gimpel Fils, 1956, 1958, 1961, 1966, 1972, 1975; Leeds City Art Gallery, 1958; Bienal São Paulo (Retrospective), (toured South America) 1959; Galerie Charles Lienhard, Zürich, 1960; British Council Scandinavian tour, 1964–5; Rijksmuseum Kröller-Müller, Otterlo, (Retrospective) (toured to Basle, Turin, Karlsruhe and Essen), 1965–6; Marlborough Galleries, (London, New York and Zurich), 1966, 1970, 1972, 1974, 1975, 1979, 1982; Tate Gallery (Retrospective), 1968; Gimpel-Weitzenhoffer Gallery, New York, 1969, 1971, 1977; Hakone Open Air Museum (toured Japan), 1970; Plymouth City Art Gallery and Museum, 1970; Uttoxeter, Abbotsholme (Arts Council tour of Britain), 1970–1; William Darby, 1975; Royal Botanic Garden, Edinburgh, 1976; Scottish College of Textiles, Galashiels (Scottish Arts Council tour), 1978; Gallery Kasahara, Osaka, 1978; Yorkshire Sculpture Park, West Bretton, 1980; Glynn Vivian Art Gallery, Swansea (toured to Bangor, Wrexham and Isle of Man), 1982–3.

Selected group exhibitions

Arthur Tooth Gallery (with Ben Nicholson), 1932; Lefevre Gallery (with Ben Nicholson), 1933; *Abstract-Concrete*, Lefevre Gallery, 1936; Seven and Five group, 1932–6; *Constructive Art*, London Gallery, 1937; *Abstrakte Kunst*, Stedelijk Museum, Amsterdam, 1938; *New Movements in Art*, London Museum, 1942; Salon des Réalités Nouvelles, Paris, 1947–9; *Unknown Political Prisoner*, Tate Gallery, 1953; *Dimensions*, O'Hana Gallery, 1957; *Statements*, ICA, 1957; *Documenta 1: Art of the 20th Century*, Kassel, Germany 1955, *Documenta 11: Art since 1945*, Kassel, Germany, 1959; *Sculpture in our Time*, U.S.A. tour of Hirshhorn Collection, 1959; *Penwith Society of Arts, Tenth Anniversary*, Arts Council tour, 1960; *Recent British Sculpture*, British Council tour of Canada, New Zealand, Australia, Japan and Hong Kong, 1961–4; *British Art Today*, San Francisco Museum, (toured to Dallas and Santa Barbara), 1962–3; *British Sculpture in the Sixties*, Tate Gallery, 1965; *Sculpture in the Open Air*, Battersea Park, 1966; *British Painting and Sculpture 1969–70*, National Gallery of Art, Washington, 1970; *Henry Moore to Gilbert and George*, Palais des Beaux Arts, Brussels, 1973; *Cornwall 1945–1955*, New Art Centre, 1977.

Selected bibliography

Herbert Read. *Barbara Hepworth, Carving and Drawings*. Lund Humphries, 1952.
J.D. Hodin. *Barbara Hepworth, Life and Work*. Lund Humphries, 1961.
Barbara Hepworth, Alan Bowness. *Drawings from a Sculptor's Landscape*. Cory, Adams and Mackay, 1966.
A.M. Hammacher. *Barbara Hepworth*. Thames and Hudson, 1968.
Barbara Hepworth. *A Pictorial Autobiography*. Adams and Dart, Bath 1970. Reprinted 1978.
Alan Bowness. *The Complete Sculpture of Barbara Hepworth 1960–69*. Lund Humphries, 1971.
Margaret Gardiner. *Barbara Hepworth, a Memoir*, Salamander Press, Edinburgh, 1982.

Studio Assistants to Barbara Hepworth

Denis Mitchell, 1949–59; Terry Frost, 1950–2; John Wells, 1950–1; Owen Broughton (Australian), 1951; John Milne, 1952–4; Roger Leigh, 1952–4 and 1957; Brian Wall, 1955–60; Keith Leonard, 1955–9; Tom Pierce, 1959–61; Breon O'Casey, 1959–62; Michael Broido, 1959–62; Dicon Nance, 1959–71; Tommy Rowe, 1962–4 (and 1958–62 during vacations when a student at the Bath Academy of Art, Corsham); Norman Stocker, 1962–75; Angela Conner, 1963 April–December; George Wilkinson, 1964–75.

Barbara Hepworth *c*.1947

PATRICK HERON
b.1920

Born Headingly, Leeds, 30 January 1920. Family lived in West Cornwall 1925–9, first near Newlyn for some months, then in Lelant and St Ives. Spent winter 1927–8 at Eagles Nest, Zennor. Slade School part time 1937–9, fellow students included Bryan Wynter and Adrian Ryan. Conscientious objector during war years, worked as agricultural labourer, Cambridge and Welwyn 1940–4 and at Leach Pottery, St Ives, 1944–5, came in contact with Nicholson, Hepworth, Gabo and Stokes. Married Delia Reiss and moved to London 1945. Art critic for *New English Weekly* 1945–7 and *New Statesman and Nation* 1947–50. London correspondent for *Arts* (New York) 1955–8. Spent July 1946 at Mousehole; returned each year to a studio-cottage on sea wall at St Ives until 1955, when bought Eagles Nest, Zennor. Member of Penwith Society c.1952. Taught at Central School of Arts and Crafts 1953–6. Moved to Eagles Nest April 1956. Took over Nicholson's Porthmeor Studio, St Ives 1958. Grand Prize (International Jury) John Moores Liverpool Exhibition 1959. Visited Brazil, lectured São Paulo, Brasilia and Rio de Janeiro 1965, received Silver Medal at São Paulo Bienal. Visited Australia, 1967 and 1969 (delivered Power Lecture). CBE 1977. Delivered Doty Lectures, University of Texas at Austin 1978. Trustee of Tate Gallery 1980. Hon. D. Litt. (Exeter) 1982. Lives Zennor and London.

Selected one-man exhibition
Redfern Gallery, 1947, 1948, 1950, 1951, 1954, 1956, 1958; Downing's Bookshop, St Ives, 1947; Wakefield City Art Gallery (Retrospective) (toured to Leeds, Hull, Halifax, Scarborough and Nottingham), 1952; Waddington Galleries, 1959, 1960, 1963, 1964, 1965, 1967, 1968, 1970, 1970 (prints), 1973 (prints), 1975, 1977 (gouaches), 1979, 1983; Bertha Schaefer Gallery, New York, 1960, 1962, 1965; Galerie Charles Lienhard, Zürich, 1963; VIII Bienal de São Paulo (with Victor Pasmore) (toured to Rio de Janeiro, Buenos Aires, Santiago, Lima, Caracas), 1965–6; Dawson Gallery, Dublin, 1967; Richard Demarco Gallery, Edinburgh (Retrospective), 1967; Kunstnernes Hus, Oslo (Retrospective), 1967; Museum of Modern Art, Oxford (Retrospective), 1968;

Park Square Gallery, Leeds, 1968; Waddington Fine Arts, Montreal, 1970; Rudy Komon Gallery, Sydney, 1970; Harrogate Festival (Gallery Caballa), 1970; Whitechapel Art Gallery, 1972; Hester van Royen Gallery, 1973; Bonython Gallery, Sydney, 1973; Skinner Gallery, Perth, W. Australia, 1974; Prints on Prince Street, New York, 1974; Rutland Gallery (paintings 1958–66), 1975; Galerie Le Balcon des Arts, Paris, 1977; University of Texas at Austin Art Museum, Texas, 1978; Bennington College, Vermont, 1978; Oriel, Cardiff, 1979; Riverside Studios, 1981; Abbot Hall Art Gallery, Kendal, 1984.

Selected group exhibitions
3rd Crypt Exhibition, St Ives, 1948; Salon de Mai, Paris, 1949; *Sixty Paintings for '51*, Arts Council, 1951; Bienal di São Paulo (with Scott, Evans, Gear, Richards), 1953; *Space in Colour*, Hanover Gallery (exhibition devised by Patrick Heron), 1953; *Six Painters from Cornwall*, Montreal Museum of Fine Art (toured Canada), 1955–6; *Recent Abstract Painting*, Whitworth Art Gallery, Manchester, 1956; *Critic's Choice (Sir Herbert Read)*, A. Tooth & Sons, 1956; *Statements*, ICA, 1957; *Dimensions*, O'Hana Gallery, 1957; *Metavisual, Tachiste, Abstract*, Redfern Gallery, 1957; *Premio Lissone*, Milan, 1957; *La Peinture Britannique Contemporaine*, Galerie Creuze, Paris, 1957; *Four English Middle Generation Painters*, Waddington Galleries (with Frost, Hilton, Wynter), 1959; *Penwith Society of Arts, Tenth Anniversary*, Arts Council tour, 1960; *Carnegie International*, Pittsburgh, 1961; *Arte Britanica na Seculo XX*, Lisbon, Oporto, Coimbra, 1962; *British Art Today*, San Francisco, (toured to Dallas, Santa Barbara), 1962–3; *British Painting in the Sixties*, Tate Gallery, 1963; *Contemporary British Painting*, British Council tour in Canada and Louisiana Gallery, Copenhagen, 1963; *54–64: Painting and Sculpture of a Decade*, Tate Gallery, 1964; *Recent British Painting*, Peter Stuyvesant Foundation Collection, Tate Gallery 1967; *British Painting and Sculpture 1960–1970*, National Gallery of Art, Washington D.C., 1970; *Europalea 73: Henry Moore to Gilbert and George*, Palais des Beaux Art, Brussels, 1973.

Selected bibliography
Writings by Patrick Heron:
Vlaminck Paintings 1900–1945. Lindsay Drummond/Les Editions du Chene, 1947.
Bonnard, Vuillard, Sickert. World Review. June 1947.
The Changing Forms of Art. Routledge and Kegan Paul, 1955 and Noonday Press, New York, 1958.
Ivon Hitchens. Penguin Modern Painters, 1955.
Americans at the Tate, *Arts*. New York, March 1956.
Braque, The Faber Gallery, 1958.
Five Americans, *Arts*. New York, May 1958.
A note on my painting: 1962, *Art International*. 25 Feb. (Vol.7) 1963.
Victor Waddington Gallery, 1966. *Bonnard in 1966*. Exhib. cat.
The ascendancy of London in the sixties, *Studio International*. Dec. 1966 (vol.172).
A kind of cultural imperialism?, *Studio International*. Feb. 1968 (vol.175).
Colour in my painting: 1969, *Studio International*. Dec. 1969 (vol.178).
Two cultures, *Studio International*. Dec. 1970 (vol.180).
Murder of the art schools, *The Guardian*. 12 Oct. 1971.
American Federation of Arts, New York, 1972. 'Colour and Abstraction in the Drawings of Bonnard' in *Bonnard: Drawings 1893–1946*. Exhib. cat.
'The Shape of Colour', Text of the Power Lecture in Contemporary Art 1973, *Studio International*. Feb. 1974 (vol.187).
The British influence on New York, *The Guardian*. 10,11,12 Oct. 1974.
The Shapes of Colour: 1943–1978, (a book of twenty screenprints, signed and numbered by the artist, limited to fifty copies) Kelpra Editions and Waddington and Tooth Graphics, 1978.
The Colour of Colour, E. William Doty Lectures in Fine Arts, Third Series 1978, College of Fine Arts, The University of Texas at Austin 1979.

Writings by others:
David Sylvester. Patrick Heron, *Art News and Review*. 6 May 1950.
Wakefield City Art Gallery, 1952. *Patrick Heron*. Exhib. cat. introd. Basil Taylor.
Basil Taylor. *The Painter as Critic*, BBC

Third Programme. 14 Sept. 1955.
The spectrum on canvas, Mr Patrick
Heron's new paintings. *The Times*. 28 Feb.
1958.
John Russell. Heron aloft, *Sunday Times*.
13 Dec. 1959.
Preoccupation with colour, Mr Patrick
Heron's new paintings, *The Times*. 29 Nov.
1960.
J.P. Hodin. Patrick Heron, *Quadrum II*.
A.D.A.C. Brussels, 1961.
Stuart Preston. An English modern, *New
York Times*. 17 April 1960.
David Storey. Towards colour, *New
Statesman*. 8 March 1963.
VIII Bienal de São Paulo, Brazil, 1965.
Patrick Heron. Exhib. cat. introd. Alan
Bowness.
B. Robertson, J. Russell, Snowdon. *Private
View*. Nilson, 1965.
Robert Hughes. Colour standing up alone,
The Observer. 14 May 1967.
Ronald Alley. Patrick Heron, the
development of a painter, *Studio
International*. July-Aug. 1967 (vol.174).

Museum of Modern Art, Oxford, 1968.
On Patrick Heron's Striped Paintings.
Exhib. cat. introd. Alan Bowness.
Edward Meneeley, Christopher de
Marigny. EM46, Patrick Heron
Retrospective, *ESM Documentations*.
New York 1970.
Hilton Kramer. The American juggernaut,
New York Times. 3 Jan. 1971.
Michael McNay. Heron's nest, profile, *The
Guardian*. 21 June 1972.
Hilary Spurling. East End flame-thrower,
The Observer. 25 June 1972.
Hilton Kramer. Patrick Heron's art on view
in London, *New York Times*. 11 July 1972.
Laurie Thomas. Stirred by a wobbly hard-
edger, *The Australian*, Sydney. 16 June
1973.
James Faure Walker, Brandon Taylor,
interview with Patrick Heron, *Artscribe*.
Spring 1976 (no.2).
John Russell Taylor. High flying Heron,
The Times, preview, 4 Sept.–10 Sept. 1981.
Colin Nears (director). BBC Omnibus film,
Patrick Heron screened 13 March 1983.

Patrick Heron (in his garden at Eagles Nest) 1960,
photograph: Delia Heron

ROGER HILTON
1911–1975

Born Northwood, Middlesex 23 March
1911. Surname at birth was Hildesheim,
family changed it to Hilton 1916 because of
anti-German feeling. Father a cousin of the
art historian Aby Warburg. Slade School of
Fine Art 1929–31, awarded Orpen Bursary
1930. Awarded Slade Scholarship (not
taken up) 1931. Spent about two and a half
years on and off in Paris 1931–9, often
studied at the Académie Ranson under
Roger Bissière. War service 1939–45,
private in the army, partly in the
Commandos; taken prisoner on the Dieppe
raid 1942, prisoner of war 1942–5. Taught
art at Port Regis Preparatory School and
Bryanston 1946–7. Executed first abstract
painting 1950. Simplified the forms in his
work after met the Dutch painter Constant
in London and travelled with him to
Amsterdam and Paris 1953. Taught in the
Department of Drawing and Painting,
Central School of Arts and Crafts, 1954–6.
Visited St Ives 1956 for a few days when
invited to stay at Eagles Nest, Zennor by
Patrick and Delia Heron. Rented space for
studio in building (now a fish and chip
shop) overlooking harbour at Newlyn in
1957, painted in this studio during the
summers of 1957, 1958, 1959 and possibly
1960. Also rented one of the Piazza Studios,
St Ives in later 50s but did not use it much.
Prizewinner at 2nd John Moores Liverpool
Exhibition 1959. Awarded first prize at the
4th John Moores Liverpool Exhibition
1963. Awarded UNESCO prize at XXXII
Venice Biennale 1964. CBE 1968. Moved
from London to Botallack, St Just, West
Penwith November 1965. Confined to bed,
because of peripheral neuritis, from
October 1972, could then only paint in
gouache. Died Botallack 23 February 1975.

Selected one-man exhibitions
Bloomsbury Gallery, 1936; Gimpel Fils,
1952, 1954, 1956; Simon Quinn Gallery,
Huddersfield, 1955; ICA 1958;
Waddington Galleries, 1960–6, 1971, 1974,
1977, 1983; Galerie Charles Lienhard,
Zurich, 1961; Arnolfini, Bristol, 1968; Park
Square Gallery, Leeds, 1972; Compass
Gallery, Glasgow, 1973; Serpentine Gallery
(Retrospective) 1974; Scottish Arts Council
Gallery, Edinburgh, 1974; Orion Gallery,
Penzance, 1974; Gruenebaum Gallery,
New York (Retrospective), 1976; Graves
Art Gallery, Sheffield (tour) 1980; Mendel

Art Gallery, Saskatoon, 1981–2; Leicester Polytechnic Gallery (tour), 1984–5.

Selected group exhibitions
Coronation Exhibition, Agnews, 1937; *Abstract Art*, AIA Gallery, 1951; *British Abstract Art*, Gimpel Fils, 1951; *British Abstract Art*, Galerie de France, Paris, 1952; *Space in Colour*, Hanover Gallery, 1953; *Statements* ICA 1957; *Metavisual, Tachiste, Abstract*, Redfern Gallery, 1957; *50 Ans de Peinture Abstracte*, Galerie Creuze, Paris, 1957; *Dimensions*, O'Hana Gallery, 1957; *Documenta II, Art Since 1945*, Kassel, Germany, 1959; *Four Painters*, Waddington Galleries, 1959; *British Painting 1700–1960*, Moscow (toured to Leningrad), 1960; *Penwith Society of Arts, Tenth Anniversary*, Arts Council tour, 1960; *Recent Paintings by Six British Artists*, (with Merlyn Evans, Alan Davie, Terry Frost, William Gear and Bryan Wynter); British Council, Sorsbie Gallery, Nairobi, 1961; *Kompas 2: Contemporary Painting in London*, Stedelijk Van Abbe Museum, Eindhoven, 1962; Venice Biennale, British Pavilion (with Gwyther Irwin, Bernard Meadows and Joe Tilson), 1964; *54:64, Painting and Sculpture of a Decade*, Tate Gallery, 1964; *British Painting 1952–77*, Royal Academy, 1977; *Hayward Annual*, Hayward Gallery, 1980; *British Drawings and Watercolours*, The People's Republic of China, British Council, 1982; *Alive to It All*, Arts Council/Rochdale Art Gallery (tour), 1983.

Selected bibliography
Writings by Roger Hilton:
ICA, 1958. *Roger Hilton Paintings 1953–7*. Exhib. cat. statement.
Galerie Charles Lienhard, Zurich, 1961. 'Remarks about Painting'. *Roger Hilton*. Exhib. cat.
A letter from Roger Hilton, *Studio International*. March 1974 (vol.187).
Night Letters and Selected Drawings, selected by Rosemary Hilton. Newlyn Orion Galleries Limited, 1980.
'Transcription of Roger Hilton's letter to Terry Frost from a xerox of the original'. Note by Jack Breckenbridge. *Phoebus I, A Journal of Art History*. Art History Faculty, Arizona State University, 1976.

Writings by others:
Patrick Heron. *Roger Hilton, The Changing Forms of Art*. Routledge & Kegan Paul. 1955.
Patrick Heron. Introducing Roger Hilton, *Arts*, New York. May 1957.
Alan Bowness. Roger Hilton, *Cimaise*. Paris, Jan.–Feb. 1963 (no.63).
Norbert Lynton. Waddington Galleries, exhibition, *Studio International*. Nov. 1971 (vol.182).
William Feaver. Some vague impressions, *Art News*. May 1974.
Alan Green. Every artist is a con-man, interview with Roger Hilton, *Studio International*. March 1974 (vol.187).
Norbert Lynton. Review of 'Roger Hilton: Recent drawings and paintings', at Waddington Galleries, *Studio International*. March 1974 (vol.187).
David Brown, Alan Green. Roger Hilton, obituary, *Studio International*. March 1975 (vol.189).
Leicester Polytechnic Gallery, 1984. *Roger Hilton; The Early Years*. Exhib. cat. introd. Adrian Lewis.

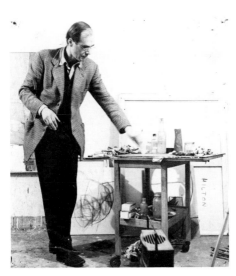
Roger Hilton 1957, photograph: Roger Mayne

MARY JEWELS
1886–1977

Born Newlyn 5 February 1886, name at birth Mary Tregurtha. Married Albert Owen Jewels 1918, he was killed in the 1914–18 war. Sister Cordelia married Frank Dobson. Met Cedric Morris when he was staying at Newlyn 1919, he encouraged her to paint, later met Christopher Wood and Augustus John. Member of the St Ives Society and founder member of the Penwith Society 1949. Died 15 December 1977.

Selected one-person exhibitions
Dorothy Warren Gallery, 1927; Fore Street Gallery, St Ives (with Tony Shiels, Don Reichert, Fred Spratt) 1963; Newlyn Gallery, 1977.

Selected group exhibitions
St Ives Society of Artists, 1930s; Penwith Society, 1949–53; C. and J. Clark Ltd. and Street Society of Arts, Bear Hotel, Somerset, 1954.

Selected bibliography
Alan Bowness. Mary Jewels and naïve painting, *Painter and Sculptor*. Autumn 1958 (vol.1, no.3).
Frank Ruhrmund. Arts and crafts in Cornwall, Mary Jewels. *Cornish Life*. 1976 (vol.3).
Denys Val Baker. Primitive visions, *Country Life*. 16 Aug. 1984.

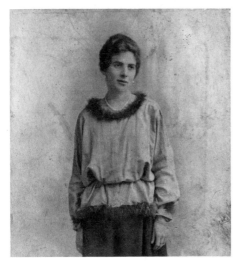
Mary Jewels *c.*1917

PETER LANYON
1918–1964

Born St Ives 8 February 1918. After leaving school had lessons from Borlase Smart who taught him to work out of doors 1936. Penzance School of Art 1936–7. Met Adrian Stokes 1937 Studied for four months at Euston Road School 1938. Met Nicholson, Hepworth and Gabo 1939, received twice-weekly lessons from Nicholson and was much encouraged by Gabo. Made first construction 1939–40. War service in Royal Air Force 1940–45. Founder member of the Crypt Group 1946. Founder member of Penwith Society, 1949, resigned May 1950 over issue of dividing membership into traditional/figurative and modern/abstract groups. Taught at Bath Academy of Art, Corsham 1950–7. 'Porthleven' commissioned 1950 by Arts Council for Festival of Britain exhibition, *Sixty paintings for '51*, bought by The Contemporary Art Society and presented to the Tate Gallery 1953. Elected member Newlyn Society 1953. Italian Government Scholarship 1953. Visited New York 1957 and met Rothko and Motherwell. Ran St Peter's Loft Art School, St Ives with William Redgrave 1955–60. Began gliding 1959. Executed mural for Liverpool University 1960. Chairman Newlyn Society of Artists 1961. Mural Commission for Stanley Seeger's house, New Jersey 1962. Completed mural for Birmingham University 1963. Died Taunton 31 August 1964 as a result of injuries in gliding accident in Somerset.

Selected one-man exhibitions
Lefevre Gallery, 1949; Downing's Bookshop, St Ives, 1947–1951; Gimpel Fils, 1952, 1954, 1958, 1960, 1962, 1968, 1975, 1983; City Art Gallery, Plymouth (toured to Nottingham), 1955; Catherine Viviane Gallery, New York, 1957, 1959, 1962, 1963, 1964; São Paulo Bienal, 1961; Sail Loft Gallery, St Ives, 1962; Marion Koogler McNay Art Institute, San Antonio, 1963; Gimpel and Hanover Galerie, Zürich, 1964; Bear Lane, Oxford, 1969; Tate Gallery (Retrospective) (toured to Plymouth, Newcastle-upon-Tyne, Birmingham and Liverpool), 1968; Sheviock Gallery, Torpoint, 1970; Arnolfini, Bristol (toured to Leeds), 1970–1; Basil Jacobs, 1971; Exeter University, 1971; New Art Centre, 1975, 1983; Whitworth Art Gallery, Manchester (Retrospective) (toured to Glasgow, Cambridge, St Ives and Bristol), 1978; Ikon Gallery, Birmingham, 1978; City Museum and Art Gallery, Stoke-on-Trent (toured to Oxford and Plymouth), 1981; Newlyn Art Gallery, 1983; Posterngate Gallery, Hull, 1984.

Selected group exhibitions
New movements in Art, London Museum, Lancaster House, 1942; *Crypt Group*, St Ives, 1946, 1947, 1948; St Ives Society of Artists, St Ives, 1946–9; *Salon des Réalitiés Nouvelles*, Paris, 1947–9; *British Abstract Art*, Gimpel Fils, 1951; *West Country Landscape*, Arts Council tour, 1953; *Space in Colour*, Hanover Gallery, 1953; The Octagon, Bath (with Wynter, Potworowski, Feiler), 1955; *Ten Years of English Lanscape Painting*, ICA, 1956; *Six painters from Cornwall*, Montreal City Art Gallery (toured Canada), 1955–6; *Metavisual, Tachiste, Abstract*, Redfern Gallery, 1957; *Dimensions*, O'Hana Gallery 1957; *British Painting 1700–1960*, Moscow (toured to Leningrad), 1960; *Primitives to Picasso*, Royal Academy, 1962; *Kompas 11, Contemporary Painting in London*, Stedelijk Van Abbe, Eindhoven, 1962; *British Art Today*, San Francisco Museum, (toured to Dallas and Santa Barbara), 1962–3; *British Painting in the Sixties*, Tate Gallery, 1963; *54:64 Painting and Sculpture of a Decade*, Tate Gallery 1964; *British Painting and Sculpture 1960–70*, National Gallery of Art, Washington, 1970; *Cornwall 1945–57*, New Art Centre, 1977.

Selected bibliography
Peter Lanyon. The face of Penwith, *The Cornish Review*. Spring 1950 (no.4).
Peter Lanyon. A sense of place, *The Painter and Sculptor*. Autumn 1962. (vol.5).
Tate Gallery, 1968. *Peter Lanyon*. Exhib. cat. introd. Alan Bowness.
Andrew Causey. *Peter Lanyon: His Painting*. (introd. Naum Gabo). Aidan Ellis, Henley-on-Thames, 1971.
Whitworth Art Gallery, 1978. *Peter Lanyon, Paintings, Drawings and Constructions 1937–64*. Exhib. cat. introd. Andrew Causey.
City Museum and Art Gallery, Stoke-on-Trent, 1981. *Peter Lanyon, Drawings and Graphic Work*. Exhib. cat. introd. Hayden Griffiths.

Peter Lanyon. Offshore in progress (transcription of British Council lecture, 1963, by Adrian Lewis), *Artscribe*. March 1982 (no.34).
Peter Lanyon, Andrew Lanyon. *Cornwall*. Alison Hodge, Penzance, 1983.

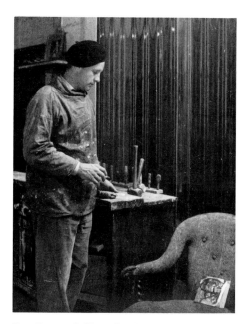

Peter Lanyon (in his studio, Little Park Owles) 1955, photograph: Sheila Lanyon

Bob Law (in his studio, Nancledra) 1958

BOB LAW
b.1934

Born Brentford, Middlesex 22 January 1934. Apprentice architectural designer, studied geometry, trigonometry, perspective drawing and planning at night school. Studied ornithology and oology. Designed and built competition formula gliders and free flight model aircraft 1949–52. National Service, North Africa 1952–4. Started painting in watercolours 1955. Moved to St Ives 1957, worked on and in Fore Street Studio Workshops. Learnt to make clay pots. Modelled in the Leonard Fuller painting school. Met Bernard and Janet Leach, Lanyon, Nicholson and others who encouraged him to paint. Lived in cottage at Nancledra, outside St Ives, which had been occupied by Bell and later by Hilton. Started to write poetry 1959. Made first 'environmental' or 'field' drawings, and all over 'field' paintings 1959. (In the artist's view his development paralleled and later became identified with American Minimalist Art). Met Lawrence Alloway who suggested showing at the ICA. Moved to Richmond 1960, worked on paintings and drawings for his exhibition at the ICA 1960 and for the RBA Situation exhibition 1960. French Government Painting Scholarship, moved to Aix-en-Provence 1961–2. Returned to Froxfield, Hampshire, worked as a shepherd, made furniture as well as painting and sculpture 1962–4. Moved back to Richmond and started the black series of paintings 1964. Visiting Lecturer at Exeter School of Art 1964–7. Arts Council awards 1967, 1975, 1981, GLAA Awards 1979, 1980, 1982. Began making own clothes from canvas off cuts 1967. Moved to Twickenham 1969, built Studio Cottage which gave him enough space to work on the very large white paintings series and the large black drawings. Since 1980 he has concentrated solely on sculpture. Lives and works Twickenham.

Selected one-man exhibitions
Grabowski Gallery, 1962, 1967–8; Christchurch College, Oxford, 1963; Konrad Fischer, Düsseldorf, 1970; Onnasch Galerie, Berlin, 1970; Lisson Gallery, 1971, 1975, 1977, 1980, 1982; Museum of Modern Art, Oxford, 1974; Rolf Preisig Gallery, Basel, 1977; Whitechapel Art Gallery, 1978.

Selected group exhibitions
Two Young British Painters, ICA, 1960; *Situation*, RBA Galleries, 1960; *Paperworks*, Museum of Modern Art, New York, 1970; *Wall Show*, Lisson Gallery, 1971; *Art Spectrum*, Alexandra Palace, 1971; *Seven Exhibitions*, Tate Gallery, 1972; *7 Aus London*, Kunsthalle, Bern, 1973; *Arte Inglese Oggi*, Palazzo Reale, Milan, 1976; *British Artists of the Sixties*, Tate Gallery, 1977; *British Painting 1952–77*, Royal Academy, 1977; *Avant-Garde Russe, Avant-Garde Minimaliste*, Galerie Gillespie-Laage, Paris, 1978; *Art Actuel en Belgique et Grande-Bretagne*, Palais des Beaux Arts, Brussels, 1979; *Aspects of British Art Today*, Tokyo, Metropolitan Art Museum, (tour) 1982; *ROSC*, The Guinness Hop Store, Dublin, 1984; *The British Show*, The Art Gallery of Western Australia, Perth, 1985.

Selected bibliography
Bob Law. *16 Drawings*. Lisson Publications, 1971.
Museum of Modern Art, Oxford 1974. *Bob Law, 10 Black Paintings 1965–70*. Exhib. cat. (Bob Law in conversation with Richard Cork.)
John Walker. Bob Law, *Studio International*. Jan–Feb. 1976 (vol.191).
Fyfe Robinson. 'Robbie' (Transcript of BBC TV interview 15 Aug. 1977), *Art Monthly*. Oct. 1977 (no.11).
Whitechapel Art Gallery, 1978. *Bob Law, Paintings and Drawings 1959–78*. Exhib. cat. introd. Sandy Nairne.
Edward Lucie-Smith. *Art in the Seventies*. Phaidon Press, 1980.
Tim Willis. Viva Panza, *The World of Interiors*. May 1983.

ROGER LEIGH
b.1925

Born Broadwell, Gloucestershire 15 August 1925. War Service in Royal Air Force 1943–7. Trained in architecture and town planning 1947–53. Scholarship to study landscape design, Harvard 1952 (not taken up). Began making sculpture, wood carvings of abstract figures 1948. Arranged to meet Barbara Hepworth at opening of *Unknown Political Prisoner* exhibition Tate Gallery 1953, who took him on as an assistant 1953–4. Hepworth told Leigh that she was glad to take a student under her wing who had not been trained at an art school as she found that they were all trained in the additive process of using clay and so found it difficult to adjust to carving. Member of Penwith Society 1954. Worked as architect for London County Council 1954–7, while being 'a weekend sculptor'. Returned to St Ives 1957 to work part-time for Hepworth for six months. Chairman Penwith Society 1959–61. Worked part-time as architect in Truro 1963–5. Moved to Aldbourne, Wiltshire 1966. Organised *Sculpture in a Landscape* exhibition, Aldbourne, 1969. Chairman Art Panel, Southern Arts Association 1970–3. Moved to Beckington, Somerset 1977 and to Erlestoke, near Devizes 1980 where lives and works, teaching part-time at Exeter School of Art since 1966.

Selected one-man exhibitions
New Vision Centre Gallery, 1964; Arnolfini, Bristol, 1965; Queens Square Gallery, Leeds, 1966; Portsmouth City Art Gallery, Portsmouth, 1968; Ulster

Roger Leigh (with 'Axil') 1964

ALAN LOWNDES

1921–1978

Museum, Belfast, 1971; Photographers Gallery, 1975; Oxford Gallery, Oxford, 1976; Marlborough Library, Wilts., 1977.

Selected group exhibitions
Drian Gallery; 1958; *Penwith Society of Arts, Tenth Anniversary*, Arts Council tour, 1960; *West Penwith Painters and Sculptors*, Arnolfini, Bristol, 1962; *Midland 21*, Nottingham, 1963; *Contemporary British Sculpture*, Arts Council tour, 1966; *Sculpture*, AIA Gallery, 1967; *The English Landscape Tradition in the 20th Century*, Camden Arts Centre, 1969; *Movement*, Lucy Milton Gallery, 1972; *First Day Cover*, Newlyn Art Gallery, 1980.

Selected bibliography
Arnolfini, Bristol, 1965. *Roger Leigh*. Exhib. cat.

Born Stockport, Cheshire 23 February 1921. Left school 14 and apprenticed to a decorator. Army service 1939–45. Various decorating and design jobs Stockport, London and Ireland. Attended evening painting classes Stockport 1945–*c*. 1948. Started painting full time in Stockport and Manchester *c*.1948. Went to St Ives, lived at one time in barn at Tremedda, Zennor, returning to the North for part of each year *c*.1951–9. Married and bought house in St Ives 1959, lived there 1959–64. Lived Halsetown, near St Ives 1964–70. Lived Dursley, Gloucestershire with frequent visits to Cornwall 1970–8. Died Gloucester 22 September 1978.

Selected one-man exhibitions
Crane Gallery, Manchester, 1950, 1952, 1955, 1966; Prospect Gallery, 1956; Crane Kalman Gallery, 1957, 1961–2, 1965, 1968, 1972, 1976, 1984; Osborn Gallery, New York, 1964; Magdalen Street Gallery, Cambridge, 1967; Curlew Gallery, Southport, 1968; Stockport Art Gallery (Retrospective) (tour), 1972; Annexe Gallery, 1977; Penwith Galleries, St Ives, 1979; Atkinson Gallery, Southport, 1979; Royal West of England Academy, Bristol, 1980.

Selected group exhibitions
Artists of Fame and Promise (part II), Leicester Galleries, 1951; *The Innocent Eye*, Crane Kalman Gallery, 1959; *Northern Artists*, Manchester City Art Gallery, Arts Council tour, 1960; *Malerie der Gegenwart aus Sudwestengland*, Kunstverein, Hanover, 1962; *The Englishness of English painting*, Andrew Dickson White Museum, Cornell University, New York, 1963–4; *Artists in Cornwall*, Leicester Museum and Art Gallery, 1965; *Art in Industry*, Walker Art Gallery, Liverpool, 1965; *Cornwall 1945–55*, New Art Centre, 1977; *Landscape in Britain 1850–1950*; Hayward Gallery (and tour), 1983.

Selected bibliography
John Berger. *The New Statesman and Nation*. 2 June 1956.
Eric Newton. Everyday art, *The Guardian*. 14 Dec. 1961.
William Gaunt. Zest of Alan Lowndes, *The Times*. 29 Apr. 1968.
Stockport Art Gallery, 1972. *Alan Lowndes, Paintings 1948–1972*. Exhib. cat. introd.

John Willett, Keith Waterhouse, Alan Lowndes, poem by W.S. Graham. Mr Alan Lowndes, Painter of northern life, *The Times*. 28 Sept. 1978.

Alan Lowndes (with his daughter Amanda) 1961, photograph: Valerie Lowndes

ALEXANDER MACKENZIE
b.1923

Born Liverpool 9 April 1923. Lived in Yorkshire 1932–41. War Service in the army 1941–6. Liverpool College of Art 1946–50. Moved to Newlyn 1950. Taught art in Penzance 1951–64, painting in his spare time. Member of Penwith Society 1952. Moved to Trefrize 1964. Head of Department of Fine Art, Plymouth Art College 1964–84. Moved to Saltash 1976 where lives and works.

Selected one-man exhibitions
Waddington Galleries, 1959, 1961, 1963; Durlacher Gallery, New York, 1960, 1962; City Art Gallery, Plymouth, 1965; Newlyn Art Gallery, 1980; Festival Gallery, Bath, 1982.

Selected group exhibitions
Penwith Society from 1952; Daily Express Young Artists Exhibition, 1955; *Graven Image*, Whitechapel Art Gallery, 1959; *Contemporary British Art*, Bradford Art Gallery, 1960, 1964; *21st Watercolour Biennial*, Brooklyn Museum, New York, 1960; Premio Marzotto International Exhibition, Rome, 1962; City Art Gallery, Plymouth (with Denis Mitchell and John Wells), 1975; Orion Gallery, Penzance (with John Wells, George Dannatt), 1975; *Cornwall 1945–1955*, New Art Centre, 1977.

Selected bibliography
Whitechapel Art Gallery, 1963. *Premio Marzotto Award*. Exhib. cat. introd. Herbert Read, Roland Penrose. A. Cumming. Profile of Alexander Mackenzie, *Arts Review*. Oct. 1968 (vol.xx). Richard Mabey (ed.). *Second Nature*. 1984.

Alexander Mackenzie 1960

MARGARET MELLIS
b.1914

Born Wu-Kung-Fu, China 22 January 1914, of Scottish parents. Came to Britain when aged one. Edinburgh College of Art 1929–33. Andrew Grant Post Graduate Award (1 year) and travelling scholarship (1 year), studied in Paris (with Andre Lhote), Spain and Italy 1933–5. Fellowship at Edinburgh College of Art 1935–7. Euston Road School 1938. Married Adrian Stokes 1938. Mellis and Stokes moved to Little Park Owles, Carbis Bay, near St Ives April 1939. Became a constructivist; worked in collage and relief carving 1940–45. Returned to painting 1945. Left Carbis Bay end of 1946 and moved to South of France 1948–50. Married Francis Davison 1948. Moved to Syleham, Suffolk 1950. Started to make colour structures 1963, and reliefs in colour 1970. Moved to Southwold 1976. Started to make driftwood reliefs 1978. Lives and works Southwold.

Selected one-person exhibitions
AIA Gallery, 1958; Scottish Gallery, Edinburgh, 1959; University of East Anglia, Norwich, 1967; Bear Lane Gallery, Oxford, 1968; Grabowski Gallery, 1969; Richard Demarco Gallery, Edinburgh, 1970; Stirling University, 1970; Exeter University, 1970; Basil Jacob's Gallery, 1972; Compass Gallery, Glasgow, 1976; Pier Arts Centre, Stromness, 1982.

Selected group exhibitions
New Movements in Art, London Museum, Lancaster House, 1942; St Ives Society of Artists, St Ives, Summer, 1946; *The Mirror and the Square*, AIA, New Burlington Galleries, 1952; *British Section of the International Guggenheim Award*, Whitechapel Gallery, 1958; *Open Paintings*, Ulster Museum, Belfast (toured to Dublin), 1966; *Art Spectrum*, Arts Council, 1971; *Cornwall 1945–55*, New Art Centre, 1977; *The Women's Art Show, 1950–1970*, Castle Museum, Nottingham, 1982.

Selected bibliography
Pier Arts Centre, Stromness, 1982. *Margaret Mellis*. Exhib. cat. introd. Douglas Hall.

Margaret Mellis (with Telfer at Little Park Owles) 1942, photograph: Bunyard-Ader Studio

JOHN MILNE
1931–1978

Born Eccles, Lancashire 23 June 1931.
Studied electrical engineering at Salford
Royal Technical College 1945, transferred
to the Art School at the Technical College,
specializing in sculpture until 1951.
Academie de la Grande Chaumière, Paris
1952. Became a pupil and later assistant to
Barbara Hepworth late 1952–4. Bought
Trewyn, a building with a garden adjoining
Hepworth's studio 1957. Annual visits to
Greece from 1962. Increased scale of work
in bronze 1966 and began to make reliefs in
bronze and aluminium. Major sculpture
prize in Westward Open Art Exhibition
1971. Died St Ives 24 June 1978.

Selected one-man exhibitions
Crane Gallery, Manchester (with Alan
Lowndes), 1959; Marjorie Parr Gallery,
1969, 1972, 1974, 1975; City Art Gallery,
Plymouth (Retrospective), 1971; Hertford
College, Oxford, 1973; Compass Gallery,
Glasgow (with Roger Hilton), 1973; Austin
Reed/Ströms Gallery, Gothenburg, 1973;
Wills Lane Gallery, St Ives (with William
Scott), 1975, 1977 (with Paul Feiler); Lad
Lane Gallery, Dublin, 1977; Saltram
House, Devon, 1977; Ben Mangel Gallery,
Philadelphia, 1977; Gilbert Parr Gallery,
1978; Alwin Gallery, 1980.

Selected group exhibitions
Penwith Society and Newlyn Society from
1956; Jefferson Place Gallery, Washington
(with Lanyon, Hilton, Frost, Heron,
Wynter, Weschke, Blow), 1959; *Penwith
Society of Arts, Tenth Anniversary*, Arts
Council tour, 1960; *Six West Country
Sculptors*, Plymouth City Art Gallery
(tour), 1967–8; *St Ives Group*, Austin Read
Gallery, 1968, 1971; *St Ives Group*, Bath
Festival, 1969; *Summer Exhibitions of Open
Air Sculpture*, Widecombe Manor, Bath,
1969; *Eight Individuals*, Derby Museum
and Art Gallery, Arts Council tour,
1971–2; *St Ives Retrospective*, Wills Lane
Gallery, St Ives, 1974; *British Art*, Genesis
Galleries, New York, 1976.

Selected bibliography
Marjorie Parr Gallery, 1969. *John Milne*.
Exhib. cat. introd. Bryan Robertson.
Plymouth Art Gallery, Plymouth, 1971.
John Milne. Exhib. cat. introd. Bryan
Robertson.

Marjorie Parr Gallery, 1972. *John Milne*.
Exhib. cat. introd. John Milne.
Marjorie Parr Gallery, 1974. *John Milne*.
Exhib. cat. introd. J.P. Hodin.
J.P. Hodin. *John Milne : Sculptor*. Latimer
New Dimensions, 1977.

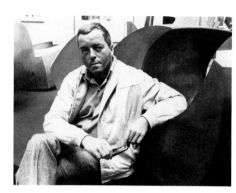

John Milne 1971, photograph: Peter Kinnear

DENIS MITCHELL
b. 1912

Born Wealdstone, Middlesex 30 June 1912.
Family moved to Swansea 1913. Evening
classes Swansea College of Art 1930. Moved
to Barnoon, St Ives 1930, to help renovate a
cottage for an aunt. Started market garden,
St Ives 1938. Tin miner at Geevor, near
St Just 1942–5. Fisherman 1946–8.
Founder member Penwith Society 1949.
Started to sculpt in wood when became
assistant to Barbara Hepworth 1949–59.
Chairman Penwith Society 1955–7. Started
Porthia Textile Prints 1957–60. First
sculptures in bronze 1959. Part-time
teacher Penzance Grammar School, then
Redruth School of Art 1960–67. Arts
Council Award 1966. Stopped teaching to
sculpt full-time 1967. British Foreign Office
sculpture commission, ZELAH I (bronze)
for presentation to the University of the
Andes, Columbia 1968. Moved from St Ives
to Newlyn 1969. Lecture tour of Columbia
including a month's teaching at University
of the Andes, Bogata 1970. Became member
of Board of Governors, Plymouth Art
College 1973 and Falmouth School of Art
1977. Lives and works Newlyn.

Selected one-man exhibitions
AIA Gallery, 1957; Drian Gallery, 1958;
Waddington Galleries, 1961; Redfern
Gallery, 1962; Deborah Sherman Gallery,
Chicago, 1962; Bianchini Gallery, New
York, 1963; Arnolfini, Bristol, 1963;
Marjorie Parr Galleries, 1967, 1969, 1971;
Richard Demarco Gallery, Edinburgh,
1968; Oxford Gallery, Oxford, 1972, 1974;
Compass Gallery, Glasgow, 1973; National
Museum, Malta, 1973; British Council tour
of Malta, Cyprus, Greece, Yugoslavia,
Malaysia, Indonesia, New Zealand and
Korea, 1973–9; City Art Gallery,
Plymouth, 1974; Alwin Gallery, 1977;
Festival Gallery, Bath, 1978, Glynn Vivian
Art Gallery, Swansea, (Retrospective) 1979.

Selected group exhibitions
Penwith Society, St Ives since 1949; 22
Fitzroy Street, 1951, 1952, 1953; *Abstract
Art*, AIA Gallery, 1951; *The Mirror and the
Square*, AIA, New Burlington Galleries,
1952; 10th Biennial Middleheim, Antwerp,
1969; *Eight Individuals chosen by Bryan
Robertson*, Derby Museum and Art Gallery,
Arts Council tour, 1971–2; *Three Sculptors*,
Newlyn Orion, 1976.

ALICE MOORE
b.1909

GUIDO MORRIS
1910–1980

Selected bibliography
Marjorie Parr Gallery, 1969. *Denis Mitchell*. Exhib. cat. introd. Patrick Heron.
Marjorie Parr Gallery, 1971. *Denis Mitchell*. Exhib. cat. introd. George Dannatt.
Glynn Vivian Gallery, Swansea, 1979. *Denis Mitchell*. Exhib. cat. introd. George Dannatt.

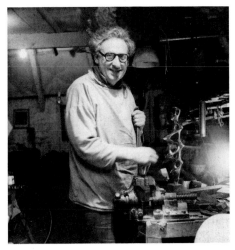

Denis Mitchell 1960

Born Honolulu 3 October 1909, where her mother and father, (who worked for Cable and Wireless) were living. Returned to Cornwall 1913. Penzance School of Art 1928–31, specialised in industrial design (illumination). Art Teacher's Diploma, Brighton College of Art 1931–2. Taught at the County Educational Grammar School, Devizes 1932–5. Studied at the Royal College of Needlework, South Kensington, 1938–9. Moved to St Ives *c*.1939. Member of the Red Rose Guild of Craftsmen and the Crafts Centre of Great Britain for some years. Member of Penwith Society within a few weeks of its foundation. Member of the Devon Guild of Craftsmen. Lives in Lelant.

Selected one-person exhibitions
Downing's Bookshop St Ives, 1948; Arra Gallery, Mousehole (with Miss Neate), 1954. Newlyn Art Gallery, 1960, Penzance Public Library, 1971.

Selected mixed exhibitions
Penwith Society exhibitions, St Ives; Crafts Centre of Great Britain; *Celtic Art Exhibition*, St Ives, 1949; *Festival of Britain Embroidery Exhibition*, St James Palace 1951; *Embroiderers Guild*, R.W.S. Galleries; Whitworth Art Gallery, Manchester; Newlyn Art Gallery; *Penwith Society of Arts, Tenth Anniversary*, Arts Council tour, 1960.

Selected bibliography
David Cox. Exhibition of embroidery by Alice Moore, *St Ives Times*. 20 August 1948. Art embroidery at Newlyn, *The Western Morning News*. 1.8.60.

Alice Moore *c*.1951, photograph: Patrick Hayman

Born Ilford, Essex 3 July 1910. Given the name Douglas (he assumed the name Guido in the early 1930s). Research assistant to biologist Solly Zuckerman in London, later in Oxford. Worked at Bristol Zoo, founded the Latin Press at Langford, Somerset 1935, using a Columbian press of 1843 bought from a local newspaper and 'Aldine' Bembo. First printed broadsheets for Bristol Zoo. Press went into voluntary liquidation 1937. Moved back to the Mendips 1938, then to 15 Cecil Court, London WC2 1938 or 1939, later moved briefly to his sister's teashop 73 Colwyn Road, Northampton, printed eight weekly posters for the Repertory Theatre there. Served in the Royal Army Medical Corps during the war and began to learn Hebrew. After an attempt to set up the press again in London in the basement of the photographer, Angus McBean, Guido Morris moved to St Ives 1946 and established the Latin Press for the seventh time at Carncrows, near the Island. Founder member of Crypt Group, showed with and printed catalogues for exhibitions 1946, 1947. Work on catalogues expanded rapidly with a series of exhibitions at G.R. Downing's bookshop, St Ives, where work by W. Barns-Graham, Sven Berlin, Terry Frost, Barbara Hepworth, Peter Lanyon, Ben Nicholson, Bryan Wynter and others was displayed. Also variety of work locally for businesses including The Leach Pottery, St Austell Brewery, Merlin Theatre Club, Mousehole and the Nance brothers. Continued pre-war contracts in London with Angus McBean, Wildenstein and Co, Art Gallery, Marlborough Gallery and Tate Gallery (for the centenary Pre-Raphaelite exhibition). Some of his finest large scale work in posters was done for London University Drama Society. Founder member of Penwith Society, 1949, printed the invitation card for the first exhibition. Resigned from Penwith Society May 1950. First printed for a commercial publisher and began to get his work printed by (though he set the type) another printer in Marazion, 1950. Began to publish the monthly series *Crescendo Poets* 1951 which ran for eight numbers and included work by Arthur Caddick, John Heath-Stubbs, David Wright and Bernard Bergonzi, as well as poetry by Morris himself. Latin Press went into liquidation 1953, Morris

left St Ives and worked first in a bookshop, later as a reader for Cambridge University Press and finally as a guard on the London Underground from 1956 until retirement 1975. Died London 5 October 1980.

Selected bibliography
Writings by Guido Morris:
The architecture of printing, *British Printer*. July–Aug. 1952, Sept.–Oct. 1952.
My first years as a printer, *Facet*. Autumn 1949 (vol.III).
My work as a printer, *Cornish Review*. Autumn, 1949 (no.3).
Styles of the house: some views on a recent publication, *British Printer*. May–June 1952.

Writings by others:
John Farleigh. *The Creative Craftsman*. 1950 (interview with Morris).
Anthony Baker. The Quest for Guido; F.G.B. Hutchings. Guido Morris, *The Private Library* (Second Series). Winter, 1969 (vol.2).
Roderick Cave. *The Private Press*. 1971.
L.M. Newman. Guido Morris, letter to the editor, *Times Literary Supplement*. 7 Nov. 1980.

DICON NANCE
b.1909

Born Nancledra, near St Ives, 17 October 1909. Worked at the Leach Pottery for a few years in the 1930s. Worked with Michael Cardew at Achimota, Ghana (then the Gold Coast) *c.*1942–5. Joined his brother in re-starting the cabinet making workshop 1946. Founder member of Penwith Society, 1949. Worked in N.E. Thailand teaching for UNESCO at Ubon 1956–9. Assistant to Barbara Hepworth 1959–71. Lives Widecombe.

ROBIN NANCE
b.1907

Born Nancledra, near St Ives 25 March 1907. Worked for and trained under Romney Green, Christchurch, Hampshire 1924–8; one colleague was Eric Sharpe. Studied for about six months at the Central School of Arts and Crafts 1928–9. Started own workshop on the Wharf, St Ives 1933. Army Service 1940–6. With brother Dicon re-started workshop 1946. Paintings by Lanyon and others exhibited in their shop. Founder member of Penwith Society, 1949. Retired from business 1972. Lives St Ives.

Selected group exhibitions
Interceltic Festival Exhibition, St Ives, 1949; Penwith Society exhibitions; Crafts Centre, Hay Hill; Arts and Crafts Exhibiting Society; Red Rose Guild, Manchester; Devon Guild of Craftsmen.

Selected bibliography
Robin Nance. My world as a woodworker, *The Cornish Review* (first series). Summer 1951, (No.8).

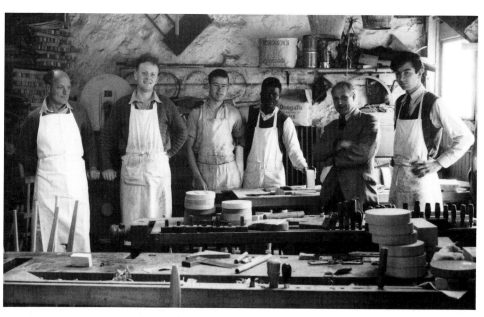

Dicon and Robin Nance (left to right: Dicon Nance, W. James, S. Vallely, A. Onobote, Robin Nance, David Care), *c.*1955 photograph: Studio St Ives

Guido Morris (at the Latin Press, St Ives) *c.*1950

BEN NICHOLSON
1894–1982

Born Denham, Buckinghamshire 10 April 1894, son of William Nicholson and Mabel Pryde. Slade School 1910–11. Travelled in Europe 1911–14. Married Winifred Dacre 1920. Joined Seven and Five Society, 1924, became President 1926. First visit to St Ives with Christopher Wood, discovered Alfred Wallis 1928. Visited France with Barbara Hepworth, met Arp, Brancusi, Picasso, Miro and Calder 1932. First meeting with Mondrian 1933. Joined Abstraction-Création and produced first reliefs 1933. Married Barbara Hepworth. Edited *Circle* with J.L. Martin and Naum Gabo 1937. Invited by Adrian Stokes to stay at Little Park Owles, Carbis Bay, August 1939. Lived Carbis Bay 1939–51 and St Ives 1951–8. Founder member of the Penwith Society. Commissioned to paint a mural for Festival of Britain 1951. First prize for painting at 39th International exhibition at Carnegie Institute 1952. Governor of Tokyo award at 3rd International, Japan 1955. Grand Prix award at 4th International, Lugano 1956. First Guggenheim International Painting prize 1956. International prize for painting at São Paulo Bienial 1957. Married Felicitas Vogler 1957. Moved to Switzerland 1958. OM 1968. Returned to England, Cambridge then London 1972. Died London 6 February 1982.

Selected one-man exhibitions
Adelphi Gallery, 1922; Lefevre Gallery, 1930, 1932, 1935, 1937, 1939, 1945, 1946, 1948, 1950, 1952, 1954; Leeds City Art Gallery (Retrospective), 1944; Durlacher Gallery, New York, 1949, 1951, 1952, 1955, 1956; Detroit Institute of Arts, Dallas and Walker Art Centre, Minneapolis (Retrospective), 1952–3; Venice Biennale, 1954; Stedelijk Museum, Amsterdam (Retrospective) (toured to Paris, Brussels, Zurich and Tate Gallery), 1954–5; São Paulo Bienial, 1957; Gimpel Fils, 1955, 1957, 1959, 1960, 1963, 1973; Galerie Lienhard, Zurich, 1959, 1960, 1962; Kestner Gesellschaft, Hanover, (toured to Mannheim, Hamburg and Essen), 1959, (toured to Lubeck, Munich and Berlin) 1967; Galleria Lorenzelli, Milan, 1960; Andre Emmerich Gallery, New York, 1961, 1965, 1974, 1975; Dallas Museum of Fine Art (Retrospective), 1964; Gimpel and Hanover, Zurich, 1966; Galerie Beyeler,

Basle, 1968, 1973; Crane Kalman, 1968, 1974; Tate Gallery (Retrospective), 1969, 1974; Waddington, 1976, 1980, 1982; Waddington and Tooth Galleries, 1978; Albright Knox Gallery, Buffalo, (Retrospective), (toured to Washington and New York) 1978–9; Tokyo Art Centre, 1982; Kettle's Yard Gallery, Cambridge (toured to Bradford, Canterbury and Plymouth), 1983; Waddington Graphics, 1983; Ateliers Lafranca, Locarno (toured to Mannheim), 1983–4.

Selected group exhibitions
Seven and Five Society Exhibitions, 1924–35; Beaux Arts Gallery (with Christopher Wood and Staite Murray), 1927; Lefevre Gallery (with Winifred Nicholson and Staite Murray), 1928; Arthur Tooth and Sons (with Barbara Hepworth), 1932; Lefevre Gallery (with Barbara Hepworth), 1933; *Cubism and Abstract Art*, Museum of Modern Art, New York, 1936; *English Art*, Stedelijk Museum, Amsterdam, 1936; *Abstract Art*, Stedelijk Museum, Amsterdam, 1938; *Abstract and Concrete*, Lefevre Gallery, 1936; *Constructive Art*, London Gallery, 1937; St Ives Society of Artists, St Ives, 1944–9; Downing's Bookshop, St Ives (with Hepworth, Lanyon and Wells) July 1947; Penwith Society, St Ives, 1949–57; *39th Pittsburgh International Exhibition*, Carnegie Institute, Pittsburgh, 1952; Venice Biennale, (with Francis Bacon and Lucien Freud) 1954; *Statements*, ICA 1957; *Dimensions*, O'Hana Gallery, 1957; *British Art and the Modern Movement: 1930–40*, National Museum of Wales, Cardiff, 1962; *Mondrian, De Stijl and Their Impact*, Marlborough-Gerson Gallery, New York, 1964; *Art in Britain 1930–40, Centred Around Axis, Circle, Unit One*, Marlborough Fine Art, 1965; *3 Back Road West, St Ives; Nicholson, Hepworth, Wallis*, Crane Kalman Gallery, 1966; *British Painting and Sculpture, 1960–70*, National Gallery of Art, Washington D.C., 1970; *Hampstead in the Thirties, a Committed Decade*, Camden Arts Centre, 1974; *Cornwall 1945–55*, New Art Centre, 1977; *The Nicholsons*, Crane Kalman Gallery, 1983.

Ben Nicholson (St Ives harbour) *c.*1952, photograph: Charles Gimpel

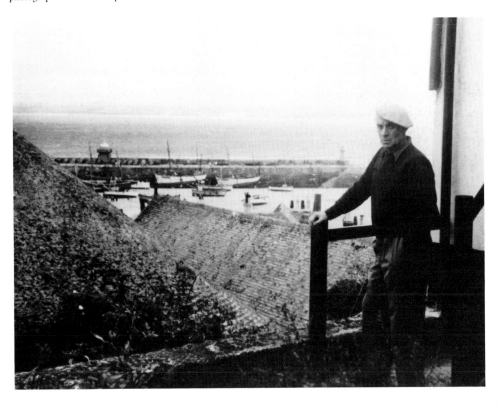

KATE NICHOLSON
b.1929

SIMON NICHOLSON
b.1934

Selected bibliography
Writings by Ben Nicholson:
The aims of the modern artist, *Studio*.
Dec. 1932, (vol.104).
Herbert Read, (ed.). *Unit 1: The Modern Movement in English Architecture, Painting and Sculpture*. 1934.
J.L. Martin, Ben Nicholson, N. Gabo, eds. *Circle: International Survey of Constructive Art*. 1937.
Notes on abstract art, *Horizon*. Oct. 1941 (vol.4).
Alfred Wallis, *Horizon*. Jan. 1943 (vol.7).
Mondrian in London, *Studio International*. Dec. 1966 (vol.172).
Tribute to Herbert Read, *Studio International*. Jan. 1969 (vol.177).
Extracts from letters, Ben Nicholson, *Studio International* (special edition). 1969.

Writings by others:
Herbert Read. *Ben Nicholson: Paintings, Reliefs, Drawings*. Lund Humphries 1948, 1956. vol.1 and 2.
John Summerson. *Ben Nicholson*. Penguin, 1948.
J.P. Hodin. *Ben Nicholson, the Meaning of his Art*. Alec Tiranti, 1957.
Ronald Alley. *Ben Nicholson*. Express Art Books, 1962.
John Russell. *Ben Nicholson, Drawings Paintings and Reliefs 1911–1968*. Thames and Hudson, 1969.
Maurice de Sausmarez. (ed.) Ben Nicholson, *Studio International* (special publication). 1969.
Albright-Knox Art Gallery, Buffalo 1978. *Ben Nicholson: Fifty Years of his Art*. Exhib. cat. introd. Steven Nash.
Kettle's Yard Gallery, Cambridge, 1983. *Ben Nicholson, the Years of Experiment 1919–1939*. Exhib. cat. introd. Jeremy Lewison.

Born Bankshead, Brampton, Cumbria 22 July 1929, only daughter of Ben and Winifred Nicholson. Visited St Ives with parents during childhood, stayed at rented cottage in Parr. Bath Academy of Art 1949–54. Visited Ben Nicholson during war years at Chy-An-Kerris, Carbis Bay. Taught at Totnes High School 1954–6. Went to live in St Ives 1956. Became associate member of Penwith Society 1956, member 1957. Began yearly visits to Greece 1961. Lives and works Cumbria and St Ives.

Selected one-person exhibitions
Waddington Galleries, 1959, 1962; Marjorie Parr Gallery, 1966, 1968, 1970; Border Gallery, Carlisle, 1969; LYC Museum and Art Gallery, Brampton, Cumbria, 1981.

Selected mixed exhibitions
1956 onwards Penwith Society; *Six Young Painters*, Arts Council tour, 1961, *Recent Trends in Painting*, 1963; Bath Festival, 1969; *Women's International*, Edinburgh, 1969; *The Nicholsons*, Crane Kalman, 1983; Wills Lane Gallery, St Ives, 1984.

Selected bibliography
David Irwin. Kate Nicholson, *Art News and Review*. Oct. 1959.
Miss Kate Nicholson takes after her father, *The Times*. 7 Oct. 1959.
Eric Newton. A sudden impulse to create, *The Guardian*. 7 Oct. 1959.
Marjorie Parr Gallery, 1970, *Kate Nicholson*. Exhib. cat.
LYC Museum and Art Gallery, Brampton, Cumbria, 1981. *Kate Nicholson, Harvey Shields, Lawrence Upton*. Exhib. cat. introd. Lawrence Upton.

Kate Nicholson (Samos, Greece) *c*.1955, photograph: Winifred Nicholson

Born Hampstead, London 3 October 1934, (one of triplets), son of Ben Nicholson and Barbara Hepworth. Royal College of Art, Sculpture Department 1953–4; Trinity College, Cambridge (archaeology and anthropology) 1954–7 and research year 1957–8. Lived in St Ives *c*.1961–4. Visiting Professor of Sculpture Moore College of Art, Philadelphia 1964–5, taught in Sculpture Department, University of California, Berkeley 1965–71. Joined teaching staff Open University, Milton Keynes 1971 where he is largely concerned with project-based courses in the practical arts. Lives Oxford.

One-man exhibitions
McRoberts and Tunnard Gallery, 1964; Galeria Van der Voort, San Francisco, 1968; Gallery for Contemporary Art, Pittsburgh, 1969; York University, 1978.

Selected group exhibitions
Play Orbit, ICA, 1970; *First International Video Exhibition*, Museum of Modern Art, Paris, 1974; *Video Legère*, Palais des Beaux-Arts, Bruxelles, 1974; *1er Salon Video*, Palais des Expositions, Geneva, 1974; *Artists' Market: 1st Session*, Warehouse Gallery, 1976; *Art in the Mail*, Manawatu Art Gallery and the QE2, Arts Council tour of New Zealand, Parmerston North, 1976–7. *Zeit, Worte und die Kamera*, Kunstlerhaus, Graz (tour) 1976–7.

Selected bibliography
Cecile N. McCann. The meticulously devised constructions of Simon Nicholson, *Westart*. 2 Feb. 1968.
Jasia Reichardt. Arts: art is not yesterday, *Architectural Design*. May 1978 (vol.XLVI).
Sue Arnold. Now, I don't know much about art, but . . ., *Observer Magazine*. 3 April 1983.
Eleanor Chute. Future shock: students write and draw their visions, *The Pittsburgh Press*. Section B, 5 May 1984 (vol.100).

TONY O'MALLEY
b.1913

Born Callan, County Kilkenny, Ireland
25 September 1913. Worked in bank
1933–58, army service 1940–1. First oil
painting 1945. Painting holiday in St Ives,
worked at St Peter's Loft painting school,
met Lanyon, Wynter and others 1955.
Retired from bank due to ill health 1958.
Settled at St Ives 1960, moved to Gulval,
near Penzance 1962, Penzance 1966, St Ives
1969. Became member of Penwith Society
1962. Work increasingly abstract from 1962.
Awarded the Douglas Hyde Gold Medal by
the Irish Arts Council 1981. Lives and
works St Ives.

Selected one-man exhibitions
Sail Loft Gallery, St Ives, 1961, 1962;
Rawinsky Gallery, 1962; Fore Street
Gallery, St Ives, 1962, 1963; Marjorie Parr
Gallery, 1966; Arts Council of Northern
Ireland Gallery, Belfast (toured to Dublin,
Bath, Truro and Newlyn), 1975; Caldwell
Gallery, Dublin, 1977, 1978; Newlyn
Gallery, Newlyn, 1977; Penwith Gallery,
St Ives, 1979; *Miles Apart*, Ulster
Museum, Belfast (toured Ireland) 1981;
Taylor Galleries, Dublin, 1982, 1983;
Ulster Museum Belfast (Retrospective),
(toured to Dublin and Cork) 1984.

Selected group exhibitions
Oireachtas Gallery, Dublin 1951, 1952,
1953, 1981; Compass Gallery, Glasgow,
1968; Marjorie Parr Gallery, 1972; *Six
Artists from Ireland*, Arts Council/Foreign
affairs, Dublin (tour), 1983.

Selected bibliography
Arts Council of Northern Ireland Gallery,
Belfast, 1975. *Tony O'Malley*. Exhib. cat.
introd. Patrick Heron.
Ulster Museum, Belfast, 1982. *A Personal
Selection: Seamus Heaney*. Exhib. cat.
introd. Seamus Heaney.
Arts Council/Foreign Affairs, Dublin 1983.
Six Artists from Ireland. Tony O'Malley
chap. Brian Fallon. Exhib. cat.
Ulster Museum, Belfast, 1984. *Tony
O'Malley*. Exhib. cat. introd. Brian Fallon.

JOHN PARK
1880–1962

Born Preston 9 November 1880. Moved to
St Ives 1899, studied there under Julius
Olsson and later in Paris at the Atelier
Colarossi. Served in the 1914–18 War. ROI
1923. Awarded Bronze Medal at Paris Salon
1924. Founder Member of the St Ives
Society of Artists 1927. RBA 1932. Lived
most of his life in St Ives which he left in
1952 to live for a short time in Brixham,
then returned to Preston. Died Preston
3 February 1962.

Selected one-man exhibitions
Ruskin Gallery, Birmingham; Penwith
Gallery St Ives, 1983.

Selected group exhibitions
RA 1905–49, Paris Salon, 1924; St Ives
Society of Artists, St Ives, 1927–52.

Selected bibliography
Profile: John Park, *Artist*. Sept. 1935.
(Vol.X).
John A. Park R.O.I. dies Aged 83, *St Ives
Times and Echo*. 16 Feb. 1962.
Penwith Gallery, St Ives, 1983. *John Park*.
Exhib. cat. introd. Roy Ray.

Simon Nicholson *c*.1963

Tony O'Malley (St Ives Harbour) 1962,
photograph: Clive Capel

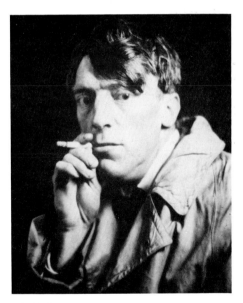

John Park *c*.1920

VICTOR PASMORE
b.1908

Born Chelsham, Surrey 3 December 1908.
Moved to London 1927. Worked in Local
Government, LCC 1927–37. Evening
classes Central School of Art 1927–30.
Joined London Artists' Association 1932
and London Group 1934. Started Euston
Road School with Claude Rogers and
William Coldstream 1937. Taught at
Camberwell School of Art 1943–9, Central
School of Arts and Crafts 1949–54.
Introduced to Ben Nicholson by Terry
Frost 1949. Visited St Ives, stayed in
Heron's rented flat summer 1950. Elected
member of Penwith Society c.1952.
Director of painting, University of
Newcastle upon Tyne 1954–61. Organised
exhibitions of abstract art with Kenneth
Martin and Robert Adams 1951. CBE 1959.
Acquired house and studio in Malta 1966.
Senior RA 1983. Lives and works in Malta.

Selected one-man exhibitions
Cooling Gallery, 1932; Wildenstein, 1940;
Redfern Gallery, 1943, 1948, 1949, 1955;
ICA (Retrospective), 1954; Cambridge Arts
Council Gallery (Retrospective), 1955;
O'Hana Gallery, 1958; Venice Biennale
(toured to major European cities), 1960;
Hatton Gallery, Newcastle upon Tyne,
1960, 1968; Joined Marlborough Galleries
1961, regular exhibitions in London, Zurich
and New York; São Paulo Bienal 1965;
Tate Gallery (Retrospective), 1965;
Galleria Lorenzelli, Milan, 1964; Museum
of Fine Arts, Valletta, Malta 1975; Musée
de Beaux Arts, Chaux de Fords,
Switzerland, 1978; Cartwright Hall,
Bradford (Retrospective) (toured to
Liverpool, Norwich, Leicester, Newcastle
upon Tyne, Royal Academy), 1980.

Selected group exhibitions
Objective Abstractions, Zwemmer Gallery,
1934; London Group, 1948; *Abstract Art*,
AIA Gallery, 1951; *Space and Colour*,
Hanover Gallery, 1953; *This is Tomorrow*,
Whitechapel Gallery, 1956; *Statements*,
ICA, 1957; *Dimensions*, O'Hana Gallery,
1957; *Metavisual, Tachiste, Abstract*,
Redfern Gallery, 1957; *British Painting
1700–1960*, Moscow (toured to Leningrad)
1960.

Selected bibliography
Tate Gallery, 1965. *Victor Pasmore*. Exhib.
cat. introd. Ronald Alley.
Marlborough Galleries, 1977. *Victor
Pasmore*. Exhib. cat. introd. Victor
Pasmore.
Cartwright Hall, Bradford/Arts Council
1980. *Victor Pasmore*. Exhib. cat. introd.
Alastair Grieve.
Alan Bowness, Luigi Lambertini. *Victor
Pasmore*. Thames and Hudson, 1980.

Victor Pasmore c.1953

Bryan Pearce 1974

BRYAN PEARCE
b.1929

Born St Ives, Cornwall 25 July 1929. As a
child suffered from phenylketonuria which
resulted in brain damage. Began drawing
and painting 1953. Studied at St Ives
School of Painting under Leonard Fuller
1954–7. Painted only in watercolour until
1957. Became member of Penwith Society
1957, Newlyn Society 1959. Has lived in
St Ives all his life.

Selected one-man exhibitions
Newlyn Gallery, 1959; Sail Loft Gallery,
St Ives, 1961; St Martin's Gallery, 1962,
1964; Fore St Gallery, St Ives, 1964; Benet
Gallery, Cambridge, 1966; Penwith
Gallery, St Ives (Retrospective), 1966; New
Art Centre, 1966, 1968, 1971, 1973;
Sheviock Gallery, East Cornwall, 1969,
1972; Dartington and The Beaford Art
Centre, North Devon, 1973; Museum of
Modern Art, Oxford, 1975; Wills Lane
Gallery, St Ives, 1977, 1980; Waddington
Gallery, 1978; Newlyn Orion Gallery,
Penzance, 1977; Falmouth Art Gallery,
1982; Stoppenbach & Delestre, 1982;
Montpelier Gallery 1984; Plymouth Art
Centre, 1984.

Selected group exhibitions
UNESCO exhibition, Monte Carlo, 1962;
John Moores exhibition, Liverpool, 1963;
Open Painting, Arts Council of Northern
Ireland, Belfast, 1966; Bath Festival, 1969;
British International Drawing Biennale,
Teeside, Middlesbrough, 1973, 1975.

Selected bibliography
Peter Lanyon. A group of primitives and
naifs, *Studio International*. Nov. 1966
(vol.172).
Museum of Modern Art, Oxford, 1975.
Bryan Pearce. Exhib. cat. introd. Alan
Bowness.
Ruth Jones. *The Path of the Son*. Sheviock
Gallery, Torpoint, 1976.
Dudley Doust, *Sunday Times Magazine*.
24 July 1977.
Falmouth Art Gallery, 1982. *Bryan Pearce*.
Exhib. cat. introd. Heinz Ohff (trans. Henry
Golding).

JACK PENDER
b.1918

Born Mousehole 1 June 1918. Started
painting 1936. Penzance School of Art
1938–9. War service with Duke of
Cornwall's Light Infantry 1939–46. Athens
School of Art 1945–6. Exeter College of Art
1946–9. West of England College of Art,
Bristol 1949–50. Returned to Mousehole
1956. Elected member of Penwith Society
1954, also member of Newlyn Society.
Lives and works Mousehole.

Selected one-man exhibitions
Arnolfini, Bristol 1963, 1967; Sheviock
Gallery, Torpoint 1968; Newlyn Gallery,
1973, 1974; Newlyn Orion Galleries, 1979.

Selected group exhibitions
Penwith and Newlyn Societies from late
1940s; *West Penwith Painters and Sculptors*,
Arnolfini, Bristol 1962; Fore Street Gallery,
St Ives (with Peter Lanyon, Elizabeth
Rainsford, Peter Rainsford) 1964; *Cornwall
1945–55*, New Art Centre, 1977; *Ten
Cornish Artists*, Cuxhaven, 1981; *Three
Men in a Boat*, Chenil Gallery, 1982.

Selected bibliography
Arnolfini Gallery, 1967. *Jack Pender*. Exhib.
cat. introd. Michael Tresillian.
Sheviock Gallery, Torpoint, 1968. *Jack
Pender, Paintings*. Exhib. cat. introd. Jack
Pender.
Orion Galleries Newlyn, 1979. *Jack Pender,
on my Knees*. Exhib. cat. introd. Jack
Pender.

Jack Pender *c.*1959

PETER POTWOROWSKI
1898–1962

Born Warsaw 14 June 1898. Name at birth
Piotr Tadeusz Potworowski. Entered
Warsaw Polytechnic School to study
architecture 1921, transferred to Painting
School 1921. Studied painting Cracow
Academy of Fine Art 1923–4. Lived Paris
1924–30, Poland 1930–9 with visits to
Paris, Holland, Germany and Italy. Lived
Sweden 1940–3. Moved to Scotland, then
to London 1943, where he made contact
with Jankiel Adler. Lived Wookey Hole,
Somerset 1946–8. From 1946 spent several
summers and later winter and Easter
vacations in Cornwall, lived in a cottage
near Sancreed which he continued renting
from Treganhoe Farm until dismantled on
building of reservoir *c.*1958. Last spent time
there 1956–7 preparing for 1958 Polish
Show. Taught at Bath Academy of Art
Corsham 1949–58, where colleagues
included William Scott, Kenneth Armitage,
Peter Lanyon, Bryan Wynter, Terry Frost
and Adrian Heath. Visited Poland with plan
to stay for one year 1958 but decided to stay
permanently. Appointed professor at
Gdańsk and Poznan art colleges. Died
Warsaw 24 April 1962.

Selected one-man exhibitions
Claridge Gallery, 1928; Klub Artystyczny
Polonia, Warsaw, 1931; Warsaw (IPS) and
Lwów, 1938–9; Gripsholm, 1941; Redfern
Gallery, 1946; Gimpel Fils, 1948, 1952,
1954, 1956; National Museum Poznan,
1958, 1962, 1976–7; Galerie Lacloche,
Paris 1962; West of England Academy,
Bristol and Institute of Education 1984.

Selected group exhibitions
XXXVIII Salon des Independents, Paris,
1927; Paris Group Exhibition, Galerie Zak,
Paris, 1930; Group exhibitions in Warsaw,
1932, 1933–4, 1937; *International
Exhibition of Art and Technique* (awarded
silver medal), Paris, 1937; *Exhibition of
work by Polish and Norwegian Painters*,
Stockholm, 1942; The Octagon, Bath, (with
Peter Lanyon, Bryan Wynter and Paul
Feiler) 1955; *Polish Painters in Great
Britain*, Crane Gallery, Manchester, 1955;
Gimpel Fils (with Alan Davie), 1956;
Venice Biennale, 1960; *15 Polish Painters*,
Museum of Modern Art, New York, 1961;
Corsham Painters and Sculptors, Arts
Council, 1965; *Cornwall 1945–55*, New Art
Centre, 1977.

Selected bibliography
David Waring. Poetry in paint, *Art News
and Review*. April 1952.
Norbert Lynton. Painters from Poland,
The Guardian. 8 March 1968.
National Museum Poznan, 1976. *Piotr
Potworowski*. Exhib. cat. introd. Irena
Moderska, Kenneth Coutts-Smith,
Kenneth Armitage.
Royal West of England Academy, Bristol,
1984. *Peter Potworowski 1898–1962*. Exhib.
cat. introd. Adrian Heath.

Peter Potworowski (Land's End) 1947

ADRIAN RYAN
b.1920

Born London 3 October 1920. Architectural
Association 1938–9. Slade School 1939–40.
First visited Cornwall, Padstow, 1943 and
1944. Visited Mousehole 1945 where he
lived until 1951, while still retaining
London studio. Taught at Goldsmiths
College 1948–83. Lived in London 1951–9.
Returned to live in Mousehole 1959 until
1965 since then has lived and worked in
London and Suffolk.

Selected one-man exhibitions
Redfern Gallery, 1943, 1944, 1945, 1948,
1951, 1953, 1983; Tooths, 1956; Minories,
Colchester, 1964; Circle Gallery, 1967;
Calouste Gulbenkian Gallery, Newcastle
upon Tyne, 1968; Search Gallery, 1972;
University of West Virginia, 1978; Gallery
10, 1980.

Selected group exhibitions
London Group, 1942, 1943; 3rd Crypt
Exhibition, St Ives 1948; RA since 1949;
Contemporary English Painting, Bristol,
1950; *Figures in their Setting*, Tate Gallery,
1953; *The Seasons*, Tate Gallery, 1956; *The
Religious Theme*, Tate Gallery, 1958;
Portraits by Contemporary British Artists,
Marlborough Fine Art, 1959; *West Country
Artists*, Kunstmuseum, Hanover, 1962;
Cornwall 1945–1955, New Art Centre, 1977.

Selected bibliography
Patrick Heron. Adrian Ryan, *New
Statesman and Nation*. 17 April 1948.
Patrick Heron. Letter from London,
Magazine of Art. New York, Nov. 1948.
Eardley Knollys. Portrait of the artist, *Art
News & Review*. 8 Oct. 1949.
P.F. Millard. Adrian Ryan, *Art News and
Review*. 22 Oct. 1949.
Patrick Heron. Peter Lanyon and Adrian
Ryan, *New Statesman and Nation*.
15 Oct. 1949.
Patrick Heron. The poetry of colour, *Art
News and Review*. 21 April 1951.

Adrian Ryan *c.*1953

William Scott 1944

WILLIAM SCOTT
b.1913

Born Greenock, Scotland 15 February 1913
of Irish and Scottish parents. Family moved
to Enniskillen, Northern Ireland 1924.
Belfast College of Art, 1928–31. Royal
Academy Schools, first in the Sculpture
School, then transferred to the Painting
School, 1931–5. Painted in Cornwall 1936.
Married fellow student Mary Lucas 1937.
Organised summer painting schools at
Pont-Aven 1937–9. War service in Royal
Engineers, 1942–6. Appointed Senior
Painting Master Bath Academy of Art,
Corsham, 1946. From 1946 spent summers
in Cornwall, mainly at Mousehole. Taught
at summer school in Canada 1953 and
visited New York, met Jackson Pollock, de
Kooning, Rothko and Frans Kline. Stopped
teaching at Corsham 1956 to concentrate on
painting. First prize 2nd John Moores
Liverpool Exhibition 1959. Lived Berlin
1963–4. Moved to farmhouse at Coleford,
near Bath 1965. CBE 1966. ARA 1978. RA
1984. Lives and works at Coleford and
London.

Selected one-man exhibitions
Leger Gallery, 1942, 1945; Leicester
Galleries, 1948, 1951; Hanover Gallery,
1953, 1954, 1956, 1961, 1962, 1963, 1965,
1967, 1969, 1971; São Paulo Bienal, 1953;
Martha Jackson Gallery, New York, 1954,
1956, 1959, 1962, 1973, 1975, 1976, 1979;
Venice Biennale (toured to Paris, Cologne,
Brussels, Zürich and Rotterdam), 1958;
Galleria Galatea, Turin (toured to Milan),
1959; Galerie Charles Lienhard, Zürich,
1959; Kestner-Gesellschaft, Hanover
(toured to Freiburg, Dortmund and
Munich), 1960; Esher Robles Gallery, Los
Angeles, 1961; São Paulo Bienal, (toured to
Rio de Janeiro and Buenos Aires), 1961;
Galerie Schmela, Düsseldorf, 1961;
Kunsthalle, Bern (with Victor Pasmore)
(toured to Belfast), 1963; Galerie
Anderson-Mayer, Paris, 1963; Ford
Foundation, Berlin, 1964; Gimpel and
Hanover Gallery, Zürich, 1966, 1974;
Dawson Gallery, Dublin, 1967; Richard
Demarco Gallery, Edinburgh, 1969;
Scottish National Gallery of Modern Art,
Edinburgh, 1971; Tate Gallery
(Retrospective), 1972; Falchi Arte

Moderna, Milan, 1972; Walter Moos Gallery, Toronto, 1973, 1978; Lister Gallery, Perth, 1973; Gimpel Fils, 1974, 1976, 1978, 1980; Albright-Knox Gallery, Buffalo, 1975; Kasahara Gallery, Japan, 1975, 1976, 1977; Galerie Angst-Orny, Munich, 1976; Fermanagh Museum, Enniskillen, Ireland (toured to Londonderry and Belfast), 1979; Imperial War Museum, 1981; Gimpel and Weitzenhoffer, New York, 1983.

Selected group exhibitions
Space in Colour, Hanover Gallery, 1953; *Nine Abstract Artists*, Redfern Gallery, 1955; *Documenta I: Art of the 20th Century, Kassel*, Germany, 1955; *The New Decade*, Museum of Modern Art, New York, (toured USA), 1955; *The Seasons*, Tate Gallery, 1956; *Documenta II: Art since 1945*, Kassel, Germany, 1959; *British painting in the Sixties*, Tate Gallery, 1963; *54:64 Painting and sculpture of a Decade*, Tate Gallery, 1964; *Documenta III*, Kassel, Germany, 1964; *Dimensions*, O'Hana Gallery 1957; *British Painting 1700–1960*, Moscow (toured to Leningrad) 1960; *Kompas II: Contemporary Paintings in London*, Stedelijk Van Abbe Museum, Eindhoven, 1962; *Corsham Painters and Sculptors*, Arts Council tour, 1965; *British Painting and Sculpture, 1960–1970*, National Gallery, Washington, 1970; *British Painting 1952–77*, RA, 1977; *Cornwall 1945–55*, New Art Centre, 1977.

Selected bibliography
Ronald Alley. *William Scott*. Methuen, 1963.
Alan Bowness. *William Scott: Paintings*. Lund Humphries, 1964.
Edward Lucie Smith. *A Girl Surveyed*. Drawings by William Scott. Hanover Gallery, 1971.
Tate Gallery, 1972. *William Scott: Paintings, Drawings and Gouaches 1938–71*. Exhib. cat. introd. Alan Bowness.
William Scott in conversation with Tony Rothon, *Studio International*. Dec. 1974 (vol.188).
Lou Klepac. *William Scott: Drawings*. David Anderson, New York, 1975.

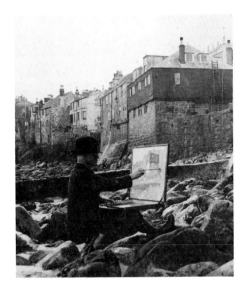

Borlase Smart (The Warren, St Ives) *c*.1930

R. BORLASE SMART
1881–1947

Born Kingsbridge, Devon 11 February 1881. Plymouth School of Art 1897–1900. Royal College of Art 1900–01. Also studied privately with Julius Olsson at St Ives in early years of this century. Art critic for *Western Morning News*, Plymouth 1903–13. Served in the army 2/24th Queen's Regiment and the Artists Rifles Machine Gun Corps 1914–19. Made drawings on the Western Front, but not as an Official War Artist. Met Leonard Fuller 1917. Settled in St Ives 1919. RBA 1919. ROI 1922, Secretary of the St Ives Art Club for some years. Lived at Salcombe, Devon *c*.1925–8. Secretary, St Ives Society of Artists 1934–47, President 1947. Author of *The Technique of Seascape Painting*, 1934, (reprinted 1965), with a foreword by Julius Olsson RA. Designed railway posters. Encouraged Peter Lanyon to begin to paint and gave him lessons 1936. Encouraged artists working in more radical idioms to exhibit with the St Ives Society of Artists from 1944. Instrumental in obtaining the Mariner's Church as an exhibition gallery for the St Ives Society of Artists 1945. Died St Ives 3 November 1947. The Borlase Smart Memorial Trust, bought, with the help of an Arts Council loan, the Porthmeor studios, St Ives for artists to rent. The Penwith Society of the Arts in Cornwall was founded as a tribute to Borlase Smart 1949.

Selected one-man exhibitions
Fine Arts Society, 1917; Lanham's, St Ives, 1919; Penwith Gallery, St Ives, 1949, 1981; City Art Gallery, Plymouth, 1950, 1975.

Selected group exhibitions
RA 1912–47.

Selected bibliography
Martha Smart. *Borlase Smart (1881–1947), The Man and his Work*. St Ives, 1981.

ADRIAN STOKES

1902–1972

Born London 27 October 1902. Studied history, later philosophy, politics and economics at Magdalen College, Oxford 1920–3. Visited India and Far East 1923–4. Started exploration of Italian Quattrocento art, published *The Quattro Cento* (1932), *Stones of Rimini* (1934) and *Colour and Form* (1937). Began painting for the first time in St Ives and Pangbourne 1936. Studied at the Euston Road School 1937. Married Margaret Mellis 1938. Bought Little Park Owles at Carbis Bay early 1939. Stokes and Mellis moved in April. Stokes started a market garden 1939. Nicholson, Hepworth and triplets given hospitality 25 August 1939 and stayed until after Christmas. Cared for Alfred Wallis from 1940, supplied paints and paid for his funeral 1942. Returned to London when marriage broke up in 1946. Married Margaret's sister, Ann Mellis 1947. Published *Cézanne* (1947), *Inside Out, Art and Science* (1949), *Michelangelo* (1955), *Greek Culture and the Ego* (1958), *Monet* (1958), *Painting and the Inner World* (1963). *Reflections on the Nude* (1967). Trustee of Tate Gallery 1960–7. Became a prolific poet 1968. Died of a brain tumour 15 December 1972.

Selected one-man exhibitions
Leger Galleries, 1951; Marlborough Galleries 1965 (with Lawrence Gowing), 1968 (with Keith Vaughan); Tate Gallery 1973; Serpentine Gallery (Retrospective) (toured to Huddersfield and Gloucester) 1982.

Selected group exhibitions
Reid and Lefevre Gallery, 1938; St Ives Society of Artists, St Ives, summer, 1946; *Cornwall 1945–55*, New Art Centre, 1977; *The Hard Won Image*, Tate Gallery, 1984.

Selected bibliography
Guy Burn. Profile: Adrian Stokes, *Arts Review*. Jan. 1965 (vol.17).
Marlborough Galleries, 1965. *Adrian Stokes*. Exhib. cat. introd. Robert Melville.
Adrian Stokes. Richard Wollheim (ed.) *The Image in Form: Selected Writings of Adrian Stokes*. Penguin, 1972.
Adrian Stokes. A drama of modesty: Adrian Stokes on his paintings, *Studio International*. Apr. 1973 (vol.185).
Adrian Stokes. Lawrence Gowing (ed.) *The*

Critical Writings of Adrian Stokes. Thames and Hudson, 1978 (3 vols).
Serpentine Gallery, 1982. *Adrian Stokes*. Exhib. cat. Stephen Bann, Richard Read, other authors ed. David Plante.

Adrian Stokes (with Margaret Mellis and Telfer at Little Park Owles) *c*.1942

JOE TILSON

b.1928

Born London 24 August 1928. Carpenter and joiner 1944–6. RAF 1946–9. St Martin's School of Art, with Auerbach and Kossoff, 1949–52. Royal College of Art 1952–5. Awarded Prix de Rome scholarship 1955. Bought house in the Nancledra area 1957, spent summers there 1958–62. John Moores Liverpool exhibition prizewinner 1957, 1967. Taught at St Martin's School of Art 1958–63. Gulbenkian Foundation Award 1960. Visiting lecturer, Slade School 1962–3. Visiting Fellow, King's College, University of Durham 1963. Taught at School of Visual Arts, New York 1966. Moved to Wiltshire 1970. Visiting lecturer, Staatliche Hochschule für bildende Künste, Hamburg 1971–2. Lives and works in Wiltshire and Italy.

Selected one-man exhibitions
Marlborough Galleries, 1962, 1964, 1966, 1968, 1970, 1971, 1976; Hatton Gallery, Newcastle upon Tyne (toured to Hull, Liverpool and Nottingham), 1963; Lane Gallery, Bradford, 1964; Venice Biennale (toured Europe), 1964; Marlborough Gallery, Rome, 1967; Galerie Brusberg, Hanover, 1968; CAYC, Buenos Aires, 1971; Reading Museum and Art Gallery, 1972; Museum Boymans-van Beuningen, Rotterdam (Retrospective) (toured to Antwerp), 1973–4; Università di Parma (Retrospective), 1974–5; Galeria Krzysztofory, Cracow, 1976; Peterloo Gallery, Manchester, 1978; Tate Gallery, 1978; Waddington Galleries, 1978, 1982; Vancouver Art Gallery (Graphic Retrospective), 1979; Van Straaten Gallery, Chicago, 1979; Joe Wolpe Gallery, Capetown (toured South Africa), 1981; Galerie Kammer, Hamburg, 1982; Studio Marconi, Milan 1982; Studio d'Arte Contemporanea, Dabbeni 1983; Palazzo Minucci-Solaini, Italy, 1983; Arnolfini, Bristol (tour) 1984.

Selected group exhibitions
Young Contemporaries, RBA Galleries, 1950–5; *Kompas II: Contemporary Painting in London*, Stedelijk Van Abbe Museum, Eindhoven, 1962; *British Art Today*, San Francisco Museum (toured to Dallas and Santa Barbara), 1962; *Pop Art*, Hayward Gallery, 1969; *Arte Inglese Oggi*, Palazzo Reale, Milan, 1976; *British*

Painting, 1952–77, RA, 1977; *Englische Kunst der Gegenwart*, Bregenz, 1977; *Prints of the 70's*, National Art Gallery, Wellington (toured New Zealand), 1980.

Selected bibliography
Hatton Gallery, Newcastle upon Tyne, 1963. *Tilson.* Exhib. cat. introd. John Russell.
Christopher Finch. Joe Tilson, *Studio International.* Nov. 1967 (vol.II).
Joe Tilson. *Alchera 1970–76.* La Nuova Foglia, Pollenza-Macerata, 1977.
Arturo Carlo Quintavalle. *Tilson.* Pre-Art, Milan, 1977.
Joseph Wolfe Gallery, Cape Town, 1981.
The Making of Oak Mantra. Exhib. cat. Joe Tilson interview with Dan Cornwall-Jones.
Michael Compton, Gillo Dorfles. *Joe Tilson.* Maestri Contemporanei, Milan, 1982.

Joe Tilson (left to right: Peter Blake, Jake Tilson, Joe Tilson and Jos Tilson) *c.*1960

JOHN TUNNARD
1900–1971

Born Sandy, Bedfordshire 17 May 1900, Royal College of Art and played in jazz bands 1919–23. Textile designer for Tootal Broadhurst Lee Manchester 1923–*c.*1927. Selector of textiles for John Lewis and Co 1928. Gave up commercial work and started painting, became part-time teacher in design at Central School of Arts and Crafts 1929, five months painting in Lizard area of Cornwall *c.*1930. Painted in Cornwall 1931 and 1932. Bought caravan and took it to Cadgwith, near Lizard and rented half a fisherman's loft, started hard-blocked silk industry with wife 1933. Painting became more abstract and influenced by Klee and Miro 1935–6. Served as an auxiliary coastguard at Cadgwith during the war 1940–5. Art master at Wellington College for two or three terms 1946. Moved from Cadgwith to Morvah, near Zennor 1947. Taught design at Penzance School of Art from 1948. Designed mural for Festival of Britain, in temporary restaurant on the South Bank 1951. Moved from Morvah to Lamorna 1953. Elected ARA 1967. Died Cornwall 18 December 1971.

Selected one-man exhibitions
Redfern Gallery, 1933; Guggenheim Jeune, 1939, Nierendorf Gallery, New York, 1944; Bignou Gallery, New York, 1947; Lefevre Gallery, 1947; McRoberts and Tunnard Ltd. 1959, 1961; Durlacher, New York, 1960; Galleria l'Antico, Rome, 1962; Leicester Galleries, 1967; RA, Arts Council tour, 1977; Gillian Jason Gallery, 1984.

Selected group exhibitions
Surrealist section, AIA, 1937; *British Surrealist and Abstract Paintings*, Northampton City Art Gallery, 1939; *New Movements in Art*, London Museum, Lancaster House, 1942; *Contemporary British Art*, British Council/Toledo Museum of Art, Ohio, 1946; *Sixty Paintings for '51*, Arts Council, 1951; *Paintings in Cornwall*, City Art Gallery, Plymouth, 1960; *British Art and the Modern Movement*, National Museum of Wales, Cardiff, 1962; *Malerei der Gegenwart aus Sudenwestengland*, Kunstverein, Hanover, 1962; *The Peggy Guggenheim Collection*, Tate Gallery, 1964–5; *Art In Britain 1930–40 (Centred Around Axis, Circle, Unit One)*, Marlborough Fine Art, 1965; *Cornwall 1945–55*, New Art Centre, 1977;

Dada and Surrealism Reviewed, Hayward Gallery, 1978.

Selected bibliography
Julian Trevelyan. John Tunnard, *London Bulletin.* 15 March 1939 (no.12).
R. Myerscough-Walker. Modern art explained, Part II, *The Artist.* April 1944.
John Anthony Thwaites. The technological eye, *The Art Quarterly.* Detroit Institute of Art, Spring 1946.
Michael Canney. Science and the artist, *Discovery.* Dec. 1959.
Jasia Reichardt. John Tunnard, *Art News and Review.* 5 Dec. 1959.
Herbert Read. The world of John Tunnard, *The Saturday Book – 25.* Hutchinson and Company Ltd, 1965.
RA/Arts Council, 1977. *John Tunnard.* Exhib. cat. introd. Mark Glazebrook, Rudolph Glossop.

John Tunnard (Cadgwith) *c.*1942

BRIAN WALL
b.1931

Born London 5 September 1931. Worked as a glass blower 1945–50. Luton College of Art 1951–2 (while serving in RAF). Lived Paris 1952–3; London 1953–4 doing odd jobs and painting, joined group of painters and poets 'The Hendon Arts Together'. Became interested in work of Ben Nicholson and decided to live in St Ives, moved there 1954. Worked in hotel and restaurant. Showed paintings in Castle Inn 1954. Worked as an assistant two or three days a week to Barbara Hepworth 1955–60. At first made architectonic painted wood constructions, moved to using welded steel 1956. Elected member of Penwith Society 1956. Returned to London 1960. Taught at Ealing College of Art 1961–2 and Central School of Art and Design, 1962–72. Served on National Council for Diplomas in Art and Design, 1966–72 and on Arts Council of Great Britain, Fine Arts panel, 1969–72. Visited New York in 1968 and 1969. Began teaching at University of California, Berkeley 1969. Resigned as Principal Lecturer and Head of Sculpture Department. Central School 1972 and moved to California permanently. Lives and works in Berkeley where he is Professor of Art at University of California.

Selected one-man exhibitions
School of Architecture, 1957; Drian Gallery, 1959, 1961; Grabowski Gallery, 1962, 1964; Manchester City Art Gallery, 1963; Grosvenor Gallery, 1966, 1968; Arnolfini, Bristol, 1967; William Sawyer Gallery, San Francisco, 1971; San Jose State University Gallery, California, 1973; Quay Gallery, San Francisco, 1974; St Mary's College, California, 1974; Braunstein/Quay Gallery, San Francisco, 1976, 1978; Dootson/Calderhead Gallery, Seattle, 1976; University of Nevada, Las Vegas, 1976; Sculpture Now, New York, 1977, 1978; Max Hutchinson Gallery, Houston, 1979; Max Hutchinson Gallery, New York, 1981; Seattle Art Museum (toured to San Francisco Museum of Modern Art), 1982–3; John Berggruen Gallery, San Francisco, 1983;

Selected group exhibitions
4 Sculptors 2 Painters (Leigh, Mitchell, Bruce Taylor, Gwen Leitch and Misome Peile), Drian Gallery, 1958; *Contemporary British Sculpture*, Arts Council, 1958; AIA Gallery (with Benjamin and Tilson), 1960; *British Art Today*, San Francisco Museum of Modern Art (toured to Dallas and Santa Barbara), 1963; *Sculpture of the Sixties*, Tate Gallery, 1965; *Sculpture in the Open*, Battersea Park, 1966; *A Silver Jubilee Exhibition of Contemporary British Sculpture*, 1977; *Aspects of British Art*, British Council tour of New Zealand and Australia, 1966–7; *British Art out of the Sixties*, ICA, 1970; *Public Sculpture/Urban Environment*, Oakland Museum, 1974; *Sculpture in California, 1975–80*, San Diego Museum of Art, 1980; *Eleventh International Sculpture Conference*, Washington D.C., 1980; *British Sculpture in the Twentieth Century, Symbol and Imagination 1951–1980*, Whitechapel Gallery, 1981; *Twelfth International Sculpture Conference*, Oakland, 1982.

Selected bibliography
Charles Spencer, Brian Wall: Sculpture of Simplicity, *Studio International*. March 1966 (vol.171).
Arnolfini, Bristol, 1967. *Brian Wall*. Exhib. cat. statement Brian Wall.
G.S. Whittet. Question and artist: Brian Wall, *Sculpture International*. Oct. 1969 (vol.3).
Seattle Art Museum, 1982. *Brian Wall*. Exhib. cat. introd. Peter Selz, George Neubert.

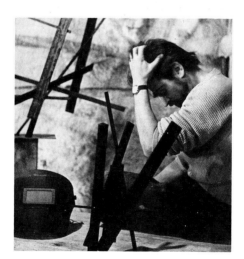

Brian Wall 1958, photograph: Brian Seed

ALFRED WALLIS
1855–1942

Born North Corner, Devonport 8 August 1855. Went to sea at the age of nine as a cabin boy, later became a seaman involved in the fishing trade between Penzance and Newfoundland. Married Susan Ward *c.*1875, his senior by 21 years. Became an inshore fisherman working on Mount's Bay Luggers *c.*1880. Moved to St Ives 1890, gave up fishing and became a marine scrap merchant. Joined the Salvation Army 1904. Retired 1912 and bought 3 Back Road West, St Ives. Death of wife 1922. Started to paint *c.*1925 to the relieve his loneliness. 'Discovered' by Ben Nicholson and Christopher Wood 1928. Moved to Madron Workhouse June 1941. Died 29 August 1942.

Selected one-man exhibitions
Bournemouth Arts Club (Retrospective), 1950; Piccadilly Gallery, 1962; Waddington Galleries, 1965; Dartington Adult Education Centre, 1966; Penwith Gallery, St Ives 1959, 1968, 1974, 1983; Tate Gallery (toured to York, Aberdeen, Kendal), 1968; Playhouse Gallery, Harlow, 1975; Bede Gallery, Jarrow, 1977.

Selected group exhibitions
Seven and Five Society, Arthur Tooth, 1929; Heals, Mansard Gallery (15 Artists and craftsmen from around St Ives), 1951; Penwith Society, St Ives, 1950s; *3 Back Road West, St Ives* Crane Kalman Gallery (with Ben Nicholson and Christopher Wood), 1966; *Christopher Wood, Alfred Wallis from the Wertheim Collection*, Towner Art Gallery, Eastbourne, 1968; Crane Arts (with Elizabeth Allen), 1973.

Selected bibliography
Sven Berlin, Ben Nicholson. Alfred Wallis, *Horizon*. Jan. 1943 (vol.7).
Sven Berlin. *Alfred Wallis, Primitive*. Nicholson and Watson, 1949.
Bournemouth Arts Club, 1950. *Paintings by Alfred Wallis*. Exhib. cat. introd. Ben Nicholson, H.S. Ede.
A.W. Rowe. *The Boy and the Painter*, broadcast on BBC Home Service 2.8.57, printed in the *St Ives Times and Echo* 27.12.57.
David Sylvester. The old man of the sea-piece, *Sunday Times Magazine*. 31 Jan. 1965.
Edwin Mullins. *Alfred Wallis, Cornish*

JOHN WELLS
b.1907

Primitive Painter. Macdonald, 1967.
Tate Gallery/Arts Council, 1968. *Alfred
Wallis*. Exhib. cat. introd. Alan Bowness.
Penwith Gallery, St Ives, 1983. *Alfred
Wallis*. Exhib. cat. introd. Roger Slack,
Tom Cross.

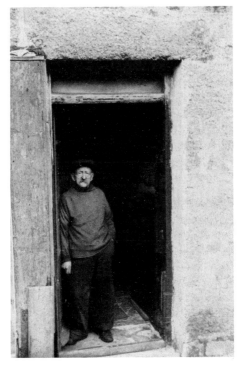

Alfred Wallis *c.*1940,
photograph: Sir John Summerson

Born London 27 July 1907. Lived
Ditchling, Sussex 1908–21. Epsom College
1916–25, University College and Hospital
1925–30, evening classes at St Martin's
School of Art 1927–8. Invited to stay in
Cornwall by cousin, Norman Williams,
1928, met Ben Nicholson and Christopher
Wood. Qualified as a doctor 1930. Hospital
work 1930–6. Medical practice at
St Mary's, Isles of Scilly 1936–45.
Frequent visits to Cornwall during war
years, met Hepworth, Nicholson and Gabo.
Moved to Anchor Studio, Newlyn,
Stanhope Forbes's old studio, 1945.
Co-founder Crypt Group 1946. Founder
member Penwith Society 1949. Worked
briefly with Hepworth 1950–1. Award Arts
Critics' Prize 1958. Lives and works in
Newlyn.

Selected one-man exhibitions
Durlacher Gallery, New York, 1952, 1960;
Waddington Galleries, 1960, 1964.

Selected group exhibitions
New Movements in Art, London Museum,
Lancaster House, 1942; Lefevre Gallery
(with Winifred Nicholson) 1946;
Downing's Bookshop (with David
Haughton), 1949; Crypt Group, 1946–8;
Salons des Réalités Nouvelles, Paris, 1949;
British Abstract Art, Gimpel Fils, 1951;
Ten English Painters, British Council tour of
Scandinavia, 1953–4; *Six Painters from
Cornwall*, Montreal City Art Gallery
(toured Canada), 1955–6; Durlacher
Gallery, New York (with Hazel Janicki),
1958; *Recent British Painting*, Tate Gallery,
1967; Richard Demarco Gallery,
Edinburgh (with W. Barns-Graham,
Campbell Macphail and Denis Mitchell),
1968; Sheviock Gallery, Torpoint (with
Bryan Illsley, Breon O'Casey, Denis
Mitchell), 1970; *Decade '40*, Whitechapel
Art Gallery (Arts Council tour), 1972–3;
*Aspects of Abstract Painting in Britain
1910–1960*, Talbot Rice Art Centre,
Edinburgh, 1974; Plymouth City Art
Gallery, (with Alexander Mackenzie and
Denis Mitchell), 1975.

Selected bibliography
J.P. Hodin. John Wells, *Quadrum 7*.
Brussels, 1959.
J.P. Hodin, The 1958 art critics' prize, *The
Studio*. June 1959 (vol.157).
Plymouth City Art Gallery, 1975. *Alexander
Mackenzie, Denis Mitchell, John Wells*.
Exhib. cat. introd. Alex. A. Cumming.

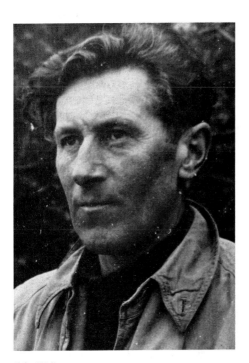

John Wells *c.*1947

KARL WESCHKE
b. 1925

Born Taubenpreskeln, Germany 7 June 1925. When a boy in his hometown, Gera, met Otto Dix, who encouraged him to paint. German Air Force 1942, taken prisoner in Holland and transferred to POW camp in Britain 1945. St Martin's School of Art 1949. Spent several months in Spain where he met members of the Borough Group 1953. Lived nine months in Sweden 1954–5. Moved to Tregerthen Cottages, Zennor 1955, after meeting Bryan Wynter in London. Became a member of Penwith Society 1957. Met Francis Bacon in Cornwall 1959. Moved to Cape Cornwall, St Just 1960. Arts Council Major Award 1976. John Moores prize winner 1978. Southwest Arts Major Award 1978. Arts Council of Great Britain Purchase Award 1980. Lives and works Cape Cornwall.

Selected one-man exhibitions
New Vision Centre Gallery, 1958; Woodstock Gallery, 1959; Matthiesen Gallery, 1960; Arnolfini, Bristol, 1964; Grosvenor Gallery, 1964; Dartington Hall (toured to Bristol) 1968; Exe Gallery, Exeter, 1969; Bear Lane Gallery, Oxford, 1971; Plymouth City Art Gallery (toured to Bristol) 1971–2); Compass Gallery, Glasgow, 1972; Newlyn Art Gallery, 1974; Whitechapel Art Gallery, 1974; Bodmin Fine Arts, Cornwall, 1978; Kettle's Yard Gallery, Cambridge (toured to Bath, Exeter) 1980–1; Moira Kelly Fine Art, 1981; Redfern Gallery, 1984.

Selected group exhibitions
Eleven British Artists, Jefferson Place Gallery, Washington, 1959; *Contemporary British Landscape*, Arts Council tour, 1960; *Malerei der Gegenwart aus Sudwest England*, Kunstverein, Hanover, 1962; *Contemporary Landscape Painting*, Upper Whitechapel Gallery, 1963; *British Painting in the Sixties*, Tate Gallery, 1963; *Impressions on Paper*, Arnolfini, Bristol, 1965; *Art Spectrum (south)*, Arts Council, 1971; *An Element of Landscape*, Arts Council tour (arranged by Arnolfini), 1974; *Artists from the West Country*, Warehouse Gallery, 1976; *Englische Kunst der Gegenwart*, Bregenz, Austria, 1977; *London Group*, 1978; *The British Art Show*, Arts Council, 1979; *Top Ten*, South West Art tour, 1979; *The Subjective Eye*, Midland Group, Nottingham (tour), 1981; *A Mansion of Many Chambers*, Arts Council tour, 1981–2.

Selected bibliography
Writing by Karl Weschke:
Karl Weschke. Artists thoughts on the seventies in words and pictures, *Studio International.* 1981 (No. 991/2 vol.195)

Writing by others:
John Berger. *Three landscapes*, New Statesman. 17 May 1958.
Mr Karl Weschke's triptych, *The Times*, 3 July 1959.
Michael Shepherd. Karl Weschke, *Arts News and Review.* 3 Dec. 1960.
Eric Rowan. Landscape and the forces of nature, *The Times.* 12 Nov. 1969.
City Art Gallery, Plymouth, 1971. *Karl Weschke.* Exhib. cat. introd. Jasia Reichardt.
Arts Council, 1974. *An Element of Landscape.* Exhib. cat. introd. Jeremy Rees.
Whitechapel Gallery, 1974. *Karl Weschke, Paintings of Women, Landscape and Allegory.* Exhib. cat.
Bregenz, 1977. *Englische Kunst der Gegenwart.* Exhib. cat. introd. Oscar Sandner.
Kettle's Yard Gallery, Cambridge, 1980. *Karl Weschke, Paintings and Drawings Since 1974.* Exhib. cat. introd. Jeremy Lewison.
William Packer. Autumn delights, *Financial Times.* 15 Sept. 1981.
John Russell-Taylor. Compassion firmly in check, *The Times.* 16 Sept. 1981.

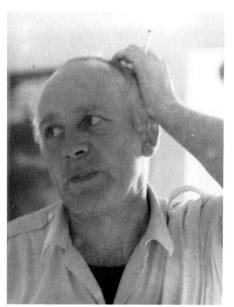

Karl Weschke *c.*1965

CHRISTOPHER WOOD
1901–1930

Born Knowsley near Liverpool 7 April 1901. Liverpool University 1919. Moved to London 1920. Visited Paris 1921, and enrolled at Académie Julian and later Grande Chaumière. Travelled widely 1921–4. Met Picasso 1923 and Jean Cocteau 1924. Designed Diaghilev's *Romeo and Juliet* 1926. First visited St Ives 1926. Met Ben and Winifred Nicholson in London 1926. Joined London Artists' Association 1926. Visited Nicholsons in their home in Cumberland 1928. Stayed at Pill Creek, Feock, near Truro, with Nicholsons, summer 1928; with Nicholson 'discovered' Alfred Wallis. Moved to St Ives, lived near Wallis's cottage in Back Road West, until November 1928. First visited Brittany 1929. Returned to Mousehole Spring 1930. Killed by a train at Salisbury station 21 August 1930.

Selected one-man exhibitions
Arthur Tooth and Sons, 1929; Wertheim Gallery, 1931; Lefevre Gallery, 1932, 1934; New Burlington Galleries (Retrospective), 1938; Redfern Gallery, 1937, 1942, 1947, 1959, (Retrospective), 1965; Scottish National Gallery of Modern Art, Edinburgh, 1966; Maltzahn Gallery, 1969; Mercury Gallery, 1972, 1977, 1981; Kettle's Yard Gallery, Cambridge, 1974; Trumpington Gallery, Cambridge, 1977; Sheffield City Art Galleries, 1977; Towner Art Gallery, Eastbourne (toured to Plymouth), 1977–8; Blond Fine Art, 1979; The Minories, Colchester (Retrospective) (Arts Council tour to Durham, Aberdeen, Eastbourne and Exeter), 1979; New Art Centre, 1983; Parkin Gallery, 1983.

Selected group exhibitions
Seven and Five Society, 1927; Beaux Arts Gallery (with Ben Nicholson and Staite Murray), 1927; *Deux Peintres Anglais*, Georges Bernheim Gallery, Paris, 1930; *3 Back Road West* (with Ben Nicholson and Wallis), Crane Kalman Gallery, 1966.

BRYAN WYNTER
1915–1975

Selected bibliography
John Piper. Christopher Wood, *The Listener*. April 1932.
Eric Newton. *Christopher Wood, his Life and Work*. Redfern Gallery, 1938.
Eric Newton. *Christopher Wood, his Life and Work*. Redfern Gallery, 1959.
Kettle's Yard Gallery, Cambridge, 1974. *Christopher Wood*. Exhib. cat. introd. Alan Bowness, Paul Clough.
The Minories, Colchester/Arts Council, 1979. *Christopher Wood*. Exhib. cat. introd. William Mason.

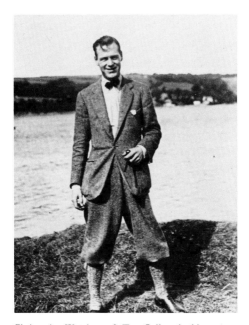

Christopher Wood *c.*1928, Tate Gallery Archives

Born London 8 September 1915. Slade School 1938–40. Conscientious objector during war, worked on the land in Oxford area, partly looking after primates for Sir Solly Zuckermann at Department of Human Anatomy, Oxford University. Moved to St Ives 1945 (had visited West Penwith on holidays before and during the war). Moved to the Carn, Zennor late 1945 or early 1946. Co-founder of the Crypt Group 1946, exhibited in 1946, 1948. Became member of Penwith Society. Married Susan Lethbridge, 1949, who had founded The Toy Trumpet in the Digey St Ives, making toys, 1945. Taught at Bath Academy of Art, Corsham 1951–6. Studio in the Boltons, SW 10 for first ten months of 1956 when his first entirely abstract works were painted. Married Monica Harman 1959. First Kinetic painting IMOOS 1960. Moved to Treverven, St Buryan 1964. Died Penzance 11 February 1975.

Selected one-man exhibitions
Redfern Gallery, 1947, 1948, 1950, 1952, 1955, 1957; Downing's Bookshop St Ives (with Kit Barker), 1948; Waddington Galleries, 1959, 1962, 1965, 1966, 1967, 1974; Galerie Charles Lienhard, Zurich, 1962; Arnolfini, Bristol, 1963; Arts Council Gallery, Belfast, 1966; Sherlock Gallery Tor Point, East Cornwall, 1969; University of Exeter, 1971; Falmouth School of Art (Retrospective), 1975; Hayward Gallery (Retrospective) 1976; New Art Centre, 1981, 1982, 1983; Penwith Galleries, St Ives 1982.

Selected group exhibitions
Crypt Group, St Ives 1946, 1948; St Ives Society of Artists, Summer 1947; *Contemporary English Painting*, Bristol City Art Gallery, 1950; *Sixty Paintings for '51*, Arts Council, 1951; *Contemporary British Watercolours*, Brooklyn Museum (toured U.S.A.), 1953; *Six Painters from Cornwall*, Montreal City Art Gallery (toured Canada), 1955; *Recent Abstract Painting*, Whitworth Art Gallery, Manchester, 1956; *Vision and Reality*, Wakefield City Art Gallery, 1956; *Dimensions*, O'Hana Gallery, 1957; *Abstract Art* (to launch Seuphor's *Dictionary of Abstract Art*) Galerie Creuze, Paris 1957; *Statements*, ICA, 1957; *Metavisual, Tachiste, Abstract*, Redfern Gallery, 1957; *Documenta II*, Kassel, Germany, 1959;

British Painting 1700–1960, Moscow (toured to Leningrad), 1960; *West Penwith Painters and Sculptors* Arnolfini, Bristol, 1962; *British Painting in the Sixties*, Tate Gallery, 1963; *British Paintings '74*, Hayward Gallery, 1974; *British Painting 1952–1977*, RA, 1977.

Selected bibliography
Alan Bowness. The paintings of Bryan Wynter, *Arts Review*. March 1959 (Vol.11).
Falmouth School of Art, 1975. *Bryan Wynter*. Exhib. cat. introd. Patrick Heron.
Patrick Heron. Bryan Wynter, *Studio International*. May 1975 (vol. 189).
Hayward Gallery/Arts Council, 1976. *Bryan Wynter 1915–1975*. Exhib. cat. introd. Alan Bowness, Patrick Heron. Statement Bryan Wynter.

Bryan Wynter 1962, photograph: Peter Kinnear

CATALOGUE NOTE

The catalogue is divided into ten chronological sections, each prefaced by a short introduction. Within each section, artists are arranged in alphabetical order.

Dimensions are given in inches, with centimetres in brackets. Details of the provenance, exhibition history and references to the literature are given in an abbreviated form, and are not exhaustive. They are concentrated on the period 1939–64. Biographies and bibliographies of every artist in the exhibition are to be found on pp. 115–147. These are also sometimes given in an abbreviated form. Numerical references in the introductions to each of the ten sections refer to works in the exhibition.

An index of artists and titles is on p. 224; an index of lenders on p. 243.

Works illustrated in colour are marked * and appear between pages 49 and 96.

CATALOGUE

I BEFORE 1939

In August 1928 Ben Nicholson (1894–1982) and Christopher Wood (1901–1930) visited St Ives and saw the paintings of an old fisherman, Alfred Wallis. These were to be an inspiration to them both, and eventually a talisman to all St Ives artists. Wood and Nicholson and Nicholson's first wife, Winifred, had been staying with friends, the Brumwells, at Pill Creek, Feock, near Truro.

Wood knew St Ives from family holidays as a child, and he had worked there for several weeks two years previously (31). After their day visit, both Wood and Nicholson decided to return and paint on Porthmeor Beach, St Ives, Nicholson staying for three weeks and Wood for three months. These 1928 paintings form the natural prelude to the exhibition: they also show how close in style and subject Wood (33) and Nicholson (6) were at the time. Wood returned to West Cornwall in 1930, shortly before his untimely death, but worked mainly in Mousehole, on the other side of the Penwith peninsula (36–38).

Alfred Wallis (1855–1942) had begun to paint shortly after his wife's death in 1922 – 'for company' as he put it. The interest and encouragement of Nicholson and his friends sustained him: every Wallis in this exhibition first belonged to Winifred or Ben Nicholson, to Wood, to Barbara Hepworth, to Gabo, to Adrian Stokes, to Margaret Mellis or to friends of the Nicholson circle, such as Helen Sutherland, Jim Ede or Cyril Reddihough. Wallis's work was not appreciated by the general run of academic painters of St Ives, who in the 1930s were strongly conservative by temperament and hostile to modernism. The three leading figures in 1939 are represented in the exhibition because, in a modified way, they were exceptions to the general rule, and did something to help the adventurous young. The outstanding St Ives painter of the 1930s was Borlase Smart (1881–1947), Plymouth born, but long resident in St Ives where he had been taught by Julius Olsson. An early member of the St Ives Society of Artists, and for many years its secretary, Smart wrote a definitive book on *The Technique of Seascape Painting* (9). Smart's friend from the first war, Leonard Fuller (1891–1973) had moved permanently to St Ives in 1938, giving up his teaching post at Dulwich College and founding the St Ives School of Painting, which he ran until his death (1). John Park (1880–1962) was the third member of this triumvirate. Working class and Preston-born, he first came to St Ives in 1899 when Olsson helped him, encouraging him to study in Paris. He settled in St Ives in 1923, painting in a post-impressionist manner that was as near as St Ives got to the mainstream of modern art before Nicholson's arrival in 1939 (8).

Away from St Ives itself, but in touch with the newcomers as soon as they arrived in 1939 were two very different painters. John Tunnard (1900–1971) was certainly a modernist who in the 1930s had chosen the relative isolation of West

Cornwall in preference to London (10). In 1939 he was living at Cadgwith on the Lizard peninsula but was to move to Morvah in 1947. Mary Jewels (1886–1977) by contrast was Cornish born, and always lived at Newlyn. Like Wallis, she had no formal art training, but began to paint in 1919 when Cedric Morris gave her paints and canvas. Encouraged by Augustus John and Christopher Wood, she painted sporadically through many years. She shared a small cottage in Newlyn with her sister, Cordelia Dobson, the first wife of the sculptor, who had known Ben Nicholson as a very young painter in London in the years immediately after the 1914–18 war. When the Nicholsons arrived with their children in 1939, she was again in touch with them (2, 3).

LEONARD FULLER

1 **Margarine Still Life** c.1939

Oil on canvas, 14 × 18 (35.6 × 45.7)
Private Collection

This title is a recent invention. Fuller painted a few still lifes; many of his pictures were portraits.

MARY JEWELS

*2 **Cornish Landscape** c.1940–50

Oil on canvas, 20 × 24⅛ (50.8 × 61.2)
Private Collection

According to the artist's sister, Mrs Cordelia Dobson, the artist executed her paintings from memory or imagination. She lived in Newlyn only a few hundred yards from the harbour, working at home. The fields in the *Cornish Landscape* are typical of those seen from the main road from Penzance to St Ives.

MARY JEWELS

3 **Cornubia** c.1940–50

Oil on canvas, 30 × 20 (76.2 × 50.8)
Exh: Newlyn Gallery 1977 (12)
Lit: *Painter and Sculptor*, 1958 (vol.1, no.3.)
Mrs Cordelia Dobson

According to Mrs Cordelia Dobson (September 1984) the picture represents the fertility of Cornwall; there is a reference to the Phoenicians in 502 BC sailing to the Cornubian shore. Cornubia is the Latin word for Cornwall and was used in England in medieval times. There is an inn in Hayle named the Cornubia and in the 1850s a ship of the same name sailing out of Hayle may have carried the name to Bristol where there is now a Cornubia tavern (information Mr L. Nott, Bristol).

BEN NICHOLSON

*4 **Porthmeor Beach** 1928

Oil and pencil on canvas, 35½ × 47¼ (90 × 120)
Prov: Helen Sutherland
Exh: *Seven and Five*, Arthur Tooth and Sons, 1929 (30); *The Helen Sutherland Collection*, Scottish National Gallery of Modern Art, Edinburgh, 1962 (26); Tate Gallery, 1969 (21); Kettle's Yard, Cambridge, 1983 (20, repr. p.21).
Lit: Lund Humphries, pl.27; Russell, pl.17
Helen Sutherland Collection (HCS 96)

Almost certainly painted in London in the winter of 1928–9, shortly after Nicholson's first visit to St Ives with Christopher Wood. Porthmeor is the grandest and most exposed of the St Ives beaches, facing north west. The building at the end of the beach (at the right in the painting) has not survived, and the view across St Ives Bay to Godrevy lighthouse, with the Cornish coast behind it stretching northwards, is not in fact visible from Porthmeor Beach. There may indeed be some confusion here: it is possible that the beach painted by Nicolson is Porthgwidden, not Porthmeor. The boat is a St Ives fishing boat; horses are still ridden on the sand of Porthmeor Beach.

1

3

BEN NICHOLSON

5 Porthmeor Beach 1928–30

Oil on board, 16 × 22⅞ (40.5 × 58)
Exh: Possibly Seven and Five Society,
1929 (30 or 40); *Decade 1920–30*, Arts
Council, 1970 (78)
City of Bristol Museum and Art Gallery

Although it is dated 1930 on the stretcher,
this work was probably begun during or
after the 1928 visit.

BEN NICHOLSON

***6 Porthmeor, Window Looking out
to Sea** 1930

Oil on canvas, 25¼ × 34½ (64 × 87.6)
Prov: Helen Sutherland
Exh: *Helen Sutherland Collection*, Arts
Council, 1970 (56, repr.)
Helen Sutherland Collection (HCS 106)

Probably conceived in the room where
Nicholson stayed in August 1928, in what
was later to be called the Beach Café,
overlooking Porthmeor Beach. This kind of
pictorial composition which uses the
window as a framing device and introduces
still life objects into the foreground was to
become a favourite one of Nicholson's.

BEN NICHOLSON

***7 Cornish Port** *c.*1930

Oil on board, 8½ × 13½ (21.6 × 34.3)
Prov: H.S. Ede
Lit: Lund Humphries, 1, pl. 24
Kettle's Yard, University of Cambridge

Probably not a particular place, but a
picture containing remembered elements of
both Feock and St Ives.

JOHN PARK

***8 Slipway House, St Ives (Chy-an-
Chy)** *c.*1930s

Oil on canvas, 11¾ × 15¾ (29.8 × 40)
Private Collection

This is a descriptive title invented in the
absence of knowledge of the original title.
The view is that from the lower end of Fore
Street looking towards the harbour to the
right. On the left is a sub post office, still in
existence; straight ahead is Slipway House
where Park lived at one time. It was
demolished when a car park was made and
replaced by a smaller building.

BORLASE SMART

9 St Ives from Clodgy 1935

Oil on canvas, 24 × 41¾ (61 × 106)
St Ives Town Council

Clodgy Point is the headland at the south
western end of Porthmeor Beach, about a
mile from the town. We are looking

5

9

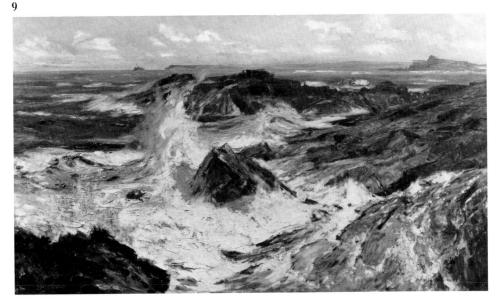

northwards: Godrevy lighthouse can be seen on the horizon, also the end of Porthmeor Beach with the Island at the top right.

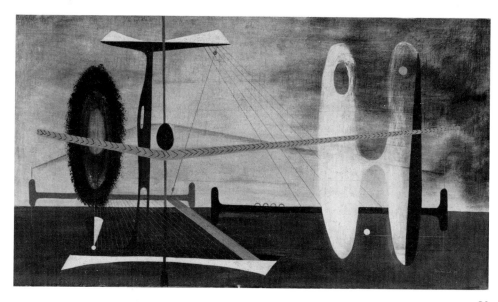

10

JOHN TUNNARD

10 **Fulcrum** 1939

Oil and graphite pencil on hardboard, $17\frac{1}{2} \times 32$ (44.5 × 81.3)
Exh: Guggenheim Jeune, 1939 (22); *British Art and the Modern Movement 1930–40*, Arts Council/Cardiff, 1962 (57); Arts Council/RA Diploma Gallery, 1977 (18, repr); *Dada and Surrealism Reviewed*, Hayward Gallery, 1978 (14.52, repr).
Lit: *London Bulletin*, June 1940, (no.18–20) p.27; *The Tate Gallery, Illustrated Catalogue of Acquisitions, 1978–80*, p.166
Tate Gallery (T 02327)

According to Mark Glazebrook (Arts Council catalogue, 1977) Tunnard's earliest 'non representational' work was made in 1935, the artist deriving his abstractions from natural forms. In *Fulcrum*, Tunnard's interest in surrealism is also evident: the painting has a dream-like quality, and the strange form suggests man-made objects.

ALFRED WALLIS

*11 **Schooner and Lighthouse** *c*.1925–8

Oil and pencil on card, $6\frac{1}{2} \times 12$ (16.5 × 30.5)
Prov: Bought from Wallis by Ben Nicholson for 2/6, when he met the artist for the first time in August 1928; given to present owner in 1958.
Exh: Penwith Society, St Ives, 1959 (28); Arts Council/Tate Gallery, 1968 (99); Penwith Gallery, St Ives, 1983 (45).
Lit: Mullins, pl.40
Private Collection

This was the first picture that Wallis sold. The artist told Ben Nicholson when he bought it that it was one of the first paintings that he had done.

Alfred Wallis painted on pieces of cardboard or wood which he found or was given. He adjusted his compositions to accord with the irregular shape of the supports, and he painted mainly with ship's or household paint, using a limited range of colours. Wallis gave only a few of his pictures titles, most titles are descriptive and have been invented since his death. No exact chronology is possible, but pictures are arranged in an approximate order of composition. Much of the imagery was based on Wallis's memory of things seen as a young sailor, and on the cottages and boats seen in St Ives in the 1920s and 1930s.

Wallis's paintings were collected particularly by H.S. Ede (many of these are now at Kettle's Yard, Cambridge), by Ben and Winifred Nicholson, by Barbara Hepworth and by Adrian Stokes and Margaret Mellis.

ALFRED WALLIS

*12 **St Ives** *c*.1928

Oil, pencil and crayon on cardboard, $10\frac{1}{8} \times 15\frac{1}{8}$ (25.7 × 38.4)
Prov: Given to Ben Nicholson by Wallis 1928
Exh: Possibly Bournemouth Art Club, 1950 (33); Arts Council/Tate Gallery, 1968, (1).
Lit: Horizon, Jan. 1943 (vol.VII, no. 37); Berlin, pl.21; Mullins, pl.1; *The Tate Gallery Report 1966–67*, (*Acquisitions*) pp.43–4
Tate Gallery (T 00881)

Nicholson records (*Horizon* Jan. 1943) 'when looking at one of these paintings of houses into which he put so much affection . . . he said, "Houses – houses – I don't like houses – give me a ship and you can take all the houses in the world".'

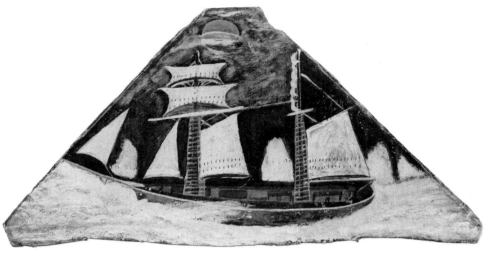

14

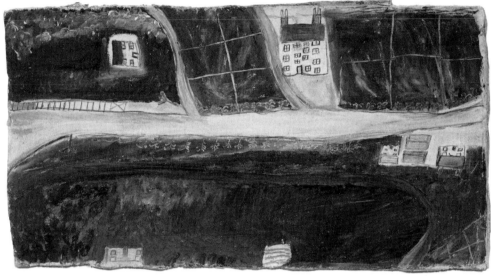

13

ALFRED WALLIS

14 **Sailing Ship and Icebergs**
Oil on card, $12\frac{3}{4} \times 26\frac{1}{4}$ (32.4×66.7)
(irregular)
Prov: Ben Nicholson, Helen
Sutherland
Exhib: Arts Council/Tate Gallery,
1968 (105)
Lit: Mullins, pl.x
Helen Sutherland Collection (HCS 187)

Wallis generally got his cardboard from
Baughan the grocer at St Ives. He
frequently used irregular shapes adapting
his design to fit the shape of the card. The
horizontal half-moon appears in many of
Wallis's paintings.

ALFRED WALLIS

***15** **'St Ives Harbour, Hayle Bay and Godrevy and the Fishing Boats'**

Oil on card, $25\frac{1}{4} \times 18$ (64.1×45.7)
Prov: Winifred Nicholson
Exh: Arts Council/Tate Gallery, 1968
(19)
Lit: Mullins, pl.18
Private Collection

This work depicts St Ives harbour with the
two lighthouses on Smeaton's pier and
Godrevy, Virginia Woolf's lighthouse, in
the top right hand corner, four miles away
across the bay. According to Mullins the
contrast in colour of the water in the open
sea and in the harbour suggests a
comparison between the safety of the
harbour and the perils of the open
sea.

ALFRED WALLIS

16 **The Blue Ship** (Mount's Bay) *c.*1934

Ship's oil paint on cardboard mounted
on plywood, $17\frac{1}{4} \times 22$ (44×56)
Prov: H.S. Ede
Lit: Mullins, pl.13; M. Chamot,
D. Farr, M. Butlin, *The Modern
British, Paintings, Drawings and
Sculpture*, Tate Gallery, 1964, (vol.11)
p.762.
Tate Gallery (T 00291)

Ede purchased this work from Wallis, who
used to post bundles of his work to him,
about 1934. Wallis often made use of the
natural colour of the board and left patches
unpainted. 'i thought it not nessery to paint

Mullins notes that in Wallis's paintings
of the town of St Ives 'the central image is a
curious-shaped house (it is Porthmeor
Square near Wallis's own house). The
house is always depicted from the same
angle, but the rest of St Ives is arranged
around it depending entirely on what he
wished to emphasise.' This house is the
largest feature in this work; in the centre at
the top of Wallis's painting is the chapel on
the Island.

ALFRED WALLIS

13 **Untitled** *c.*1928–30

Oil on cardboard 14×24 (35.6×61)
Prov: Christopher Wood, Ben
Nicholson
Private Collection

When given to the present owner Ben
Nicholson told him that it had belonged to
Christopher Wood.

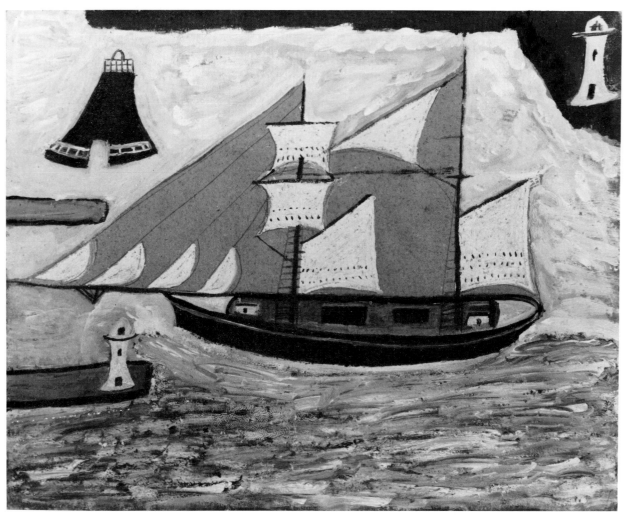

16

it all round so i never Don it' (Letter to Ede 24 April 1929).

 St Michael's Mount is seen in the top left hand part of the picture: the lighthouses are probably those in Mount's Bay.

ALFRED WALLIS

17 **Saltash Bridge**

 Oil on card $11\frac{3}{4} \times 19\frac{3}{4}$ (29.8 × 50.2) (irregular)
 Prov: H.S. Ede
 Exh: Arts Council/Tate Gallery, 1968 (42, repr. pl.XVIII)
 Lit: Mullins, pl.52
 Kettle's Yard, University of Cambridge

Wallis was born in Devonport in 1855. In 1859 I.K. Brunel's Royal Albert Bridge was completed over the River Tamar at Saltash, a few miles away. It was an extraordinary engineering achievement which must have impressed Wallis, as memories of the bridge appear in many of his paintings.

17

18

ALFRED WALLIS

18 **Saltash Bridge and Training Ship**

Oil on card, $14\frac{1}{2} \times 15\frac{1}{2}$ (36.8×39.5)
Prov: H.S. Ede
Exh: Arts Council/Tate Gallery, 1968
(43)
Lit: Mullins, p.53; H.S. Ede, *A Way of Life*, Cambridge University Press, 1984, p.216
Kettle's Yard, University of Cambridge

Wallis has included one of the eighteenth-century hulks that were anchored at Hamoaze, just below Saltash bridge during the last century. Ede notes (op. cit.) the strong contrast between the tossing of the little boats and the solidity of the great bridge.

ALFRED WALLIS

19 **Houses with Horse Rider**

Oil and pencil on thin white card,
$11 \times 7\frac{1}{2}$ (27.9×19)
Prov: H.S. Ede
Exh: Arts Council/Tate Gallery 1968
(58)
Lit: Mullins, pl.65
Private Collection

The same gateway appears in 'Gateway' at Kettle's Yard, Cambridge.

ALFRED WALLIS

20 **Cottages in a Wood, St Ives**

Oil on card, $11\frac{3}{4} \times 18\frac{3}{4}$ (29.8×47.6)
Prov: H.S. Ede
Exh: Possibly Bournemouth, 1950
(39); Arts Council/Tate Gallery, 1968
(78)
Lit: Mullins, pl.50
Kettle's Yard, University of Cambridge

The countryside on the south side of St Ives is well wooded and there are houses and cottages with paths and white gates.

ALFRED WALLIS

*21 **Houses and Trees**

Oil on card, $13\frac{3}{4} \times 26$ (35×66)
Prov: H.S. Ede
Exh: Arts Council/Tate Gallery, 1968
(75)
Lit: Mullins, pl.51
Kettle's Yard, University of Cambridge

Most of the country scenes are not identifiable, but they are almost certainly based on things remembered.

ALFRED WALLIS

*22 **'The Hold House port mear square island port mear Beach'**

Oil on cardboard, $12 \times 15\frac{1}{4}$
(30.5×38.5)
Prov: Purchased from the artist by Barbara Hepworth
Exh: Arts Council/Tate Gallery, 1968
(5, repr. pl.XIII)
Lit: Mullins, pl.14; *The Tate Gallery Acquisitions 1968–9*, p.27
Tate Gallery (T 01087)

Wallis' own title was discovered in 1969

19

when the picture was temporarily removed from the painted board on which it had been mounted. This also showed that the picture had been painted on the back of a printed advertisement for an exhibition of the St Ives Society of Artists at the Porthmeor Gallery.

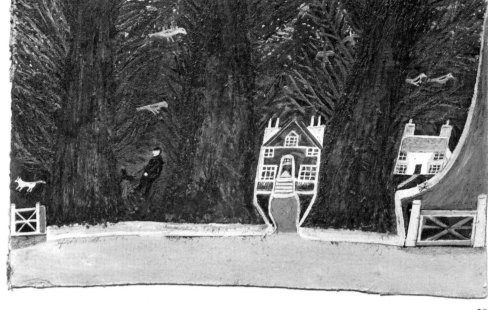

20

ALFRED WALLIS

23 Four Boats Sailing before the Wind 1938 or before

Oil on wood panel, $4\frac{3}{8} \times 16\frac{5}{8}$
(11×42.3)
Exh: Arts Council/Tate Gallery, 1968
(165)
Margaret Mellis

Margaret Mellis purchased this work from Wallis in 1938.

ALFRED WALLIS

24 St Ives with Godrevy Lighthouse

Oil and pencil on card, $6\frac{3}{4} \times 37\frac{1}{2}$
(17×95)
Prov: Adrian Stokes
Exh: Possibly Bournemouth, 1950
(73); Arts Council/Tate Gallery, 1968
(15)
Lit: Mullins, pl.III
Private Collection

This is one of Wallis's broadest views of St Ives Bay. From left to right – Porthmeor Beach, the Island, St Ives Harbour, the seine nets off Porthminster, Hayle Estuary with Godrevy Lighthouse and the cliffs and rocks beyond up the coast to Portreath.

ALFRED WALLIS

25 Houses in St Ives

Oil, chalk and pencil on card, $7\frac{3}{4} \times 10\frac{3}{8}$
(19.5×26.3)
Prov: Ben Nicholson
Exh: Arts Council/Tate Gallery, 1968
(2, repr. pl.XII); Penwith Gallery,
St Ives, 1983 (5, repr.)
W. Barns-Graham

Wallis frequently painted the houses near his own home at 3 Back Road West. The larger late Victorian houses built on the hill above the old part of the town appear in the background.

ALFRED WALLIS

***26 'This is Sain Fishery that use to be'**

Oil and pencil on card $16 \times 22\frac{3}{4}$
(40.5×58)
Prov: Barbara Hepworth
Exh: Bournemouth, 1950 (14);
Penwith Society, St Ives, 1959 (6);
Arts Council/Tate Gallery, 1968
(20, repr. pl.IX)
Lit: Berlin, pl.12; Mullins, pl.43
Private Collection

Seine nets were used for pilchard fishing. These large nets were kept anchored near the shore until shoals of pilchards were spotted in the bay; fishermen would then go out in the rowing boats that they kept ready on Porthminster Beach. Wallis saw the decline in seine fishing in the early years of this century. Wallis often thought of his paintings as instructive documents about the old times. 'What i do mosley is what use To Bee out of my own memery what we may never see again as Thing are altered all To gether Ther is nothin what Ever do not look like what it was sence i Can Rember.' (letter to Ede, 6 April 1935).

ALFRED WALLIS

27 The Wreck of the Alba and Life Boat 1938 or after

Oil on card $10\frac{1}{2} \times 13\frac{1}{4}$ (26.5×33.5)
Prov: H.S. Ede

27

28

Exh: Arts Council/Tate Gallery, 1968
(24)
Kettle's Yard, University of Cambridge

On January 31 1938 the Panamanian
steamer Alba bound from Barry to Civita
Vecchia with a cargo of coal ran aground on
Porthmeor Beach. The St Ives lifeboat was
launched to save the Alba's crew, but it
capsized in the storm and was driven on to
the rocks. A line was thrown to the crew and
all the lifeboatmen and all but five of the
Alba's crew were saved. Wallis probably
witnessed the event. Godrevy lighthouse is
not actually visible from Porthmeor Beach,
even at low tide, when the wreckage of the
Alba can still be seen.

ALFRED WALLIS

**28 Untitled (Lighthouse and Six
Boats)**

Oil on cardboard $8\frac{1}{2} \times 11\frac{1}{2}$ (21.5 × 29)
Prov: Naum Gabo
Owen and Sonja Franklin

ALFRED WALLIS

29 Land and Ships

Oil on card $22 \times 27\frac{1}{2}$ (56 × 70)
Prov: Adrian Stokes
Exh: Waddington Galleries, 1965 (39);
Arts Council/Tate Gallery, 1968 (87,
repr. pl.1); Penwith Gallery, St Ives,
1983 (25)
Lit: Mullins, pl.31
Private Collection

Wallis often painted boats sailing close to
the shore and up estuaries.

ALFRED WALLIS

30 Three-Master Barque in Wild Sea

Oil on card, $10\frac{1}{4} \times 14$ (26 × 35.5)
Prov: Adrian Stokes
Exh: Waddington Galleries, 1965 (42);
Arts Council/Tate Gallery, 1968 (126)
Lit: Mullins, pl.16
Private Collection

A late painting according to Adrian Stokes.
Wallis painted many two- and more
masters, some of them perhaps the kind of
ship in which he sailed in his youth.

CHRISTOPHER WOOD

31 China Dogs in a St Ives Window 1926

Oil on board 25 × 30 (63.5 × 76.2)
Prov: Frosca Munster, Winifred
Nicholson
Exh: The New Burlington Galleries,
1938 (168); Arts Council, 1979
(5, repr. p.15)
Private Collection

Probably painted during Wood's first visit
to St Ives in August – October 1926.

CHRISTOPHER WOOD

***32 Porthmeor Beach** 1928

Oil on canvas 18¼ × 21¾ (46.5 × 55.2)
Prov: Michael Parkin
Exh: Crane Kalman Gallery (with Ben
Nicholson, Alfred Wallis) 1966 (15)
Michael Nicholson

Painted from Man's Head, on the path to
Clodgy Point, at very low tide. In the centre
background is the Island, with its Chapel;
the spur of land on which St Ives is built is
seen clearly on the right, with the blue
water of St Ives Bay visible behind the houses.

CHRISTOPHER WOOD

33 Cornish Window Scene 1928

Oil on board 21 × 25 (53.3 × 63.5)
Exh: Possibly The New Burlington
Galleries, 1938 (285); *Modern British
Paintings*, Crane Kalman, 1970–1 (17);
Sheffield City Art Gallery, 1977 (8);
Arts Council, 1979 (15, repr. p.26)
Private Collection

Both Wood and Nicholson painted the sea,
using a window as a framing device, and
introducing still life objects into the
foreground of their pictures. This was
probably painted from a window
overlooking Porthmeor Beach. The steamer
may show Wallis's influence.

CHRISTOPHER WOOD

34 Fishermen, The Quay, St Ives 1928

Oil on canvas, 25 × 30 (63.5 × 76.2)
Prov: Mrs York Baker
Exhib: The New Burlington Galleries,
1938 (282); Redfern Gallery, 1959
(40); Arts Council, 1979 (16, repr. p.22)
Aberdeen Art Gallery

33

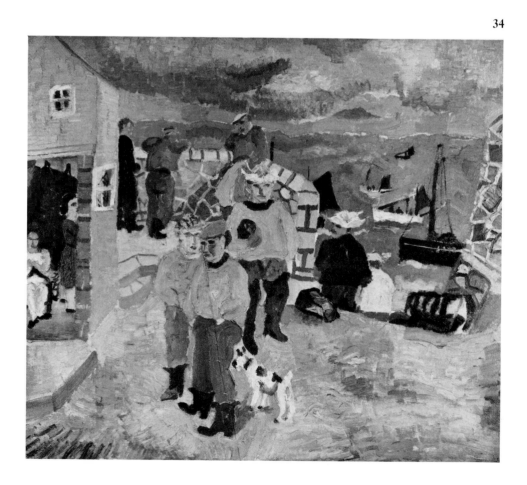

34

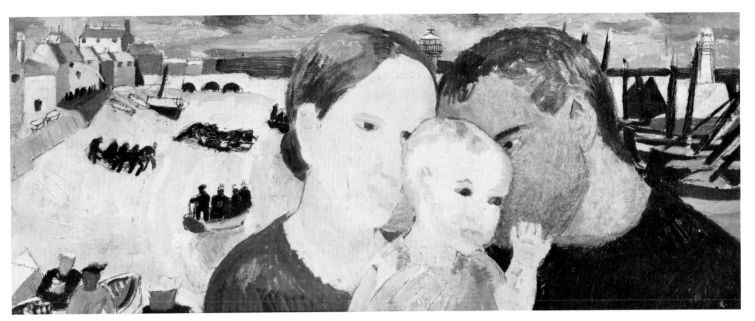

35

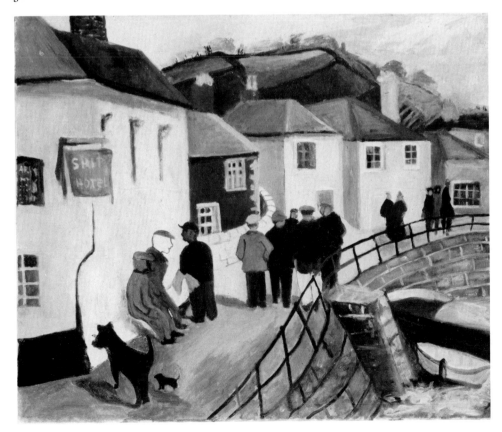

36

CHRISTOPHER WOOD

35 The Fisherman's Farewell 1928

Oil on panel 11 × 27½ (27.9 × 70)
Exh: The New Burlington Galleries,
1938 (254); Redfern Gallery, 1959 (3);
Sheffield City Art Gallery, 1979 (11);
Arts Council, 1979 (10).
Sir Michael Culme-Seymour, Bart.

The fisherman and his wife and child are in
fact portraits of Ben and Winifred
Nicholson, and their elder son, Jake. In the
background is the harbour beach of St Ives,
with Smeaton's pier and lighthouse.

CHRISTOPHER WOOD

36 Ship Hotel, Mousehole 1928

Oil on canvas, 19⅝ × 25¼ (50 × 64)
Exh: Arts Council, 1979 (19, repr.
p.19)
Private Collection

CHRISTOPHER WOOD

***37 The Harbour, Mousehole** 1930

Oil on canvas 19¼ × 25 (49 × 63.5)
Exh: Sheffield City Art Gallery, 1977
(10); Arts Council, 1979 (41, repr. p.7).
Glasgow Art Gallery and Museum

The harbour at Mousehole is a small and
enclosed one, surrounded on two sides by
houses and cottages. The Cornish landscape
in the background is very similar to the
landscape in Wood's earlier Cumbrian
paintings.

CHRISTOPHER WOOD

38 PZ 134 Cornwall 1930

Oil on hardboard $19\frac{3}{4} \times 27\frac{1}{4}$ (50×69.3)
Prov: Lucy Wertheim
Exh: Wertheim Gallery, 1931 (16);
The New Burlington Galleries, 1938
(433); Redfern Gallery, 1959 (61);
Sheffield City Art Gallery, 1977
(15, repr.); Arts Council, 1979
(47, repr. p.31)
Lit: Eric Newton, 1938, pl.433
The Towner Art Gallery, Eastbourne

One of the last of a series of boats in
harbour that Wood painted between
1928–30. PZ refers to Penzance, and
applies to all boats sailing out from
harbours between the Lizard and Land's
End. The harbour is probably Mousehole,
with Mount's Bay in the background and
the coastline stretching on to the Lizard.

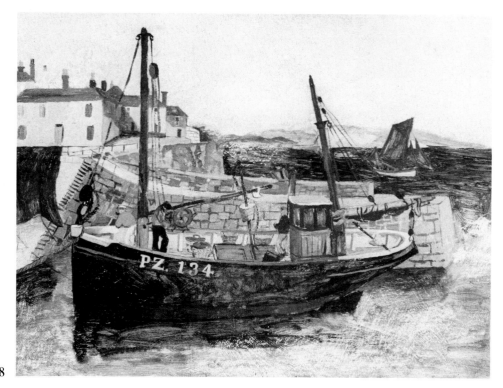

38

II 1939–45 THE WAR YEARS

Ben Nicholson and Barbara Hepworth arrived at Little Park Owles, Adrian Stokes's home in St Ives a fortnight before the Second World War began on 3 September. At the time it was expected that the war would last no more than a few weeks, but families with young children were advised to evacuate London, and the Nicholsons had taken up Stokes's invitation. They were of course old and close friends from Hampstead days, but Stokes had recently married Margaret Mellis, and they had early in 1939 bought a rambling 1920s house in Carbis Bay with room enough for visitors. William Coldstream was also staying there in the first months of the war.

As it became clear that the war was going to last, the Nicholson family first rented a small house, Dunluce, in Wheal Venture Road, Carbis Bay, and then in September 1942 moved to a larger house, Chy-an-Kerris, in Headland Road. Meanwhile Naum Gabo and his wife Miriam had also moved to St Ives in September 1939, and were to stay in a bungalow in Carbis Bay (where their daughter was born) until they left for the United States in November 1946. The Nicholsons had invited Mondrian to London in 1938, and found him a place to live and work in Parkhill Road, Hampstead. They tried to persuade Mondrian to join them in St Ives, particularly when his London studio was damaged by bombing in 1940, but Mondrian did not like the country, and preferred to wait for his ticket to New York.

Stokes, Nicholson, Hepworth and Gabo soon got to know Bernard Leach, who was also living in Carbis Bay, and in war-time conditions and in the isolation of West Cornwall this small group kept alive the ideas of the 1930s that had been so succinctly expressed in the publication, *Circle*. The group was very close, and mutually dependent. Nobody had a proper studio, materials were scarce, world news was often bleak and discouraging. Nicholson, Hepworth and Gabo could only work at first on a very small scale, making projects and maquettes, with the sculptors expressing themselves in painting and drawing. By 1943 however larger works were possible for Nicholson and Hepworth, who had moved into a house which gave each of them a room in which to work.

Nicholson had immediately reacted to the Cornish environment and, parallel with his abstract paintings and reliefs, began to make drawings and paintings of the landscape. It was certainly true that they were relatively easier to sell than the abstract work, and in a very difficult financial climate sales were important. But Nicholson found the Cornish landscape attractive in itself, as did Hepworth, and both were looking for ways in which it could nourish their work without compromising it. Gabo too was tempted into carving granite pebbles, and into extending his ideas into painting.

Four younger artists, two men and two women, were associated with this tight-knit group. Peter Lanyon, St Ives-born, had met Adrian Stokes in 1937, and Stokes took great interest in the young painter, encouraging him to study at the Euston Road School in 1938, and then in September 1939 with Ben Nicholson. Lanyon was also very attracted to the work of Gabo, and when he was called up in 1940 made his small studio available to the older man. Lanyon's

work, both before (58) and after (59) his six years of war service made his allegiances clear. John Wells also remade his contact with Nicholson, who encouraged him to work (72) during what spare time he had as the doctor on the Scilly Isles.

Margaret Mellis produced some remarkable works in the first years of the war (60–1), rather more innovative than those of her husband, Adrian Stokes (71) who was not really to find himself as a painter until the very end of his career. Mellis encouraged a friend of her Edinburgh School of Art days, Wilhelmina Barns-Graham to settle in St Ives in 1940 (39) and she too learnt much from Nicholson who, though never a teacher in any formal sense, had a great influence over the young artists whose work interested him.

W. BARNS-GRAHAM

***39 Island Sheds, St Ives No. 1** 1940

Oil on wood panel, 13 × 16 (33 × 40.5)
Exh: Crypt Group, St Ives, 1947 (87a)
W Barns-Graham

For the first two years or so after arriving in St Ives, W. Barns-Graham did not know many St Ives artists other than Borlase Smart and Bernard Leach. Her artist friends were those at Carbis Bay, Mellis, Stokes, Gabo, Nicholson and Hepworth. Gabo's studio fascinated her and she had never seen work such as his before. The purity of his shapes and being able to see their intersections as a result of being made of transparent material, together with the restricted range of colours used by Wallis in his paintings had a great impact on Barns-Graham. She painted 'Island Sheds, St Ives I' not long after arriving. 'Island Sheds, St Ives I', together with versions II and III were exhibited in the Second Crypt exhibition in 1947. (Discussion with W. Barns-Graham 3.11.84)

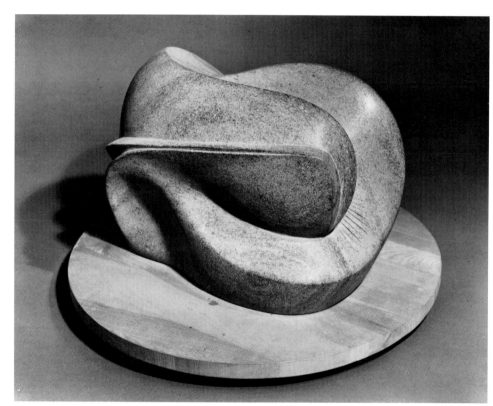

40

NAUM GABO

40 Kinetic Stone Carving 1936–44

Portland stone on wooden turntable, $9\frac{1}{2} \times 14\frac{1}{2}$ (24 × 37)
Exh: Museum of Modern Art, New York, 1948 (12, repr. pp.32–3); New Haven, 1949 (9); Museum of Art, Baltimore, 1950 (2); Chicago Arts Club, 1952 (2); Boymans Museum, Rotterdam, 1958 (7, repr.); Stedelijk Museum, Amsterdam, 1965 (P7, repr.); Tate Gallery, 1966 (11, pl.6b);

Albright-Knox Art Gallery, 1968 (8)
Lit: Read, Martin, pl.55, 56, 108
Private Collection

Gabo started this sculpture whilst living in London and worked on it for several years, completing it in 1944. It is shown in a completed state in a photograph taken of Gabo and Bernard Leach at St Ives in 1944. (Information for this work and all others by Gabo, from Mrs Miriam Gabo and Dr Christina Lodder.)

NAUM GABO

41 Carved Pebbles 1939–46

Stone, $2 \times 3\frac{1}{8} \times 3\frac{9}{16}$ ($5 \times 8 \times 9$),
$1\frac{3}{4} \times 3\frac{3}{4} \times 3\frac{1}{4}$ ($4.5 \times 9.5 \times 8.2$)
Miriam Gabo

Gabo carved from childhood, and on one occasion he carved a brick. He used stone in 'Stone with a Collar' a construction of 1933 (models at the Tate 1930–1) and carved pebbles before he went to Carbis Bay. He always collected pebbles and friends gave him many. When living in Carbis Bay he collected pebbles on beaches west of St Ives and took many to America in 1946.

NAUM GABO

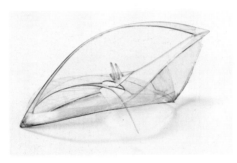

42

42 Spiral Theme (model) 1941

Plastic, $2\frac{1}{2} \times 6\frac{3}{4} \times 4\frac{1}{2}$
($6.3 \times 17.2 \times 11.4$)
Exh: Tate Gallery, 1976–7 (68)
Lit: R. Alley, *Catalogue of The Tate Gallery's Collection of Modern Art, other than works by British Artists*, 1981, p.250
Tate Gallery (T 02181)

The model for no.43. Gabo often made small models for larger sculptures. He frequently made drawings in working out ideas and then when he had arrived at a concept for a sculpture would make it in three-dimensional form, which would not require any modification. From the first idea to realization would sometimes take as long as ten years.

NAUM GABO

***43 Spiral Theme (1st version)** 1941

Plastic, $5\frac{1}{2} \times 9\frac{5}{8} \times 9\frac{5}{8}$ ($14 \times 24.4 \times 24.4$)
Prov: Miss M. Pulsford
Exh: *New Movements in Art, Contemporary Work in England* London Museum, 1942 (L); Tate Gallery, 1966 (14); Tate Gallery 1976–7 (69, repr. pl.40)
Lit: *The Listener*, XXVII, 1942, p.376; Read, Martin, pl.80; R. Alley, *Catalogue of the Tate Gallery's Collection and Modern Art, other than works by British Artists*, 1981, pp. 250-1
Tate Gallery (T 00190)

This piece was preceded by a small model

(no.42). Gabo also made a version for the Museum of Modern Art, New York, which is almost identical in form but has a special base.

Perspex was invented in 1927 and first produced commercially in 1934. In about 1937 Marcus Brumwell introduced Gabo to Dr John Sisson of Imperial Chemical Industries Ltd who showed Gabo some 'Perspex', a very stable plastic compared with 'Rhodoid' which he had used up to that time. On his return home he told his wife 'I have now found my material'.

After he moved to Carbis Bay in 1939 Gabo had the materials and equipment in his studio despatched to him from London. Within a year or two he ran short of some materials, but he was able to obtain further supplies both from Sisson and elsewhere with the intervention and help of Sir Kenneth Clark. Sisson kept in touch with Gabo until Gabo's death and sent him samples of new plastics which might be suitable for making sculpture and advised Gabo on technical problems concerning plastics.

Dr John Sisson (1908–1983) born in Bristol, studied at Bristol University and joined ICI as a chemist at Billinghurst in 1933 and worked in the plastics group being formed then. He became works manager of a small ICI plastics factory in Croydon in 1936 where he worked until 1943. He became Director of the Plastics Division and a member of the General Board of ICI in 1965. (see appreciation of Sisson by Sir Peter Allen in *Headline* (ICI newspaper) 28.10.83.

NAUM GABO

44 Linear Construction No.1 variation winter 1942–3

Plastic with nylon threads,
$13\frac{3}{4} \times 13\frac{3}{4} \times 3\frac{1}{2}$ ($35 \times 35 \times 9$)
Prov: Miss E.M. Pulsford
Exhib: Tate Gallery, 1976–7 (71, repr. pl.41)
Lit: M. Compton, *Optical and Kinetic Art*, 1967, pl.13; R. Alley, *Catalogue of the Tate Gallery's Collection of Modern Art, other than works by British Artists*, 1981, pp.251–2.
Tate Gallery (T 00191)

There are a number of other versions, including some with all four sides curved. This work represents an intermediate stage

between this form and 'Linear Construction No.1, Variation' in the Phillips Collection, Washington, in which the stepped-back treatment of the two sides is much more developed.

Guggenheim would only buy the sculpture if Gabo sold this painting as well. Reluctantly Gabo agreed.

In conversation with Mondrian, who said that he was concerned with 'flatness', Gabo stressed his concern with 'depth' in illusory pictorial space.

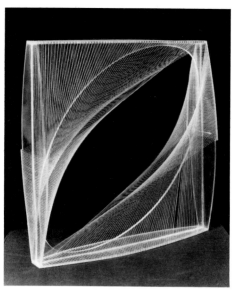

44

NAUM GABO

***45 Kinetic Oil Painting in Four Movements** 1943

Oil on board, $10\frac{1}{2} \times 7\frac{1}{2}$ (26.5×19)
Exh: Museum of Modern Art, New York, 1948 (27); Pierre Matisse Gallery, New York, 1953 (14); Wadsworth Atheneum, Hartford, 1953 (23); Museum Boymans, Rotterdam, 1958 (30); Albright-Knox Art Gallery, Buffalo, 1968 (40).
Lit: Read, Martin, pl.125; Gabo, *Of Divers Arts*, pl.34
Miriam Gabo

In 1940 when he was undecided about whether to go and live in America, Gabo was reluctant to start work on new projects, both sculpture and paintings. Most of the paintings executed in St Ives were done either between 1939 and 1940 or between 1943 and 1946.

Gabo told his wife in about 1943 that he intended to do a series of paintings in pure colours and there is one in yellow, (Guggenheim Museum) (46) and another in green. This work is intended to be viewed with any of its four sides uppermost. Also known as 'Red Painting' and 'Structure in Red'.

NAUM GABO

***46 Painting: Construction in Depths** 1944

Oil on laminated panel, $15 \times 17\frac{7}{8}$ (38×45.5)
Exh: Museum Boymans, Rotterdam, 1958 (26); Stedelijk Museum, Amsterdam, 1965 (S14); Tate Gallery, 1966 (46)
Lit: Read, Martin, pl.123.
Solomon R. Guggenheim Museum, New York

When Gabo arrived in New York in November/December 1946 he went to see Guggenheim to show him some sculpture.

NAUM GABO

***47 Linear Construction in Space No.1** 1944–45

Plastic with nylon threads $12 \times 12 \times 2\frac{1}{2}$ ($30.5 \times 30.5 \times 6.5$)
Prov: Frank and Vera Strawson, Joy Finzi, H.S. Ede
Lit: Museum of Modern Art, New York, 1948. *Gabo, Pevsner* Exhib. cat. pl.43 (different version); Read, Martin, pl.76 (different version).
Kettle's Yard, University of Cambridge

Seventeen other versions exist in different sizes. Others are at Solomon R. Guggenheim Museum, New York; Pier Gallery, Stromness; Tate Gallery and the Hirshhorn Museum and Sculpture Garden, Washington.

Gabo used the technique of stringing for the first time in the initial model for this work which he made in 1938. This version is probably about the fifth that Gabo made. Gabo played chess with Frank Strawson and the Strawsons were in possession of this work by the summer of 1943.

NAUM GABO

48 Turquoise, Kinetic Oil Painting 1945

Oil on canvas, mounted on circular canvas board, $7\frac{7}{8} \times 9$ (20×23)
Diameter of circular board $17\frac{1}{8}$ (43.5)
Exh: Pierre Matisse Gallery New York, 1953 (11); Wadsworth Atheneum, Hartford, 1953 (20); Museum Boymans, Rotterdam, 1958 (28); Stedelijk Museum, Amsterdam, 1965 (S16); Tate Gallery, 1966 (48); Albright-Knox Art Gallery, Buffalo, 1968 (43).
Lit: Read, Martin, pl.120.
Miriam Gabo

Mounted on a motor, intended to be viewed turning.

BARBARA HEPWORTH

49 **Sculpture with Colour Deep Blue and Red** 1940

Plaster, painted white and deep blue, with red strings, height 4 (10.2)
Prov: Ben Nicholson
Exh: *Art in Britain 1930–40*, Marlborough Fine Art, 1965 (ex catalogue); Tate Gallery 1968 (37)
Lit: Gibson, pl.42; Read, pl.61a (9″ version); Hodin, cat. 117.1
Private Collection

This is the first and smallest of a number of plaster sculptures which Hepworth made in 1940. There are four more plasters of larger dimensions, and a final version in wood (no.50). The somewhat stiff geometry relates it to Hepworth's purely abstract works of the 1930s.

BARBARA HEPWORTH

***50** **Sculpture with Colour, Deep Blue and Red** 1940–3

Wood, painted white and deep blue, with red strings, height 16 (40.6)
Prov: U.S. private collection, Carnegie Institute, Pittsburgh.
Exh: Leeds, 1943 (101); Whitechapel, 1954 (37)
Lit: Hodin, cat.118
Private Collection

The final and definitive version of cat. no.49, carved in wood, but painted white and deep blue like all the smaller plaster

versions. Hepworth was not able to make sculptures during the period that she lived at Dunluce (late 1939–September 1942). With the move to Chy-an-Kerris she had a large workroom once again, and this work and cat.no.54 are probably the first to be completed in 1942–3.

BARBARA HEPWORTH

51 **Drawing for Sculpture** 1941

Gouache and pencil on paper on board, $9\frac{1}{2} \times 14$ (24 × 35.5)
Prov: John Wells
Exh: Leeds, 1943; Whitechapel, 1954 (56)
Lit: Read, pl.62a; Hammacher, pl.60
Private Collection

Hepworth was living in a small house in 1940–2, looking after her children and without facilities to make sculpture. Her artistic activity was largely limited to drawing, usually of geometric structures with parts joined to others by lines converging, crossing and diverging. Her interest in Gabo's constructions is obvious: the relationship between the two artists was a fruitful one, with Hepworth encouraging Gabo's interest in direct carving.

BARBARA HEPWORTH

52 **Drawing for Sculpture (Red to Grey)** 1941

Gouache and pencil on paper, $9\frac{1}{4} \times 11\frac{3}{4}$ (23.5 × 30)
Exh: Lefevre Gallery, 1946 (2); Whitechapel, 1954 (58)
Lit: Read, pl.63a
David Lewis

BARBARA HEPWORTH

53 **Forms in Movement** 1943

Gouache and pencil on paper, 13 × 13 (33 × 33)
Prov: Ben Nicholson, Helen Sutherland
Exh: Leeds, 1943; Venice Biennale, 1950; Whitechapel, 1954 (68)
Lit: *Horizon*, 1943 (vol.VII, no.42); Gibson, pl.45
Helen Sutherland Collection (HCS 28)

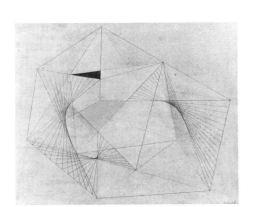

52

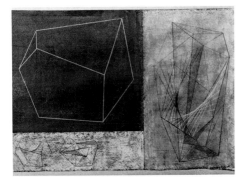

51

53

BARBARA HEPWORTH

***54 Sculpture with Colour (Oval Form), Pale Blue and Red** 1943

Wood painted white and pale blue with strings, $12\frac{1}{2} \times 19 \times 15$ ($31.8 \times 48.2 \times 38$)
Prov: Helen Sutherland
Exh: Downing's Bookshop, St Ives, 1947; Whitechapel, 1954 (36); Tate Gallery, 1968 (39, repr. p.17); Marlborough, 1982 (4, repr. p.12)
Lit: Gibson, pl.48, 49; Read, pl.66b, 67; Hodin, cat.119; Hammacher, pl.63
Helen Sutherland Collection (HCS 37)

This is Hepworth's other sculpture of the early war years, the companion to no.50.

BARBARA HEPWORTH

55 Wave 1943–4

Plane wood with colour and strings, interior pale blue, length $18\frac{1}{2}$ (47)
Exh: Lefevre Gallery, 1946 (19); Venice Biennale, 1950 (73); Wakefield, 1951 (20); Whitechapel, 1954 (41); Tate Gallery, 1968 (41, repr.)
Lit: Read, pl. 74a, 74b, 75a, 75b; Hodin, cat.122; Hammacher, pl.62
Private Collection (on loan to Scottish National Gallery of Modern Art)

Hepworth began to make sculpture again in 1943, and her new work immediately reflects the experience of living in Cornwall. Natural forms now become of overwhelming importance to her, as the titles of the sculptures often make clear.

BARBARA HEPWORTH

***56 Wood and Strings** 1944

Plane wood with colour, pale blue and grey and strings, height 34 (86.3)
Exh: Lefevre Gallery, 1946 (11); St Ives Society of Artists, St Ives, 1948 (134); Wakefield, 1951 (25); Whitechapel, 1954 (40); Whitechapel, 1962 (4, repr.); Tate Gallery, 1968 (42, repr. p.18)
Lit: Read, pl.70; Hodin, cat. 125
Private Collection

Compared with her compact pre-war carving there is much more openness and lightness in Hepworth's work of 1943–7. Here the use of strings define the edge of a space transparently, rather like a wire fence around a field.

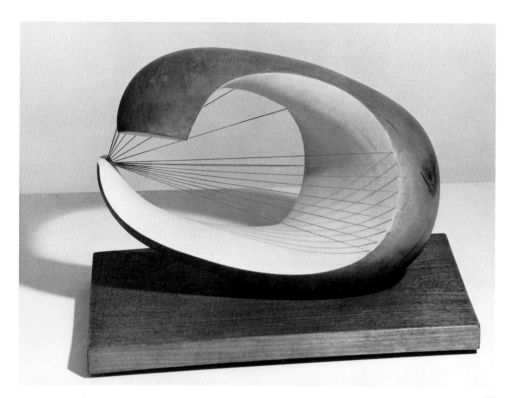

55

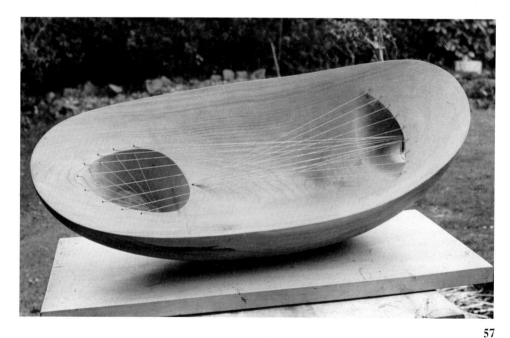

57

BARBARA HEPWORTH

57 Landscape Sculpture 1944

Broadleaf elm with strings, length 26 (66)
Exh: Lefevre Gallery, 1946 (13); Wakefield, 1951 (22).
Lit: Read, pl. 72a, 72b, 73a, 73b; Hodin, cat.127; Whitechapel, 1954, exhib. cat. pl.K; Hammacher, pl.65
Trustees of the Hepworth Estate, on permanent loan to the Barbara Hepworth Museum, St Ives (L. 00944)

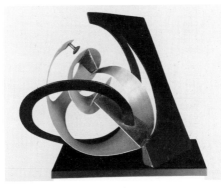

59

PETER LANYON

58 White Track 1939

Wood and string, partly painted,
$17\frac{1}{2} \times 19\frac{1}{2} \times 2\frac{3}{8}$ (44.5 × 49.5 × 6)
Exh: Sail Loft Gallery, St Ives, 1962
(47); Tate Gallery/Arts Council, 1968
(6); Gimpel Fils, 1975 (1); Whitworth
Art Gallery, 1978 (5, repr. fig.3)
Lit: Causey, pl.25; *The Tate Gallery,*
Illustrated Catalogue of Acquisitions
1980–82, pp.162–3.
Tate Gallery (T 03324)

One of Lanyon's first constructions, made
under the influence of the teaching of Ben
Nicholson. Lanyon described his intentions
in making 'White Track' in a recorded talk,
1962 (Arts Council Catalogue, 1968): 'The
object was to reduce the heaviness of the
wood in the centre by the use of dynamic
elements. A white dish shape is held by a
sling on the diagonal, and a red cylindrical
form travels round a white track. These two
elements make the whole construction light
and dynamic instead of heavy and static.'

PETER LANYON

59 Construction 1947

Painted aluminium and plywood,
$10\frac{1}{4} \times 12\frac{7}{8} \times 9\frac{3}{4}$ (26 × 32.7 × 24.8)
without the glass base
Exh: Downing's Bookshop, St Ives,
1947; *3rd Annual Crypt Show*, St Ives,
1948; Tate Gallery/Arts Council, 1968
(12, repr. pl.2)
Lit: Causey, pl.8; *The Tate Gallery*
Acquisitions 1970–1972, pp.135–6
Tate Gallery (T 01496)

Lanyon's immediately post-war work shows
the strong influence of Gabo, whose ideas
were soon to be incorporated in Lanyon's
landscape paintings.

MARGARET MELLIS

60 Collage with Red Triangle 1940

Paper collage, $11\frac{5}{8} \times 9$ (29.5 × 23)
Prov: Naum Gabo
Exh: *Cornwall 1945–55*, New Art
Centre, 1977 (76)
Private Collection

Margaret Mellis wrote (October 1984):
'I was simplifying my painting when B & G
[Ben Nicholson and Gabo] came to St Ives
[in August and September 1939
respectively]. B was interested and
suggested that I should do a collage. At the
beginning of 1940 I did one. I got
completely hooked. The 11th one was the
first *constructivist* one, it was *Construction*
with a Red Triangle, [coll. Victoria and
Albert Museum]. Gabo liked it so much
that he asked me to make another, the same.
I did and it came out slightly better than the
first one. When he left for America he gave
it back. He said it would be useful to me.

'At first I used all sorts of papers and
cardboard and then made one with
transparent papers, very much liked by
B & G. I thought of using that idea in wood.
Although it was the same idea the thickness
and opaqueness of the wood made me think
of a different way to convey the idea. It
came out quite well, that is the *Construction*
in Wood'.

Mellis later made 'rougher' collages with
pieces of scrap paper with words and images
on them, and some with cardboard and then
of wood. Later she made slate reliefs and
free-standing sculptures in stone and
marble. All were abstract and the last made

58

late in 1944 or early 1945. During the period when she was making abstract collages and sculptures Mellis painted abstract pictures but was dissatisfied with them.

MARGARET MELLIS

61 Construction in Wood 1941

Wood, $14\frac{3}{8} \times 14\frac{3}{4}$ (36.5 × 37.3)
Exh: *Cornwall 1945–55*. New Art Centre, 1977 (79, repr.); Pier Arts Centre, Stromness, 1982 (1, repr.)
Scottish National Gallery of Modern Art, Edinburgh

BEN NICHOLSON

62 1940 (St Ives) 1940

Oil on board, $12\frac{5}{8} \times 15\frac{3}{8}$ (32 × 39)
Exh: Leeds, 1944 (36)
Lit: Lund Humphries, 1, pl.113; Russell, pl.109
Private Collection

Soon after his arrival in St Ives, Nicholson began to paint the landscape again. Though sometimes dismissive of such work, the influence of the colours and shapes of the Cornish landscape soon came to permeate all of Nicholson's paintings and reliefs, however abstract. Other paintings were made from the same vantage point.

BEN NICHOLSON

***63 1940 (Painted Relief, Version 1)** 1940

Oil on carved board, $20\frac{5}{8} \times 19\frac{5}{8}$ (52.5 × 50)
Prov: Helen Sutherland
Exh: *Artists International Association*, London Museum, 1940; Tate Gallery, 1969 (68)
Lit: Lund Humphries, 1, pl.114
Helen Sutherland Collection (HCS 124)

BEN NICHOLSON

***64 1941 (Painted Relief, Version 1)** 1941

Oil and pencil on carved board, $26 \times 55\frac{1}{4}$ (66 × 140.3)
Exh: Possibly Lefevre Gallery, 1945; Venice Biennale, 1954 (14); Tate

Gallery, 1955 (30); Tate Gallery, 1969 (69)
Lit: Lund Humphries, 1, pl.129
Private Collection

A project was made for this relief and there are four related paintings; this is one of the largest of Nicholson's works of the early war years.

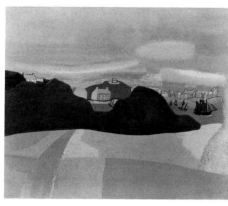

62

BEN NICHOLSON

65 1940–43 (Two Forms) 1940–3

Oil on canvas mounted on board, $23\frac{3}{4} \times 23\frac{1}{4}$ (60.5 × 59)
Prov: C.S. Reddihough
Exh: Bradford Spring Exhibition, 1944 (516); Leeds, 1944 (39); Albright-Knox Art Gallery, Buffalo, 1978–9 (35, repr.)
Lit: Lund Humphries, 1, pl.106; Summerson, pl.21
National Museum of Wales

The same composition is known in nine versions with different colours and sizes. This particular version was first signed and dated in 1940 and then reworked in 1943.

65

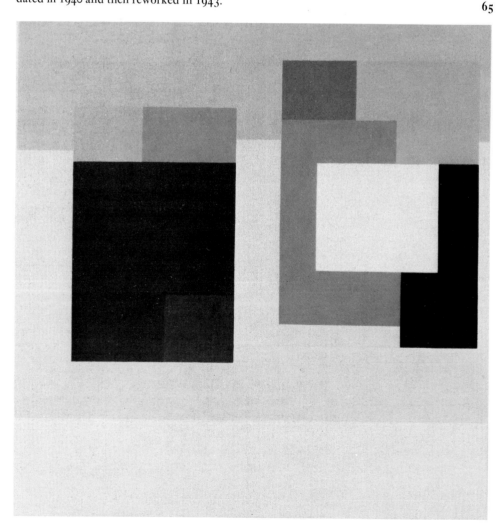

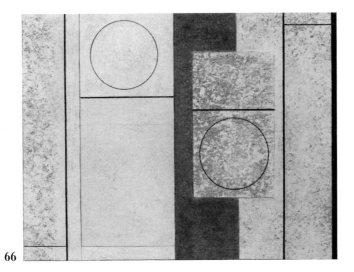

66

BEN NICHOLSON

66 1943 (Project for Painted Relief) 1943

Oil on board, 10 × 12 (25.5 × 30.5)
Prov: Barbara Hepworth
Exh: Possibly Lefevre Gallery, 1945;
Albright-Knox Art Gallery, Buffalo,
1978–9 (37, repr.)
Lit: Lund Humphries, 1, pl.123
(different version); Summerson, pl.25
(different version)
Private Collection

'Projects' often preceded a larger painting
or relief. Several versions of this
composition are known.

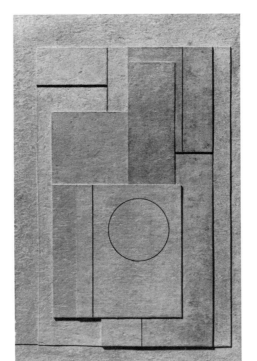

67

BEN NICHOLSON

67 Painted Relief 1943

Oil on carved board, $12\frac{5}{16} \times 8\frac{7}{8}$
(31.3 × 22.5)
Prov: Barbara Hepworth
Exh: Possibly Lefevre Gallery, 1945
Lit: Lund Humphries, 1, pl.166
Private Collection

BEN NICHOLSON

68 St Ives, Cornwall 1943–5

Oil on canvas board, $16 \times 19\frac{3}{4}$
(40.5 × 50.2)
Exh: Lefevre Gallery, 1945 (61)
Lit: *Horizon*, XII, 1945; Lund
Humphries, 1, pl.132; M.Chamot,
D. Farr, M. Butlin, *The Modern
British Paintings, Drawings and
Sculpture*, Tate Gallery, 1964, p.485
Tate Gallery (N 05625)

The still life in the foreground was
reworked in 1945, perhaps to celebrate the
end of the war in Europe.

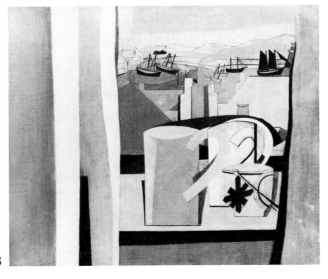

68

BEN NICHOLSON

***69 Still Life and Cornish Landscape** 1944

Oil on board, 31 × 33 (78.7 × 83.8)
Lit: Lund Humphries, 1, pl.144
*Collection IBM Gallery of Science
and Art* (Lent by IBM UK
Laboratories Ltd, Hursley Park,
Winchester)

This is one of Nicholson's favourite compositions: a still life of simple domestic objects on a table in the foreground; a curtain and a window looking out on a landscape. The farm is probably Higher Carnstabba Farm, a few miles inland from Carbis Bay. St Ives is behind the hill in the distance; on the right is St Ives Bay.

BEN NICHOLSON

70 1945 (Parrot's Eye) 1945

Oil and pencil on carved board,
$7\frac{1}{2} \times 9\frac{1}{2}$ (19 × 24)
Prov: Barbara Hepworth
Exh: Lefevre Gallery, 1945 (59);
Venice Biennale, 1954 (19); Tate
Gallery, 1955 (36); Tate Gallery, 1969
(73); Albright-Knox Art Gallery,
Buffalo, 1978–9 (38, repr)
Lit: Lund Humphries, 1, pl.135;
Summerson, pl.27
Private Collection

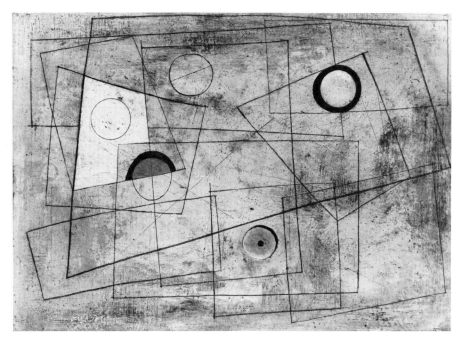

70

ADRIAN STOKES

71 Landscape, West Penwith Moor *c*.1937

Oil on canvas, 24 × 20 (61 × 50.8)
Exh: Possibly Marlborough Galleries,
1965 (7); *Cornwall 1945–1955*, New
Art Centre, 1977 (137); Serpentine
Gallery, 1982 (13)
Private Collection

Painted in West Penwith, Cornwall *c*.1937 before Stokes went to the Euston Road School.

JOHN WELLS

72 Relief Construction 1941

Gouache, pencil, string, cardboard and
perspex, $12\frac{5}{8} \times 16\frac{5}{8} \times 1\frac{3}{8}$
(32 × 42.2 × 3.5)
Exh: *New Movements in Art,
Contemporary Work in England*,
London Museum, 1942 (38); Crypt
Gallery, St Ives, 1946 (36); *Decade 40s,
Painting, Sculpture and Drawing in
Britain 1940–49*, Arts Council
tour, 1972–3 (144)
Lit: *The Tate Gallery 1972–74,
Biennial Report and Illustrated
Catalogue of Acquisitions*, pp.254–5
Tate Gallery (T01759)

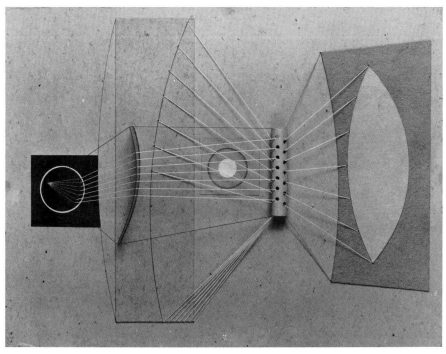

72

This work, originally titled 'Relief Construction 1', is one of a series of five or six similar works; only one other (Anthony Froshaug collection) is believed to be still in existence. The artist wrote (18 Dec. 1973): 'I met Ben Nicholson in 1928 and later Barbara Hepworth and Naum Gabo. They all became dear friends and had a profound influence on me.

'The Relief Constructions were the result of these influences. But I think they express (unconsciously perhaps) my deep awareness of the living tensions of the environment of the islands.' [the Scillies]

When war ended in 1945 Nicholson was 51 and Hepworth 42. Both had had important retrospective exhibitions at Leeds, at the invitation of Philip Hendy, and they were soon to remake their international careers after the interruption of the war years. Both showed for the first time in New York in 1949, and received important commissions for the 1951 Festival of Britain. Hepworth was the major British exhibitor at the Venice Biennial in 1950, Nicholson showed in 1954, with subsequent retrospective exhibitions in Paris, London and at the Tate Gallery in 1955. Hepworth was a second prize winner in the 1953 Unknown Political Prisoner Competition, and designed stage sets for *Electra* at the Old Vic in 1951, and for Michael Tippett's *Midsummer Marriage* at Covent Garden in 1955.

Their work at this period exudes confidence. Nicholson continued to draw and paint the Cornish landscape, but it was the post-cubist still life composition that mainly attracted his attention. The scale of his work slowly increases: this is particularly noticeable when he begins to use the largest of the Porthmeor Studios in 1949. Hepworth bought Trewyn Studio in August 1949, and this allowed her much greater freedom: she could carve much larger works than she had attempted before and for the first time needed the help of assistants.

The post war years were good ones for Bernard Leach too. The Leach Pottery was back on its feet, producing domestic ware of high quality. Leach slowly remade his international contacts, particularly difficult of course in the case of Japan. He was able again to make studio pots, and needed to give less time to the standard ware.

BARBARA HEPWORTH

*73 **Pelagos** 1946

Wood, painted interior and strings, $14\frac{1}{2} \times 15\frac{1}{4} \times 13$ ($37 \times 39 \times 33$) on wooden base, $2 \times 18 \times 15\frac{1}{2}$ ($5 \times 45.7 \times 39.5$)
Prov: Duncan Macdonald
Exh: Lefevre Gallery, 1946 (21); Venice Biennale, 1950 (74); Wakefield, 1951 (27, repr.); Whitechapel, 1954 (45, repr. pl.H); São Paulo Bienal, 1959 (3); Whitechapel, 1962 (3, repr.); Tate Gallery, 1968 (45)
Lit: Read, pl.82a, 82b, 83a, 83b; Hodin, cat.133; *The Tate Gallery Report 1964–65, (Acquisitions)* p.40; Hammacher, pl.76
Tate Gallery (T 00699)

In 1952, Barbara Hepworth wrote of the landscape content of this sculpture:
'A new era seemed to begin for me when we moved into a larger house high on the cliff overlooking the grand sweep of the whole of St Ives Bay from the Island to Godrevy lighthouse. There was a sudden release from what had seemed to be an almost unbearable diminution of space and now I had a studio workroom looking straight towards the horizon of the sea and enfolded (but with always the escape for the eye straight out to the Atlantic) by the arms of land to the left and the right of me. I have used this idea in Pelagos 1946.'

'Pelagos' is a Greek word for the sea.

BARBARA HEPWORTH

74 **Reconstruction** 1947

Oil and pencil on board, $13\frac{1}{2} \times 18\frac{1}{4}$ (34.3×46.4)
Exh: Wakefield, 1951 (62)
Arts Council of Great Britain

Barbara Hepworth witnessed her first operation in 1947, and began to make oil

and pencil drawings from the rough
sketches executed in the operating theatre.
The drawing is inscribed 9/12/47. It is one
of the first of over fifty-five.

BARBARA HEPWORTH

**75 Fenestration of the Ear, (The
Hammer)** 1948

Oil and pencil on board, $15\frac{1}{8} \times 10\frac{5}{8}$
(38.4×27)
Exh: Durlacher Bros., New York, 1949
(2); Whitechapel, 1954 (108); *Three
British Artists*, Martha Jackson
Gallery, New York, 1954 (10); Walker
Art Centre, Minneapolis, 1955–6 (20)
Lit: *The Tate Gallery, Illustrated
Catalogue of Acquisitions, 1976–8*,
pp.80–4
Tate Gallery (T 02098)

This drawing is one of six based on
operations Hepworth attended at the
London Clinic early in 1948 for treating a
form of deafness, entailing the making of
another window (fenestration) on to the
inner ear. (The technique was used in the
1940s but has since been superseded).
An approach was made through the mastoid
bone, behind the ear, using a mallet and
gouges, which is depicted here.
A sketchbook of on-the-spot drawings for
the fenestration operation is in the Science
Museum.

BARBARA HEPWORTH

76 Concentration of Hands No.1 1948

Oil and pencil on board, $21 \times 15\frac{3}{4}$
(53.5×40)
Exh: *Moderne Englische Zeichnungen
und Aquarelle*, Germany, 1950–1 (17);
Contemporary British Drawings, British
Council tour, *c.*1952–81; Tate Gallery,
1968 (201)
Lit: Hepworth/Bowness, pl.30
The British Council

BARBARA HEPWORTH

***77 The Cosdon Head** 1949

Blue marble, height 24 (61)
Exh: Lefevre Gallery, 1950 (2, repr.);
Venice Biennale, 1950 (78);
Whitechapel, 1954 (84 repr. pl.N);

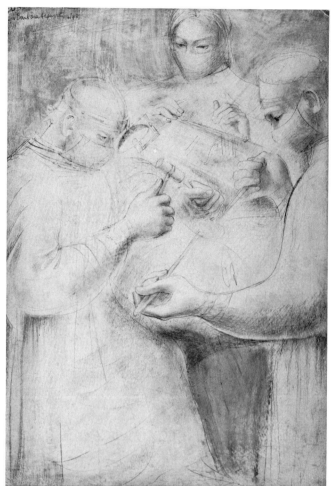

75

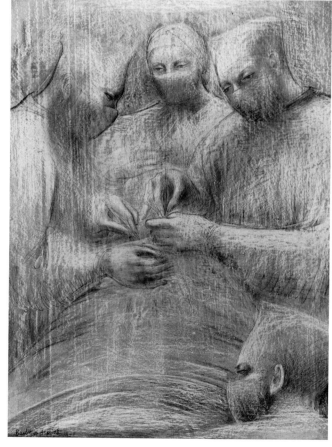

76

Tate Gallery, 1968 (54)
Lit: Read, pl.114–17; Hodin, cat.157
Birmingham Museums and Art Gallery

In 1948–51 Hepworth seemed particularly interested in the human figure in both her drawings and her sculptures. From some viewpoints this sculpture is completely abstracted but from others, because of the three indentations a nose, lips and chin appear. The shallow-hollowed circle can also be read as an eye.

BARBARA HEPWORTH

78 Bicentric Form 1949

Blue limestone, $62\frac{1}{2} \times 19 \times 12\frac{1}{4}$
($159 \times 48.3 \times 31$)
Exh: Lefevre Gallery, 1950 (1); Venice Biennale, 1950 (83); Tate Gallery, 1968 (57)
Lit: Read, pl.135, 136, 137a, 137b; Hodin, cat.160; M. Chamot, D. Farr, M. Butlin, *The Modern British Paintings, Drawings and Sculpture*, Tate Gallery, 1964, p.278; Hammacher, pl.75
Tate Gallery (N 05932)

The artist wrote (in Read, 1952) of her work of 1946–9: 'I began to consider a group of separate figures as a single sculptural entity, and I started working on the idea of two or more figures as a unity, blended into one carved and rhythmic form. Many subsequent carvings were on this theme, for instance *Bicentric Form* in the Tate Gallery.' In a letter of 7 February 1958 she added: 'It was carved during a period when my main interest was in the fusion of the "two form" idea, so that it would be fair to describe *Bicentric Form* as a fusion of two figures into one sculptural entity. I think from a purely abstract point of view, it was a logical and inevitable development from the separate forms in association.' Purchased in 1950, this was the first work by Hepworth to enter the Tate Gallery.

BARBARA HEPWORTH

***79 Group I (Concourse)** 4 February 1951

Serravezza marble, $9\frac{3}{4} \times 19\frac{7}{8} \times 11\frac{5}{8}$
($24.8 \times 50.5 \times 29.5$) (including base)
Prov: Miss E.M. Hodgkins
Exh: Lefevre Gallery, 1952 (1); Whitechapel, 1954 (143, repr.); Rijksmuseum Kröller-Müller, Otterlo, 1965 (8, repr.); Tate Gallery, 1968 (58, repr. p.22)
Lit: Read, pl.149a, 149b; Hodin, cat.171; *The Tate Gallery, Illustrated Catalogue of Acquisitions 1976–8*, pp.84–5.
Tate Gallery (T 02226)

Part of the genesis of this sculpture was Hepworth's first visit to Venice in June 1950 when her work was shown in the British pavilion at the Biennale. Of this visit she wrote (in Herbert Read *Barbara Hepworth, Carvings and Drawings* 1952): '... Everyday I sat for a time in the Piazza San Marco, a miracle of man-made space ... The most significant observation I made for my own work was that as soon as people or groups of people, entered the Piazza they responded to the proportions of the architectural space. They walked differently, discovering their innate dignity. They grouped themselves in unconscious recognition of their importance in relation to each other as human beings'. There are two other sculptures on the theme 'Group II (people waiting)' (private collection U.S.A.) and 'Group III (evocation)' (Pier Gallery, Orkney).

BARBARA HEPWORTH

80 Pastorale 1953

White marble, length 45 (114)
Exh: Whitechapel, 1954 (157, repr. pl.T); Kröller-Müller, Otterlo, 1965 (9, repr.); Tate Gallery, 1968 (67, repr. p.27)
Lit: Hodin cat.192; Hammacher, pl.85; Hepworth, p.72
Rijksmuseum Kröller-Müller, Otterlo

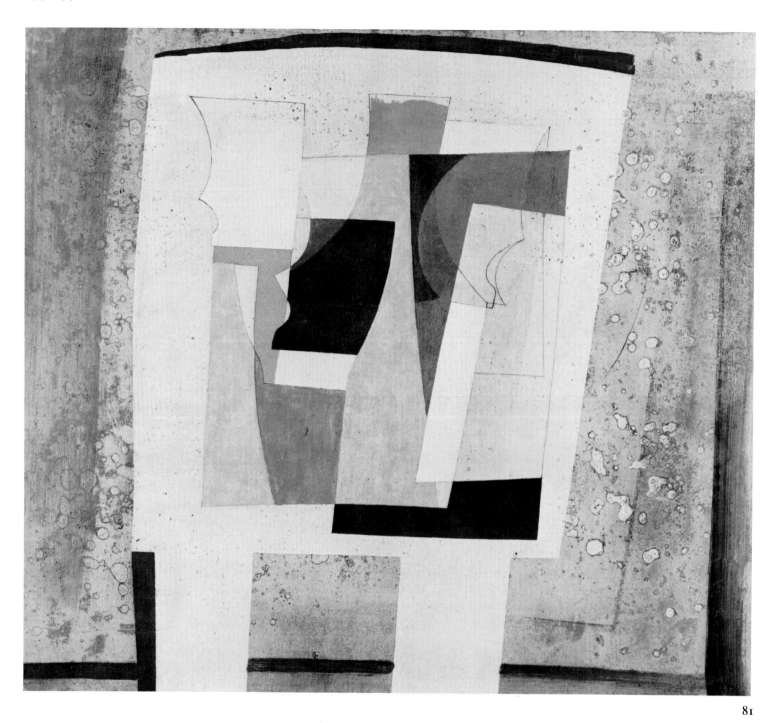

81

BEN NICHOLSON

81 Still Life (Spotted Curtain)
14 March 1947

Oil on board, $23\frac{1}{2} \times 25\frac{1}{4}$ (59.7 × 64)
Exh: Lefevre Gallery, 1947 (99);
Decade 40–49, Arts Council, 1972–3,
(135)
Lit: Lund Humphries, 1, pl.179
Aberdeen Art Gallery

One of the first of the series of paintings,
based on a still life of objects on a table top;
which Nicholson made in the late 1940s and
1950s. The objects themselves – bottles,

jugs, mugs, glasses – are not treated literally
(though they may be seen in photographs of
Nicholson's studio), but are used as
elements in what might be called a post-
cubist composition. While occupied on this
series (see also nos.87, 93) Nicholson made
few totally abstract pictures.

BEN NICHOLSON

82 1947 (Mount's Bay) Summer 1947

Pencil on paper, $9\frac{1}{4} \times 14$ (23.5 × 35.5)
Exh: *A Selection of Paintings and
Drawings from the Rutherston*

82

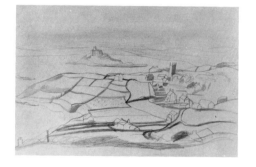

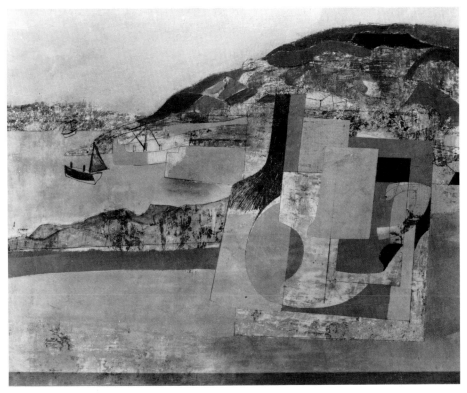

83

84

Collection, Arts Council, 1955 (40);
Decade 40–49, Arts Council, 1972–3
(136); Albright-Knox Art Gallery,
Buffalo, 1978–9 (45, repr.)
Lit: Lund Humphries, 1, pl.196
City of Manchester Art Galleries

Nicholson continued to make drawings of
the West Cornish landscape throughout this
period. St Michael's Mount can be seen in
the centre of the composition, surrounded
by water at high tide. The style of these
landscape drawings was established by
Nicholson and Christopher Wood in the
late 1920s, and varied little throughout
Nicholson's long career.

BEN NICHOLSON

83 **Mousehole, November 11–47**

**Oil and pencil on canvas, mounted
on wood, $18\frac{1}{4} \times 23$ (46.5 × 58.5)**
Exh: Lefevre Gallery, 1948 (7); Tate
Gallery, 1955 (42); Tate Gallery, 1969
(75, repr. p.46); *Decade 40–49*, Arts
Council, 1972–3 (137); Albright-Knox
Art Gallery, Buffalo, 1978–9 (44,
repr.)
Lit: Lund Humphries, 1 pl.181; Alley,
p.36
The British Council

Nicholson's treatment of the harbour at
Mousehole compares interestingly with the
paintings of the same subject by
Christopher Wood and William Scott. The
still life group in the right foreground is
treated in the semi-abstract, post-cubist
manner, and contrasts with the more
naturalistic treatment of the landscape
background.

BEN NICHOLSON

84 **Trendrine (2) December 13–47**

Oil on canvas, $15 \times 14\frac{1}{2}$ (38 × 37)
Exh: Durlacher Bros., New York, 1949
(23)
Lit: Lund Humphries, 1, pl.201
Phillips Collection, Washington, D.C.

Trendrine is one of the farms on the Land's
End road out of St Ives. In the foreground
on the window ledge there is a group of still
life objects.

BEN NICHOLSON

85 January 1948 (Towednack)
January 1948

Oil and pencil on board, $19\frac{1}{4} \times 20\frac{3}{4}$
(49×52.7)
Prov: C.S. Reddihough
Exh: Lefevre Gallery, 1952 (1);
Tate Gallery, 1955 (43, repr. pl.4);
São Paulo, 1957 (22)
Lit: Lund Humphries, 11, pl.4;
Hodin, pl.41
Private Collection

Towednack is a hamlet in the neigh-
bourhood of St Ives.

BEN NICHOLSON

86 March 1948 (Tree Lelant)
March 1948

Pencil on paper, $12\frac{3}{4} \times 17$ (32.5×43)
Prov: Barbara Hepworth
Exh: Lefevre Gallery, 1950 (38); Tate
Gallery, 1955, (66); Dallas, 1964 (32);
Albright-Knox Art Gallery, Buffalo,
1978–9 (46, repr.)
Lit: H. Read, *The Philosophy of
Modern Art*, 1952, p.97; Read, 11,
pl.8; Alley, p.26
Private Collection

The tree stands in the cemetery of Lelant
Church, which is the oldest church in the
St Ives area.

BEN NICHOLSON

87 March 1949 (Trencrom)
March 1949

Oil and pencil on canvas, $43 \times 31\frac{1}{8}$
(109×79)
Exh: Salon des Réalités Nouvelles,
Paris, 1949; Lefevre Gallery, 1950 (9);
Tate Gallery, 1969 (78, repr. p.45);
Decade 40–49, Arts Council, 1972–3
(138)
The British Council

Trencrom is the name of the hill
overlooking Carbis Bay, on the summit of
which the remains of a prehistoric hill fort
can be seen. On this occasion Nicholson
uses the title to identify a post-cubist still
life painting, though there may be a
particular association of shape or colour or
light behind the title.

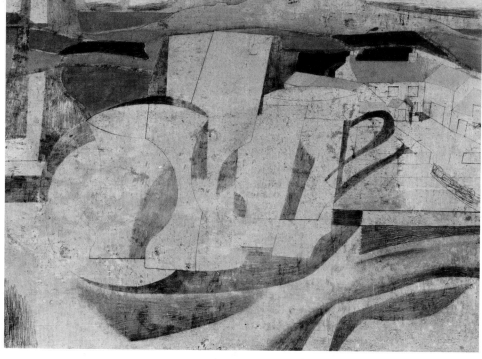

85

86

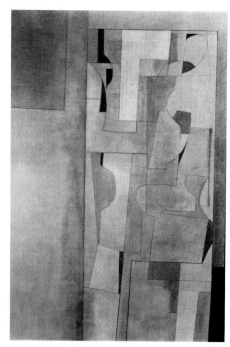

87

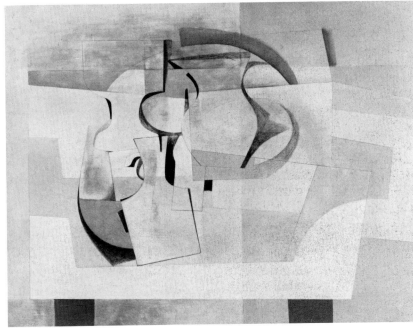

88

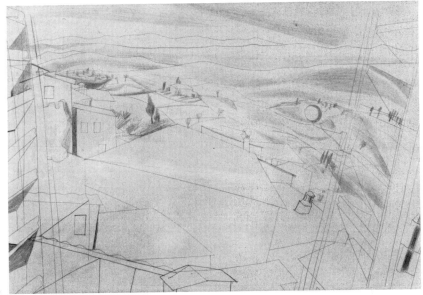

89

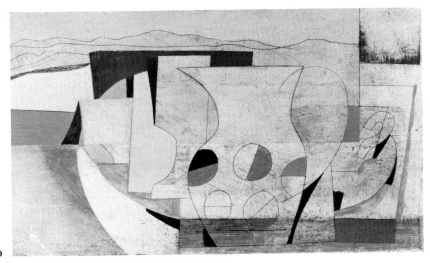

90

BEN NICHOLSON

88 **December 1949 (Poisonous
Yellow)** December 1949

Oil on canvas, 49 × 64 (124.4 × 162.5)
Exh: Lefevre Gallery, 1952 (2, repr.);
Carnegie International, Pittsburgh,
1952 (192); Venice Biennale, 1954
(23); *Decade 40–49*, Arts Council
1972–3 (139)
Lit: Lund Humphries, II, pl.13;
Russell, pl.66
*Museo d'Arte Moderna di Ca' Pesaro,
Venezia*

BEN NICHOLSON

89 **May 1950 (Early Morning from San
Gimignano)** May 1950

Oil wash and pencil on paper,
$14\frac{1}{2} \times 21\frac{1}{4}$ (37 × 54)
Exh: Lefevre Gallery, 1950 (52); Tate
Gallery, 1955 (70); Kestner-
Gesellschaft, Hanover, 1959 (35);
Galerie Charles Lienhard, Zurich,
1959 (16); Tate Gallery, 1969 (79,
repr. p.48)
Lit: Lund Humphries, II, pl.66
Private Collection

Nicholson began to travel to Italy again
from 1950 onwards, bringing back drawings
of the landscape and the countryside.

BEN NICHOLSON

90 **November 1950 (Winter)**
November 1950

Oil and pencil on masonite, $12\frac{1}{2} \times 22\frac{1}{2}$
(32 × 57)
Lit: Lund Humphries, II, pl.2
Phillips Collection, Washington, D.C.

BEN NICHOLSON

91 **St Ives, Dark Shadow** *c*.1951

Pencil on paper, $13\frac{5}{8} \times 17\frac{1}{4}$ (34.5 × 44)
Exh: Regional College of Art,
Manchester, 1955; *Masterpieces of
British Art from the Whitworth Art
Collection*, Aldeburgh, 1977 (31)
Lit: Albright-Knox Art Gallery,
Buffalo, 1978. Exhib. cat. p.97
*Whitworth Art Gallery, University of
Manchester*

In the foreground is the steeple and spire of

the Catholic Church at St Ives, tucked behind it the tower of St Ia Parish Church. In this almost panoramic view of St Ives, the Island with its chapel is seen in the centre of the horizon line, with the harbour on the right, and Godrevy lighthouse across the bay.

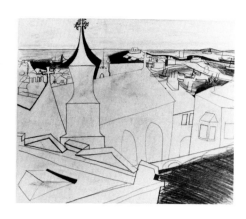

91

BEN NICHOLSON

*92 **October 20 1951 (St Ives Harbour from Trezion)** October 1951

Oil and pencil on board, $17\frac{7}{8} \times 20\frac{1}{2}$ (45.5 × 52)
Prov: Helen Sutherland
Exh: Tate Gallery, 1969 (80 repr. p.47); Albright-Knox Art Gallery, Buffalo, 1978–9 (51, repr.)
Helen Sutherland Collection (HCS 133)

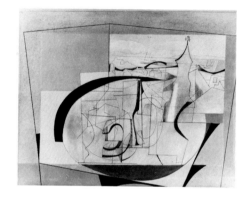

94

This is the view of the harbour from the house called Trezion in Salubrious Place in which Nicholson lived from 1951 until he left St Ives in 1958. There is a chapel roof in the foreground.

BEN NICHOLSON

93 **December 1951 (Opal, Magenta and Black)** December 1951

Oil on canvas, $45\frac{5}{8} \times 63\frac{3}{8}$ (116 × 161)
Exh: Lefevre Gallery, 1952 (39); Venice Biennale, 1954 (27); Tate Gallery, 1955 (46); Tate Gallery, 1969 (81, repr. p.8)
Lit: Lund Humphries, 11, pl.16
Museo de Arte Moderna, Rio de Janeiro

BEN NICHOLSON

94 **December 1951 (St Ives Oval and Steeple)** December 1951

Oil and pencil on board, $19\frac{3}{4} \times 26$ (50 × 66)
Exh: Lefevre Gallery, 1952 (43, repr.); Albright-Knox Art Gallery, Buffalo, 1978–9, (52, repr.)
Lit: Alley, p.28; *Catalogue of Oil Paintings*, City Art Gallery, Bristol, p.88, repr. cover
City of Bristol Museum and Art Gallery

The painting relates to the subject of the undated drawing (91), but a still-life group is introduced into the foreground.

BEN NICHOLSON

*95 **June 4–52 (Tableform)** June 1952

Oil and pencil on canvas, $62\frac{1}{2} \times 44\frac{3}{4}$ (159 × 113.5)
Prov: Barbara Hepworth
Exh: Durlacher Bros., New York, 1952 (24); Tate Gallery, 1955 (48, repr. pl.1); Albright-Knox Art Gallery, Buffalo, 1978–9 (53, repr.)
Lit: Lund Humphries, 11, pl.143
Albright-Knox Art Gallery, Buffalo, New York, Gift of Seymour H. Knox, 1957

After 1950, the scale of Nicholson's paintings increases markedly, partly due to his use of the Porthmeor studio.

BEN NICHOLSON

*96 **February 1953 (Contrapuntal)** February 1953

Oil on board, 66 × 48 (167.6 × 121.9)
Exh: Venice Biennale, 1954 (31); Tate Gallery, 1955 (50); Tate Gallery, 1969 (82); Albright-Knox Art Gallery, Buffalo, 1978–9 (55, repr.)
Lit: Lund Humphries, 11, pl.1
Arts Council of Great Britain

IV 1946–54 THE YOUNGER GENERATION (AND THE SUMMER VISITORS)

It was more difficult for the younger generation whose careers had been interrupted by the war to get back to their painting. Wells moved to Newlyn in 1945, and was quickly in touch with Lanyon, demobilised from the RAF, and Wynter, who moved to St Ives in 1945. The activities of the Crypt Group in 1946–8, and the foundation of the Penwith Society in 1949 helped provide an attractive and stimulating working environment. Lanyon in particular seized the opportunity offered by the Arts Council's 1951 Festival of Britain commission to work on larger paintings. His work of 1951–2 has a scale unrivalled by his St Ives contemporaries: it was immediately taken up and shown in New York from 1952 onwards.

Wynter's work remained small in scale, and mainly in gouache: it is here that the St Ives connection with the neo-romantic painting of Sutherland, Vaughan and Minton is seen at its strongest. Frost on the other hand had strong links with the abstract painters in London, notably Adrian Heath, and when he had completed his delayed art training in 1950, he was quickly accepted as a recruit to this group – he is the only artist resident in St Ives to appear in the little volume on *Nine Abstract Artists* which was published in 1954.

Summer visitors were however very important in these years, and the links forged prevented any sense of isolation in St Ives. In the later 1940s foreign travel was still difficult, but family holidays in Cornwall brought artists such as Scott and Heron regularly into contact with St Ives. The connection with the Bath Academy of Art at Corsham was a particularly strong one: Scott was painting master there at the time, to be succeeded by Potworowski, another summer visitor. Lanyon and Wynter and Frost all taught at Corsham. Pasmore and Heath also visited St Ives, not for any length of time, but for both the link with Nicholson was important.

W. BARNS-GRAHAM

97 Upper Glacier 1950

Oil on canvas, $15\frac{1}{2} \times 24\frac{3}{4}$ (39.4 × 62.9)
Exh: *Abstract Art*, The Riverside Museum, New York 1951; Hong Kong Festival of the Arts, 1955
The British Council

This work was painted after Barns-Graham's visit to Switzerland in 1948. The artist wrote (1 February 1965): 'At Grindelwald I was climbing on the two glaciers 'Upper' and 'Lower'. The massive strength and size of the glaciers, the fantastic shapes, the contrast of solidity and transparency, the many reflected colours in strong light . . . This likeness to glass and transparency, combined with solid rough ridges made me wish to combine in a work all angles at once, from above, through, and all round, as a bird flies, a total experience.'

SVEN BERLIN

98 Serene Head 1948–9

Alabaster, height 16 (40.5)
Prov: Miss Pat Chambers
Exh: Bladon Gallery, Hurstbourne Tarrant, 1956; New Art Centre, 1983
Mrs Monica Askew

This work was commissioned by Miss Pat Chambers, a patron and friend of the artist.

Sven Berlin wrote (October 1984): 'The Serene Head is not only the memory of a unique friendship, but of carving out of my own solitude a sculptural form by which I discovered the serene austerity a work of art requires to be truthful, and to bring equilibrium to the soul. It is not a portrait of any kind . . . it is of a man of any or even no religion contemplating the serenity at the centre of the universe.'

TERRY FROST

*99 **Walk Along the Quay** 1950

Oil on canvas, 60 × 22 (152.5 × 56)
Prov: E.C. Gregory
Exh: *Abstract Art*, AIA, 1951 (23);
Leicester Galleries, 1952 (6); Laing Gallery, Newcastle upon Tyne, 1964 (4, repr.); Arts Council/South West Arts, 1976–7 (7, repr. p.33)
Adrian Heath (On loan to Graves Art Gallery, Sheffield)

'When I walked out of our cottage with the baby early in the morning the purpose was to get the crying child away from the house and neighbours. Walking from our cottage 12 Quay Street along the Quay, Smeaton's Pier to the lighthouse was always a visually exciting experience. I was forced to notice the colours and shapes of the boats and looking along and down in passing I covered a whole range of particular shapes and colours, each morning was different, depended on tide in [or] out, rain or fine. What was I going to do with a walk, how could I do it in paint. By chance I did have an old long and slim stretcher and frame, long and slim like Smeaton's Pier and the idea clicked that I could walk up that canvas. I did many versions, dry-point, watercolour and collage, it was a lovely period of innocent discovery. I had soaked up a lot of influences. Walk along the Quay was not just feeling and chance, it was the result of influence, a lot of thought and experience' (Letter from Terry Frost October 1984).

97

98

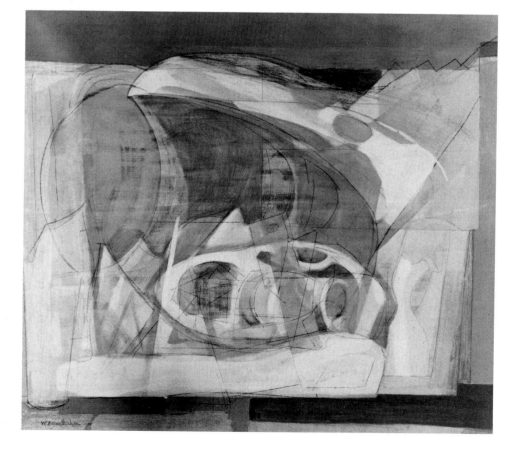

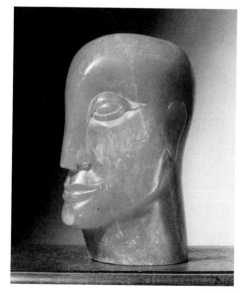

TERRY FROST

100 Green, Black and White Movement 1951

Oil on cotton duck, 43 × 33½ (109 × 85)
Prov: Howard Bliss, Alistair McAlpine
Exh: *Seventeen Collectors*, Tate Gallery, 1952 (159); Laing Gallery, Newcastle upon Tyne, 1964 (6)
Lit: L. Alloway, *Nine Abstract Artists*, 1954, pl.8; *The Tate Gallery, 1970–72 Acquisitions* p.104
Tate Gallery (T 01501)

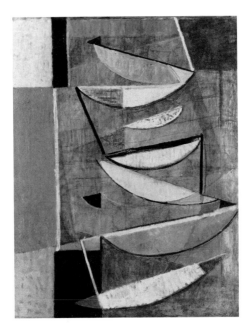

100

101

102

This picture is based on the artist's observation of the movement of boats in St Ives harbour. Some remarks Frost made about 'Blue Movement', 1953 (Vancouver Art Gallery) apply to this work: 'In this painting I was trying to give expression to my total experience of that particular evening. I was not portraying the boats, the sand, the horizon or any other subject-matter, but concentrating on the emotion engendered by what I saw. The subject matter is in fact the sensation evoked by the movements and colour in the harbour. What I have painted is an arrangement of form and colour which evokes for me a similar feeling.' (L. Alloway, *Nine Abstract Artists*).

TERRY FROST

101 Construction 1951–2

Oil and cord on wood 9¾ × 18¾ × ¾ (25 × 47.5 × 2)
Exh: Arts Council/South West Arts, 1976–7 (10)
Terry Frost

Terry Frost worked part-time 1950–2 as an assistant to Barbara Hepworth and did not paint a great deal 1951–2 and made his first constructions in 1951; these grew out of working in collage. At Camberwell Frost had been taught by Pasmore who made his first relief in 1951 as did also Mary Martin; Nicholson had been making reliefs since 1933. Several other painters were to make reliefs and constructions during the next few years including Anthony Hill. In 1954 Heath made two but did not continue, partly because of the time involved in changing a composition, and at about this time Hilton made some paper reliefs (which have not survived) but he was too committed to painting to continue such explorations. From the later 1950s Frost was to make many large constructions of painted canvas over a wooden framework; often these suggest the female body.

TERRY FROST

102 Construction Leeds 1954

Oil on metal, wood and hardboard, 7½ × 10½ × 3½ (19 × 26.5 × 9)
Exh: Arts Council/South West Arts, 1976–7 (14)
Terry Frost

DAVID HAUGHTON

103 Quarry Buildings 1948

Oil on canvas, $21\frac{1}{4} \times 17\frac{1}{4}$ (54×44)
Prunella Clough

DAVID HAUGHTON

104 St Just: Carne Bosaverne The First *c*.1948

Oil on board, $2\frac{1}{2} \times 15$ (6.5×38)
Exh: *Cornwall 1945–55*, New Art
Centre, 1977 (46); Newlyn Gallery,
1979 (repr.)
David Haughton

Carne Bosaverne is a part of St Just. David
Haughton began to paint St Just in the late
1940s; when he left Cornwall in 1951 he
returned every year to paint at St Just. In
1961 he wrote to Norman Levine (Newlyn
Gallery catalogue, 1977): 'The turning
point in my life occurred when I first
discovered the town of St Just.' Haughton
made drawings and a painting of Carne
Bosaverne in 1958, and has made an etching
on the motif.

103

104

PATRICK HAYMAN

105 Hillside with Houses and Trees 1952

Oil on canvas, 8×10 (20.3×25.5)
Patrick Hayman

'Like many of my small oils of this period,
with heavily encrusted pigment, this
painting recalls the woods on the hillside
above Draycott cottages, the front windows
of which overlooked Porthminster Beach at
the back over verdant, mysteriously heavy
dark trees, seen outlined against an oceanic
white sky'. (Patrick Hayman, October
1984). Hayman felt frequently a sense of
mystery and a certain calm closing in of the

105

106

land sheltering the small houses against the turbulence of the ocean. Talland House, where Virginia Woolf spent her childhood holidays, is in this part of St Ives.

PATRICK HAYMAN

106 Mother and Child with a Tree 1953

Oil on canvas board, 7 × 10 (18 × 25.5)
Barbara Hayman

'A companion picture to *Hillside with Houses and Trees*, painted a few months later at Draycott Cottages above Porthminster Beach, uses the, to me, frequent image of a mother and child. Against a winter Cornish landscape, of earth colours, a dark gaunt tree and small deserted building, the scene is set. In this silent hour calm prevails, but not for long.' (Patrick Hayman, October 1984).

ADRIAN HEATH

107

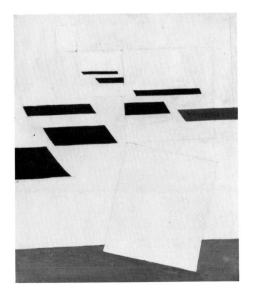

107 Composition 1951–2

Oil on canvas, 24 × 20 (61 × 51)
Exh: *Cornwall 1945–55*, New Art Centre, 1977 (48, repr.)
Adrian Heath

The artist wrote September 1984: 'This painting owes its origin to two pages of a

notebook used by me when staying with Terry Frost at St Ives during the summer of 1951. The drawn lines of written notes were intended to clarify my understanding of the movement of the sea observed over quite long periods of time . . . My notes were not representational; black lines grouped at different angles stood for the white of the recurring breakers.'

PATRICK HERON

108 The Boats and the Iron Ladder: 1947

Oil on wood panel, 12 × 24 (30.5 × 61)
Exh: Redfern Gallery, 1947 (48); Wakefield, 1952 (29, repr.); Richard Demarco Gallery, Edinburgh 1967 (18, repr.)
Private Collection

Painted in London just before, or just after a visit to St Ives. Heron had lived in St Ives as a child, and remembered well the harbour with upturned boats, lobster pots and the iron ladders attached to granite piers. 'The Boats and the Iron Ladder' merges memories of St Ives harbour with impressions of Mousehole, where he spent the summer of 1946.

PATRICK HERON

***109 Harbour Window with Two Figures, St Ives: July 1950**

Oil on hardboard 48 × 60 (122 × 152.5)
Exh: Redfern Gallery, 1951 (1); Wakefield, 1952 (56, repr.); *Tio Engelska Målare*, British Council tour of Sweden, 1953–4 (19, repr.); Redfern Gallery, 1954 (23 repr.); Richard Demarco Gallery, Edinburgh, 1967 (26, repr.); *Cornwall 1945–1955*, New Art Centre, 1977 (53); Waddington Galleries, 1979 (repr.)
Lit: *Studio*, 1951, p.134; *The Tate Gallery Illustrated Catalogue of Acquisitions, 1980–82*, pp.129–30
Tate Gallery (T 03106)

Every summer, from 1947 to 1955, Heron rented a studio on the sea wall at St Ives, with a big window that looked out over the harbour and bay. The artist writes: 'The "inside-outside" theme of this harbour window subject became the main feature of my paintings from 1946 onwards . . . The

sensation of *recession* was especially well accommodated by (this) theme which dominated my painting so long as it remained figurative . . . Though I did not think up the phrase "space in colour" until I needed a name for the mixed exhibition I selected for the Hanover Gallery in July–August 1953, the space generated by colour was just as much the subject of a painting such as this as were St Ives harbour, Godrevy Island (with lighthouse) seen across the Bay, or the famous three arches under Smeaton's Pier (in olive and white, top left). The images of the two figures were based on Delia, my wife, and Katharine, our elder daughter. Today I notice that the light generated in this picture – despite the pink sea and the blues inside the room – has the whiteness of St Ives light . . . This picture was not painted in front of its subject, but in another studio at St Ives and in London'. (Artist's note, 12 October 1984).

PETER LANYON

110 The Yellow Runner September 1946

Oil on board, $18\frac{1}{2} \times 24$ (47 × 61)
Exh: Crypt Group, St Ives, 1947 (64); Tate Gallery/Arts Council, 1968 (9); Basil Jacobs, 1971 (2); *Cornwall 1945–1955*, New Art Centre, 1977 (72); Whitworth Art Gallery, 1978 (8, repr. fig.5).
Lit: Causey, pl.26, cat.12
Guy Howard

Painted after his demobilisation, this is one of several paintings of 1946–7 connected with ideas of fertility and generation.

'. . . a horse travelling very fast across a hill in the distance, returning to the yellow section in the middle where two horses and a number of other shapes are combined. I think this is a painting of fertility. The seed is where the yellow runner finds the flower, or the seed finds the womb in the centre section.' (Recorded conversation with Lanyon, Tate Gallery cat. 1968).

PETER LANYON

111 Generation 1947

Oil on plywood, $34\frac{1}{4} \times 13\frac{1}{4}$ (87 × 33.5)
Exh: Downing's Bookshop, St Ives, 1947 (18); Crypt Group, St Ives, 1947

(65); Lefevre Gallery, 1949 (47); Plymouth 1955 (1); Tate Gallery/Arts Council 1968 (14, repr. pl.4); Whitworth Art Gallery, 1978 (12)
Lit: Causey pl.10, cat.14
Mrs Sheila Lanyon

This work is the culmination of Lanyon's Generation series 1946–7. The artist stated (Whitworth cat.) that the image had a general connection with the Italian Renaissance mother and child theme. The forms show the influence of Gabo's paintings of the 1940s; there are also parallels with Hepworth's sculptures that refer to wave and shell forms.

PETER LANYON

112 Portreath 1949

Oil on strawboard, 20 × 16 (50.7 × 40.5)
Exh: Penwith Society, St Ives, 1949 (35); Lefevre Gallery, 1949 (61); Downing's Bookshop, St Ives, 1951 (2); Plymouth, 1955 (4); Tate Gallery/Arts Council, 1968 (18, repr. pl.5); Whitworth Art Gallery, 1978 (20, repr. fig.9)
Lit: Causey, pl.11, cat.29
Mrs Frederica Freer (née Forbes-Dennis)

Lanyon here returns to his earlier abstract works, such as 'Box Construction' (1939). 'It is a very frontal picture with shapes looking at you, and it might almost have been made in a square box.' (Recorded talk, Arts Council cat. 1968).

Portreath is a small port near Redruth.

112

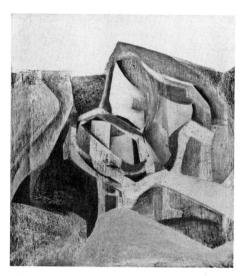

111

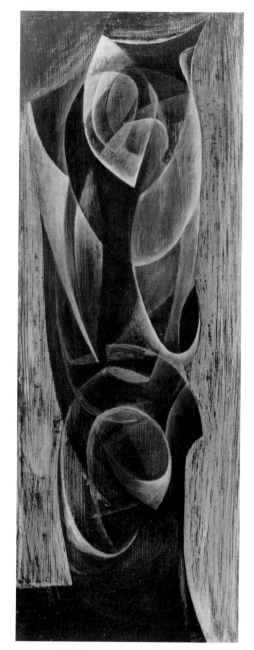

110

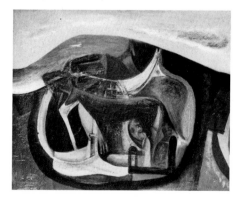

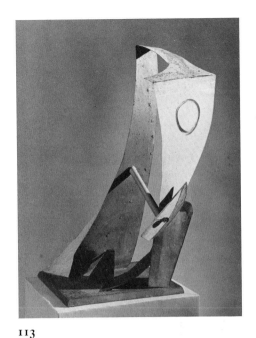

113

PETER LANYON

113 Porthleven Boats 1950–1

Oil paint on wood and sheet metal, $24\frac{3}{4} \times 14\frac{1}{8} \times 16\frac{1}{2}$ (70 × 36 × 42)
Exh: Tate Gallery/Arts Council 1968 (20)
Lit: *The Tate Gallery Acquisitions 1967–8*, p.67.
Tate Gallery (T 00950)

One of the five constructions made by the artist before painting 'Porthleven'. Lanyon did not regard these constructions as complete in themselves but as experiments in space to establish the illusion and content of the space in the painting. This construction was a study for the boat-like shapes at the bottom of the picture.

PETER LANYON

***114 St Just** 1951

Oil on canvas, 96 × 48 (244 × 122)
Exh: *Space in colour*, Hanover Gallery, 1953 (34); Gimpel Fils, 1954 (10); Plymouth, 1955 (13); Tate Gallery/Arts Council 1968 (23, repr. pl.3)
Lit: *Arts*, New York, Feb. 1956, pp. 33–8; Causey, pl.1, cat.42.
Private Collection

This work was to be the centre piece of a polyptych with 'Corsham Summer' and 'Harvest Festival' on either side and 'Bojewyan Farms' as the predella panel.
'Many people in St Just lost their lives in mine disasters, so the mineshaft in the middle becomes a cross, and the barbed

115

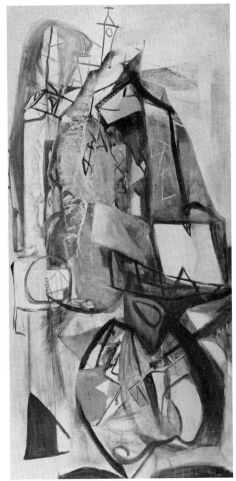

wire round the disused mines a crown of thorns.' (Recorded talk, Arts Council cat. 1968).

PETER LANYON

115 Porthleven 1951

Oil on hardboard, $96\frac{1}{4} \times 48$ (244.5 × 122)
Exh: *60 paintings for '51*, Arts Council, 1951 (29); *Contemporary Art Society, The First Fifty Years*, Tate Gallery, 1960 (39); Tate Gallery/Arts Council, 1968 (21, repr. pl.6); Whitworth Art Gallery, 1978 (35, repr. pl.11)
Lit: P. Heron. *The Changing-forms of Art*, 1955, pl.10; Causey, pl.27, cat.41; *Chamot, Farr, Butlin. The Modern British Paintings, Drawings and Sculpture, Tate Gallery*, 1964, pp.371–2
Tate Gallery (T 06151)

This work was commissioned in April 1950 by the Arts Council for the Festival of Britain Exhibition *Sixty Paintings for '51*. The painting originally intended for the exhibition became so overloaded through repainting that the artist destroyed it and executed the present work in four hours. The idea was developed gradually with the help of constructions. Porthleven is a small fishing port near Helston.

PETER LANYON

116 Bojewyan Farms 1951–2

Oil on masonite, 48 × 96 (121.9 × 243.9)
Exh: Gimpel Fils, 1952 (1); Plymouth,

116

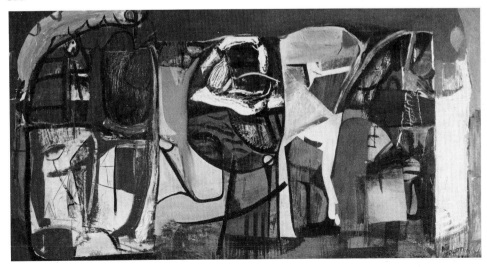

1955 (8); Tate Gallery/Arts Council,
1968 (25); Whitworth Art Gallery,
1978 (38, repr. fig.18)
Lit: Causey, pl.28, cat.44
The British Council

This work was intended to be the predella
of the St Just polyptych. Lanyon said in a
recorded talk (Arts Council cat., 1968):
'In some ways it's a picture about life and
death, which is why it belongs with the
Crucifixion triptych.'

Bojewyan is a small village near St Just.

VICTOR PASMORE

117 Beach in Cornwall 1950

Pen and ink on card, $10\frac{1}{4} \times 12\frac{3}{4}$
(26×32.5)
Exh: *A Selection from the Arts Council
Collection*, Arts Council, 1955 (95,
pl.18); *Cornwall 1945–55*, New Art
Centre, 1977 (103)
Arts Council of Great Britain

One of a number of drawings of Porthmeor
Beach made by the artist in 1950.

VICTOR PASMORE

118 Porthmeor Beach, St Ives 1950

Pen and ink $9\frac{1}{2} \times 11\frac{3}{8}$ (24×29)
Lit: *Burlington Magazine*, (CII), 1960,
p.202; M. Chamot, D. Farr,
M. Butlin, *The Modern British
Paintings, Drawings and Sculpture*,
Tate Gallery, 1964, p.510
Tate Gallery (T 00092)

The artist wrote (27 October 1957): 'The
drawings are quite independent and
complete works and in fact were done after
I had conceived the spiral formations
leading to the Snow Storm painting (Tate
Gallery N 06191). Nevertheless the rock
formations in the Porthmeor drawings were
used subsequently as an abstract motif in
combination with the spiral in the painting
of the Snow Storm. So there is a
connection.'

JACK PENDER

119 Lyonesse 1951–2

Oil on canvas $20\frac{1}{2} \times 32\frac{1}{2}$ (52×82.5)
Exh: Newlyn Gallery
Jack Pender

This work depicts the artist's father's boat,
which was built in the early 1930s. PZ
applies to all boats sailing out from
harbours between the Lizard and Land's
End.

119

118

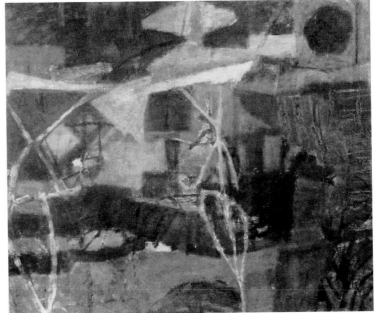

120

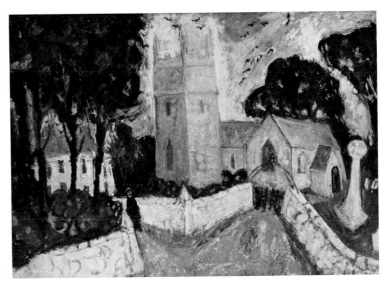

121

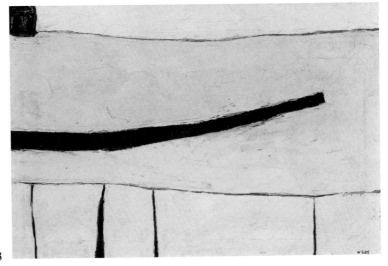

123

PETER POTWOROWSKI

120 Forest (Cornwall) 1954

Oil on canvas, 25 × 30 (63.5 × 76)
Exh: Royal West of England Academy,
Bristol and Institute of Education,
1984 (35)
The artist's family in London

Painted in the garden of the artist's cottage below Sancreed.

ADRIAN RYAN

121 Sancreed Church, near Penzance c.1950

Oil on canvas, $25\frac{5}{8} \times 35\frac{3}{8}$ (65 × 90)
Christina Reis

When living at Mousehole Adrian Ryan painted many landscapes in West Penwith in the area near to the coastline. He painted pictures of a few churches – Paul, St Just, St Buryan and Zennor as well as Sancreed. (Information from Adrian Ryan, September 1984).

WILLIAM SCOTT

***122 The Harbour** 1950–1

Oil on canvas, $22\frac{1}{2} \times 39$ (57 × 99)
Exh: Redfern Gallery Summer
Exhibition, 1952 (280); São Paulo,
1953 (94); Tate Gallery, 1972
(25, repr.)
Lit: Bowness, pl.24
Private Collection

William Scott painted harbours both before the war in Brittany, near Pont Aven, and after the war in Mousehole, where he spent several summers after 1946. This scene is viewed horizontally with a few simple shapes denoting the harbour, boats and fishing boats.

WILLIAM SCOTT

123 The Harbour 1952

Oil on canvas, 24 × 36 (61 × 91.5)
Exh. São Paulo, 1953 (97); Kestner-
Gesellschaft, Hanover, 1960 (12);
Bern, 1963 (2); Belfast, 1963 (3); Tate
Gallery, 1972 (30, repr.)
Lit: Bowness, pl.29
William Scott

'The Harbour' is seen almost directly from

above. The painting also has suggestions of a figure.

JOHN WELLS

***124 Crystals and Shells** 1946

> Oil on canvas, 20 × 24 (50.8 × 61)
> *Exh:* St Ives Society of Artists, 1946 (127); Crypt Gallery, St Ives, 1946; Durlacher Bros., New York, 1952 (4); Penwith Summer Exhibition, St Ives 1960 (19); Waddington Galleries, 1960 (1); *Decade 40s Paintings, Sculpture and Drawing in Britain 1940–49*, Arts Council tour, 1972–3 (145); Plymouth Art Gallery, 1975 (42)
> *John Wells*

'Crystal and Shells' comes out of Wells' experience of living on the Scilly Isles. The artist explained (24 Sept. 1984) that when he stood on the rocks on the Scilly Isles looking at the sea all around the horizon appeared to be curved.

JOHN WELLS

***125 Music in a Garden** 1947

> Oil on canvas, 20 × 24 (50.8 × 61)
> *John Wells*

This work is based on Golden Section grid (see 'Sea Bird Forms') and named by the artist after completion.

JOHN WELLS

126 Aspiring Forms 1950

> Oil on board, 42 × 28½ (106.7 × 72.5)
> Prov: Purchased by Miss E.M. Hodgkins from the Penwith Gallery 1950
> Exh: *Summer Exhibition*, Penwith Gallery, St Ives, 1950 (7); *Contemporary British Painting 1925–1950*, Academy of Fine Arts, Philadelphia, 1950–1 (86); *Cornwall 1945–1955*, New Art Centre, 1977 (146)
> Lit: *The Tate Gallery 1976–78, Illustrated Catalogue of Acquisitions*, pl.139
> *Tate Gallery (T 02231)*

This is one of Wells' largest paintings and reflects his long standing interest in flight.

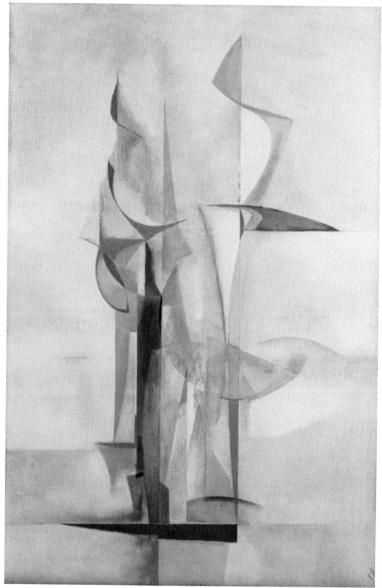

126

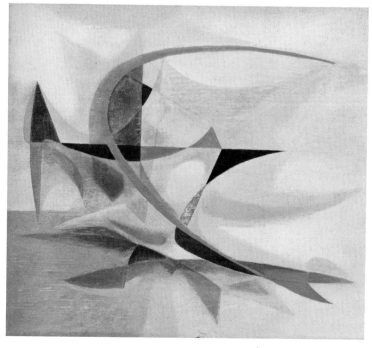

127

JOHN WELLS

127 Sea Bird Forms 1951

Oil on board, 17 × 19½ (43 × 49.5)
Prov: Miss E.M. Hodgkins
Lit: *The Tate Gallery Illustrated
Catalogue of Acquisitions 1976–78*,
p.139
Tate Gallery (T 02230)

This work is based on a Golden Section
grid, the seagull forms developed during the
course of the painting.

BRYAN WYNTER

**128 Birds Disturbing the Sleep of the
Town** 1948

Gouache, 14 × 20 (35.5 × 51)
Exh: Downing's Bookshop, St Ives,
1948; Redfern Gallery (with Kenneth
Wood), 1950 (18); Hayward Gallery,
1976 (9, repr.)
Lit: *Cornish Review*, summer 1950
*Miss Elma Mitchell and Miss Jeannette
R. Taylor*

BRYAN WYNTER

129 Foreshore with Gulls 1949

Watercolour and bodycolour on paper,
11½ × 17¾ (29.2 × 45)
Exh: Hayward Gallery, 1976 (11);
Cornwall 1945–1955, New Art Centre,
1977 (156, repr.)
The British Council

BRYAN WYNTER

130 Zennor Coast from the Sea 1949

Gouache, 13 × 29 (33 × 73.5)
Exh: Hayward Gallery, 1976 (13)
Molly Marriner

130

129

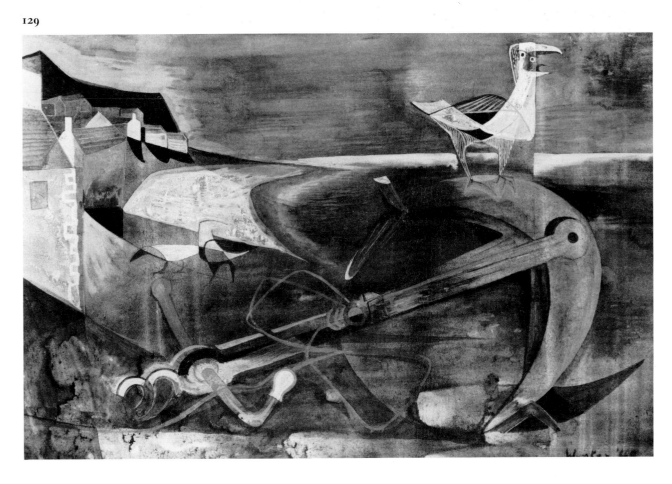

V NICHOLSON AND HEPWORTH

Nicholson's final years in St Ives were marked with continuing international success – the Guggenheim Painting Prize in 1956, and the First Prize for Painting at São Paulo in 1957. In the same year he married Felicitas Vogler, and they left St Ives for Switzerland in 1958. Between 1954 and 1958 he was often away from St Ives, drawing in Yorkshire or in Italy, and in the big paintings of this period he looked beyond Cornwall, as if to assert his new status as an international modern master. When he left after nineteen years he was never to return.

Hepworth, by contrast, became increasingly reluctant ever to leave her studio in St Ives, and her trips away were few. Some major commissions led to her seeking larger premises, and in 1960 she bought the old Palais de Danse across the street from Trewyn Studio. It was there that she made her largest work, the 'Single Form' that stands as a memorial to Dag Hammarskjöld outside the United Nations building in New York.

Hepworth never stopped carving in wood and stone, though she began to make metal sculpture, particularly bronzes, in the 1950s. Such works as 'Oval Form (Trezion)' (137) and 'Sea Form (Porthmeor)' (135) show how she could extend her formal language when using a new material. At heart however she remained a carver, and the great wood sculptures that she made from Nigerian guarea are perhaps the zenith of her work.

Leach too in this period produced probably the finest pots of his career, with a strong sculptural quality that can be related to the work of both Nicholson and Hepworth.

BARBARA HEPWORTH

131 Corinthos 1954–5

Scented guarea wood, interior painted white, 41 × 42 × 40 (104 × 107 × 102)
Exh: *The Seasons*, Tate Gallery, 1956 (54); Whitechapel, 1962 (8, repr.); Tate Gallery, 1968 (69)
Lit: Hodin, cat.198; M. Chamot, D. Farr, M. Butlin, *The Modern British Paintings, Drawings and Sculpture*, Tate Gallery, 1964, pp.279–80; Hammacher, pl.92; Hepworth, pl.192
Tate Gallery (T 00531)

In 1954, shortly after her return from a visit to Greece, Barbara Hepworth was unexpectedly given a consignment of large pieces of scented guarea wood from Nigeria, which she later described as 'the biggest and finest I had ever seen – most beautiful, hard, lovely warm timber' (Barbara Hepworth, *A Pictorial Autobiography*, 1970, p.72). She had carved twelve sculptures out of this material by 1963, most of which have Greek place names as titles. Although made over a period of nine years these carvings all have a certain resemblance: an expanse of dark brown polished wood, with concavities and holes cut into it and painted white, within a simple, rounded shape.

Other sculptures made from guarea wood include 'Curved form' (Delphi) 1955 (132) and 'Oval Sculpture' (Delos) 1955 (133).

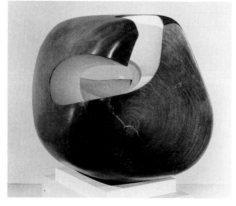

131

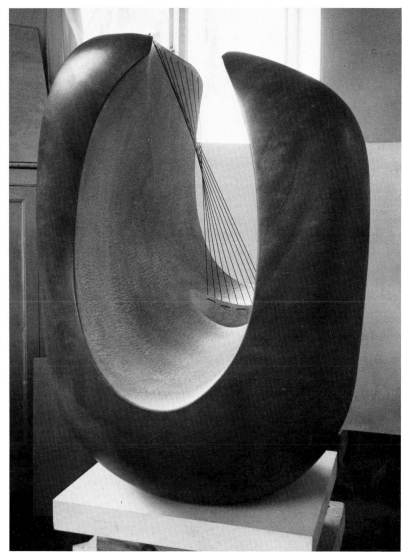

132

BARBARA HEPWORTH

132 Curved Form (Delphi) 1955

Scented guarea, with dark drown strings, interior painted white, height 42 (106.5)
Exh: Gimpel Fils, 1956 (5); São Paulo, 1959 (11); Whitechapel, 1962 (14, repr.); Rijksmuseum Kröller-Müller, Otterlo, 1965 (12, repr.); Tate Gallery, 1968 (70)
Lit: Hodin, cat. 199; Hammacher, pl.93; Hepworth, pl. 203
Ulster Museum, Belfast

BARBARA HEPWORTH

***133 Oval Sculpture (Delos) 1955**

Scented guarea, interior painted white, length 48 (122)
Exh: Gimpel Fils, 1956 (3); São Paulo, 1959 (10); Whitechapel, 1962 (11, repr.); Tate Gallery, 1968 (72, repr. p.28), Marlborough 1982 (7, repr. p.15)
Lit: Hodin, cat.201; Hammacher, pl.89; Hepworth, pl.190
National Museum of Wales

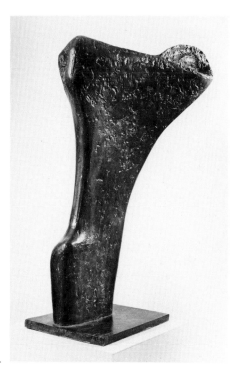

134

BARBARA HEPWORTH

134 Torso I (Ulysses) 1958

Bronze, height $51\frac{1}{2}$ (131)
Edition of six, cast 2
Exh: Gimpel Fils, 1958 (9); São Paulo, 1959 (16); Galerie Charles Lienhard, Zürich, 1960 (4); Whitechapel, 1962 (31, repr.); Rijksmuseum Kröller-Müller, Otterlo, 1965 (18); Tate Gallery, 1968 (87)
Lit: Hodin, cat.233; Hammacher, pl.105
The Trustees of the Hepworth Estate

In 1956 Hepworth started to make sculptures for casting in bronze: she did not however use a modeller's technique, but had the general form of the work made in plaster of Paris on a wooden armature which she then carved and scraped to achieve the final form and finish.

Other casts are in the Art Gallery of Ontario, Toronto, and in the Hirshhorn Museum, Washington.

BARBARA HEPWORTH

135 Sea Form (Porthmeor) 1958

Bronze, $30\frac{1}{4} \times 44\frac{3}{4} \times 10$
($77 \times 113.5 \times 25.5$)
Edition of seven
Exh: *5e Biennale voor Beeldhouwkunst*,
Middelheimpark, Antwerp, 1959 (50);
São Paulo, 1959 (19); Whitechapel,
1962 (38, repr.); Rijksmuseum
Kröller-Müller, Otterlo, 1965 (20);
Tate Gallery 1968 (93, repr. p.31)
Lit: Hodin, cat.249; Hammacher,
pl.116; *The Tate Gallery 1967–8*,
(Acquisitions) p.63; Hepworth, pl.205
Tate Gallery (T 00957)

The artist took a small studio flat
overlooking Porthmeor Beach in 1957
which she used particularly at weekends for
drawing and painting. This sculpture is in
part based on her observation of breaking
waves, and the pattern left on the beach by
waves and tides. Other casts are in the
Gemeente Museum, The Hague, and Yale
University Art Gallery.

BARBARA HEPWORTH

***136 Single Form** September 1961

Walnut, $32\frac{1}{2} \times 20 \times 2\frac{1}{4}$
($82.5 \times 50.5 \times 5.7$)
Exh: Whitechapel, 1962 (73, repr.);
Tate Gallery, 1968 (122, repr.)
Lit: Hammacher, pl.141; Bowness,
pl.3, 54, cat. 312; Hepworth, pl.237;
The Tate Gallery, Illustrated Catalogue

of Acquisitions, 1980–82, p.120
Tate Gallery T 03143

The Secretary-General of the United
Nations, Dag Hammarskjöld, was a close
personal friend of Barbara Hepworth, and
this sculpture was made at the moment she
learnt of his tragic death in a plane crash on
17 September 1961. Hammarskjöld had
already discussed with Hepworth the
possibility of her making a sculpture to
stand outside the United Nations building
in New York City; in the event the work
became a memorial to him. The final
monumental bronze is based on this wood
sculpture; smaller bronze versions also
exist.

BARBARA HEPWORTH

137 Oval Form (Trezion) 1961–3

Bronze, length $57\frac{1}{2}$ (146)
Edition of seven, cast three
Prov: Helen Sutherland
Exh: Gimpel Fils, 1964 (27, repr.);
Copenhagen, 1964 (24); Rijksmuseum
Kröller-Müller, Otterlo, 1965 (34,
repr.); Marlborough, New York, 1966
(14, repr.); Tate Gallery, 1968 (114)
Lit: Hammacher, pl.137; Bowness,
pl.4, 46, cat. 304
Trustees of the British Museum

Other casts are in the collections of
Aberdeen Art Gallery; Abbot Hall Art
Gallery, Kendal; Rijksmuseum Kröller-
Müller, Otterlo and the National Art
Gallery of New Zealand, Wellington.

135

137

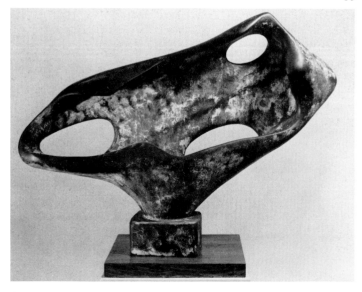

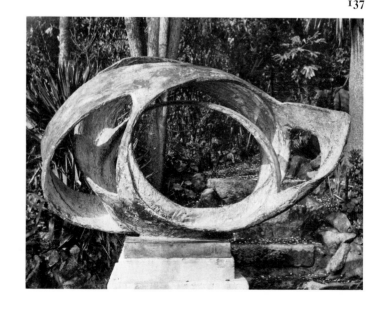

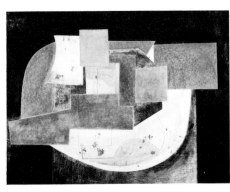

142

BARBARA HEPWORTH

***138 River Form** 1965

American Walnut, length 74 (188)
Exh: Tate Gallery, 1968, (162, repr.
p.40); Marlborough, New York, 1970
(5, repr. p.15)
Lit: Hammacher, pl.153; Bowness,
pl.137, 138, cat.401; Hepworth, pl.291
Trustees of the Hepworth Estate

The wood began to split shortly after the
carving had been completed, and the artist
made a version in bronze of which casts can
be seen outside Kensington Town Hall,
London, and in the Barbara Hepworth
Museum, St Ives.

BEN NICHOLSON

139 October 1954 (Rievaulx) October
1954

Oil wash and pencil on paper,
$22\frac{1}{2} \times 15\frac{1}{4}$ (57 × 38.5)
Exh: Tate Gallery, 1955 (86, repr.
pl.3); Galerie Charles Lienhard,
Zurich, 1959 (22); Tate Gallery, 1969
(85, repr. pl.49)
Lit: Lund Humphries, 11, pl.97;
Russell, pl.65
Private Collection

This drawing was made while the artist was
staying with Herbert Read, at his house at
Stonegrave, Yorkshire.

141

BEN NICHOLSON

**140 February 1955 (West
Cornwall)** February 1955

Oil on masonite, 42 × 42
(106.5 × 106.5)
Exh: Gimpel Fils, 1955 (5)
Lit: Lund Humphries, 11, pl.135;
Russell, pl.146
Mr and Mrs Ian Stoutzker

BEN NICHOLSON

**141 October 1955 (Cathedral,
Pienza)** October 1955

Oil wash and pencil on paper, 21 × 16
(53.3 × 40.5)
Exh: Gimpel Fils, 1957 (22)

Lit: Lund Humphries, 11, pl.109;
Russell, pl.158
*Trustees of the Cecil Higgins Art
Gallery, Bedford*

BEN NICHOLSON

**142 November 1955 (Still Life,
Nightshade)** November 1955

Oil and pencil on board, $37\frac{7}{8} \times 50$
(96.3 × 127)
Exh: Galerie Charles Lienhard,
Zurich, 1959 (28, repr. p.18); Kestner-
Gesellschaft, Hanover, 1959 (48, repr.
p.16); *Painting and Sculpture of a
Decade*, Tate Gallery, 1964 (30, repr.
p.73); Tate Gallery, 1969 (86, repr.
p.50)
Lit: Russell, pl.199
Private Collection, Switzerland

BEN NICHOLSON

***143 December 1955 (Night
Facade)** December 1955

Oil on board, $42\frac{1}{2} \times 45\frac{3}{4}$ (108 × 116.2)
Exh: Galerie de France, Paris, 1956;
11ième Salon des Réalités Nouvelles-
Nouvelles Réalités, Musée des Beaux-
Arts de la Ville de Paris, Paris, 1956;
Dallas, 1964 (43); The Art Club of
Chicago, 1976 (8, repr.); Albright-
Knox Art Gallery, Buffalo, 1978–9
(61, repr.)
Lit: Lund Humphries, 11, pl.129;
Russell, pl.64; *The Guggenheim
Museum Collection 1900–1980*,
pp.304–5
*Solomon R. Guggenheim Museum,
New York*

BEN NICHOLSON

***144 Boutique Fantasque** 1956

Oil and pencil on board, 48 × 84
(122 × 213.5)
Exh: *54:64 Painting and Sculpture of a
Decade*, Tate Gallery, 1964 (31, repr.
p.73)
Private Collection

BEN NICHOLSON

***145 August 56 (Val d'Orcia)** August
1956

Oil on masonite, 48 × 84 (122 × 213.5)
Exh: *Critic's Choice*, Tooth's, 1956 (1);
Guggenheim International Award,
Musée d'Art Moderne, Paris, 1956;
São Paulo, 1957 (36); Galerie Charles
Lienhard, Zurich, 1959 (33); Kestner
Gesellschaft, Hanover, 1959 (53, repr.
p.22); *Painting and Sculpture of a
Decade*, Tate Gallery, 1964 (32, repr.
p.73); Marlborough-Gerson Gallery,
New York, 1965 (5)
Lit: Alley, p.2; *The Tate Gallery
Report Acquisitions 1965–66* pp.37–8
Tate Gallery (T 00742)

This painting was given the first
Guggenheim International Award by an
international jury in 1956. The title in
brackets was intended as a label only and
has no associative content.

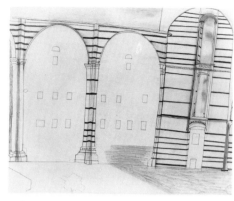

146

BEN NICHOLSON

**146 October 1956 (Siena
Cathedral)** October 1956

Pencil and oil wash on paper, $16\frac{3}{4} \times 21$
(42.5 × 53.5)
Prov: Barbara Hepworth
Exh: Albright-Knox Art Gallery,
Buffalo, 1978–9 (64, repr.)
Lit: Hodin, pl.49; Russell, pl.55 (as
September)
Private Collection

'I have favourite places – Mycenae and Pisa,
and Siena, for instance – and I feel that in a
previous life I must have laid two or three of
the stones in Siena Cathedral, and even
perhaps one or two of those at Mycenae!
Of course, when you draw something that's
already a work of art it sets a special
problem. But you really get to know the
spirit of a place that way – there's a big
difference between merely looking at a
building and living with it for two or three
hours (or for a couple of centuries) while
making a drawing. When I draw one of
those pieces of Greek and Italian
architecture I am, I suppose, drawing the
form. But it's the spirit of the architecture
that I look at, not its stones. (Ben
Nicholson, *Sunday Times*, 28 April, 1963).

147

BEN NICHOLSON

**147 November 1957 (Yellow
Trevose)** November 1957

Oil and pencil on canvas, $75 \times 26\frac{3}{4}$
(190.5 × 68)
Exh: Kestner-Gesellschaft, Hanover,
1959 (65); Kunsthalle, Berne, 1961
(77)
Lit: Russell, pl.149
*Kunsthaus Zurich, Vereinigung Zürcher
Kunstfreunde*

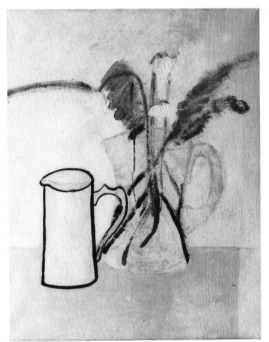

148

KATE NICHOLSON

148 Leaf Jug, St Ives May 1957

Oil on canvas, 25 × 20 (63.5 × 50.7)
Exh: Border Gallery, Carlisle, 1969
(30); *Flower Paintings and Botanical
Drawings by Artists of the XXth
Century*, Manchester Cathedral, 1984
(9)
Kate Nicholson

This picture was painted in May 1957,
shortly after the artist moved into her new
studio at Porthgwidden, St Ives. The studio
looks out across the Bay to Godrevy
lighthouse and has a particularly beautiful
light according to Kate Nicholson. Still lifes
and flower pieces are amongst her favourite
themes for paintings. (Information Kate
Nicholson 4.11.84)

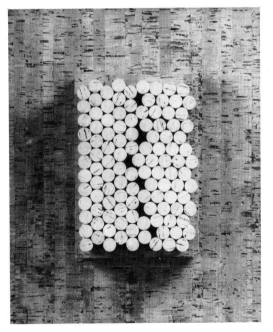

149

SIMON NICHOLSON

149 6406 February 1964

Wood, $23 \times 19\frac{9}{16} \times 5\frac{7}{8}$
$(58.3 \times 49.7 \times 15)$
Exh: San Francisco, 1968; Gallery for
Contemporary Art, Pittsburgh, 1969
Simon Nicholson

Simon Nicholson uses either found objects
or industrial products bought from
manufacturers in large quantities, for
example, plastic cylinders, ping-pong balls,
ice-lolly sticks and cork.

VI LANYON

Lanyon's first one man exhibition in New York in 1957 was very well received, and Lanyon was accepted as an equal by the American painters who were just beginning to win an international reputation. He and Rothko became good friends, and Lanyon brought Rothko to St Ives in August 1958 to look for a chapel in the West Penwith landscape which Rothko could decorate. Nothing came of this, but Lanyon spent increasingly more of his time in the United States, and towards the end of his life began to get impatient with England and with the small world of St Ives.

He took up gliding in 1959, primarily as a way to get to know the landscape better. The experience brought to his pictures a greater feeling of sea and air, in contrast to the heavy earthiness of the earlier work. The tendency towards monochrome gives way to a much greater range of colour, and it was this that Lanyon was exploring at the time of his accidental death in August 1964. Totally unexpected and gratuitous, it was a blow from which painting in St Ives was never quite to recover.

PETER LANYON

150 Europa 1954

Oil on masonite, 48 × 72 (122 × 183)
Exh: Plymouth, 1955 (21);
Contemporary British Painting,
Copenhagen, 1956 (48); Catherine
Viviano Gallery, New York, 1957 (4);
Tate Gallery/Arts Council, 1968 (36,
repr. pl.8); Whitworth Art Gallery,
1978 (59, repr. fig.30)
Lit: Causey, pl.32, cat. 65
Private Collection

Painted after the artist visited Italy early
1953. 'For me this is a story about primitive
life, about living among the animals. The
God comes to Europa in the form of a
beautiful white bull, and from their union
the Minotaur is born.' (Recorded talk, Arts
Council cat. 1968).

PETER LANYON

151 Wheal Owles 1958

Oil on masonite, 48 × 71¾
(122 × 182.5)
Exh: Gimpel Fils, 1958 (13); 5th
Tokyo Biennale, 1959; *British Painting*

1700–1960, Moscow and Leningrad,
1960 (135); Tate Gallery/Arts Council,
1968 (47); Whitworth Art Gallery,
1978 (66)
Lit: Causey, pl.31; cat. 121
Private Collection, Geneva

'Wheal Owles' means 'mine on the cliff',
and refers both to an extinct mine in the
garden of Lanyon's home, Little Park
Owles, and to the Levant mine.

PETER LANYON

152 Zennor Storm 1958

Oil on hardboard, 48 × 72 (122 × 183)
Prov: Catherine Viviano
Exh: Catherine Viviano Gallery,
New York 1959 (9)
Lit: Causey, cat.122
Tate Gallery T 03209

Painted in the artist's studio, which was the
garage of 'Little Park Owles' Carbis Bay.
Sheila Lanyon suggested (12.7.83) that the
picture might be of a storm over Carn
Galver, a hill near Zennor, a village about
four miles west of St Ives. No studies were
made for the painting, the only one Lanyon
did of a storm.

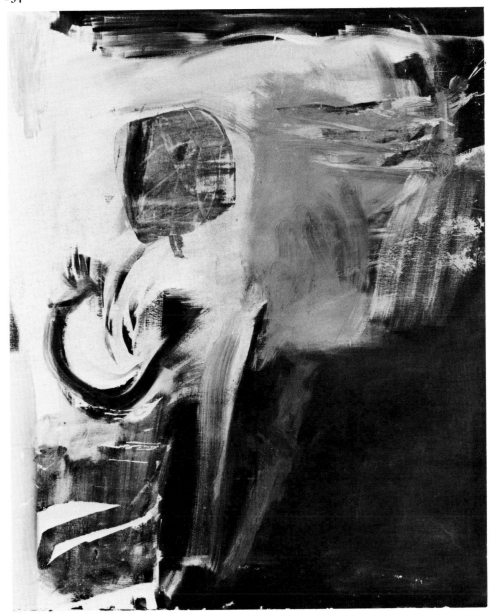

153

154

PETER LANYON

153 Rosewall 1960

Oil on canvas, 72 × 60 (183 × 152.5)
Exh: *Contemporary British Landscapes*,
Arts Council, 1960–1 (33); *54:64,
Painting and Sculpture of a Decade*,
Calouste Gulbenkian Foundation,
Tate Gallery, 1964 (211); Tate
Gallery/Arts Council, 1968 (58);
Whitworth Art Gallery, 1978 (70, repr.
pl.IV)
Lit: *Connoisseur*, July 1964, p.190;
Causey, pl.33, cat.138; *Some Recent
Acquisitions*, Ulster Museum, 1976
Ulster Museum, Belfast

An aerial view of Rosewall hill outside
St Ives, on the road to Zennor and
Land's End.

PETER LANYON

154 Thermal 1960

Oil on canvas, 72 × 60 (183 × 152.5)
Exh: Gimpel Fils, 1960 (7); Tate
Gallery/Arts Council 1968 (62); *British
Painting and Sculpture 1960–70*,
National Gallery, Washington, 1970
(15, repr.)
Lit: M. Chamot, D. Farr, M. Butlin.
*The Modern British, Paintings,
Drawings and Sculpture*, Tate Gallery,
1964 p.372; Causey, pl.67, cat.142
Tate Gallery (T 00375)

Lanyon wrote: 'The experience in
"Thermal" does not only refer to glider
flight. It belongs to pictures which I have
done before, e.g. "Bird-Flight", and which
are concerned with birds describing the
invisible, their flight across cliff faces and
their soaring activity.

The picture refers to cloud formation
and to a spiral rising activity which is the
way a glider rises in an up-current.'
(28 November 1960, quoted in the 1964
Tate Gallery catalogue).

PETER LANYON

***155 Drift** 1961

Oil on canvas, 60 × 42 (152.5 × 106.5)
Exh: VI São Paulo Bienal, 1961 (9);
British Painting in the Sixties, Tate
Gallery, 1963 (63); Tate Gallery/Arts
Council, 1968 (63)
Lit: *Studio*, Aug. 1965, pp.76–9;
Causey, pl.42, cat.154
Private Collection

Another gliding picture, which refers to
Lanyon's own experience of flying high
above the West Cornwall landscape.

PETER LANYON

***156 Loe Bar** 1962

Oil on canvas, 48 × 72 (122 × 183)
Exh: Gimpel Fils, 1962 (6); *Four
Painters*, Arnolfini, Bristol, 1963 (14);
Gimpel and Hanover Gallery, Zurich,
1961 (5); Tate Gallery/Arts Council,
1968 (74); Whitworth Art Gallery 1978
(74)
Lit: Causey, pl.51, cat.179
Private Collection

Loe Bar is a sand bar on the coast of the
Lizard peninsula between Porthleven and

Gunwalloe. The Bar stops the river Loe
reaching the sea, and this forms an inland
lake. The painting also refers to beach-
combing and to Lanyon's walks along the
sand bar – he has related how the U-shape
in the painting derives from a piece of
rusted metal that he saw on the Bar.

PETER LANYON

***157 Clevedon Bandstand** 1964

Oil on canvas, 48 × 72 (122 × 183)
Exh: Gimpel and Hanover Galerie,
Zürich, 1964 (16); *Corsham Painters
and Sculptors*, Arts Council, 1965
(125); Tate Gallery/Arts Council, 1968
(90, repr. pl.11); Whitworth Art
Gallery, 1978 (101, repr. fig.40)
Lit: Causey, pl.58, cat.205
Mrs Sheila Lanyon

Lanyon visited Clevedon, in a North
Somerset, in May 1964 with a group of
students from the West of England College
of Art at Bristol. The artist made several
drawings of Clevedon and took photographs
of the pier, boatpool and bandstand.

PETER LANYON

158 Clevedon Night 1964

Oil and polystyrene collage on canvas,
48 × 72 (122 × 183)
Exh: Bristol, 1970 (15); Whitworth
Art Gallery, 1978 (100, repr. pl.VIII)
Lit: Causey, pl.56; cat.206
Mrs Sheila Lanyon

The two pieces of polystyrene added to the
surface of the canvas represent boats in
front of the Regency iron pier at Clevedon.

PETER LANYON

159 Glide Path 1964

Oil and plastic collage on canvas,
60 × 48 (152.5 × 122)
Exh: Gimpel and Hanover Galerie,
Zürich, 1964 (18, repr.); *Corsham,
Painters and Sculptors*, Arts Council,
1965, (126); Tate Gallery/Arts
Council, 1968 (93); Whitworth Art
Gallery, 1978 (85, repr. fig.35)
Lit: *London Magazine*, May 1968;
Causey, pl.59; cat.212
*Whitworth Art Gallery, University of
Manchester*

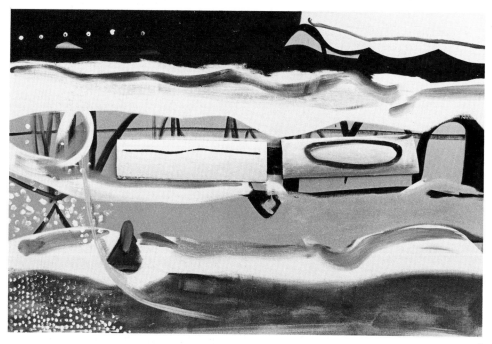
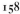

158

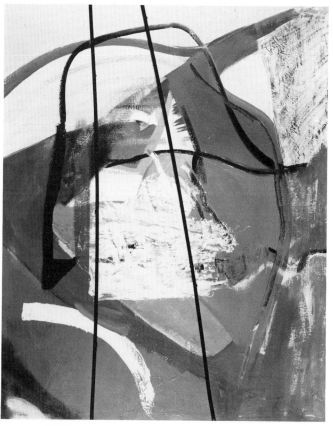

159

VII 1954–64 FROST, WYNTER AND THEIR CONTEMPORARIES

It was in the second half of the 1950s that St Ives was at its liveliest. Many young painters and sculptors began to move into the area, or at least came as summer visitors, sometimes staying for quite extended periods. The artists already there found this influx a stimulating one, and in many cases their best work is done in these years.

Bryan Wynter completely changed style in January 1956, working non-figuratively and on a larger scale, seeking to express a more elemental vision of the natural world. There was a tension in the paintings that seemed to slacken after Wynter's first heart attack in 1962, and from 1960 Wynter's experiments with kinetic constructions (191) took up more and more of his time.

Frost was in Leeds in 1954–7, at first as Gregory Fellow and then as a teacher at the Leeds College of Art. He did not lose contact with St Ives in this period however, and returned permanently in the summer of 1957 to paint full-time. He showed in New York for the first time in 1960, and like Lanyon and Heron before him immediately came into contact with the abstract expressionist painters, and was welcomed as a colleague. Frost's own painting, though abstract, retains a feeling of landscape, and increasingly of the figure.

Among the younger painters who moved to West Cornwall were Alexander Mackenzie (176) who had arrived in 1951, and Karl Weschke (185), Trevor Bell (161) and Anthony Benjamin (162) who all arrived in 1955. Tony O'Malley (225) came in 1960. Paul Feiler (164), though teaching and living in Bristol, had been partly resident since 1952, and Patrick Hayman (169) had several long stays in St Ives. Joe Tilson (180) had a summer cottage on the high moors between Nancledra and Zennor from 1957 until 1962: among his summer visitors was Peter Blake in 1960 when the Arts Council's 'Boy Eating Hot Dog' was painted. But Blake's work can't be related to St Ives painting, nor can the pictures of Alan Davie, who was spending summers at his cottage at Bottoms, near St Buryan, at this time. Bob Law on the other hand was in St Ives and Nancledra 1957–60, and his drawings of the period (170–74) extend the St Ives sensibility, as do the paintings of Sandra Blow (163) who was in Zennor 1957–8.

When he stopped working for Barbara Hepworth in 1959, Denis Mitchell (178–9) began to make sculpture on his own which expressed a distinct and personal voice. Hepworth employed several assistants at this time who went on to make their own reputations. Some, like John Milne (177) continued to work in a manner recognisably related to Hepworth, but others, including Roger Leigh (174), and in particular Brian Wall (181–2), chose a quite different path. Wall's welded metal abstract sculpture was made from 1956 onwards independently of Caro and his followers in London: it stemmed from a different modernist tradition, that of the constructivist art of Gabo and others, which remained very much alive in St Ives.

W. BARNS-GRAHAM

160 March 1957 (Starbotton) March 1957

Oil on canvas, 25 × 30⅛ (63.5 × 76.5)
Scottish National Gallery of Modern Art, Edinburgh

'March 1957 (Starbotton)' was painted in Leeds where Barns-Graham taught at the Art College in 1956–7. In her view the painting reflects the heavy black skies and the bright hues of the clothes of coloured people.

Starbotton is the name of a pot hole she visited in Yorkshire.

TREVOR BELL

161 Black 1959

Oil on canvas, 72 × 60 (183 × 152.5)
Exh: Waddington Galleries, 1960 (9)
Mr. and Mrs. Eugene Rosenberg

In 1958 Trevor Bell spent several months at Anticoli Corrado, near Tivoli, Italy, on an Italian Government Scholarship. Bell's interest in the Italian piazza and in pierced facades is reflected in the 'beaded curtain' effect in this work, which was painted in his Porthmeor studio after he returned to Cornwall.

ANTHONY BENJAMIN

162 Inland 1960

Oil on canvas, 25¾ × 33¾ (65.5 × 85.5)
John Christopherson

Painted during the time when Benjamin was changing from figurative to abstract painting. He made many charcoal sketches out of doors near his home at Cripplesease and the countryside; these were used as the basis for oil paintings in the studio. (Benjamin, Dec. 1984).

SANDRA BLOW

163 Untitled 1957–8

Sacking, plaster and oil on wood and hardboard, 44⅞ × 44¹¹⁄₁₆ (114 × 114.2)
Exh: *Young British Painters*, Rotterdam, Zurich and Dusseldorf, 1958
Sandra Blow

Sandra Blow used hessian in her pictures, when she lived in Italy, where she first met the Italian artist, Burri. When she lived in Tregerthen in 1957–8, she also incorporated hessian into her work and often painted out of doors.

PAUL FEILER

164 Morvah 1958

Oil on board, 35 × 47½ (89 × 120.5)
John Christopherson

'I have always enjoyed writing down with paint what I felt the world around me looked like. This has been a limited world; a world of open spaces with snow and ice-covered mountains; later, the sea and the rocks seen from a height.

This has led me to try to communicate a universal aspect of forms in space; where the scale of shapes to each other and their tonal relationship convey their physical nearness to the spectator and where the overall colour and its texture supplies the emotional overtones of the personality of the "Place".' *Statements, a Review of British Abstract Art in 1956*, ICA, 1957.

Morvah is the name of a village on the road from St Ives to St Just.

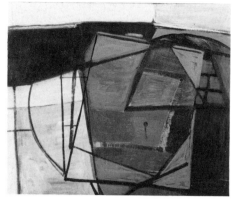

160

163

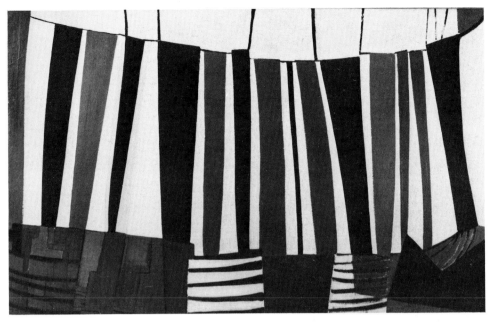

165

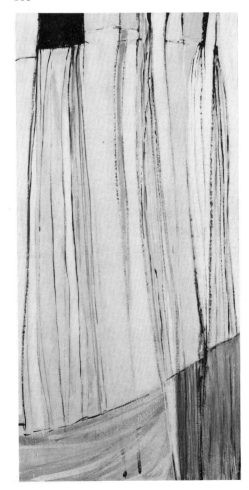

166

TERRY FROST

165 Red, Black and White, Leeds 1955

Oil on hardboard, 48 × 72 (122 × 183)
Exh: Possibly Leicester Galleries,
1956; *54:64 Painting and Sculpture of a
Decade*, Tate Gallery, 1964 (199, repr.
p.167) Arts Council/South West Arts,
1976–7 (18, repr. p.8)
Private Collection

TERRY FROST

166 Winter, 1956, Yorkshire 1956

Oil on hardboard, $97\frac{1}{8} \times 49\frac{1}{8}$
(246.7 × 125)
Exh: *Pictures Submitted for the
Guggenheim Awards*, City Art Gallery,
Manchester, 1958 (33); *Guggenheim
International Award*, Guggenheim
Museum, New York, 1958
Lit: T. Measham, *The Moderns*, 1976,
no.25; Arts Council/South West Arts,
1976–7, p.14; *The Tate Gallery,
Illustrated Catalogue of Acquisitions,
1974–6*, pp. 95–6
Tate Gallery (T 01924)

Painted in Leeds in the very cold winter of
1955–6 after a visit to Pickering where
Frost was impressed with vast landscapes
under snow with dry stone walls appearing
like black lines. On his return to Leeds he
went tobogganing, fell off on a descent and
collided with a group of people. One of
Frost's companions, Rosemary Blackburn
(the other was Kenneth Armitage) wore a

black hat which is reflected in the black
shape near the top left hand corner of the
painting. 'The picture', says Frost,
'expresses what happened to me when I
went from top to bottom of the hill.'

TERRY FROST

***167 Three Graces** June 1960

Oil and canvas collage on canvas,
78 × 96 (198 × 244)
Exh: Waddington Galleries, 1961 (13);
British Painting in the Sixties, Tate
Gallery, 1963 (30); Laing Gallery,
Newcastle upon Tyne, 1964 (34); Arts
Council/South West Arts, 1976–7 (23,
repr. p.38)
City of Bristol Museum and Art Gallery

Terry Frost first used collage in a few works
about 1951; he began to use it again about
1960 when he incorporated it into some
large works such as 'Three Graces'. He had
copied Rubens' 'Three Graces' in the
National Gallery when a student. 'I liked
the idea of three forms turning in space, the
lines made by glances from the eyes of the
Three Graces to Paris and Mercury, the
three reds of the cloaks, all kinds of time
and space suggested by a flat surface'. (letter
from Terry Frost, October 1984).

TERRY FROST

***168 Force 8** October 1960

Oil on canvas, 87 × $68\frac{1}{4}$ (221 × 173.5)
Exh: Waddington Galleries, 1961 (22);
Laing Galleries, Newcastle upon Tyne,
1964 (36, repr.); Arts Council/South
West Arts, 1976–7 (24, repr. p.12)
*Ferens Art Gallery: City of Kingston
upon Hull Museums and Art Galleries*

'The title came because as I walked to the
studio I had to lean against a gale and when
I got in and started to work on the painting
the radio said Force 8 gale and I realised
that was the title I needed for the painting I
was working on.

'The rhythm and expressionist type of
paint had a relationship with the kind of
gale pressure I had just experienced and
could now hear bashing against my studio
window'. (Terry Frost, letter October
1984).

PATRICK HAYMAN

***169 Tristan and Isolde in Cornwall** 1965

Gouache on paper, 22 × 30
(55.9 × 76.2)
Exh: Grosvenor Gallery, 1965 (54)
Arts Council of Great Britain

One of the many works by Patrick Hayman on this theme. 'Romantic or sinister, the couple appear against a dark sea, a ship highlighted against the sky, mysterious build-up near at hand denote Cornwall, a phallic mine chimney sets the tone. Isolde's face is drawn, one feels the bones of her face and the sense of clenched teeth against her lips. Tristan wears a hat, his face reminiscent of a much later epoch of suffering, against his heart an alarm clock.' (Patrick Hayman, September 1984).

170

171

173

172

174

BOB LAW

170 21.4.59 (Field Drawing)
21 April 1959

Pencil on paper, $9\frac{7}{8} \times 13\frac{3}{4}$ (25 × 35)
Bob Law

In 1959 when living at Nancledra Bob Law started to make 'environmental' or 'field' drawings, while lying in fields or soon afterwards (Nos.170–173).

'The early field drawings were about the position of myself on the face of the earth and the environmental conditions around me: the position of the sun, the moon and the stars, the direction of the wind, the way in which the trees grew, an awareness of nature's elements, an awareness of nature itself and my position in nature on earth in a particular position in time. I was finding myself and the map that went with myself. I was transcribing it graphically into charts.'

Bob Law in conversation with Richard Cork. (Museum of Modern Art Oxford, 1974. *10 Black Paintings 1965–70*. Exhib. cat).

In 1960 Law made drawings deriving from the 'field' drawings, in which lines were drawn parallel to and close to the edge of the paper (171 and 173). Two were large, one with the central area heavily shaded and the other not (both coll. Tate Gallery).

BOB LAW

171 Landscape XIII, 10.1.60
10 January 1960

Pencil on paper, 11 × 15 (28 × 38)
Exh: Whitechapel, 1978 (38, repr. pl.C)
Bob Law

BOB LAW

172 24.6.60 24 June 1960

Pencil on paper, $12\frac{3}{8} \times 9\frac{7}{8}$ (31.5 × 25)
Bob Law

BOB LAW

173 29.8.60 29 August 1960

Pencil on paper, $9\frac{7}{8} \times 13\frac{3}{4}$ (25 × 35)
Bob Law

ROGER LEIGH

174 Cledhdan 1960

Aluminium bolted to concrete base, 34 × 12 × 12 (86.5 × 30.5 × 30.5)
Exh: Penwith Gallery, St Ives, summer 1961 (51); Queen's Square Gallery, Leeds, 1966 (2)
Private Collection

The artist wrote (November 1984): 'It was only the second work made when I moved

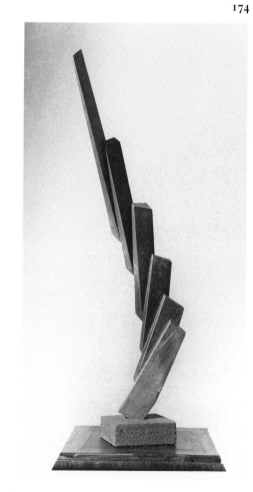

from solid carved forms (with Barbara Hepworth's influence) to sculpture constructed from separate elements, initially in wood and usually expressing implied movement.' The word 'Cledhdan' means 'flaming sword' in Cornish.

'Cledhdan' was made in an edition of five, this work is 4/5.

ALAN LOWNDES

175 Porthmeor Beach, St Ives 1955

Oil on board, $23\frac{1}{2} \times 28\frac{1}{2}$ (59.7 × 72.5)
Exh: Crane Gallery, Manchester, 1955 (48, repr.); Stockport Art Gallery, 1972 (32, repr. p.39)
Private Collection

Alan Lowndes worked in studios near to Porthmeor Beach. In the 1950s he shared one of the Piazza studios with Michael Broido and then was lent the Piazza Studio of Linden Travers. Later he painted in a sail loft in Norway Square and then in one of the Porthmeor Studios. After moving to Halsetown in 1964 he had a studio built in the garden. Lowndes often painted Porthmeor Beach and made sketches of it from his boat. (Information Mrs Valerie Lowndes 31 October 1984).

175

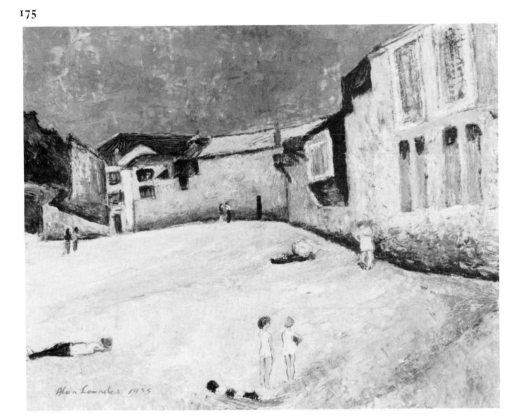

ALEXANDER MACKENZIE

176 Painting October/November 1960

Oil on board, 28×72 (71 × 183)
John Crowther

This painting was commissioned by John Crowther, an architect in Cornwall, who specified that the painting should be generally of Cornwall. The artist wrote (September 1984): 'I considered the Penwith peninsula, detached, yet remaining part of the mainland . . . a composition

176

developed which seemed to describe this detachment, the colour, texture and scoring represented the worn granite landmass of Penwith, and the holes symbolised the hut circles and burial mounds of the ancient area, the white surrounding areas represented sea and sky.'

JOHN MILNE

177 Gnathos 1960–1966

Polished bronze on black Belgian marble base, $25\frac{1}{4} \times 34 \times 14\frac{3}{4}$ ($64 \times 86.5 \times 37.5$)
Prov: Professor Rodewald
Exh: *St Ives Group 3rd Exhibition*, Austin Reed Gallery, 1971 (20)
Lit: Marjorie Parr Gallery, 1969, Exhib. cat. (Arts Council version repr.); *Tate Gallery 1970–72*, pp. 149–50
Tate Gallery (T 01449)

'Gnathos' was made in two editions, each of three casts. This is 2/2 in the polished bronze edition. 1/2 belongs to the Arts Council. The Greek word 'Gnathos' means jaw.

DENIS MITCHELL

178 Oracle 1955

Guarea wood, height $49\frac{3}{4}$ (126.5)
Exh: Arnolfini, Bristol, 1967 (19); *Cornwall 1945–55*, New Art Centre, 1977 (87); Glyn Vivian Art Gallery, Swansea, 1979 (42, repr.)
Private Collection

The artist bought the wood for this sculpture from Barbara Hepworth.

DENIS MITCHELL

179 Turning Form 1959

Bronze, $56 \times 7 \times 11$, ($142.2 \times 17.8 \times 28$)
Prov: Bought by Miss E.M. Hodgkins from the Penwith Gallery 1959
Exh: Penwith Gallery, St Ives 1959 (75); Festival Gallery, Bath, 1978 (9)
Lit: *The Tate Gallery 1976–78 Illustrated Catalogue of Acquisitions*, p.112; Glynn Vivian Art Gallery, Swansea, 1979. *Denis Mitchell*. (Works

177

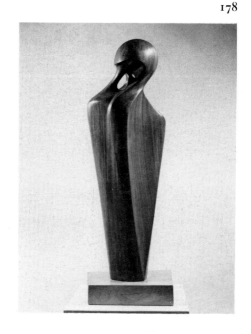

178

not included in the exhibition: bronzes section). Exhib. cat.
Tate Gallery (T 02235)

'Turning Form' was sand cast in solid bronze by Holman's Foundry, St Just, in an edition of three plus one for the artist. The Tate cast is no.2; no.1 belongs to Manchester University, no.3 to an English private collector and the artist's copy is in a private collection in the U.S.A. The artist stated in 1977 that this work owed something to John Wells' painting 'Aspiring Forms' 1950, which in turn came out of bird's flight.

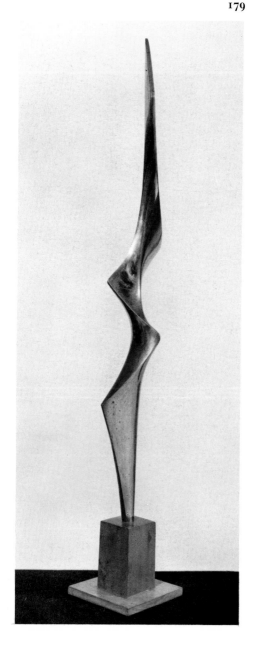

179

JOE TILSON

180 Conquer 1958-9

Oil on canvas on hardboard, 84 × 60
(213.5 × 152.5)
Exh: London Group, 1959 (84)
Joe Tilson

When living in Italy 1955-7 Tilson made a
number of paintings, based on landscape,
using collage. Sheets of coarse hessian
covered in thick paint were cut into pieces
and glued onto other pieces of canvas and
painting continued. At this time he also
started making his first wood reliefs, with
canvas glued onto wood and assembled in
boxes, 'early attempts to make the painting
more like an object, more tangible – less
illusionistic not abstract but with a strong
physical presence'. Tilson says that he was
excluded from the *Situation* exhibition in
1960 'because of my references to landscape
(which linked me to Peter Lanyon and the
St Ives painters whose work they [the
Situation painters] did not like) the object-
like nature of my works as opposed to their
view that painting should be rectangular
and flat – with flat colours evenly applied –
and my insistence on subject matter –
("Subject is crucial" – Rothko) opposing
their insistence on abstraction.'

The image in 'Conquer' was based on the
area Conquerdown around Tilson's cottage
where the picture was painted. (Letter from
Joe Tilson 24 October 1984).

180

BRIAN WALL

181 Sculpture *c.*1956

Painted steel, height 48 (122)
Exh: *British Sculpture in the 20th
Century*, Part 2, Whitechapel Art
Gallery, 1981-2 (68)
Private Collection

'I moved from painting to the painted wood
reliefs in 1954, influenced by John
Forrester's work of the time and by Ben
Nicholson's early reliefs. By the following
year I moved to three-dimensional painted
wood constructions, in part encouraged by
Terry Frost. Shortly thereafter (1956)
I began working in welded steel, at first
painting the pieces according to the same
formula as I had employed on the wooden
constructions: the rods black, vertical and
horizontal plates various colours.

'By 1958 I had primarily eliminated the
coloured elements, using only black paint or
leaving the surface unpainted.

'I was already making sculpture before I
went to work for Hepworth. Although I was
never influenced stylistically by her work, I
learnt a great deal from her about what it
means to be a professional artist. I was very
impressed by her commitment to her art
and by her work habits, which have
remained a life long influence.' (Brian Wall,
23 October 1984).

BRIAN WALL

182 Landscape Sculpture 1958

Iron, 20 × 15 × 10 (50.8 × 38.1 × 25.4)
Exh: *British Sculpture in the 20th
Century*, Part 2, Whitechapel Art
Gallery, 1981–2 (67)
Arts Council of Great Britain

JOHN WELLS

183 Painting 1956

Oil on board, $35\frac{3}{8} \times 47\frac{1}{2}$ (90 × 120.5)
Exh: *The Penwith Society of Arts in
Cornwall*, Arts Council, 1957 (37);
Aspects of Abstract Painting in Britain,
Talbot Rice Art Centre, Edinburgh,
1974 (88, repr.)
Ken Powell

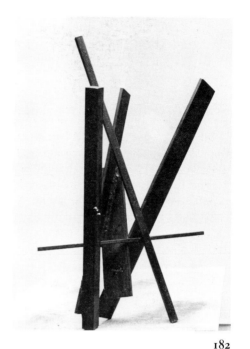

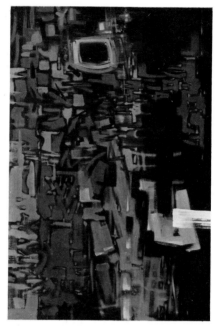

182 186

JOHN WELLS

184 Composition Variation 3 1963

Oil on reversed hardboard, $35 \times 6\frac{1}{4}$
(89 × 16)
Exh: Waddington Galleries, 1964 (22)
Private Collection, London

This work can be hung both horizontally
and vertically.

KARL WESCHKE

***185 View of Kenydjack** 1962

Oil on canvas, $30 \times 49\frac{1}{4}$ (76 × 125)
Exh: Grosvenor Gallery, 1964 (12);
Plymouth City Art Gallery, 1971 (9);
Whitechapel Art Gallery, 1974 (4);
Newlyn Art Gallery, 1974 (3)
Gian and Jeanette Ongaro

Based on a view from the artist's kitchen
window looking north from the cottage at
Cape Cornwall into which the artist moved
in 1960.

BRYAN WYNTER

186 Mars Ascends 1956

Oil on canvas, $60\frac{1}{8} \times 39\frac{7}{8}$
(152.5 × 101.3)
Prov: Fello Atkinson
Exh: Redfern Gallery, 1957 (22);
Penwith Gallery, St Ives, 1957 (2);
Hayward Gallery, 1976 (21, repr.)

183

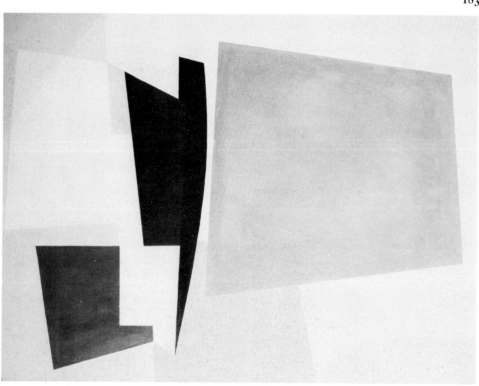

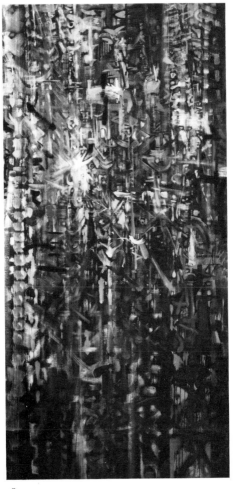

189

191

Lit: *The Tate Gallery, Illustrated Catalogue of Acquisitions 1980–82*, pp.225–6.
Tate Gallery (T 03289)

The artist's widow wrote (20 October 1982): '1956 was a very productive year for him . . . Now, with the stimulus of being in London, no more teaching and some relief from financial worries leading to a sense of freedom and optimism, he produced a series of paintings which seemed a breakthrough to him, the result of a release of creative energy, and paintings which no longer contained direct references to landscape or other subject matter.'

'Mars Ascends' was painted after the artist returned to Zennor from London.

BRYAN WYNTER

187 River Boat Blues 1956

Oil on canvas, 44 × 56 (112 × 142)
Prov: Peter Stuyvesant Foundation
Exh: International Art Exhibition, Japan, 1957; Arnolfini, Bristol, 1963 (1); Hayward Gallery, 1976 (26, repr.)
The Waddington Galleries

BRYAN WYNTER

*188 The Indias 1956

Oil on canvas, 90 × 44 (228.5 × 112)
Exh: Redfern Gallery, 1957; *Recent Paintings by 7 British Artists*, British Council tour of Australia, 1959; *Recent Paintings by 6 British Artists*, British Council tour of Mexico and East Africa, 1960–1; Hayward Gallery, 1976 (28, repr.)
Monica Wynter

BRYAN WYNTER

189 Impenetrable Country 1957

Oil on canvas, 90 × 40 (228.5 × 101.5)
Exh: *Metavisual, Tachiste, Abstract*, Redfern Gallery, 1957 (62); Hayward Gallery, 1976 (33)
Monica Wynter

Monica Wynter writes (letter, October 1984) of Bryan Wynter's work 'His paintings were very much a response to the landscape in which he lived and moved . . .

His was not a static view of it . . . he took numerous colour slides, not so much views, more in the nature of records of different textures and colours to be found in his surroundings – close-ups of things found on the shore – pools, pebbles, seaweeds, water in movement – and on land – mosses, lichens, rocks, stone walls, the growth of grasses, hedges, and the movement of these in contrast to the immovability of the underlying rock. It seems to me that his paintings record what it felt like to be moving in the landscape.'

BRYAN WYNTER

*190 Firestreak II 1960

Oil on canvas, 72 × 56 (183 × 142)
Exh: Charles Lienhard, Zurich, 1962 (1, repr.); Waddington Galleries, 1962 (19); Hayward Gallery, 1976 (50, repr.)
Monica Wynter

BRYAN WYNTER

191 Imoos VI 1965

Motorised mobile of six gouache-coloured cards suspended on wire arms with plastic threads, in front of a 36″ concave parabolic mirror in a chipboard box with interior lighting. Dimensions of the box, 43 × 39¾ × 46 (109 × 101 × 117), plus a smaller box on top housing the motor, 4¼ × 15 × 15 (11 × × 38 × 38).
Exh: Waddington Galleries, 1965 (6)
Tate Gallery (T 00765)

From 1960 Bryan Wynter began to experiment with kinetic paintings, usually constructed from forms cut out of cardboard and painted, and then suspended in front of mirrors. He called these works IMOOS, which means 'images moving out onto space'; and wrote of them: 'My painting has long been concerned with metamorphosis and movement. My kinetic work extends but does not replace it. It is a matter of submitting to the necessary mechanical restrictions to gain a new particular freedom because no other way is open'. (Catalogue of the exhibition *Kinetics* at the Hayward Gallery, 1970).

This work is shown at the south end of Gallery 61.

VIII HERON

When Heron bought Eagles Nest at Zennor in 1955 and moved in in April 1956 he was returning to an area, indeed a house, in which he had lived for long periods before. But Heron's move from London, where he was established as a leading figure of his generation of painters, marked the beginning of a short period when St Ives could reasonably claim to be a world centre of modern art. Heron had stronger contacts with the United States than any other London artist of his generation. Though he had largely stopped writing about art, he contributed a series of articles to the New York magazine *Arts* (then edited by Hilton Kramer) from 1955 to 1958, writing at length about Lanyon in February 1956 and about Hilton in May 1957. He also discussed the first exhibition of work by American abstract expressionist painters in Europe in March 1956. Heron was also very friendly with the American critic, Clement Greenberg, who stayed with him at Eagles Nest in 1959: there were many North American visitors at this time, including Rothko, Hilton Kramer, Bertha Schaefer and Martha Jackson.

Heron had not lost his position in London, and the group show that he advised on at the Redfern Gallery in April 1957, *Metavisual, Tachiste, Abstract Painting in England Today* was a landmark. Like his neighbour at Zennor, Bryan Wynter, Heron had begun to paint totally non-figurative pictures in 1955 and 1956 which seemed to mark a complete break with his earlier work. Unlike most earlier abstract art – Nicholson and Hepworth apart – Heron's paintings were imbued with a feeling for nature. It is not altogether surprising that the remarkable garden at Eagles Nest should have inspired the garden paintings, nor that Heron should have found in the light of West Cornwall a subject for his art. The stripe paintings of 1957–8 were among the most revolutionary of their date in England: they were all painted in the house at Zennor.

Early in 1958, when Nicholson left St Ives, he suggested that Heron should move into the large Porthmeor Studio that he had occupied. The change of painting space was an immediate stimulus to Heron: the scale of his work increased, and he quickly established a formal vocabulary of soft cornered squares and soft-edged lozenges, set in a ground that dominated the paintings of 1958–63.

PATRICK HERON

*192 **Autumn Garden: 1956**

Oil on canvas, 72 × 36 (183 × 91.5)
Exh: *Sir Herbert Read's Critic's Choice*,
Tooths, 1956 (20)
Private Collection

The artist writes: 'The majority of the "garden paintings" were stimulated by the wonderfully exuberant froth of the numerous camellias and azaleas in flower all over the garden at Eagles Nest when we arrived there to live, in April 1956 . . . (they) were a response to the actual petals, whether fleshy or papery, of the flowers themselves, as well as to their small new leaves (azaleas) and the large glossy leaves (camellias) on the trees – all of which hung, before one's eyes, like bead curtains punctuating deep space, as one gazed right into these trees and bushes.' (12 October 1984).

PATRICK HERON

193 Vertical Light: March 1957

Oil on canvas, 22 × 48 (56 × 122)
Prov: Barbara Neil
Exh: Redfern Gallery, 1958 (15);
Richard Demarco Gallery, Edinburgh,
1967 (46, repr.); Museum of Modern
Art, Oxford, 1968 (1, repr.);
Whitechapel, 1972 (6, repr. pl.1)
Lit: *Studio International*, July-August
1967; *Art International.* Sept 20 1970,
p.79 (Vol XIV/7); The British
influence on New York, *The Guardian.*
10 Oct 1974 (repr.); *Paintings by
Patrick Heron 1965–1977*, University
of Texas at Austin, 1978. Exhib. Cat
(repr.); Patrick Heron, *The Shapes of
Colour: 1943–1977*, Kelpra Editions
and Waddington and Tooth Graphics,
1978 (repr.); Patrick Heron, *The
Colour of Colour*, E. William Doty
Lectures in Fine Arts, Third Series
1978, College of Fine Arts, University
of Texas at Austin, 1979.
Private Collection

The artist writes: 'This was the first
painting with vertical stripes and it
immediately succeeded certain "garden
paintings" which were totally dominated by
vertical brushstrokes, almost exactly
equivalent in length, breadth and touch to
the brushstrokes which constitute the
separate "stripes" in this canvas. . .
By reducing the opposed colours to parallel
stripes, or strips, one was enabled to
concentrate wholly on the process of
contrasting colour with colour, with all the
conventional compositional problems and
complexities put aside, as it were.'
(12 October 1984).

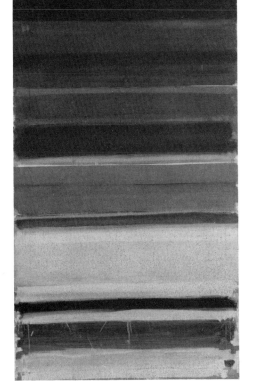

195

PATRICK HERON

**194 Red Layers, (with Blue and
Yellow): December 1957**

Oil on canvas, 72 × 36 (183 × 91.5)
Exh: Redfern Gallery, 1958
(5); Richard Demarco Gallery,
Edinburgh, 1967 (53); Museum of
Modern Art, Oxford, 1968 (7);
Whitechapel, 1972 (10, repr. pl.4)
Private Collection

The artist writes: 'Nine months after
painting *Vertical Light* . . . I found myself
wishing to blend the separate, differentiated
stripes of that year's earlier works in such a

way that they did not any longer stand
apart, stripe from stripe, on a single
'ground', a single plane, but were instead
merged together somewhat, in a ground
that was brushed in, in strokes parallel to
the stripes themselves. That is what is
happening in this painting. Yet, strangely, it
was this very swept-together blending of
the bands of parallel colour which gave rise
to that suspicion of a possible figurative,
land-and-sea-and-sky reading which very
soon led me beyond the format of the pure
stripes.' (12 October 1984).

PATRICK HERON

**195 Horizontal Stripe Painting:
November 1957–January 1958**

Oil on canvas, 108 × 60 (274.5 × 152.5)
Prov: Commissioned by E.C. Gregory
for Percy Lund Humphries and Co.
Ltd 1957
Exh: Whitechapel, 1972 (11, repr.
pl.5); *Henry Moore to Gilbert and
George*, Palais des Beaux-Arts,
Brussels, 1973 (85, repr.)
Lit: Patrick Heron, Two reception
rooms, *Architecture and Building*, Oct.
1958; Offices at Bedford Square WC1,
Architectural Review, Nov. 1958;
Patrick Heron, The Shape of Colour
(Text of the 5th Power Lecture),
Studio International, Feb. 1974; *The
Tate Gallery 1972–4 Biennial Report
and Illustrated Catalogue of
Acquisitions*, pp. 164–7; Terry
Measham, *The Moderns*, 1976 (repr.);
Patrick Heron, *The Colour of Colour*,
E. William Doty Lectures in Fine Arts.
[op. cit.]
Tate Gallery (T 01541)

The largest of the stripe paintings, and
much the largest that Heron made at
Eagles Nest, this picture was commissioned
by E.C. Gregory for the reception room of
the offices of Lund Humphries, the printers
and publishers, at 18 Bedford Square,
which were converted by the architect
Trevor Dannatt.

PATRICK HERON

***196 Cadmium Scarlet: January 1958**

Oil on canvas, 72 × 42 (183 × 107)
Exh: Redfern Gallery, 1958 (3);
Guggenheim International, Whitechapel

Art Gallery, 1958 (37); Museum of
Modern Art, Oxford, 1968 (9);
Whitechapel, 1972 (12)
Private Collection

'This painting shows not only the
introduction of the soft-edged squares, but
also the expansion of the horizontal band
into such wide horizontal areas that the total
composition appears to have departed from
the format of the assembled stripes and
arrived at something which must be
described as an organisation of rectilinear
areas, only briefly interrupted by the
vestiges of horizontal stripes here and there
–and these identify themselves with the
very wide horizontal brushstrokes by which
the whole canvas is covered, the total
imagery rendered solid.' (12 October 1984).

PATRICK HERON

197 Brown Ground with Soft Red and
Green: August 1958–July 1959

Oil on canvas, 60 × 80 (152.5 × 203)
Prov. Susanna Ward
Exh: Bertha Schaefer Gallery, New
York, 1960 (15); Richard Demarco
Gallery, Edinburgh, 1967 (58, repr.
pl.15); Museum of Modern Art,
Oxford, 1968 (12); Whitechapel, 1972
(15, repr. pl.7)
Lit: *Studio International*, July–August
1967; *The Tate Gallery 1974–76,
Illustrated Catalogue of Acquisitions*
pp.107–9
Tate Gallery (T 01878)

According to the artist, this is 'an example
of that phase in my painting when the
individual colour area shapes were being
arrived at by overpainting – either the
smaller individual shapes being overpainted
on the largest colour area (i.e. 'the ground')
– or vice-versa. On the whole, the shapes
were being arrived at without prior
delineation, or "drawing-in". Colour-area
was eating into colour-area by manipulation
of the mass. . . . *delineation* was not there
beforehand, although it was sometimes
added . . . *on top* of the shapes, as it is in this
painting . . . these shapes – soft-cornered
squares and soft-edged lozenges, set in a
'ground' – provided the formal vocabulary
of my painting from 1958 to 1963.'
(12 October 1984).

PATRICK HERON

198 Big Green with Reds and
Violet: December 1962

Oil on canvas, 60 × 84 (152.5 × 213.5)
Exh: Waddington Galleries, 1963 (11);
Museum of Modern Art, Oxford, 1968
(28); *British Painting and Sculpture
1960–1970*, National Gallery of Art
Washington D.C., 1970 (19, repr.);
Whitechapel, 1972 (17, repr. pl.8);
Rutland Gallery, 1975
Private Collection

In the early 1960s Heron began to empty
his paintings of any incident except varied
brushwork. This emptying process
culminates in paintings like 'Big Green with
Reds and Violet'. As the artist writes: 'The
fact that shapes other than the three left
finally showing were overpainted during the
making of the painting is evident; the
suppressed shapes remain vestigiously;
ghost-shapes revealing themselves only
in relief, under the tide of green.'
(12 October 1984).

197

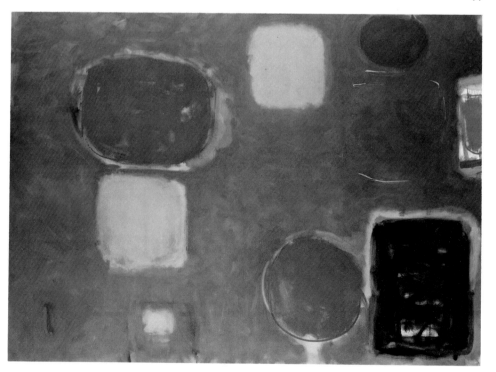

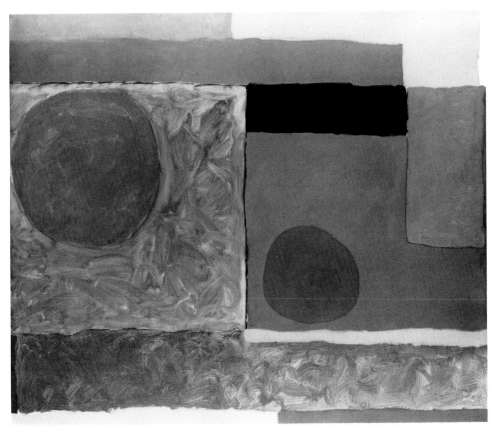

199

PATRICK HERON

199 Rectilinear Reds and Blues: 1963

Oil on canvas, 60 × 72 (152.5 × 183)
Exh: Waddington Galleries, 1964 (17);
VIII São Paulo Bienal, 1965 (8, repr.)
Lit: Richard Demarco Gallery,
Edinburgh, *Patrick Heron
Retrospective* 1967. Exhib. cat.; *Studio
International*, July–August 1967;
Museum of Modern Art, Oxford
*Patrick Heron Retrospective Exhibition
of Paintings 1957–66*, 1968. Exhib. cat.
Plymouth City Museum and Art Gallery

After writing of his painting methods in the
period 1958–63 that 'I do not find myself
designing a canvas: I do not *draw*.' (in
a note published in *Art International*,
25 February 1963), Heron immediately
reacted against the very habits he had
described: '*Rectilinear Reds and Blues 1963*
itself *was* that reaction – in that (a) I seized a
piece of charcoal and *drew in* all the
boundaries between the colours, right at the
beginning: and (b) I abolished the overall
"ground", taking the frontier between
colour areas right out to the edges of the
canvas. Thus ended five years of floating
forms on a single ground.' (12 October
1984).

PATRICK HERON

**200 Yellows and Reds with Violet
Edge: April 1965**

Oil on canvas, 60 × 66 (152.5 × 167.5)
Exh: Bertha Schaefer Gallery, New
York, 1965; Richard Demarco Gallery,
Edinburgh, 1967 (78, repr. pl.21);
Museum of Modern Art, Oxford, 1968
(40); Whitechapel, 1972 (19, repr.);
University of Texas at Austin Art
Museum, 1978(1).
Lit: Patrick Heron. The shape of
colour (text of the 5th Power Lecture),
Studio International. Feb. 1974
Private Collection

'This painting shows the frontiers between
the colour areas becoming progressively
tighter and more complex in their drawing
(a sharp Pentel replacing the blunt stick of
charcoal as the instrument of delineation).
It also shows area-shapes being overlapped
for the first time.' (12 October 1984).

Roger Hilton was the last major artist to settle in St Ives. A friend of Patrick Heron and of William Scott in London, he was also on the fringe of the group of abstract and constructive artists that included Terry Frost and such St Ives summer visitors as Heath and Pasmore. In 1957 he began to spend more and more time in West Cornwall, working at Newlyn and showing with the Penwith Society in St Ives. By 1958 when he had a small but important retrospective exhibition at the Institute of Contemporary Art in London it was clear that his own painting was being affected by the shapes and colours of Cornwall. It was no longer as purely abstract as the work of 1952–4, and the titles that Hilton sometimes chose – 'Grey Day by the Sea' (203) or 'Desolate Beach' (206) make the new relationship with landscape clear.

Some of the paintings of 1958–62 were executed in Hilton's London studio, but increasingly Hilton was to spend his time in West Cornwall. Figure, as well as landscape, enters Hilton's painting, which is essentially a prolonged and groping exploration of the body's sensations in the intractable terms of paint on canvas. In 1965 Hilton settled permanently at Botallack Moor, near St Just, which was to remain his home until the end of his life.

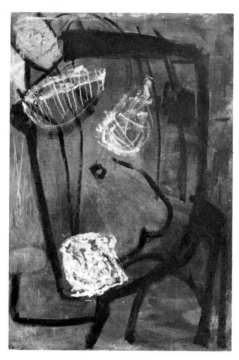

201

ROGER HILTON

201 Grey Figure February 1957

Oil on board, 68½ × 48 (174 × 122)
Exh: *Metavisual, Tachiste, Abstract*, Redfern Gallery, 1957 (145); *British Painting 1700–1960* Moscow, Leningrad, 1960, (128); Venice Biennale, 1964 (repr.); Serpentine Gallery, 1974 (29); Scottish Arts Council Gallery, Edinburgh, 1974 (20)
Southampton Art Gallery

During 1953 and 1954 Hilton painted some of his most uncompromisingly abstract pictures, but from 1955 the figurative references in his work increased. 'Grey Figure' is the first major picture Hilton executed in his room overlooking Newlyn harbour. It is on a gesso board prepared by Michael Broido.

ROGER HILTON

***202 Blue Newlyn** 1958

Oil on canvas, 25 × 30 (63.5 × 76)
Exh: Waddington Galleries, 1960 (13); Serpentine Gallery, 1974 (30) (included in catalogue not shown); Scottish Arts Council Gallery, Edinburgh, 1974 (21)
Ronnie Duncan Collection

ROGER HILTON

203 Grey Day by the Sea March 1959

Oil on canvas, 30 × 25 (76 × 63.5)
Exh: Waddington Galleries, 1960 (11, repr.); Venice Biennale, 1964 (repr.); Serpentine Gallery, 1974 (35, repr.); Scottish Arts Council Gallery, Edinburgh, 1974 (24)
Dr J.J.G. Alexander

This is one of Hilton's most overtly landscape pictures of the period. A boatshape, which he used time and time again, was often a surrogate female figure for the artist.

ROGER HILTON

204 Palisade August 1959

Oil on canvas, 60 × 54 (152.5 × 137)
Exh: Waddington Galleries, 1960 (19); *British Art Today*, San Francisco and tour, 1963 (35); Serpentine Gallery, 1974 (ex. catalogue)
Scottish National Gallery of Modern Art, Edinburgh

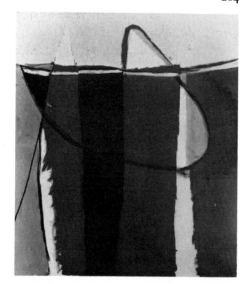

204

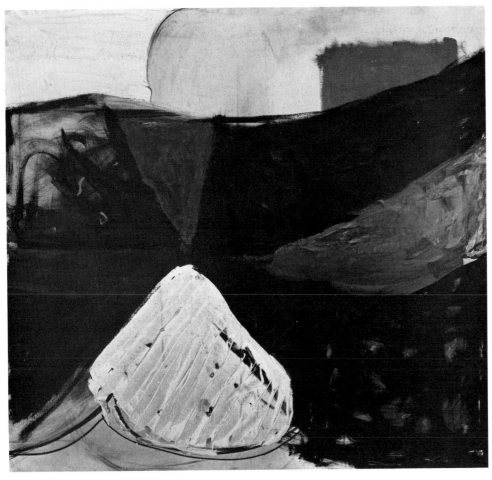

207

208

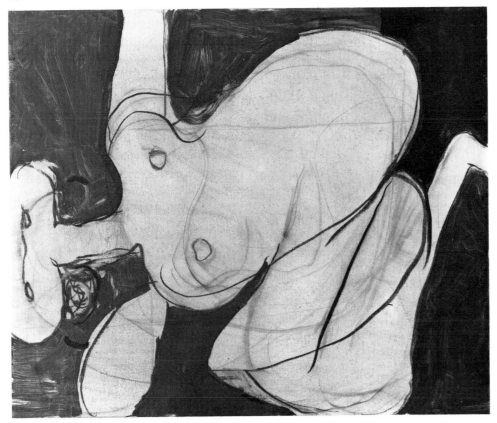

ROGER HILTON

205 Dark Continent August 1959

Oil on canvas, 40 × 60 (101.5 × 152.5)
Exh: Waddington Galleries, 1960 (6);
Serpentine Gallery, 1974 (33)
Arts Council of Great Britain

ROGER HILTON

206 Desolate Beach January 1960

Oil on canvas, 60 × 40 (152.5 × 101.5)
Exh: Waddington Galleries, 1960 (16);
Venice Biennale, 1964 (repr.)
*Centro de Arte Moderna Fundação
Calouste Gulbenkian*

ROGER HILTON

207 March 1961 March 1961

Oil on canvas, 52 × 55 (132 × 140)
Exh: Waddington Galleries, 1962 (8 or
9); Scottish Arts Council Gallery,
Edinburgh, 1974 (33)
*Whitworth Art Gallery University of
Manchester*

ROGER HILTON

208 Figure 1961

Oil and charcoal on canvas, 30 × 36
(76 × 91.5)
Exh: *Six Painters*, Waddington
Galleries, 1961 (5, repr.); Venice
Biennale, 1964 (repr.); Serpentine
Gallery, 1974 (57, repr.); Scottish Arts
Council Gallery, Edinburgh, 1974 (37)
Private Collection

This work was the first of a small number of
paintings of the female nude *c.*1961–3, a
subject which he drew constantly, from
imagination. This painting surprised and
even dismayed some of Hilton's admirers in
1961, a time when abstraction was the
current orthodoxy. The body is suggested
by a near empty area of charcoal scrawling
on a primed canvas and space by near-solid
paint.

ROGER HILTON

209 January 1962 (Tall White) January
1962

Oil and charcoal on canvas, 60 × 30
(152.5 × 76)
Exh: Waddington Galleries 1962 (22,
repr.); *British Painting in the Sixties*,
Tate Gallery, 1963 (48, repr.); Venice
Biennale, 1964 (repr.); Serpentine
Gallery, 1974 (62)
Private Collection

ROGER HILTON

**210 January (Black and Red on White)
1962** January 1962

Oil on canvas, 45 × 50 (114 × 127)
Exh: Waddington Galleries, 1962 (21,
repr.); Venice Biennale, 1964 (repr.);
Serpentine Gallery, 1974 (61, repr.);
Scottish Arts Council Gallery,
Edinburgh, 1974 (39)
Ulster Museum, Belfast

ROGER HILTON

211 May 1963 (Red) May 1963

Oil on canvas, 70 × 46 (178 × 117)
Exh: Venice Biennale, 1964 (repr.)
The British Council

ROGER HILTON

***212 Figure and Bird** September 1963

Oil on canvas, 46 × 70 (117 × 178)
Exh: Venice Biennale, 1964 (repr.);
Serpentine Gallery, 1974 (74, repr.);
Scottish Arts Council Gallery,
Edinburgh, 1974 (42)
Private Collection

In 1963 Hilton painted three female figures,
this picture, 'Oi Yoi Yoi' (cat.no.213) and
'Dancing Figure' (Scottish National Gallery
of Modern Art, Edinburgh). The first two
were shown at the Venice Biennale the
following year.

In this painting the horned moon
suggests a foetus and hence a distant
reference to the myth of Leda and the Swan.

ROGER HILTON

***213 Oi Yoi Yoi** December 1963

Oil and charcoal on canvas, 60 × 50
(152.5 × 127)
Exh: Venice Biennale, 1964 (repr.);
Serpentine Gallery, 1974 (76, repr.);
Scottish Arts Council Gallery,
Edinburgh, 1974 (43)
Lit: Robertson, Russell, Snowdon,
Private View, 1965, p.110; *The Tate
Gallery, Illustrated Catalogue of
Acquisitions 1972–4, p.172*
Tate Gallery (T 01855)

The theme of this painting originated
during a holiday in France in 1962 when
Hilton and his wife were quarrelling and
she was dancing up and down naked on a
balcony shouting 'Oi Yoi Yoi', (and,
incidently, distracting the attention of a
crowd of watching firemen fighting a blaze
in a house opposite). Almost immediately
after finishing his picture Hilton repeated
the same composition, the only time he ever
did so, but painting it in different colours
(coll. Scottish National Gallery of Modern
Art, Edinburgh).

209

211

210

X POST 1964

Nicholson's departure in 1958 and Lanyon's death in 1964 removed two leading figures from the scene, and the sudden change in the art climate that occurred with the appearance of pop art in London in the early 1960s led to an increasing suspicion that St Ives was becoming a backwater again. Frost had moved away from Cornwall in 1963, only returning to Newlyn in 1975. Both Wynter and Hilton suffered from periods of illness which inevitably affected their work and reduced its powerful impact. The coincidence of their deaths in 1975 with that of Barbara Hepworth was a heavy blow to art in St Ives.

In this last section of the exhibition is shown exemplary late work by the major figures active in St Ives after 1964, together with the painting of Bryan Pearce whose work exphasises the continuing St Ives commitment to the direct and untutored vision.

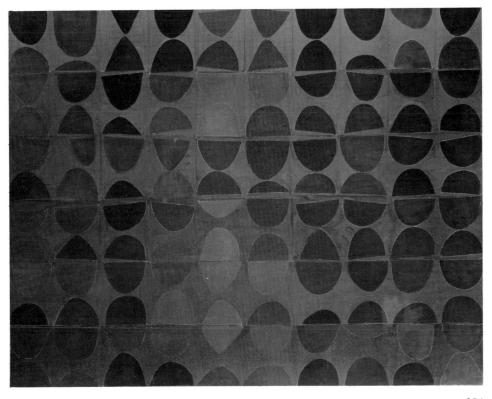

214

TERRY FROST

214 Through Blacks 1969

Acrylic and canvas collage on canvas,
78 × 102 (198 × 259)
Exh: *British Painting and Sculpture
1960–1970*, National Gallery of Art,
Washington, 1970–1 (14, repr.)
Lit: *The Tate Gallery Illustrated
Catalogue of Acquisitions, 1974–6*,
pp.96–7
Tate Gallery (T 02022)

One of Terry Frost's continuing interests has been investigating the colour 'black' in all its varieties. In executing 'Through Blacks' he first painted a number of six-feet square canvases with blacks mixed with red, blue and yellow, each primary in a series of varying amounts. The canvases, a large number, were then cut up into small pieces about 9 × 5 inches and each then cut into a shape with a curved edge to fit the shapes he had drawn on the canvas of the finished picture. 'I worked on the collage quite a lot,

in paint, until I made it simple but clear to me. Black can be so strong, so seductive, so cruel it contains all colours and emotions'.

In 1975 Frost painted 'Through Blues' and 'Through Yellows' similar in size and conception to 'Through Blacks'.

TERRY FROST

215 Pisa August 1974

Acrylic and collage on canvas, 94 × 68 (239 × 172.7)
Exh: Waddington Galleries, 1974 (repr.)
Terry Frost

In this work the artist was primarily using colour for its own sake. The tilted image and a recent trip to Pisa suggested the title.

BARBARA HEPWORTH

216 Fallen Images 1974–5

White marble, 48 × 51¼ × 51¼ (122 × 130 × 130) including base
Exh: Marlborough Gallerie, Zurich, 1975 (24, repr. p.51)
Lit: Hepworth, pl.354; *The Tate Gallery, Illustrated Catalogue of Acquisitions 1980–82*, pp.124–5; *Barbara Hepworth*, cat.no.574 (unpublished)
Tate Gallery (T 03153) (exhibited at the Barbara Hepworth Museum, St Ives)

'Fallen Images' is the last major carving by Hepworth, and shows the interest in groups of form that characterised her late work – c.f. the large bronze groups 'The Family of Man' (Yorkshire Sculpture Park) and 'Conversation with Magic Stones'. (Barbara Hepworth Museum. St Ives).

PATRICK HERON

***217 Big Cobalt Violet: May 1972**

Oil on canvas, 82 × 180 (208 × 457)
Exh: Whitechapel Art Gallery, 1972 (37); Bonython Art Gallery, Sydney, 1973 (14), *Sydney Biennale*, Sydney Opera House, 1973; *British Painting '74*, Hayward Gallery, 1974; The University of Texas at Austin Art Museum, 1978 13, repr.

Lit: Patrick Heron, *The Colour of Colour*, E. William Doty Lectures in Fine Arts, Third Series 1978, College of Fine Arts, The University of Texas at Austin 1979
Frederick Weisman Foundation

Procedures initiated in such paintings as 'Yellows and Reds with Violet Edge' April 1965 (cat.no.200) are continued by Heron into the 1970s with a single coat of paint growing denser in colour. In all this sequence of pictures, his preoccupation was 'with the spatial illusion which the frontiers between flat, opaque colour-areas inescapably generated along their entire length'. (12 October 1984). These ideas are discussed at length by the artist in his lectures, *The Colour of Colour*, given at the University of Texas at Austin in April 1978.

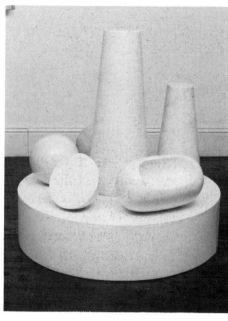

216

ROGER HILTON

218 Figure 1972 1972

Oil on canvas, 35½ × 29¼ (90 × 74.2)
Harriman Judd Collection

This is one of Hilton's last oil paintings.

ROGER HILTON

219 Blue Bird June 1974

Gouache, 19 × 15½ (48.3 × 39.4)
Exh: Graves Art Gallery, Sheffield, 1980 (34); Mendel Art Gallery, Saskatoon, 1982 (22, repr.); *Alive to it All*, Rochdale Art Gallery (tour including Serpentine) (83)
Private Collection

From October 1972 Hilton was confined to bed in his cottage at Botallak near St Just. He was unable to paint in oils, but soon began to work in poster paint and gouache, sitting up in bed or leaning across to a table at his bedside. The late works employ a wide range of imagery, both abstract and figurative (really one continuum for Hilton). He often depicted animals, domestic, wild or imaginary. Some of the gouaches seem to have reference to the artist himself, and to his family, and his predicament, close to death.

219

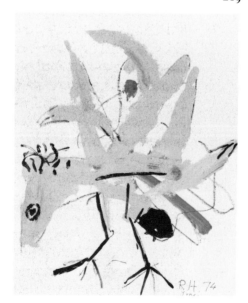

ROGER HILTON

**220 Sailing Ship with Grey Sails and
Floating Figure** 1974

Gouache, $19\frac{1}{2} \times 15$ (49.5 × 38)
Exh: Graves Art Gallery, Sheffield,
1980 (37, repr. fig.8); Mendel Art
Gallery, Saskatoon, 1982 (25)
Private Collection

ROGER HILTON

221 Female Nude 1974

Gouache, $16\frac{1}{2} \times 12\frac{3}{4}$ (42 × 32.4)
Exh: Graves Art Gallery, Sheffield,
1980 (38, repr. fig.2); Mendel Art
Gallery, Saskatoon, 1982 (26, repr.)
Private Collection

ROGER HILTON

222 Untitled 1974

Gouache, $13\frac{1}{2} \times 16\frac{1}{8}$ (34.2 × 41)
Exh: *Alive to it All*, Rochdale Art
Gallery (tour including Serpentine),
1983 (82)
Rose Hilton

ROGER HILTON

223 Untitled February 1975

Gouache, $13\frac{1}{2} \times 9\frac{1}{2}$ (34.5 × 24)
Exh: Mendel Art Gallery, Saskatoon,
1982 (43)
Rose Hilton

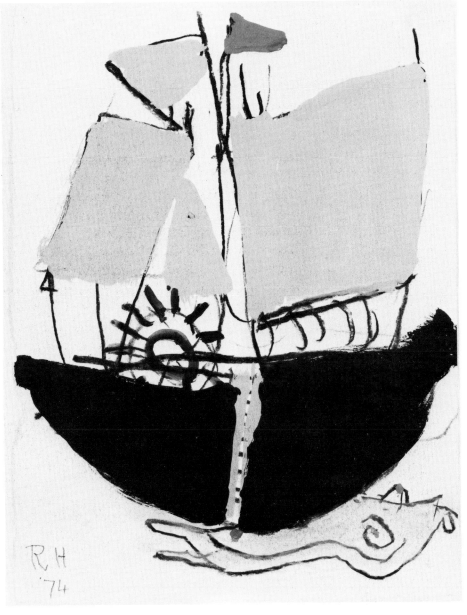

220

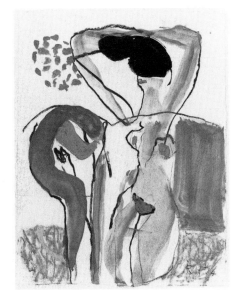

221

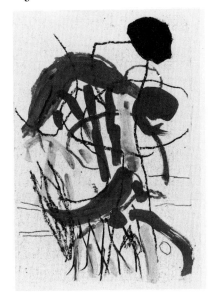

223

ROGER HILTON

*****224 Untitled** February 1975

Gouache and charcoal on paper,
$20\frac{3}{4} \times 17$ (52.7 × 43)
Exh: Graves Art Gallery, Sheffield,
1980 (47)
Private Collection

This gouache was painted four or five days
before the artist's death.

TONY O'MALLEY

225 St Martin's Field Spring 1972

Oil on board, 48 × 31 (122 × 79)
Exh: Belfast, (tour) 1984 (76, repr. p.87)
Tony O'Malley

In the spring of 1972 Tony O'Malley
visited the Scilly Isles, as he often does, and
made drawings on St Martin's, one of the
smaller islands. Soon after his return to
St Ives he painted this picture which
reflects the field pattern, the small fields, the
neat clipped hedges and the spring colours,
mainly green with dark patches where some
of the fields had been burnt off. (Tony
O'Malley, discussion 25 Oct 1984).

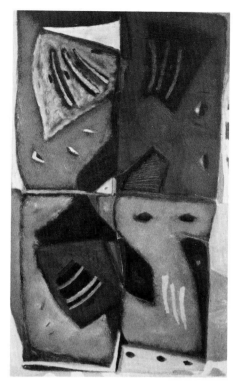

225

BRYAN PEARCE

226 Portreath 1962

Oil on board, 21 × 48 (53.5 × 122)
Exh: Museum of Modern Art, Oxford,
1975 (20)
Private Collection

Portreath is a small port on the north
Cornish coast near Redruth. The subject
was also painted by Peter Lanyon, see
cat.no.112.

226

BRYAN PEARCE

***227 St Ia Church, St Ives** 1971

Oil on board, 28 × 22 (71 × 56)
Lit: R. Jones, *The Path of the Son*,
1976, pl.41
Peter Rainsford

St Ia is the parish church of St Ives, located
near the harbour, Ia being the Cornish
word for Ives.

229

KARL WESCHKE

229 The Meeting 1974

Oil on canvas, $71\frac{1}{2} \times 53\frac{3}{4}$
(181.6 × 136.5)
Exh: Whitechapel Art Gallery, 1974
(35, repr. back page); Newlyn Art
Gallery, 1974 (25); *A Mansion of Many
Chambers: Beauty and Other Works*,
Arts Council tour, 1981–3 (16, repr.)
Arts Council of Great Britain

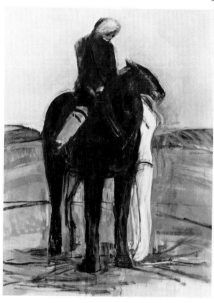

KARL WESCHKE

228 November Sea 1973

Oil on board, 48 × 60½ (122 × 153.5)
Exh: Whitechapel Art Gallery, 1974
(29) (exhibited as 'January Sea')
Private Collection

The contrasting patterns of sky and sea
combine to produce the mood of this
picture. The rollers surge forward under an
oppressive sky.

The subject of this painting was developed
from the artist's personal experience of a
surprise meeting where he felt completely
vulnerable.

230

BRYAN WYNTER

230 Saja 1969

Oil on canvas, $83\frac{3}{4} \times 66$ (212.7×167.5)
Exh: Exeter University, 1971;
Falmouth School of Art, 1975 (5);
Hayward Gallery, 1976 (70)
Tate Gallery (T 03362)

Wynter's last group of paintings were based on drawings of moving water, and arose 'not just from observing the patterns of flowing water, but from his enjoyment of canoeing – mind and body united in skill to manoeuvre the boat in the changing movement of water through the static features of the river bed. (Letter from Monica Wynter, October 1984).

WORKS EXHIBITED IN THE ARCHIVE DISPLAY

231

ALICE MOORE

231 Fish in the Harbour 1966

Embroidery, $17 \times 24\frac{3}{4}$ (43×63)
Private Collection

Alice Moore has always lived near the sea and her work frequently refers to the creatures that live above and below the water.

ALICE MOORE

232 Water Garden 1972

Embroidery, $15\frac{1}{2} \times 21\frac{1}{4}$ (39.5×55)
Captain W.J. Moore

The last work made by the artist.

ROBIN/DICON NANCE

233 Book Rack *c.*1950

Wood, $4 \times 8 \times 15$ ($10 \times 20.3 \times 38$)
Patrick and Barbara Hayman

Made in two separate pieces, held together by two wooden wedges. Robin and Dicon Nance made tables, chairs, sideboards, cupboards, chests and other items of furniture, some commissioned, others for stock. They also did work for churches, specialist jobs for builders and exhibited paintings in their shop.

233

232

THE ST IVES POTTERY

OLIVER WATSON

On his return from Japan in 1920 Bernard Leach was persuaded to set up his first
English workshop in St Ives for two reasons. The first was that St Ives was
known to him as a colony of artists, where no doubt he hoped to find minds
sympathetic to his venture. Secondly was the offer of capital from a certain Mrs
Frances Horne. She was a wealthy woman, concerned with lack of employment
in the area and with an interest in the crafts, who had recently set up The
Handicraft Guild with a textile workshop in St Ives. She had advertised for a
potter, and Leach had been recommended by a friend in England to apply. Not
only was Leach accepted, but it was agreed that Shoji Hamada, a young Japanese
ceramic technology student should accompany him.

St Ives was perhaps an odd choice. The artistic community tuned out, until
the war at least, to be a grave disappointment to Leach. Even more serious was
the lack of suitable materials for the pottery in the immediate vicinity. Leach
wished to recreate the traditional means and methods of the best types of Chinese
stoneware, and of English country pottery. He did not want the help of the
'industrial devils' of Stoke-on-Trent for either materials or expertise, neither of
which were particularly suitable for his work. However, Cornwall was not a
traditional area for English country-pottery. The local clays were mostly only
suitable for high-firing industrial wares, and the demand for timber over
centuries of tin-mining had removed the trees which might have supplied
sufficient quantities of fuel. Had Leach been intending to set up a production
workshop for quantities of tablewares, as the Pottery later became, the choice of
St Ives would have been disastrous. At that time, however, Leach had neither the
desire, nor expertise to do such a thing.

When Leach left for Japan in 1909, he went as a practising artist, who wished
to discover something of the life and art of the East, while earning a living
teaching etching – a technique unknown at that time in the East. In Tokyo he
made friends with a group of young intellectual artists concerned in various ways
with rediscovering their artistic heritage and traditional crafts. He was
introduced to pottery at a *raku* party in 1911 where the guests decorated vessels
which were then glazed and fired on the spot. Leach and a close friend,
Tomimoto, decided to take up this activity and sought lessons from an aged
potter of the Kenzan family, from whom both young students eventually
inherited the title Kenzan VII. For nine years Leach exhibited pots, drawings
and etchings, and acquired some reputation. By 1920 he wanted to return to
England – to bring to the West the ideals and standards of the best periods of
Chinese ceramics and to explore the traditional roots of English country pottery.
He wished to combine in his work the lost qualities of the European pre-
industrial era with Far Eastern sensibility, and thus to start his life-long aim of
bridging through art the differing philosophies of East and West. He also wished
to give his two sons an English education. Mrs Horne's offer gave him the
opportunity.

With capital of £1,500 provided by Mrs Horne and a similar sum that he had managed to save from his earnings in Japan, Leach purchased a plot of land in St Ives and constructed a pottery and workshops. The Pottery is said to have been the last traditional granite structure built in St Ives. With Hamada's help he constructed a three-chambered climbing kiln of Far Eastern design – the first ever built in the West. Neither of them had much of the special expertise required; the kiln was temperamental and inefficient. After a year of use it was on the point of collapse. To build the next kiln they summoned expert advice from Japan in the form of Tsurunosuke Matsubayashi (abbreviated to 'Matsu'), a member of an old potting family from Kyoto. He was a kiln specialist and would lecture the assembled company of an evening on ceramic technology, his somewhat wayward command of English causing mirth. He rebuilt the climbing kiln which then lasted until rising fuel costs and concern over clean air rendered it obsolete in the 1970s. In spite of the new kiln and help from Matsu, the Leach pottery was still struggling with its techniques and materials. Leach and Hamada searched the countryside for suitable clay deposits and sources of fuel. What could not be found had to be bought-in, in particular the Devon ball clays for the making of stoneware. Their work in the first years was experimental, learning the behaviour of the kiln, of the materials, and developing new techniques, designs and shapes. Just how inexperienced they were is seen in the minimum of 20 per cent wastage rates in the firings, with, in Leach's estimation, only 10 per cent fit for exhibitions. Leach recounts their excitement at learning how to 'pull' handles for jugs and mugs from Lake's pottery in Truro – one of the last of the English country potteries and the only Cornish one of any note – and the abandoning of a cream tea when the interaction of blackberry jam and clotted cream suggested the solution to a technique of old English slipwares which had puzzled them.

Production was of two sorts: stonewares in the large climbing kiln and slipped earthenwares in a smaller updraft kiln. The earthenwares included large chargers decorated in a manner adapted from the seventeenth-century English potter Thomas Toft and simpler pieces – jugs, bowls and dishes – designed to sell at modest prices to provide something of a regular income. The products of the stoneware kiln were largely non-functional vases and bowls derived from the Chinese. These formed the basis of the exhibitions. Looking back from the mid-1930s Leach summed up their achievement in the 1920s: '. . . we have carried two types of ware through the main experimental stages. We have revived Old English Slipware and recovered I should say about 80 per cent of its technique and quality. We have also transplanted the processes of Oriental stoneware, found corresponding English materials for body, pigment and glazes, and produced by hand at least twenty well known effects which have come down . . . from the greatest period of Chinese potting.'

In Japan Leach had been an artist, and his workshop was a studio. He had lived partly off sales and partly off private income. The setting-up of the workshop in St Ives was an ambitious project, his product technically uncertain, his market as yet uncreated. No other similar Pottery had been tried in England: studio potters such as William Staite Murray were struggling equally, but using industrial materials and kilns, and, based in London, moving in fine art circles. Leach was, as Michael Cardew recalled, a voice crying in the wilderness. In 1946 Leach wrote 'The conclusion...was that...planning round the individuality of

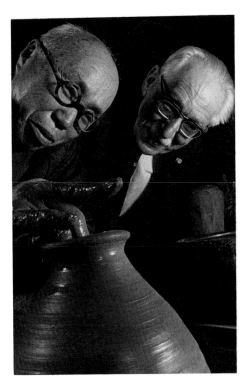

Hamada Shoji and Bernard Leach

the artist was a necessary step in the evolution of the crafts. So at St Ives we based our economics on the studio, not the country workshop or the factory.' St Ives was, therefore, during the 1920s run as a craft studio, where artistic aims were more important than economic efficiency. The production of standardised ware, for which the Leach Pottery became best known, was an idea that only developed later.

The pottery's income at this period was modest. Sales rose gradually from only £29 in 1921 to a peak of £1,030 in 1927, falling to £383 in 1929. The pottery registered a loss for the first four years of production and averaged £262 per annum profit from 1925–1930. Leach recalls: 'Neither Hamada nor I, nor Edgar Skinner (a retired bank manager and secretary to the Pottery), ever took more than one hundred pounds per year, and George Dunn, our clay-worker and wood-cutter, to within a year of his death (1940) was easily the best paid as an unskilled worker'. Exhibitions in London provided the bulk of the earnings and much needed publicity. After Hamada's departure in 1923, pots were regularly sent for exhibitions in Japan, where Leach's reputation persisted. They provided some income, but perhaps more importantly, the public recognition that was lacking in England.

In Japan Leach had worked on his own, occasionally with the help of friends or a professional assistant. The Pottery at St Ives was conceived on a larger scale. In the first years he had the help of Shoji Hamada, and they employed George Dunn for the labouring tasks. Michael Cardew was the first English student taken on. A classics graduate from Oxford, he had become enthused with ceramics during holidays near Fishley Holland's old country pottery at Braunton. Hearing of the new Leach Pottery he applied to be an apprentice, and, as Hamada was about to leave, was taken on. In the same year Katherine Pleydell-Bouverie applied to join but was told by Leach that there was no room. It was apparently the secretary Skinner who realised the benefits that students could offer, and in 1924 Pleydell-Bouverie joined for a year, learning while doing menial jobs and paying, at first, 10/- a week for the privilege. These were the first

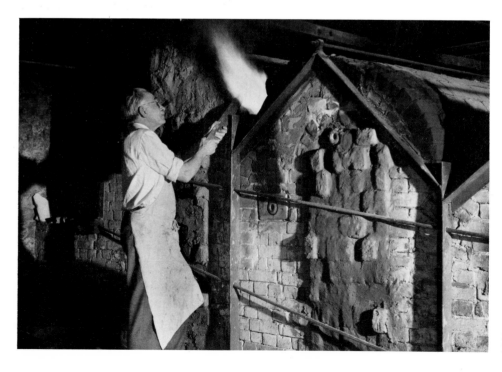

Bernard Leach firing the large climbing kiln at St Ives

of a constant stream of students who worked at the pottery. Some, like Cardew came for a full three years, others for a year, others when holidays from other jobs permitted.

Cardew is the most important of the pre-war students. He set up his own pottery in Winchcombe, Gloucestershire, where he developed a range of slipped earthenwares based on traditional English types. His later work in Africa and, after the war, at Wenford Bridge, near Bodmin, have established him as the most important figure after Leach in the studio pottery movement, both as potter and teacher.

Norah Braden, from the Central and Royal College schools of art, spent three years at St Ives from 1925, and later joined Katherine Pleydell-Bouverie at her family home, Coleshill, Berkshire, where, thanks to a well-stocked garden, they were able to explore a wide range of glazes fluxed by plant ashes, sometimes of quite an exotic nature. Both Cardew at Winchcombe, and Pleydell-Bouverie and Braden at Coleshill were carrying on experiments first started at St Ives in the Leach Pottery.

1930–1945 The 1930s were unsettled times for both Bernard Leach and the St Ives Pottery. Financial uncertainty through the 1920s, made more acute by the slump of 1929, and combined with the continuing indifference from the English public, gave the Pottery a gloomy future. The possibility of bankruptcy loomed. The only bright light on the horizon came from Dartington, where Dorothy and Leonard Elmhirst were in process of setting up their estate and community. They had been in touch with Leach in the mid-1920s, seeking someone to teach pottery. Leach had at that time refused their offer, recommending someone else. In 1929 Hamada came to England with Soestu Yanagi, the leader of the growing folk-craft movement in Japan, who was in many ways Leach's mentor. Leach took them to meet the Elmhirsts at Dartington, where they found themselves very much in sympathy with the philosophy and ideals on which the community was based. Yanagi wrote to them that Leach was the teacher they needed at Dartington, that he had 'an inborn sense of art', was keenly interested in social questions, '. . . and I firmly believe that from his point of view he will be able to do better work at Dartington than where he is now.' Leach arrived at Dartington only in 1932, able by then to leave the St Ives Pottery in charge of his eldest son David who had joined him as an apprentice in 1930.

At Dartington, Bernard taught children in the school and adults at evening classes. He also set about constructing a small workshop to supply the needs of the estate, and a wider market, with functional ware. The ideas for this pottery grew fast, settling upon the production of slipwares and tiles at first and of stoneware domestic pottery later. The possibility of transferring the entire St Ives Pottery to Dartington was soon raised. David Leach was brought in to do the teaching at Dartington in 1933, while Bernard continued to build and experiment in the workshop. At St Ives pottery production was left in the hands of Harry Davis, while Laurie Cookes, later to become Bernard's second wife, looked after the office; David and Bernard worked at St Ives during the holidays.

Early in 1934 Bernard returned to Japan, funded by the Elmhirsts for whom

he collected folk artifacts and took ciné-films. In his absence, plans for the Dartington pottery continued. David Leach was aware that neither he nor his father had sufficient technical or managerial skill to organise the production of standardised wares in the quantities that were envisaged for Dartington. While the Elmhirsts appreciated absolutely those qualities that Bernard Leach was seeking to reinstate in ceramics through hand-made processes, the Dartington Hall Trust was based on sound financial principles, and the pottery would have to pay its way, and produce a ware that was marketable.

In the past, St Ives had not been organised to meet any such need. In Hamada's words: 'In those days there was not any overall organisation in the pottery. We did what we were enthusiastic about.' To produce economically a steady supply of standardised table wares, even without losing the special qualities of studio ceramics, required a more disciplined management of workers and materials, and, most particularly, better technical control. It was for this reason that David Leach decided to go to a technical course at North Staffordshire Technical College, Stoke-on-Trent. Bernard was in Japan when he heard of this decision, and he was naturally disappointed, fearing that his son's standards would be corrupted. He wrote letters saying that David would do far better to spend his time in Japan, where a real appreciation of ceramics could be learnt, or at least in Copenhagen where artistic standards in industry were, in his estimation, higher. However, David had the support of Dartington, who were anxious to establish their pottery quickly, who agreed with David's reasoning, and who paid for the course.

On his return to England in 1935, Bernard drew up a proposal for transferring the Leach Pottery in its entirety to Dartington, giving details of the wares he proposed to make, the salaries to be paid to the staff (£300 p.a. for himself and £175 for the rest), and even an estimation of the time needed for the pottery to show a profit (4 years). The reasons he gives for the transfer are an indication of the disadvantages of St Ives. He boldly states that Dartington 'is a very much better site for a pottery' (presumably meaning that clay and fuel were more readily available), that 'freight to and from is less', that visitors are fairly constant and not restricted to the six-week summer season, that other potteries in the neighbourhood could be involved, that distribution centres and networks were developing, and 'lastly, capital, which I have not got, is available'. Leach was short of money, and St Ives was too isolated and without natural advantages for a pottery.

However, by this time, circumstances were not as favourable for the Dartington project as they had been earlier. Dartington was having to trim its financial commitments, and the social and political unease of the pre-war years made the plan seem less immediately feasible. The transfer was not abandoned, but postponed. Bernard Leach continued teaching at Dartington and, with the help of Laurie Cookes, preparing his work *A Potter's Book* which was eventually published in 1940. At St Ives, however, David Leach prepared for an enlarged and more organised production using the knowledge he had gained at Stoke. This work was still done with the idea of an eventual transfer to Dartington, which invested the considerable sum of £3,500 in the St Ives Pottery over the three years 1936–9. The wood-fired kiln was converted to oil, earthenware was abandoned in favour of the more durable stoneware. Basic machinery, such as a

pug mill for the preparation of clay, was installed for the first time – previously all the materials had been prepared by hand. David started the policy of employing local school-leavers as trainee production-line potters because students, who had provided most of the manpower before, tended to leave just as they had learnt enough to be useful to the Pottery. The first of the local employees was William Marshall, who joined in 1938 at the age of 15. A start was made to design a range of useful wares which would form, from now on, the basis of the Pottery's production.

The war interrupted this preparatory work. Bernard returned to St Ives in 1940; David Leach was called up in 1941 and William Marshall in 1942. However, Bernard Leach managed to keep the Pottery going, in spite of the damage caused by a German land-mine in January 1941, and the suspicion of some locals who knew of Leach's friendship with the Japanese, and thought that he had been signalling to the enemy with the kiln fires. For help in the Pottery, Leach managed to persuade the authorities to release to him a couple of conscientious objectors. Two former Slade students were eventually detailed to him – one, Dick Kendall, eventually married his daughter Jessamine, and became head of the Pottery Department at the Central School, the other was Patrick Heron. Between them they managed to carry on a limited production of both standard and special ware. Bernard was helped in the running of the Pottery by Margaret Leach (no relation), while Laurie Cookes, whom he married in 1944, continued at Dartington.

Post-War Years It is ironic that the disruption of the war was the cause of the Leach Pottery finally achieving economic security. The Pottery had kept up production during the war, and was thus prepared after it had ended to take full and immediate advantage of the surge in demand. David returned in 1945; William Marshall in 1947. The first illustrated mail-order catalogue of standard ware was produced in 1946. The country, tired of utility ware, could not get enough. David and Bernard Leach were astonished as Harry Trethowan of Heal's, Mrs McDermot of Peter Jones, and the buyers from Liberty's and John Lewis came begging to take anything the Pottery could supply. This demand had two effects. It gave the Pottery immediate financial security, but, perhaps more importantly, it opened up the mass London market, thereby educating the taste of a public hitherto unreached.

The years till the mid-1950s were the hey-day of the Pottery: an extension was built on to the workshops, bonuses were paid. The working team consisted of Bernard as owner and artistic director, with David as partner and general manager. Bill Marshall acted as foreman, with a core of local workers – mostly relations of Bill Marshall – trained at the Pottery: Scott Marshall, and Kenneth Quick, Bill's cousin, taken on in 1945. Students and visitors still came, though fewer English ones as the Arts Schools were developing their own courses. By 1952 the catalogue offered over 70 items, ranging from an egg cup at 2/- to a 'Tall Jug & 6 Mugs' at £3/10/-. 'Individual' pots, 'the personal work of Bernard or David Leach, . . . whose seal they usually bear' were priced from 10/- to £10/-/-.

It appears that plans to transfer the Pottery to Dartington were by this time

forgotten, for no further mention is found in the Hall's records. The Pottery that the Elmhirsts had hoped to set up in Dartington had been successfully achieved in St Ives, and in no small part thanks to their support. David's training at Stoke had paid handsome dividends in the high technical quality of the standard ware that was produced in large quantities. In 1952, some 18,000 pieces of standard ware and 2,000 individual pots were made.

In 1952, the International Conference of Potters and Weavers was held at Dartington Hall, attended by delegates from all over the world. Yanagi and Hamada, now the foremost figures in the Japanese craft movement, gave papers, and afterwards travelled with Bernard Leach through America and Japan, giving lectures and demonstrations. Bernard Leach had formed the idea of moving permanently to Japan, and of marrying Janet Darnell there, an American student he had recommended to study with Hamada. In 1954, Bernard travelled home, to finalise his plans. However, once home, Bernard decided to stay in England, perhaps because by that time David Leach, feeling that he had accomplished his task at the St Ives Pottery, wished to set up on his own. David and his brother Michael, who had also been working at St Ives, left to establish their own potteries by the end of 1955. Janet was persuaded to come and take over the management of the Pottery in 1956. She and Bernard were married in the same year.

This was a difficult patch for the pottery, with the loss of its manager of 25 years, and with the post-war boom calming down. Bernard Leach complained that purchase tax was robbing the pottery of two-thirds of its profits. For a short time, cuts in wages and longer working hours were accepted. Financial stability returned in the 1960s.

No great changes were instituted in the pottery in the years after Janet arrived. Bill Marshall continued to oversee the production of the standard ware and the work of the students. He also acted as assistant to Bernard Leach. More emphasis was placed on the production of individual pots for exhibitions, and Bernard, now in his 70s, went on to produce the series of large vases that many regard as his finest achievement. These were generally thrown by William Marshall to designs by Bernard, who would then add the neck, refine the profile, and add any necessary decoration. No more local employees were taken on, though students still came in large numbers, mostly from the USA, Canada, Australia and New Zealand. They came and worked for two years, but as most already had Art School training, they were able within a short time to contribute to the Pottery's output. Hamada's son, Atsuya, spent two years at the pottery from 1957, coinciding with Richard Batterham, one of the better known English potters to have passed through St Ives. John Leach, David's son, spent two years from 1961 at the pottery. Kenneth Quick, having enjoyed five years running his own pottery at Tregenna Hill, returned to the Leach Pottery in 1960. His death in Japan during a trip for which he had long saved, deprived St Ives of one of its most accomplished local potters.

Were Bernard Leach known only for the pots he made, he would rank as one of the studio pottery movement's leading artists and craftsmen. In fact, his importance ranges far wider than his production as a potter. The thriving studio pottery movement that is found now throughout the world would now be of a very different character were it not for his influence. One cannot credit Leach as

sole founder of the movement, nor even for its concentration on Oriental styles and standards, for other potters such as Staite Murray, Charles Vyse and Reginald Wells, were similarly occupied even as early as the 1920s. What Bernard Leach contributed was a truly oriental appreciation of ceramic qualities, and a technique based not upon the refined, deadened materials and procedures of industry, but upon 'natural' resources. He introduced the idea of pottery as a way of life, in whose every activity, digging the clay and grinding the glaze as much as throwing and decorating the pot, satisfaction was to be found. Together with David, he revived the 'country pottery' producing good cheap pots for ordinary people to enjoy, but with designs and technology suited to a modern lifestyle. Bernard's writing, especially *A Potter's Book*, was an inspiration for a whole generation of potters; his chapter entitled 'Towards a Standard' counts among the best writing on ceramic appreciation. He not only introduced a whole new approach to the appreciation of ceramics, but made this appreciation part of a wider aesthetic and social philosophy. His work as a teacher and the role of the St Ives Pottery in training young potters was crucial, not only in this country but throughout the world.

We cannot hope to show in this exhibition anything but a small sample of the work of Bernard Leach and his Pottery. Many people who worked with Leach at St Ives developed individually as potters only after they left, and their true worth is seen in pieces they made in later years and in other places. Students and visitors to the pottery were numerous, and those shown here are randomly selected, to give an idea of the variety of people and their pots done over the years.

ACKNOWLEDGMENTS

I would like to thank all those people who generously gave time, information and the pots themselves for this exhibition. In particular I am grateful to David Leach, Janet Leach and William Marshall for long and fascinating talks, and to Mary Bride Nicholson, curator of the Dartington Hall Trust, for opening their archives up to me. Others who have contributed much are William Ismay, Pan Henry, Patrick Heron, John Leach, Richard Batterham, Sheila Lanyon, Mr and Mrs George Wingfield Digby, Katherine Pleydell-Bouverie, Sarah Northcroft of the York City Art Gallery, Barley Roscoe of the Craft Study Centre in Bath, Paul Rice, and David Brown who involved me in the exhibition in the first place.

Oliver Watson

CERAMICS

Potters are listed approximately in date order of their arrival at the St Ives Pottery.

The books referred to under Lit. are as follows:

HOGBEN, *The Art of Bernard Leach*, London 1978
WOOD, *British 20th Century Studio Ceramics*, Christopher Wood Gallery, Autumn 1980
ROSE, Muriel Rose, *Artist Potters in England*, London 1970
LEACH BOOK, B. Leach, *A Potter's Book*, London 1940
LEACH, HAMADA, B. Leach, *Hamada, Potter*, Tokyo and New York, 1975

BERNARD HOWELL LEACH

1887–1979

St Ives Pottery: 1920–1979

1887 5 January born in Hong Kong
1897 To Beaumont Jesuit College, Windsor, England
1903 To Slade School of Art under Henry Tonks
1906 Enters Hong Kong and Shanghai Bank as clerk
1907 Leaves bank, to London School of Art under Frank Brangwyn to learn etching
1909 Leaves for Japan
1911 Discovers pottery at Raku tea party, meets Yanagi, and Ogata Kenzan 6th
1913 Kenzan builds kiln in Leach's workshop
1914–1916 Visits China
1916 Rebuilds Kenzan's kiln on Yanagi's land at Abiko
1918 Visits Korea with Yanagi
1919 Meets Hamada
1920 Returns to England with Hamada and establishes pottery at St Ives
1922–24 Matsubayashi joins pottery and builds kiln
1923 Exhibition of work with Hamada in London, Hamada returns to Japan
1929 Yanagi and Hamada visit St Ives
1930 David Leach joins pottery as apprentice
1932 Starts teaching at Dartington, pottery built at Shinner's Bridge
1934 Bernard visits Japan and 1935 visits Korea returning July

1934–1937 David Leach to College, pottery left in charge of Laurie Cookes and Harry Davis
1936 Bernard resumes teaching at Dartington
1937 David Leach installs oil-fired kiln at St Ives, end of earthenware production
1941 Returns to St Ives when David Leach is conscripted. German landmine damages pottery
1944 Marries Laurie Cookes
1945 David Leach returns from army
1950 Travels in USA for four months
1952 International Crafts Conference, Dartington Hall, Yanagi and Hamada attend
1952–1954 Tour in U.S.A. afterwards to Japan
1955 David and Michael Leach leave St Ives to set up own potteries
1956 Janet Darnell arrives, and marries Bernard
1960 Lecture tour in U.S.A., visit to Scandinavia
1961 Hon. D.Litt. at Exeter University, visits U.S.A. and Japan
1962 Returns to England via Australia and New Zealand. Awarded CBE
1964 Visits Japan, attending Japanese Folk Crafts meeting in Okinawa
1966 Visits Venezuela, Colombia returns via U.S.A. and Japan, where awarded Order of the Sacred Treasure, second class

1968 With Barbara Hepworth awarded Freedon of the Borough of St Ives
1969 Visits Japan with Janet Leach. Awarded C.H.
1970 Visits Denmark
1972 Sight failing, virtually ceases to pot
1973 Visits Japan
1974 Visits Japan, Japanese Foundation cultural award
1977 Retrospective exhibition at the Victoria and Albert Museum
1979 6 May dies

Publications by Bernard Leach

A Review, 1909–1914, Tokyo, 1914
An English Artist in Japan, 1920
The Leach Pottery, St Ives, 1928
A Potter's Outlook, London, 1928
A Potter's Book, London, 1940
The Leach Pottery, 1920–1946, London, 1946 (new edition, 1952)
A Potter's Portfolio, London, 1951
A Potter in Japan, London, 1960
Kenzan and his traditions, London, 1966
A Potter's Work, London, 1967
The Unknown Craftsman, with Yanagi, London, 1972
Drawings, Verse and Belief, London, 1976
Hamada, Potter, Kodansha, 1975
A Potters Challenge, London, 1976
Beyond East and West, London, 1978

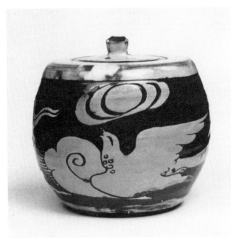

CI

Principal Exhibitions

1914 Tokyo
1919 Tokyo
1920 Tokyo
1921 Artificers' Guild, London
1922 Cotswold Gallery, London
1923 Patterson's Gallery and Three Shields Gallery, London, and in Japan
1924 Japan
1925 Japan
1926 Japan (with William Staite Murray and Ethel Mairet)
1927 Three Shields, London
1928 Beaux Arts Gallery, London
1931 Ditto (with Tomimoto), and Osaka, Japan (with Cardew and Staite Murray)
1932 Little Gallery, London
1933 Beaux Arts Gallery, London, (with Tomimoto)
1934 Several in Japan, Beaux Arts Gallery, London
1936 Little Gallery, London
1946 Berkeley Galleries, London
1949 Exhibitions in Scandinavia
1950 Travelling exhibition, U.S.A.
1952 Beaux Arts Gallery, London
1953 Exhibitions in Japan
1957 Liberty's, London
1958 Primavera, London, and travelling show in U.S.A.

1961 *Fifty Years a Potter* retrospective, Arts Council Gallery, London, and retrospective in Japan
1962 Primavera, London, and (with Hamada) Louvre, Paris
1964 Primavera and Craft Centre, London, and Tokyo
1966 Primavera, London and (with Hamada and del Pierre) in Venezuela and Columbia. Retrospective in Tokyo, Japan
1967 Crane Kalman Gallery, London, (with Hamada and del Pierre) Hamburg, and (with Hamada and Kawai) Osaka, Japan
1968 Primavera, London (with Lucie Rie and Janet Leach)
1969 Okinawa, Japan
1971 Marjorie Parr Gallery, London, and retrospective in Japan
1973 Okayama, Japan
1977 *The Art of Bernard Leach*, retrospective, Victoria and Albert Museum, London
1980 Ohara, Japan, retrospective

Exhibition Catalogues

1946 *The Leach Pottery, 1920–1946*, London
1966 *Bernard Leach*, Tokyo
1977 *The Art of Bernard Leach*, London

C2

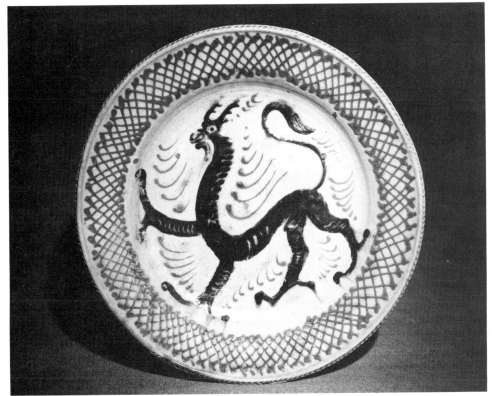

BERNARD LEACH

CI Biscuit Barrel

Earthenware with decoration cut through white slip under yellow galena glaze. Mark: BL and SI impressed, diameter $5\frac{7}{8}$ (15)
St Ives, 1923–4
Lit: Hogben, 17
Trustees of the Victoria and Albert Museum (Circ. 405+a–1934)

BERNARD LEACH

C2 Dish

Earthenware with decoration of griffon in brown slips over white slip under a yellow galena glaze. Mark: BL and SI painted in coloured slip, diameter 18 (45.7)
St Ives, 1929
Lit: Hogben, 38
Mr and Mrs George Wingfield Digby

BERNARD LEACH

***C3 Vase**

Stoneware with matt-white bracken glaze and painting of leaping salmon in brown. Mark: BL and SI impressed, with BL painted, height 12¾ (32.5)
St Ives, 1931
Lit: Hogben, 56
Milner White Collection, York City Art Gallery (935/71)

This vase is one of a very few glazed with a special bracken-ash glaze which was made in 1931. Leach describes the laborious task of collecting and burning the bracken in *Hamada, Potter*, p. 47–9. The effort was immense for the small amount of glaze material collected, though the quality of the matt-white glaze was superb. Later versions of the fish vases use smaller quantities of bracken ash, and the oil- rather than wood-firing gives the glaze a much less subtle quality.

BERNARD LEACH

C4 Jug

Stoneware, glazed inside with celadon glaze, outside unglazed Mark: BL and SI impressed, height 12¼ (31.5)
St Ives, *c*.1942–3
Lucie Rie

This jug with its characteristic 'pie-crust' foot, is based on an English medieval form, though the material and glaze are Far Eastern in origin. The piece is one of Leach's most successful blends of eastern and western ceramic traditions.

BERNARD LEACH

***C5 Vase**

Stoneware with 'Tree of Life' designs painted in brown on an oatmeal glaze. Mark: BL and SI impressed, height 12¼ (31)
St Ives, *c*.1946
Lit: Hogben, 82
Milner White Collection, York City Art Gallery (935/70)

The 'Tree of Life' was considered to be symbolic by Leach. The design is taken from Chinese temple stone-carvings of the Han period which Leach must have seen

C4

during his visit to China in 1914–16. He used it regularly from the 1920s onwards; the Plough constellation is his own addition.

BERNARD LEACH

***c6 Vase**

Stoneware, with impressed decoration under a yellow ash glaze. Mark: BL and SI impressed, height 14 (35.5)
St Ives, c.1955
Lit: Hogben, 90
Trustees of the Victoria and Albert Museum (Circ. 29-1968)

This piece is unusual for the particularly Japanese quality seen in the rather uneven shape and the mottled glaze that has run in the firing. Though Leach discovered the craft of pottery while in Japan, and largely developed his artistic appreciation and philosophy through his experiences there, it is noticeable that he, along with his Japanese friends and contemporaries, sought their inspiration and measured their standards against Chinese and Korean art, and took little lead from purely Japanese styles. Leach had, indeed, little knowledge of Japanese country wares until his trips in the 1950s.

BERNARD LEACH

***c7 Vase**

Stoneware with fluted decoration under a tenmoku glaze. Mark: BL and SI impressed, height 14½ (36.8)
St Ives, 1959
Lit: Hogben, 101
Trustees of the Victoria and Albert Museum (Circ. 129-1960)

BERNARD LEACH

c8 Lidded Jar

Stoneware with hexagonal cut sides and tenmoku glaze. Mark: BL and SI impressed, height 12⅜ (31.5)
St Ives, c.1960
Lit: Hogben, 108
Private Collection

BERNARD LEACH

c9 Footed Dish

Porcelain with matt white glaze. Mark: BL and SI impressed, diameter 8¾ (22)
St Ives, c.1960
Trustees of the Barbara Hepworth Estate

C10

HAMADA SHOJI
1894–1978

St Ives Pottery: 1920–1923

1913 Studies ceramics at Tokyo Technical College
1918 Meets Leach
1919 Works with Leach at Abiko
1920 Accompanies Leach to England, helps build climbing kiln at St Ives
1923 Two shows in London
1923–1924 Tours Europe, returns to Japan
1929 Revisits England
1930 Establishes pottery at Mashiko
1952 To Dartington with Yanagi for conference, followed by trip to U.S.A. with Leach and Yanagi
1950s–1960s frequent trips in U.S.A.
1978 5 January dies

Bibliography
Bernard Leach, *Hamada, Potter*, 1975

HAMADA SHOJI

c10 Bowl

Stoneware with wax resist decoration and tenmoku glaze. Mark: Hamada's personal seal and SI impressed, diameter 7¾ (19.5)
St Ives, 1923
Trustees of the Victoria and Albert Museum (C. 106-1924)

This very early piece already shows Hamada's skill with a brush. The rather unsympathetic, over-refined clay was acquired from a commercial pottery in Devon, and over the years was replaced by a coarser textured and warmer coloured body, that Leach liked to compare to wholemeal bread.

HAMADA SHOJI

c11 Jar

Stoneware, with white slip and brown painting under a transparent glaze. No marks, height 8 (19.5)
St Ives, c.1923
Private Collection

Hamada claimed to have painted only three pieces with figurative designs; all his other work is either abstract or vegetal. A version of this Bull is found on a dish in slip-trailed technique done in the same year, now in the Stoke-on-Trent Art Gallery.

CII

HAMADA SHOJI

CI2 Vase

Stoneware with wax resist decoration
in a tenmoku glaze. No marks,
height $14\frac{1}{8}$ (36)
Mashiko, Japan, 1926
*Milner White Collection, York City Art
Gallery (1050/4)*

Purchased from Hamada's Paterson Gallery
show in 1929.

CI3

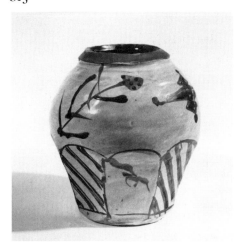

HAMADA SHOJI

CI3 Vase

Red earthenware with white slip under
a transparent glaze, painted in
overglaze red and green enamels.
No marks, height $7\frac{7}{8}$ (19.5)
Okinawa, Japan, *c.*1970
Janet Leach

In both the European and Far Eastern
ceramic traditions overglaze enamels are
associated in the main with highly refined
decoration on porcelain. Their use on
earthenwares, and with such bold
spontaneous painting, comes as a surprise,
particularly to the English studio pottery
movement where muted brown tones
predominate.

MICHAEL CARDEW
1901–1983

St Ives Pottery: 1923–1926

1919–1923 Exeter College, Oxford
1923 1 January, visits St Ives; takes up
apprenticeship in November
1923–1926 At St Ives
1926 In June, sets up own pottery at the
old Greet pottery near Winchcombe
1939 Sets up new pottery at Wenford
Bridge
1942–1965 Cardew works in Africa
1983 11 February dies

Bibliography
1976 Michael Cardew, CAC 1976 (with
good bibliography)

MICHAEL CARDEW

CI4 Dish

Earthenware with decoration scratched
through a white slip under a greenish
galena lead glaze. Mark: MAC
(indistinct) and SI impressed, $6\frac{3}{4}$
(17.25)
St Ives, 1923–4
Lit: Wood, 11
Paul Rice Gallery

The raw lead-sulphide galena glaze, though
poisonous, gives a brilliant finish and bright
varied colours. It is, however, very erratic in
the firing. Compare the duller colours and
finish of the more reliable and yet more
poisonous lead-oxide lithage glaze (Harry
and May Davis, C26), to which the St Ives
Pottery changed in the mid-1930s in a bid
to achieve uniformity and reduce wastage.
Cardew continued to use the galena glaze at
Winchcombe, valuing its quality and
accepting the inevitable high number of kiln
losses.

MICHAEL CARDEW

CI5 Cider Jug

Earthenware with slip decoration in
brown and green under a galena lead
glaze. Mark: MC and WP impressed,
height $10\frac{3}{4}$ (27.3)
Winchcombe pottery, *c.*1929
David Leach

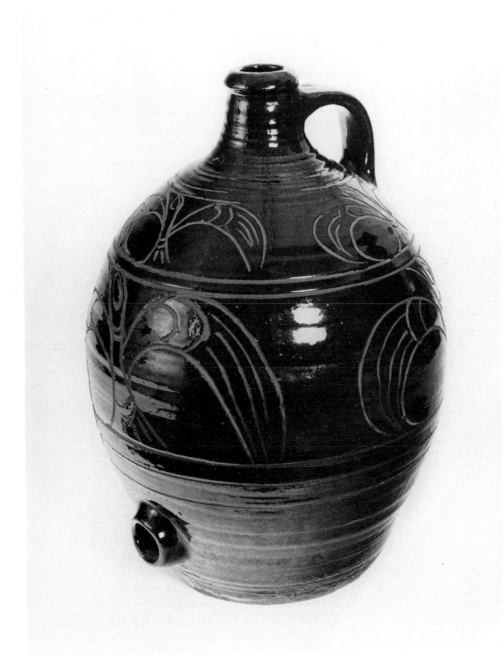

C16

TSURUNOSUKE MATSUBAYASHI

39th generation of Asahi family of potters from Kyoto.
St Ives Pottery: 1924–1926

1922–1924 To St Ives to build climbing kiln at the invitation of Bernard Leach.

TSURUNOSUKE MATSUBAYASHI

C17 Bowl

Stoneware with marbled decoration.
Mark: Personal seal and SI impressed, diameter $8\frac{1}{4}$ (20)
St Ives, *c*.1922–4
Trustees of the Victoria and Albert Museum (Circ. 1370-1924)

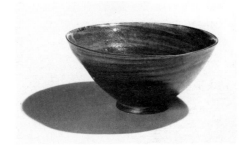

C17

MICHAEL CARDEW

C16 Cider Jar

Earthenware, with decoration scratched through dark glaze. Mark: MC and WP impressed, height $14\frac{1}{2}$ (41.9)
Winchcombe Pottery, 1936
Crafts Study Centre, Holburne Museum, Bath, (P.74.95)

This piece is a kiln waster as a firing crack runs down the front and round part of the base. It shows, nevertheless, the quality of Cardew's throwing and decoration at its most powerful.

NORAH BRADEN

born 1901

St Ives Pottery: 1925–1928

1919–1921 Studies at Central School of
Art
1922 Studied at Royal College
1925 To St Ives
1928 Joins Katherine Pleydell-Bouverie at
Coleshill
1936 Leaves Coleshill, teaching at Brighton
Art School
1939 Ceases to pot

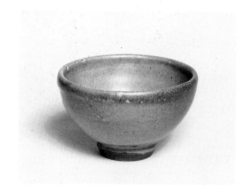

c18

c19

NORAH BRADEN

c18 Bowl

Stoneware with greyish ash glaze.
Mark: NB (indistinct) and SI
impressed, diameter $3\frac{3}{4}$ (8.8)
St Ives, 1925
*Trustees of the Victoria and Albert
Museum (Circ.59-1973)*

This piece shows Braden's interest in ash
glazes even before she joined Katherine
Pleydell-Bouverie at Coleshill in 1938.

NORAH BRADEN

c19 Vase

Stoneware with grey-bronze glaze.
Mark: NB painted, height 8 (20.3)
Coleshill, c.1933
Lit: Rose, 59
*Trustees of the Victoria and Albert
Museum (Circ. 31-1943)*

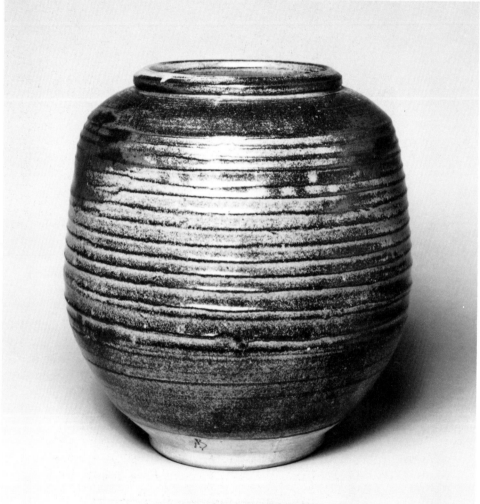

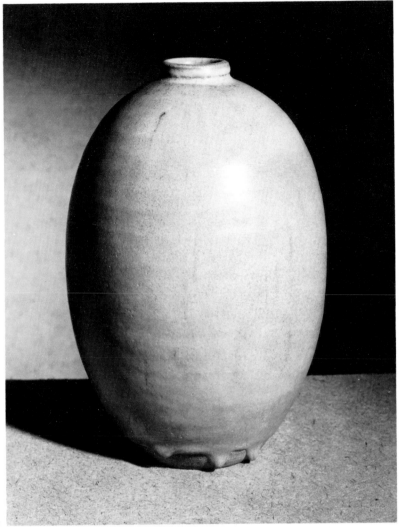

C20

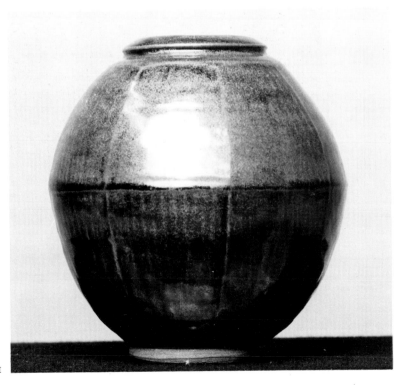

C21

KATHERINE PLEYDELL-BOUVERIE
1895–1985

St Ives Pottery: 1924

1923 Sees Leach exhibition in London, applies to join pottery at St Ives
1923–1924 Studies at Central School with Dora Billington
1924 Accepted as pupil by Leach
1924 Sets up own pottery at Coleshill
1928 Norah Braden joins pottery
1936 Norah Braden leaves
1940 Coleshill destroyed by fire
1946 Moves to Kilmington, Wilts.
1985 January dies

KATHERINE PLEYDELL-BOUVERIE

C20 Vase, 'Roc's egg'

Stoneware with grey ash glaze. Mark: KPB impressed, height 10 (25.5)
Coleshill, c.1930
Trustees of the Victoria and Albert Museum (Circ. 236-1930)

KATHERINE PLEYDELL-BOUVERIE

C21 Vase

Stoneware with reddish brown 'tessha' glaze. Mark: KPB impressed, height 8 (20.3)
Lit: Rose, 54
Trustees of the Victoria and Albert Museum (Circ. 763-1931)

CHARLOTTE EPTON

St Ives Pottery: 1930s

CHARLOTTE EPTON

C22 Vase and cover

Stoneware with grey crackled glaze.
Marks: EP and SI impressed,
diameter 7 (17.8)
St Ives, *c.*1930
*Trustees of the Victoria and Albert
Museum (Circ. 766-1931)*

This piece shows the individual nature of
students' work done before the war. Later
students were responsible for the output of
standard ware, and made individual pots
only in their own time. Epton visited the
Pottery regularly in the 1930s, and amongst
other activities assisted the young David
Leach to learn to throw. After her marriage
to Edward Bawden, she ceased potting.

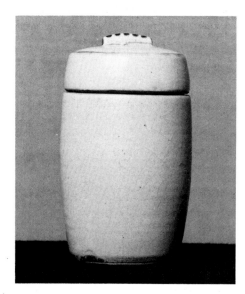

C22

DAVID LEACH
born 1911

St Ives Pottery: 1930–1955

1911 7 May born in Tokyo, Japan
1930 Joins St Ives pottery as an apprentice
1933–1934 Worked at Dartington teaching
 and working on experiments for
 projected pottery
1934–1937 Attended course at North
 Staffordshire Technical College,
 Stoke-on-Trent
1937 Dartington Hall scheme shelved.
 Returns to St Ives, and installs oil-
 fired kiln there. Earthenware
 abandoned and standard ware
 developed in stoneware
1941 Conscripted into army
1945 Demobilised, returns to St Ives
1946 Forms partnership with Bernard to
 run St Ives and train apprentices
1955 Leaves St Ives and establishes own
 pottery at Lowerdown, Bovey Tracey
1966 First one-man show at the CPA
1967 Chairman CPA, Gold medallist at
 Istanbul

Bibliography
R. Fournier (ed), *David Leach*, 1977

DAVID LEACH

C23 Two slipware dishes

Slab-moulded earthenware with
combed slip decoration. Mark: SI
impressed, diameter 7 (19)
St Ives, *c.*1936
Lit: Leach Book, 20
*Crafts Study Centre, Holburne
Museum, Bath*

These two dishes formed part of the
'standard ware' of the period immediately
prior to the change to oil-fired stoneware.
They were mostly made by Harry Davis
and David Leach. This particular pattern
was David Leach's own, though examples
have erroneously been attributed to Bernard
Leach.

DAVID LEACH

C24 Teacup and Saucer

Porcelain with fluted decoration under
a pale celadon glaze. Mark: DAL
incised and SI impressed, height 3 (7.6)
St Ives, 1952
David Leach

This cup and saucer were part of David
Leach's experiments in developing a
porcelain body that was both plastic and
translucent and yet manageable by studio
potters at reasonable temperatures. The
experiments resulted in the commercial
preparation of the successful 'Leach
porcelain body'. The fine throwing and
fluted decoration have become the
hallmarks of this potter.

DAVID LEACH

C25 Large Vase

Stoneware with tenmoku glaze.
Mark: DL impressed, height 19 (49.5)
Lowerdown Pottery, 1966
Daphne Swann

This piece shows David Leach's
considerable skill as a thrower – a skill that
owes something to the discipline of
producing standard wares in large numbers.

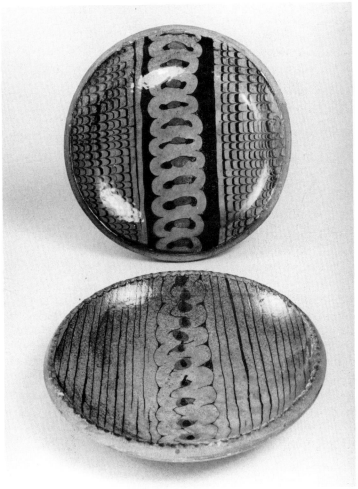

C23

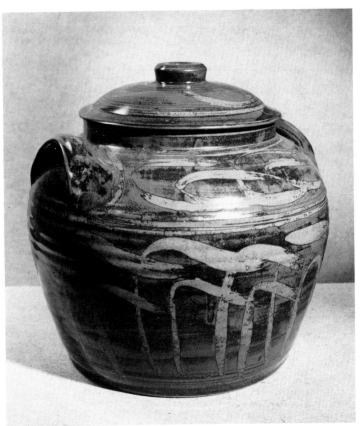

C27

HARRY AND MAY DAVIS

St Ives Pottery 1933–1937

*c.*1930 Works as thrower in small tourist
 pottery at Broadstone, near Poole
1933–1937 Works at St Ives, running the
 pottery with Laurie Cookes during
 absence of Bernard and David Leach
1937–1946 Working in Africa and America
1946 Sets up Crowan pottery, Praze,
 Cornwall with May Davis
1962 Emigrate to New Zealand

HARRY DAVIS

C26 Vase

Earthenware with slip decoration in
brownish colours under a lithage glaze.
Mark: SI impressed, height $9\frac{1}{2}$ (24.2)
St Ives, *c.*1936
David Leach

By the mid-1930s the St Ives earthenwares
had reached a high degree of technical
quality. The material, however was
considered too soft for domestic use – a
consideration which prompted the change
to the higher fired and harder stoneware.

HARRY AND MAY DAVIS

C27 Casserole

Stoneware, with wax-resist decoration.
Mark: CP impressed, height 13 (33)
Crowan Pottery, Praze, 1958
*Trustees of the Victoria and Albert
Museum (Circ.18+a-1959)*

After working abroad for a long period,
Harry Davis returned to Cornwall with his
wife, May, where they concentrated on the
production of high quality domestic wares.
He took a particular interest in the
development of strong clay bodies that
would not easily chip in use.

WILLIAM MARSHALL
born 1923

St Ives Pottery: 1938–1977

1923 Born St Ives
1938 August joins Pottery as apprentice
1942 August conscripted
1947 April rejoins Pottery
1977 Leaves to set up own pottery at Lelant; teaching at Cornwall Technical College, Redruth

WILLIAM MARSHALL

c28 Vase

Porcelain, with cut sides and iron ash glaze. Mark: WM and SI impressed, height $12\frac{1}{4}$ (31)
St Ives, c.1965
William Marshall

William Marshall, taken on in 1938 for the production of standard wares, became the most proficient thrower in the Pottery, and after the war was responsible for throwing the basic forms of the larger of Bernard's vases. His own ware is often of distinct shape compared to those he made to Bernard's designs.

WILLIAM MARSHALL

c29 Yunomi

Stoneware with painted decoration. Mark: WM and SI impressed, height $3\frac{1}{2}$ (9)
St Ives, 1968
W.A. Ismay
Purchased from the Penwith Society.
The 'yunomi', a form of Japanese mug, was a common article made as individual pieces by potters at St Ives.

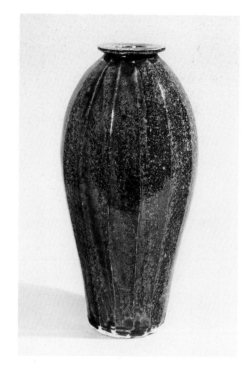

C28

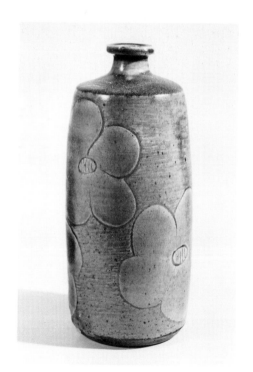

C31

KENNETH QUICK
1931–1963

St Ives Pottery: 1945–1955, 1960–1963

1931 Born St Ives, cousin to William Marshall
1945 Joins St Ives as apprentice
1955 Sets up own pottery at Tregenna Hill
1959 Spends six months in U.S.A.
1960 Rejoins Pottery in St Ives
1963 Visits Hamada's pottery in Mashiko, Japan; accidentally drowned

KENNETH QUICK

c30 Yunomi

Stoneware with hakame decoration and brushwork in brown. Marks: KQ and SI impressed, height $3\frac{3}{4}$ (9.5)
St Ives, c.1961
W.A. Ismay

KENNETH QUICK

c31 Vase

Stoneware with carved decoration under a grey ash glaze. Mark: KQ and SI impressed, height $11\frac{1}{2}$ (29.2)
St Ives, 1962
Lit: Rose, 73
Janet Leach

KENNETH QUICK

c32 Vase

Stoneware with incised decoration and celadon glaze. No mark, but remains of paper label dated 1963, height $7\frac{1}{4}$ (16)
Mashiko, Japan, 1963
Lit: Wood, 32
Trustees of the Victoria and Albert Museum (C.81-1981)

This vase was made by Kenneth Quick during a visit to Hamada's workshop in Japan, very shortly before he was drowned.

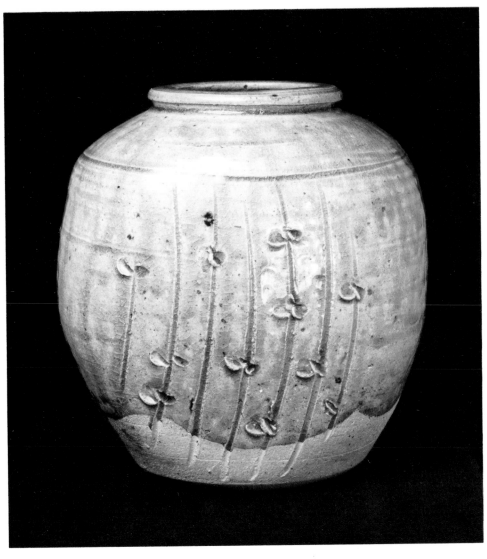

C32

MICHAEL LEACH
born 1913

St Ives Pottery: *c.*1938–1955

1938–1939 Works at St Ives Pottery
1946–1948 Works at Bullers with Agnete Hoy
1948 Returns to St Ives
1955 Leaves St Ives to set up own pottery at Fremington, North Devon
1983 Ceases potting

MICHAEL LEACH

C33 Vase

Stoneware with mottled brownish glaze. Mark: ML and Y impressed, height 9⅜ (23.8)
Yellard Manor Pottery, Fremington, Barnstaple, 1962
Trustees of the Victoria and Albert Museum (C.440-1962)

Michael Leach, though he showed more aptitude as a child, took up full-time potting much later than his elder brother, David. He confined his production mostly to domestic wares that he sold locally.

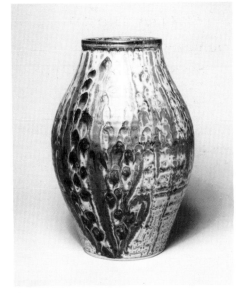

C33

ALIX AND WARREN MACKENZIE

St Ives Pottery 1950–1952

1950–1952 Work at St Ives arriving June, then return to U.S.A. to continue potting and teaching in Minnesota

ALIX AND WARREN MACKENZIE

C34 Covered Bowl

Stoneware with oatmeal glaze and decoration in tenmoku and blue.
No mark, height $3\frac{1}{4}$ (9.5)
St Ives, *c.*1952
Sheila Lanyon

The MacKenzies were among the first of the foreign students to come to St Ives after the war. They accompanied Bernard Leach back to England in 1950. They produced some much admired individual work before returning to the U.S.A. in 1952, where they championed the growing studio pottery movement from their base in Minnesota. This piece was given to the Lanyons as a parting gift.

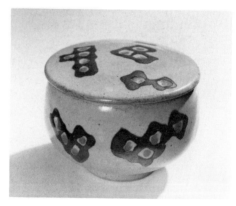

C34

JANET LEACH

born 1918

St Ives Pottery: 1956–

1918 Born in Texas, U.S.A. (Janet Darnell)
1938 Goes to New York, enrols in sculpture classes
1939–1945 Works as welder on war ships on Staten Island
1952 Meets Hamada and Leach on tour in U.S.A.
1954 Visits Japan, working at Mashiko and Tamba, travels with Leach, typing for him
1956 Comes to England to St Ives to marry Bernard Leach

Bibliography
Janet Leach: American Foreigner, *Studio Potter*, 11 February 1983

JANET LEACH

***C35 Jar**

Stoneware, with decoration of dark bands with scratched ornament. Mark: JL and SI impressed, height 16 (40.6)
St Ives, 1963
Lit: Rose, 86
Private Collection

Janet Leach's work is much influenced by the village potteries of Japan where she studied spending some time with Hamada at Mashiko, and a longer period at Tamba village. This and the following two pieces were owned by Barbara Hepworth.

JANET LEACH

***C36 Vase**

Stoneware unglazed with splashed glaze decoration. Mark: JL and SI impressed, height $17\frac{1}{4}$ (44)
St Ives, *c.*1962–3
Private Collection

This piece was given by the potter to Barbara Hepworth as a house-warming present when she bought a flat in Barnaloft. The technique of poured glaze decoration is one that Janet introduced to St Ives.

JANET LEACH

C37 Vase

Porcelain, slab-built with white and brown glazes. Mark: JL and SI impressed, height $7\frac{1}{2}$ (19)
St Ives, *c.*1960
Private Collection

HAMADA ATSUYA

St Ives Pottery: 1957–1958

Son of Hamada Shoji
*c.*1957–1958 Student at St Ives

HAMADA ATSUYA

C38 Yunomi

Stoneware with salt glaze. Mark: SI
impressed, height $3\frac{3}{4}$ (9.5)
St Ives, 1958
W.A. Ismay

HAMADA ATSUYA

C39 Bottle

Stoneware with salt glaze. Mark: SI
impressed, height $4\frac{5}{8}$ (11.7)
St Ives, 1958
W.A. Ismay

Both these pieces of Atsuya's were made in
the small kiln that was built by Janet Leach
for the use of students in their own time.

RICHARD BATTERHAM

born 1936

St Ives Pottery: 1957–1958

1957–1958 Two-year apprenticeship at
St Ives Pottery
1959 Establishes own pottery at
Durweston, near Blandford, Dorset.

RICHARD BATTERHAM

C40 Dish

Stoneware with cut decoration under a
celadon glaze. Diameter $7\frac{1}{2}$ (19.5)
Durweston, *c.*1962
Pan Henry

Richard Batterham, one of the country's
most skilled domestic ware potters, quickly
developed a very personal style after leaving
the Leach Pottery where he spent two years
from 1957. At St Ives he concentrated on
making standard ware, and made no
individual pieces.

JOHN LEACH

born 1939

St Ives Pottery: 1961–1962

1957 Leaves school, works with father,
David Leach
1961–1962 Works at St Ives
1962–1964 Travels in U.S.A.
1964 Establishes pottery at Muchelney,
Somerset

JOHN LEACH

C41 Teapot

Stoneware, with tenmoku glaze.
No mark: height $4\frac{5}{8}$ (11.7)
St Ives, 1961
Mrs John Leach

John Leach trained with his father David
Leach for three years, before spending some
time with Ray Finch at Winchcombe, and
two years at St Ives. After a period in the
U.S.A., he set up his own pottery in
Muchelney, Somerset, where he produces a
much acclaimed range of sturdy functional
pots. This teapot is not part of the St Ives
Standard Ware catalogue, but was made to
his own design for his wife's birthday.

GENERAL BIBLIOGRAPHY

H.H. Robinson. 'St Ives as an Art Centre', in W. Badcock, *Historical Sketch of St Ives and District*. St Ives, 1896.

Denys Val Baker. *Paintings from Cornwall*. Cornish Library, Penzance, 1950.

J.P. Hodin. The Cornish Renaissance, *Penguin New Writing*. 1950 (no.39).

Denys Val Baker. Painting from Cornwall, *Cornish Review*. Spring 1951.

Hanover Gallery, 1953. *Space in Colour*. Exhib. cat. introd. Patrick Heron.

Lawrence Alloway (ed.). *Nine Abstract Artists*. Tiranti, 1954.

Patrick Heron. *The Changing Forms of Art*. Routledge and Kegan Paul, 1955.

Montreal City Art Gallery, 1955. *Six Painters from Cornwall*. Exhib. cat. introd. Norman Levine.

O'Hana Gallery, 1957. *Dimensions, British Abstract Art 1948–1957*. Exhib. cat. introd. Lawrence Alloway, Toni del Renzio.

ICA, 1957. *Statements, A Review of British Abstract Art in 1956*. Exhib. cat. introd. Lawrence Alloway.

Denys Val Baker. *Britain's Art Colony by the Sea*. George Ronald, 1959.

Arts Council, 1960. *Penwith Society of Arts, Tenth Anniversary Exhibition*. Exhib. cat. introd. Alan Bowness.

S. Conynge Caple. *St Ives Scrap Book*. N.d. *c*.1960.

Denys Val Baker. *The Timeless Land – The Creative Spirit in Cornwall*. Adams and Dart, Bath, 1973.

Grant M. Waters. *Dictionary of British Artists Working 1900–1950*. (2 vols.), Eastbourne, 1975.

New Art Centre, 1977. *Cornwall 1945–55*. Exhib. cat. introd. and chronology David Brown.

Newlyn Orion Galleries, Penzance, 1979. *Artists of the Newlyn School, 1880–1900*. Exhib. cat. introd. Caroline Fox, Francis Greenacre.

Peter Davies. Notes on the St Ives School, *Art Monthly*. July/August 1981 (no.48).

Adrian Lewis. The fifties, British avant-garde painting 1945–56, *Artscribe*. March 1982 (no.34); June 1982 (no.35); August 1982 (no.36).

Peter Davies. St Ives in the forties, *Artscribe*. March 1982 (no.34).

Peter Davies. *The St Ives Years (Essays on the Growth of an Artistic Phenomenon)*. The Wimborne Bookshop, 1984.

Denys Val Baker. Primitive visions, *Country Life*. 16 August 1984 (vol.CLXXVI).

Tom Cross. *Painting the Warmth of the Sun, St Ives Artists 1939–75*. Alison Hodge, Lutterworth Press, 1984.

A REQUEST

During the preparation of this exhibition the number of catalogues, (in photocopy form) of St Ives Society of Artists exhibitions, in the Tate Gallery Library increased four-fold, from 1 to 4. Almost all the information of that Society's exhibitions has been obtained from newspaper reports as few records survive from much before 1970. Likewise there are few records of the Newlyn Society of Artists before 1974. The Tate Gallery Library would be grateful for the loan of catalogues of the Societies' exhibitions so that photocopies can be made. We should also like to see copies of the *West Cornwall Arts Review*, published in the 1890s, if any exist.

LIST OF LENDERS

Aberdeen Art Gallery 34, 81
Albright-Knox Art Gallery, Buffalo 95
Dr J.J.G. Alexander 203
Arts Council of Great Britain 74, 96, 117, 169, 182, 205, 229
Mrs Monica Askew 98

W. Barns-Graham 25, 39
Bath Crafts Study Centre c16, c23
Birmingham Museums and Art Gallery 77
Sandra Blow 163
Bristol City Museum and Art Gallery 5, 94, 167
British Council 76, 83, 87, 97, 116, 129, 211
Trustees of the British Museum 137

Cecil Higgins Art Gallery, Bedford 141
John Christopherson 162, 164
Prunella Clough 103
John Crowther 176
Sir Michael Culme-Seymour, Bt. 35

Mrs Cordelia Dobson 3
Ronnie Duncan 202

Ferens Art Gallery, City of Kingston upon Hull 168
Owen and Sonja Franklin 28
Mrs Frederica Freer 112
Terry Frost 101, 102, 215

Miriam Gabo 41, 45, 48
Glasgow Art Gallery and Museum 37
Fundação Calouste Gulbenkian 206
Solomon R. Guggenheim Museum, New York 46, 143

Harriman Judd Collection 218
David Haughton 104
Barbara Hayman 106
Patrick Hayman 105
Patrick and Barbara Hayman 233
Adrian Heath 99, 107
Pan Henry c40
Trustees of the Hepworth Estate 57, 134, 138, c9
Rose Hilton 222, 223
Guy Howard 110

IBM UK Laboratories Ltd 69
W.A. Ismay c29, c30, c38, c39

Kettle's Yard 7, 17, 18, 20, 21, 27, 47
Rijksmuseum Kröller-Müller, Otterlo 80

Sheila Lanyon 111, 157, 158, c34
Bob Law 170, 171, 172, 173
David Leach c15, c24, c26
Janet Leach c13, c31
Mrs John Leach c41
David Lewis 52

Manchester City Art Galleries 82
Molly Marriner 130
William Marshall c28
Margaret Mellis 23
Miss Elma Mitchell 128
Captain W.J. Moore 232

Kate Nicholson 148
Michael Nicholson 32
Simon Nicholson 149

Tony O'Malley 225
Gian and Jeanette Ongaro 185

Jack Pender 119
Phillips Collection, Washington DC 84, 90
Plymouth City Museum and Art Gallery 199
Potworowski family in London 120
Ken Powell 183
Private Collection 1, 2, 8, 11, 13, 15, 19, 24, 26, 29, 30, 31, 33, 36, 40, 49, 50, 51, 55, 56, 60, 62, 64, 66, 67, 70, 71, 85, 86, 89, 108, 114, 122, 139, 142, 144, 146, 150, 151, 155, 156, 165, 174, 175, 178, 181, 184, 192, 193, 194, 196, 198, 200, 208, 209, 212, 219, 220, 221, 224, 226, 228, 231, c8, c11, c35, c36, c37

Peter Rainsford 227
Christina Reis 121
Paul Rice Gallery c14
Lucie Rie c4
Museo de Arte Moderna, Rio de Janeiro 93
Mr and Mrs Eugene Rosenberg 161

St Ives Town Council 9
William Scott 123
Scottish National Gallery of Modern Art, Edinburgh 61, 160, 204
Southampton Art Gallery 201

Mr and Mrs Ian Stoutzker 140
Helen Sutherland Collection 4, 6, 14, 53, 54, 63, 92
Daphne Swann c25

Tate Gallery 10, 12, 16, 22, 42, 43, 44, 58, 59, 68, 72, 73, 75, 78, 79, 100, 109, 113, 115, 118, 126, 127, 131, 135, 136, 145, 152, 154, 166, 177, 179, 186, 191, 195, 197, 213, 214, 216, 230
Miss Jeannette R. Taylor 128
Joe Tilson 180
Towner Art Gallery, Eastbourne 38

Ulster Museum, Belfast 132, 153, 210

Museo d'Arte Moderna di Ca'Pesaro, Venice 88
Victoria and Albert Museum c1, c6, c7, c10, c17, c18, c19, c20, c21, c22, c27, c32, c33

Waddington Galleries 187
National Museum of Wales 65, 133
John Wells 124, 125
Frederick Weisman Foundation 217
Whitworth Art Gallery, University of Manchester 91, 159, 207
Mr and Mrs George Wingfield Digby c2
Monica Wynter 188, 189, 190

York City Art Gallery c3, c5, c12

Kunsthaus Zurich 147

INDEX

Abstraction Création, 14, 120, 124, 135
Adams, Robert, 33, 105, 109, 113, 138
Adler, Jankiel, 139
Allan, R.W., 97
Allen, Dennis, 107
Alloway, Lawrence, 109, 111, 129
Andrews, Michael, 108
Armitage, Catherine, 118
Armitage, Kenneth, 139, 201
Armstrong, Elizabeth, 102
Armstrong, John, 105, 109
Armstrong, Shearer, 99, 100, 105, 113
Arnold Foster, W., 99, 105, 109, 113
Arp, Jean, 14, 15, 32, 135
Atkinson, Fello, 30
Auden, W.H., 14
Auerbach, Frank, 142
Auty, Giles, 112

Bacon, Francis, 110, 146
Badcock, W., 97, 98
Barker, George, 16, 26, 27, 105
Barker, Kit, 26, 105
Barlett, W.H., 97
Barlow, 98
Barnes, Garlick, 104, 105, 113
Barns-Graham, W., 25 (ill), 26, 27, 29, 30, 31, 33,
 34, 36, 37, 100, 101, 102, 103, 104, 105, 106,
 108, 109, 111, 112, 113, 115 (ill), 133, 162
 Composition February 1954, 31 (ill)
 Island Sheds, St Ives, No.1, 72 (ill), 162
 March 1957 (Starbotton), 200 (ill)
 Porthleven, 37 (ill)
 Upper Glacier, 179, 180 (ill)
Bateman, 109
Bath Academy of Art, Corsham, 104, 109, 119,
 123, 124, 128, 136, 139, 140, 147, 179
Batterham, Richard, 226, 241
Baughan, 153
Bawden, Edward, 236
Baxandell, David, 34
Bayley, Dorothy, 105, 113
Baziotes, William, 109, 110
Bedding, John, 113
Bell, Trevor, 33, 103, 109, 111, 114 (ill), 116 (ill),
 129, 199
 Black, 200
Benjamin, Anthony, 109, 112, 114 (ill), 116,
 117 (ill), 199
 Inland, 200
Berlin, Sven, 25, 26, 27, 32 (ill), 33, 100, 102,
 103, 104, 105, 106, 108, 109, 110, 116, 117 (ill),
 133
 Portrait of Guido Morris, 26 (ill)
 Serene Head, 179, 180 (ill)
Bergonzi, Bernard, 133
Bernal, Desmond, 33, 100
Bertram, Jean, 115
Biederman, Charles, 103

Bill, Max, 103
Billington, Dora, 235
Birch, Lamorna, 99, 103, 105
Bissière, Roger, 126
Blackburn, Rosemary, 201
Blake, Peter, 110, 143 (ill), 199
Blake, William, 15
Blomefield, 98
Blow, Sandra, 33, 110, 118 (ill), 199
 Untitled, 200 (ill)
Bomberg, David, 104
Bottome, Phyllis, 106
Bottomley, Fred, 105,
Bottrall, Ronald, 107
Bourne, Bob, 103, 113
Braden, Norah, 223, 234 (ill), 235
Bradshaw, George, 26, 99, 100, 105
Bradshaw, Kathleen, 105
Bramham, Benjamin, 98
Bramley, Frank, 102
Brancusi, Constantin, 14, 15, 124, 135
Brangwyn, Frank, 228
Braque, Georges, 14, 35, 124
Bratby, John, 108
Brennan, Robert, 29, 112, 113
Broido, Michael, 103, 111, 112, 113, 124, 203,
 212
Brooks, James, 110
Broughton, Owen, 124
Brown, Arnesby, 98, 102
Brown, Don, 113
Brown, Ernest, 34
Brown, H.T., 105
Brown, Oliver, 103
Brumwell, Marcus and Irene, 21, 33, 99, 112,
 149, 163
Brunel, I.K., 154
Burri, Alberto, 200
Butler, Howard Russell, 98

Caddick, Arthur, 27, 32, 106, 107, 133
 Cuckoo Song, 107
Calder, Alexander, 36, 135
Canetti, Elias, 33
Cardew, Michael, 29, 32, 134, 221, 222, 223, 232,
 233 (ill)
Care, David, 134 (ill)
Carne, Alec, 105, 113
Caro, Anthony, 111, 199
Castle Inn, 27, 32 (ill), 33, 103, 104, 105, 144
Chadwick, 97, 98
Chambers, Pat, 179
'Circle', 22, 100, 120, 135, 161
Clark, Kenneth, 24, 163
Cock, Martin, 98, 99
Cocteau, Jean, 146
Cohen, Bernard, 111
Cohen, Harold, 108
Coldstream, William and Nancy, 99, 100, 138, 161

Coleman, Roger, 111
Colquhoun, Robert, 102
Conn, Roy, 112, 113
Conner, Angela, 124
Connolly, Cyril, 101
Constant, Nieuwenhuys, 33, 126
Cookes, Laurie, 223, 224, 225, 228, 237
Cooper, Douglas, 14, 15
Corneille, 36
Corser, Trevor, 113
Cox, David, 105, 106
Cresta, 35, 99
Crossley, Bob, 113, 114 (ill)
Crouch, John, 111
Crowther, John, 112, 203
Crypt Group, 26 (ill), 104, 105, 117, 128, 133,
 145, 147, 162, 179
Cryséde Silks, 99
Cuneo, Terence, 99

Dannatt, Trevor, 209
Dartington College, 223, 224, 225, 226, 228, 231,
 236
Davie, Alan, 33, 110, 199
Davis, Harry and May, 223, 228, 232, 236,
 237 (ill)
Davison, Francis, 131
De Stijl, 36, 120
Dean, Michael, 112
Denny, Robyn, 111
Diaghilev, 120, 146
Digby, Wingfield, 28
Dix, George, 33, 34
Dix, Otto, 146
Dobson, Cordelia, 98, 127, 150
Dobson, Frank, 98, 127, 150
Dolan, Patrick, 113, 114 (ill)
Dorfman, Stanley, 109, 113
Dow, Millie, 98, 99
Downing, George, 26, 104, 105, 108, 109
Downing's Bookshop, 26, 104, 105, 106, 109, 133
Drey, Agnes, 103, 105, 109, 110, 113
Du Maurier, Jeanne, 105, 113
Duckworth, Arthur, 100
Duncan, Ronnie, 114 (ill)
Dunn, George, 222
Dunsmuir, Nessie, 102, 114 (ill)
Dyer, Lowell, 98

Eadie, William, 98
Early, Tom, 103, 104, 105, 106, 108, 113
East, Alfred, 98
Eastlake, Lawrence, 98
Eates, Margot, 100
Ede, Jim, 101, 103, 149, 152, 153
Edmunds, Jacqueline, 112
Eliot, T.S., 14, 15
Elmhirst, Dorothy and Leonard, 223, 224, 226
Éluard, 14, 15

Emanuel, John, 113
Epton, Charlotte, 236 (ill)
Euston Road School, 99, 100, 128, 131, 138, 142, 161, 170
Evans, Merlyn, 112
Ewan, Frances, 105

Fairfax, John, 16
Fardoe, F., 106
Featherstone, William, 111
Feiler, Paul, 33, 108, 110, 113, 118, 119 (ill), 199
 Morvah, 200
Finch, Ray, 241
Forbes, Stanhope, 15, 97, 99, 102, 103, 104, 105, 118, 123, 145
Fore Street Gallery, 112
Forrester, John, 33, 105, 109, 113, 205
Francis, Sam, 110
Froshaug, Anthony, 33
Frost, Terry, 27, 29 (ill), 30, 31, 32, 33, 34, 36, 37, 38, 103, 104, 105, 107, 108, 109, 111, 112, 113, 114 (ill), 116, 119 (ill), 120, 123, 124, 133, 138, 139, 179, 183, 199, 205, 212, 215
 Construction, 181 (ill)
 Construction Leeds, 181 (ill)
 Force 8, 81 (ill), 201
 Green, Black and White Movement, 181 (ill)
 Pisa, 216
 Red, Black and White, Leeds, 201 (ill)
 Three Graces, 82 (ill), 201
 Through Blacks, 215 (ill), 216
 Walk Along the Quay, 30, 80 (ill), 180
 Walk Along the Quay, First version, 30 (ill)
 Winter, 1956, Yorkshire, 201 (ill)
Froy, Martin, 108
Fry, Maxwell, 23
Fuller, Leonard, 98, 99, 100, 102, 103, 105, 107, 108, 110, 113, 119, 120 (ill), 129, 138, 141, 149
 Herbert Thomas, 120 (ill)
 Margarine Still Life, 150 (ill)
Furness, Jane, 113

Gabo, Miriam (see Miriam Israels), 21, 22, 23, 24, 100, 101, 102, 120, 161, 162
Gabo, Naum, 17, 21, 22 (ill), 23, 24 (ill), 25, 27 (ill), 31, 100, 101, 102, 103, 104, 120, 121 (ill), 124, 125, 128, 135, 145, 149, 161, 162, 165, 167, 170, 184, 199
 Carved Pebbles, 163
 Construction in Space Crystal, 23 (ill)
 Kinetic Oil Painting in Four Movements, 65 (ill), 164
 Kinetic Stone Carving, 162 (ill)
 Linear Construction in Space, 63 (ill), 164
 Linear Construction No.1 Variation, 163, 164 (ill)
 Painting : Construction in Depths, 65 (ill), 164
 Spiral Theme (1st Version), 64 (ill), 101, 163
 Spiral Theme (Model), 101, 163 (ill)
 Turquoise, Kinetic Oil Painting, 164
Gaputyte, Elena, 111, 113
Gardiner, Margaret, 20 (ill), 33, 100, 103
Garstin, Alethea, 99, 103, 113
Garstin, Norman, 98, 102, 103

Gear, William, 105, 109, 115
Gilbert, Dick, 113
Giles, Tony, 113
Gimpel, Charles, 112
Ginner, Charles, 99
Glynn, Grylls, R., 107
Gollancz, 14
Gorky, Arshile, 109, 110
Gotch, T.C., 97
Gottlieb, Adolph, 110
Graham, W.S. (Sydney), 27, 33 (ill), 102, 109, 114 (ill)
 Dear Bryan Wynter, 46, 47
 Lines on Roger Hilton's Watch, 42, 43
 Night Fishing, The, 40, 102
 Thermal Star, The, 44, 45
 Voyages of Alfred Wallis, The, 48
Greaves, Derrick, 108
Green, Romney, 134
Greenberg, Clement, 110, 119, 208
Gregory, E.C. (Peter), 33, 101, 209
Grier, E. Wyly, 98
Grier, Louis, 98, 99, 102
Gris, Juan, 14, 15, 20
 Still Life with Fruit Dish and Water Bowl, 14 (ill)
Grönvold, 98
Guggenheim, Solomon, 164
Guston, Philip, 110
Guthrie, Derek, 111, 112, 113
Gwynne-Jones, Allan, 99

Haines, Lett, 98
Halliday, Frank and Nancie, 38
Hamada, Atsuya, 226, 241
Hamada, Shoji, 27, 28, 29, 99, 220, 221 (ill), 222 (ill), 223, 224, 226, 228, 231 (ill), 232 (ill), 238, 240, 241
Hammarskjöld, Dag, 190, 192
Hartigan, Grace, 110
Haughton, David, 16, 26, 27, 103, 104, 105, 106, 113, 122, 122 (ill)
 Quarry Buildings, 182 (ill)
 St Just : Carne Bosaverne The First, 182 (ill)
Havinden, Ashley, 100
Hayman, Patrick, 33, 103, 109, 111, 112, 113, 122, 123 (ill), 199
 Hillside with Houses and Trees, 182 (ill), 183
 Mother and Child, 183 (ill)
 Tristan and Isolde in Cornwall, 93 (ill), 202
Hearn, Lafcadio, 27
Heath, Adrian, 30, 33, 99, 109, 119, 123 (ill), 139, 179, 181, 212
 Composition, 183 (ill)
Heath, Isobel, 105, 106
Heath-Stubbs, John, 16, 105, 133
Hélion, Jean, 23
Hendy, Philip, 103, 171
Heppenstall, Rayner, 101
Hepworth, Barbara, 14, 15, 17 (ill), 18, 22, 23, 24, 25, 26, 27, 31, 32, 33, 36, 38 (ill), 39, 99, 100, 101, 102, 103, 104, 105, 106, 107, 108, 109, 110, 111, 112, 113, 115, 119, 124 (ill), 125, 128, 129, 132, 133, 134, 135, 136, 142, 144, 145, 149, 152, 161, 162, 170, 171, 181, 184, 190, 199, 203, 204, 205, 208, 215, 228

Bicentric Form, 108, 173
Concentration of Hands No 1, 172 (ill)
Corinthos, 190 (ill)
Cosdon Head, The, 38 (ill), 68 (ill), 172, 173
Curved Form (Delphi), 190, 191 (ill)
Drawing for Sculpture, 165 (ill)
Drawing for Sculpture (Red and Grey), 165 (ill)
Fallen Images, 216 (ill)
Fenestration of the Ear (The Hammer), 172 (ill)
Forms in Movement, 165 (ill)
Group 1 (Concourse), 68 (ill), 173
Landscape Sculpture, 166 (ill)
Oval Form (Trezion), 190, 192 (ill)
Oval Sculpture (Delos), 70 (ill), 190, 191
Pastorale, 173
Pelagos, 69 (ill), 171
Pendour, 18 (ill)
Reconstruction, 171, 172
River Form, 71 (ill), 193
Sculpture with Colour Deep Blue and Red (cat.no.49), 104, 165
Sculpture with Colour Deep Blue and Red (cat.no.50), 66 (ill), 165
Sculpture with Colour (Oval Form) Pale Blue and Red, 66 (ill), 166
Sea Form (Porthmeor), 190, 192 (ill)
Single Form, 71 (ill), 190, 192
Tides I, 36 (ill)
Torso 1 (Ulysses), 191 (ill)
Two Figures with Folded Arms, 38 (ill)
Wave, 166 (ill)
Wood and Strings, 67 (ill), 105, 166
Hepworth, Dorothy, 99
Hepworth Museum, 102, 124
Heron, Delia, 35, 109, 118, 125, 126, 184
Heron, Patrick, 16, 25, 30, 32, 33, 34 (ill), 35, 102, 103, 104, 105, 106, 107, 108, 109, 110, 111, 112, 113, 114 (ill), 118, 125, 126 (ill), 138, 179, 199, 208, 212, 225
Autumn Garden : 1956, 88 (ill), 208
Big Cobalt Violet : May 1972, 90 (ill), 216
Big Green with Reds and Violet : December 1962, 210
Boats and the Iron Ladder : 1947, The, 183
Brown Ground with Soft Red and Green : August 1958–July 1959, 210 (ill)
Cadmium Scarlet : January 1958, 89 (ill), 209, 210
Harbour Window with Two Figures, St Ives : July 1950, 87 (ill), 183, 184
Horizontal Stripe Painting : November 1957–January 1958, 209 (ill)
Portrait of Herbert Read, 15 (ill)
Rectilinear Reds and Blues : 1963, 211 (ill)
Red Layers (With Blue and Yellow) : December 1957, 209
Vertical Light : March 1957, 209
Yellows and Reds with Violet Edge : April 1965, 211, 216
Heron, Katharine, 184
Heron, Tom, 35, 99
Hewitt, Graham, 113
Hill, Anthony, 33, 181

Hilton, Roger, 33, 35(ill), 42, 102, 103, 105, 109, 110, 111, 112, 116, 126, 127(ill), 129, 181, 208, 212, 215
 Blue Bird, 216(ill)
 Blue Newlyn, 83(ill), 212
 Dark Continent, 213
 Desolate Beach, 213
 Female Nude, 217(ill)
 Figure, 213(ill)
 Figure and Bird, 84(ill), 214
 Figure 1972, 216
 Grey Day by the Sea, 212
 Grey Figure, 212(ill)
 January (Black and Red on White), 214(ill)
 January 1962 (Tall White), 214(ill)
 March 1961, 213(ill)
 May 1963 (Red), 214(ill)
 Oi Yoi Yoi, 85(ill), 214
 Palisade, 212(ill)
 Sailing Ship with Grey Sails and Floating Figure, 217(ill)
 Untitled (cat.no.222), 217
 Untitled (cat.no.223), 217(ill)
 Untitled (cat.no.224), 86(ill), 217
Hocken, Marion, 105, 113
Hodgkins, Ethel M., 103
Hodgkins, Frances, 98, 99
Hodin, J.P., 33, 108
Holland, Fishley, 222
Hook, James Clark, 97
Horne, Frances, 220, 221
Hoskin, John, 114(ill)
House, Gordon, 111
Hoy, Agnete, 239
Hoyton, E.B. and Enid, 101
Hubbard, John, 110
Hulbert, Thelma, 99
Hunter, Elizabeth, 113

Illsley, Bryan, 103, 113
Illsley, Leslie, 113
Ince, John, 103
Ingham, Bryan, 103, 113
Irwin, Gwyther, 112
Israels, Miriam (see Miriam Gabo), 102, 120

Jackson, Martha, 208
Jacobs, W.J., 98
James, Philip, 33, 34, 106
James, W., 134(ill)
Jameson, 98
Jevons, 98
Jewels, Mary, 98, 105, 109, 113, 127(ill), 150
 Cornish Landscape, 52(ill), 150
 Cornubia, 150(ill)
Jillard, Hilda, 104, 105, 113
John, Augustus, 106, 127, 150
Joyce, James, 14, 15

Kandinsky, Wassily, 120
Keeley, Philip and Sally, 30
Kendall, Dick, 225
Kenzan, Ogata, 220, 228
Kidner, Michael, 109
Klee, Paul, 143

Kline, Franz, 109, 110, 119, 140
Knight, Laura, 102
Kokoschka, Oskar, 100
Kooning, Willem de, 109, 110, 119, 140
Kossoff, Leon, 142
Kramer, Hilton, 110, 208

Langley, Walter, 97, 103
Lanham, James, 98
Lanham's Gallery, 98, 99
Lanyon, Andrew, 103
Lanyon, Peter, 15, 16(ill), 17(ill), 18, 20, 21, 23, 24, 25, 26, 27, 29, 32, 33, 34, 35(ill), 39, 40(ill), 99, 100, 101, 102, 103, 104, 105, 106, 107, 108, 109, 110, 111, 112, 113(ill), 114(ill), 128(ill), 129, 133, 134, 137, 139, 141, 161, 179, 196, 199, 205, 208, 215, 218, 240
 Bojewyan Farms, 185(ill), 186
 Box Construction, 100, 184
 Christmas Card, 32(ill)
 Clevedon Bandstand, 76(ill), 198
 Clevedon Night, 198(ill)
 Construction, 167(ill)
 Drift, 74(ill), 197
 Europa, 196
 Generation, 184(ill)
 Glide Path, 198(ill)
 Loe Bar, 75(ill), 197, 198
 Porthleven, 128, 185(ill)
 Porthleven Boats, 185(ill)
 Portreath, 112(ill)
 Rosewall, 112, 197(ill)
 St Just, 73(ill), 185, 186
 Thermal, 197(ill)
 Wheal Owles, 196
 White Track, 167(ill)
 Yellow Runner, The, 184(ill)
 Zennor Storm, 196
Lanyon, Sheila, 17, 21, 106, 112
Law, Bob, 110, 112, 128(ill), 129, 199
 Landscape XIII 10.1.60, 202(ill)
 Nine Wheeler, 112
 Ten Wheeler, 112
 21.4.59 (Field Drawing), 202(ill)
 24.6.60, 202(ill)
 29.8.60, 202(ill)
Lawrence, D.H., 14, 16
Le Corbusier, 23
Le Grice, Jeremy, 111, 113
Le Grice, Mary, 111
Leach, Bernard, 27(ill), 28(ill), 29, 33, 38, 94(ill), 95(ill), 96(ill), 99, 100, 102, 104, 105, 106, 108, 109, 112, 113, 129, 161, 162, 171, 190, 220, 221(ill), 222, 223, 224, 225, 226, 227, 228, 229(ill), 230(ill), 231, 235, 236, 237, 238, 240
Leach, David, 28, 105, 113, 223, 224, 225, 226, 227, 228, 236, 237(ill), 239, 241
Leach, Janet, 96(ill), 110, 112, 113, 129, 226, 228, 240, 241
Leach, John, 226, 241
Leach, Margaret, 225
Leach, Michael, 113, 226, 228, 239(ill)
Leach, Pottery, 25, 27, 28, 101, 102, 103, 125, 133, 134, 171, 220, 221, 222, 223, 224, 225, 226, 227, 228, 236, 238, 241

Leeds School of Art, 115, 116, 119, 199, 200
Lehmann, John, 14
Leigh, Roger, 109, 110, 112, 113, 114(ill), 124, 129(ill), 130, 199
 Cledhdan, 202(ill), 203
Leonard, Keith, 124
Levine, Norman, 106
Lewis, David, 25(ill), 35(ill), 105, 106, 107, 108, 115(ill)
Lewis, Neville, 15
Lhote, André, 131
Lindner, Moffat, 98, 103, 105
Lister-Kaye, M.V., 112
Little Park Owles, 20(ill), 21, 22, 24, 25, 99, 100, 110, 124, 131, 135, 142(ill), 161, 196
Lodder, Christina, 100, 162
Lowenstein, Edgar and Jane, 103
Lowndes, Alan, 102, 103, 109, 111, 112, 130(ill)
 Porthmeor Beach, St Ives, 203(ill)
Lucas, Mary, 140
Ludby, 98

MacKenzie, Alexander, 103, 109, 111, 112, 113, 131(ill), 199
 Painting, 203(ill), 204
MacKenzie, Alix and Warren, 28, 109, 240(ill)
McBean, Angus, 133
McBryde, Robert, 102
McDonald, Duncan, 103
Maeckelberghe, Margot, 111, 112, 113
Malevich, Kasimir, 120
Mankowitz, Wolf, 15
Mansfield, Katherine, 16
Mariners' Church, 103, 104, 141
Marshall, Herbert, 98
Marshall, Scott, 113, 225
Marshall, William, 28, 112, 113, 225, 226, 238(ill)
Martin, F.R., 113
Martin, J.L., 22, 120, 135
Martin, Kenneth, 138
Martin, Mary, 181
Marx, Karl, 15
Matisse, Henri, 35, 105
Matsubayashi, Tsurunosuke, 221, 228, 233(ill)
Meadows, Bernard, 112
Mellis, Anne, 100, 142
Mellis, Margaret, 21, 22, 24, 25, 99, 100, 101, 102, 103, 104, 115, 124, 131(ill), 142(ill), 149, 152, 156, 161
 Collage with Red Triangle, 167, 168
 Construction in Wood, 168
Mempes, Mortimer, 97
Miler, Masie, 114(ill)
Miles, June, 108, 113, 114(ill), 118
Milne, John, 109, 113, 124, 132(ill), 199
 Gnathos, 204(ill)
Milner, Fred, 98
Minton, John, 102, 103, 179
Miró, Joan, 21, 135, 143
Mitchell, Denis, 27, 33, 36(ill), 38, 39, 99, 100, 103, 104, 105, 106, 107, 108, 109, 110, 111, 113, 114(ill), 124, 132, 133(ill), 199
 Oracle, 204(ill)
 Turning Form, 204(ill)
Mitchell, Endell, 27, 103, 106

Mondrian, Piet, 14, 21, 22, 23, 36, 101, 124, 135, 161, 164
 Composition in Red, Yellow and Blue, 22 (ill)
Monier, Robert, 113
Moore, Alice, 104, 105, 106, 113, 133 (ill)
 Fish in the Harbour, 219 (ill)
 Water Garden, 219 (ill)
Moore, Henry, 14, 15, 22, 24, 39, 124
Moore, Henry, RA, 97
Morris, Cedric, 98, 127, 150
Morris, Guido, 26, 27, 33, 103, 104, 105, 106, 107, 108, 109, 133, 134 (ill)
Morton, Alastair, 100
Moss, Marlow, 99, 103
Mostyn, Marjorie, 99, 105, 107, 113, 120
Motherwell, Robert, 109, 110, 119, 128
Mount, Paul, 113
Mundy, Henry, 111
Munnings, Alfred, 102, 105
Murray, Middleton, 16

Nance, Dicon, 103, 105, 106, 113, 124, 133, 134 (ill)
Nance, Robin, 103, 105, 106, 109, 113, 133, 134 (ill)
 Book Rack, 219 (ill)
Nankervis, Vivian, 110
Nash, Paul, 14, 99
Newlyn Art Gallery, 98
Newman, Barnett, 110, 119
Nicholson, Ben, 14, 17, 18, 19 (ill), 20 (ill), 21, 22 (ill), 23, 24, 25, 26, 27, 29, 30, 31, 32, 33, 34, 36, 37, 38, 39, 99, 100, 101, 102, 103, 104, 105, 106, 107, 108, 109, 110, 113, 115, 120, 123, 124, 125, 128, 129, 133, 135 (ill), 136, 138, 142, 144, 145, 146, 149, 150, 152, 153, 158, 159, 161, 162, 167, 170, 171, 179, 181, 190, 205, 208, 215
 August 56 (Val d'Orcia), 61 (ill), 194
 Boutique Fantasque, 62 (ill), 193
 Cornish Landscape, Pendeen, 24 (ill)
 Cornish Port, 55 (ill), 151
 December 1949 (Poisonous Yellow), 177 (ill)
 December 1951 (Opal, Magenta and Black), 178
 December 1951 (St Ives Oval and Steeple), 178 (ill)
 December 1955 (Night Facade), 60 (ill), 193
 February 1953 (Contrapuntal), 59 (ill), 178
 February 1955 (West Cornwall), 193
 January 1948 (Towednack), 176 (ill)
 June 4–52 (Tableform), 58 (ill), 178
 March 1948 (Tree Lelant), 176 (ill)
 March 1949 (Trencrom), 176 (ill)
 May 1950 (Early Morning from San Gimignano), 177 (ill)
 Mousehole, November 11–47, 175 (ill)
 November 1950 (Winter), 177 (ill)
 November 1955 (Still Life, Nightshade), 193 (ill)
 November 1957 (Yellow Trevose), 194 (ill)
 October 20 1951 (St Ives Harbour from Trezion), 57 (ill), 178
 October 1954 (Rievaulx), 193
 October 1955 (Cathedral Pienza), 193 (ill)
 October 1956 (Siena Cathedral), 194 (ill)
 Painted Relief, 169 (ill)
 Porthmeor Beach, (cat.no.4), 54 (ill), 150
 Porthmeor Beach, (cat.no.5), 151 (ill)
 Porthmeor, Window Looking out to Sea, 55 (ill), 151
 St Ives, Cornwall, 169 (ill)
 St Ives Dark Shadow, 177, 178 (ill)
 Still Life and Cornish Landscape, 57 (ill), 169, 170
 Still Life (Spotted Curtain), 174 (ill)
 Trendrine (2) December 13–47, 175 (ill)
 White Relief, 34 (ill), 104
 1940 (Painted Relief, Version 1), 56 (ill), 168
 1940 (St Ives), 168 (ill)
 1940–43 (Two Forms), 168 (ill)
 1941 (Painted Relief, Version 1), 56 (ill), 168
 1943 (Project for Painted Relief), 169 (ill)
 1945 (Parrot's Eye), 170 (ill)
 1947 (Mount's Bay), 174 (ill), 175
Nicholson, Kate, 103, 109, 111, 113, 136 (ill)
 Leafjug, St Ives, 195 (ill)
Nicholson, Simon, 103, 112, 136, 137 (ill)
 6406, 195 (ill)
Nicholson, William, 135
Nicholson, Winifred, 21, 31, 99, 135, 136, 146, 149, 152, 159
Ninnes, Bernard, 105, 106, 109
Noall, Cyril, 97

O'Casey, Breon, 112, 113, 124
O'Malley, Tony, 111, 112, 113, 137 (ill), 199
 St Martin's Field, 218 (ill)
Olsson, Julius, 98, 99, 102, 103, 137, 141, 149
Onobote, A, 134 (ill)

Painter, George, 16
Paolozzi, Eduardo, 15
Park, John, 99, 102, 109, 110, 137 (ill), 149
 Slipway House, St Ives, 52 (ill), 151
Parr, Marjorie, 112
Pasmore, Victor, 32, 33, 34, 99, 103, 108, 109, 138 (ill), 179, 181, 212
 Beach in Cornwall, 186
 Porthmeor Beach, St Ives, 186 (ill)
Passmore Edwards Gallery, 98
Pearce, Bryan, 103, 109, 111, 113, 138 (ill), 215
 Portreath, 218 (ill)
 St Ia Church, 92 (ill), 218
Peile, Misomé, 104, 105, 108, 113
Jack Pender, 103, 111, 112, 113, 139 (ill)
 Lyonesse, 186 (ill)
Penwith Society, 31, 32, 33, 102, 105, 106, 107, 108, 109, 110, 111, 112, 115, 116, 117, 118, 119, 120, 122, 124, 125, 127, 128, 129, 131, 132, 133, 134, 135, 136, 137, 138, 139, 141, 144, 145, 146, 147, 179
Penzance Art Gallery, 98
Penzance School of Art, 97, 108, 143
Peploe, Denis, 115
Perry, R.G., 105
Pevsner, Antoine, 23, 120
 Surface Développable, 23 (ill)
Picasso, Pablo, 14, 32, 124, 135, 146
Pickvance, Ronald, 110

Pierce, Tom, 124
Piper, John, 14
Plato, 23
Pleydell-Bouverie, Katherine, 29, 222, 223, 234, 235 (ill)
Pollock, Jackson, 109, 110, 140
Pope, Terrence, 113
Portway, Douglas, 112, 113
Potworowski, Peter, 33, 104, 139 (ill), 179
 Forest (Cornwall), 187 (ill)
Pound, Ezra, 14, 15
Praed, Michael, 113
Preece, Patricia, 99
Proctor, Dod, 32, 99, 102, 103, 104, 105, 113
Proctor, Ernest, 99
Proust, Marcel, 16
Pryde, Mabel, 135
Pulsford, Charles, 115

Quick, Kenneth, 28, 113, 225, 226, 238, 239 (ill)

Rainier, Priaulx, 33, 34 (ill), 38, 108
Rainsford, Elizabeth, 112
Rainsford, Peter, 113
Ramsden, E.H., 100, 101
Ray, Roy, 97
Read, Herbert, 14, 15, 20 (ill), 22, 23, 29, 31, 33, 35, 100, 102, 105, 106, 107, 112, 193
Reddihough, Cyril, 149
Redgrave, William, 109, 111, 112, 113, 114 (ill), 128
Reid, Norman, 34, 115
Reiseger, Joanna, 110
Reiser, Dorf, 13
Reitz, Bosch, 98
Rich, Mary, 113
Rie, Lucie, 29
Ritman, Lieke, 113
Robinson, Harewood, 97, 98
Robinson, H.T., 105
Robinson, Joan, 100
Rogers, Claude, 138
Rothko, Mark, 33, 109, 110, 114 (ill), 119, 128, 140, 196, 205, 208
Rountree, Harry, 104, 105
Rowe, Tommy, 113, 124
Rubens, Peter Paul, 201
Ruskin, John, 34
Ryan, Adrian, 103, 105, 125, 140 (ill)
 Sancreed Church, near Penzance, 187 (ill)

St Ives Art Club, 98
St Ives School of Painting, 99, 103, 119, 120, 129, 138
St Ives Society of Artists, 26 (ill), 31, 99, 101, 102, 103, 104, 105, 106, 109, 110, 111, 115, 122, 127, 137, 141, 156
St Peter's Loft School of Painting, 109, 128, 137
Sackville-West, Eddie, 22
Sail Loft Gallery, 111
Sandberg, Willi, 33
Schaefer, Bertha, 208
Scherfbeck, 98
Schwitters, Kurt, 103
Scott, William, 33, 99, 103, 104, 108, 109, 139,

140(ill), 141, 175, 179, 212
The Harbour, (cat.no.122), 72(ill), 187
The Harbour, (cat.no.123), 187(ill), 188
Seeger, Stanley, 128
Sefton, A, 106, 113
Segal, Hyman, 105, 106
Seven and Five Society, 124, 135
Sharp, Dorothea, 105
Sharpe, Eric, 134
Shaw, Hugh, 111
Shiels, Tony, 112
Show Day, 98, 99, 101, 102, 103, 104, 105
Sickert, Walter, 97
Simmons, E.E., 98
Simpson, Charles, 102
Sisson, John, 24, 163
Skeaping, John, 101, 124
Skelton, Robin, 33
Skinner, Edgar, 222
Slack, Roger, 17
Sloop Inn, 33, 114(ill)
Smart, Borlase, 99, 100, 102, 103, 104, 105, 106,
 108, 115, 120, 128, 141(ill), 149, 162
 St Ives from Clodgy, 151(ill), 152
Smart, Irene, 106
Smith, Hassell, 112
Smith, Marcella, 98, 105
Smith, Matthew, 99
Snow, M.N. Seward, 109, 111, 112, 113
Somerville, Lilian, 34
Spencer, Stanley, 99
Spender, Stephen and Natasha, 25, 100
Spenlove, F., 99
Staite Murray, William, 221, 227
Stamos, Theodurus, 110
Steps Gallery, 112
Still, Clyfford, 109, 110
Stocker, Norman, 124
Stokes, Adrian RA and Marianne, 98, 99, 102
Stokes, Adrian, 17, 21, 22, 24, 25, 99, 100, 101,
 102, 104, 117, 124, 125, 128, 131, 135, 142(ill),
 149, 152, 161, 162
 Landscape, West Penwith Moor, 170
Stokes, Folliot, 98
Stone, CAC 'Bunny', 104
Strawson, Frank and Vera, 164
Summerson, Elizabeth, 100
Summerson, John, 33, 100
Sutherland, Graham, 14, 101, 179
Sutherland, Helen, 101, 149
Sutton, Philip, 108
Symonds, Ken, 112, 113

Talmage, Algernon, 98
Tambimuttu, 14
Tatlin, Vladimir, 120
Taylor, Bruce, 109, 110
Tilson, Joe, 110, 112, 142, 143(ill), 199
 Conquer, 205(ill)
Tilson, Jos, 143(ill)
Tippett, Michael, 33, 171
Titcomb, W.H.Y., 98, 99
Tobey, Mark, 109
Toft, Thomas, 221
Tollemach, Duff, 97

Tomimoto, 220
Tomlin, Stephen, 109, 110
Tonks, Henry, 27, 228
Toy Trumpet Workshop, 104, 147
Travers, Linden, 203
Treloyhan Manor, 102
Trethowan, Harry, 225
Tribe, Barbara, 106, 113
Truman, W.H., 99
Tuke, H.S., 102, 103
Tunnard, John, 99, 103, 105, 109, 143(ill), 149,
 150
 Fulcrum, 152(ill)
Turnbull, William, 15, 111
Turner, J.M.W., 21, 97
Tworkov, Jack, 110

Unit One, 14, 124
Uren White, James, 98

Val Baker, Denis, 106, 107, 108, 110
Vallely, S., 134(ill)
Van Eyck, Aldo, 36
Van Velde, Bram, 36
Vaughan, Keith, 179
Ventris, Michael, 100
Vernier, 97
Vogler, Felicitas, 110, 135, 190
Vyse, Charles, 227

Walker, Alec, 99
Walker, Roy, 113
Wall, Brian, 33, 109, 110, 111, 112, 114(ill), 116,
 124, 144(ill), 199
 Landscape Sculpture, 206(ill)
 Sculpture, 205
Wallis, Alfred, 17, 20(ill), 21, 22, 25, 26, 29, 32,
 36, 99, 102, 103, 108, 109, 110, 117, 135, 142,
 144, 145(ill), 146, 149, 150, 158, 162
 Blue Ship, The, 153, 154(ill)
 Cottages in a Wood, St Ives, 155, 156(ill)
 Four Boats Sailing before the Wind, 156
 *Hold House port meor square island port meor
 Beach', 'The*, 50(ill), 155, 156
 Houses and Trees, 49(ill), 155
 Houses in St Ives, 156
 Houses with Horse Rider, 155(ill)
 Land and Ships, 157
 St Ives, 50(ill), 152, 153
 *'St Ives Harbour, Hayle Bay and Godrevy
 and the Fishing Boats'*, 51(ill), 153
 St Ives with Godrevy Lighthouse, 156
 Sailing Ship and Icebergs, 153(ill)
 Saltash Bridge, 154(ill)
 Saltash Bridge and Training Ship, 155(ill)
 Schooner and Lighthouse, 57(ill), 152
 'This is Sain Fishery that use to be', 49(ill), 156
 Three-Master Barque in Wild Sea, 157
 Untitled, 153(ill)
 Untitled (Lighthouse and Six Boats), 157(ill)
 Wreck of the Alba and Life Boat', 'The, 156,
 157(ill)
Warburg, Aby, 126
Ward, Susan, 144, 149
Waterlow, Ernest, 98

Waters, Billie, 113
Watkiss, Kathleen, 112
Watson, Francis, 105
Wellington, Hubert, 115
Wells, John, 15, 16(ill), 21, 26, 27, 31, 33, 34, 35,
 38, 99, 101, 102, 103, 104, 105, 106, 108, 109,
 110, 113, 124, 145(ill), 162, 179, 204
 Aspiring Forms, 188(ill), 204
 Composition Variation 3, 206
 Crystals and Shells, 77(ill), 188
 Music in a Garden, 77(ill), 188
 Painting, 206(ill)
 Relief Construction, 170(ill)
 Sea Bird Forms, 188(ill), 189
Wells, Reginald, 227
Weschke, Karl, 32(ill), 103, 109, 111, 113,
 114(ill), 116, 146(ill), 199
 Meeting, The, 218(ill)
 November Sea, 218
 View of Kenydjack, 91(ill), 206
Whistler, James Abbot McNeill, 97
Wilkinson, George, 124
Wilkinson, Norman, 105
Williams, Leonard, 112
Williams, Norman, 145
Wills Lane Gallery, 112
Wölfflin, 120
Wood, Alan, 110
Wood, Christopher, 21, 22, 99, 127, 135, 144,
 145, 146, 147(ill), 149, 150, 153, 175
 China Dogs in a St Ives Window, 158
 Cornish Window Scene, 158(ill)
 Harbour, Mousehole, The, 53(ill), 159
 Fisherman's Farewell, The, 159(ill)
 Fishermen, The Quay, St Ives, 158(ill)
 Porthmeor Beach, 53(ill), 158
 PZ 134, Cornwall, 160(ill)
 Ship Hotel, Mousehole, 159(ill)
Woolf, Virginia, 153
Worsdell, Guy, 113
Wright, David, 16, 105, 133
Wylde, W.P., 112
Wynne-Jones, Nancy, 103, 114(ill)
Wynter, Bryan, 15, 16, 26, 27, 32, 33(ill), 34,
 35(ill), 102, 103, 104, 105, 106, 108, 109, 110,
 111, 112, 113, 118, 125, 133, 137, 139, 146
 Birds Disturbing the Sleep of the Town, 189
 Firestreak 11, 79(ill), 207
 Foreshore with Gulls, 189(ill)
 Immos VI, 207(ill)
 Impenetrable Country, 207(ill)
 Indias, The, 78(ill), 207
 Mars Ascends, 206(ill), 207
 River Boats Blues, 207
 Saja, 219(ill)
 Zennor Coast from the Sea, 189(ill)
Wynter, Monica, 147
Wynter, Susan, 27, 147

Yanagi, Soetsu, 27, 29, 223, 226, 228, 231
Yates, Marie, 112
Yeats, W.B., 14

Zorn, Anders, 98
Zuckerman, Solly, 33, 100, 133, 147